Creative
Enterprise

INTERNATIONAL TEXTS IN CRITICAL MEDIA AESTHETICS

VOLUME #3

Creative Enterprise

Contemporary Art between Museum and Marketplace

MARTHA BUSKIRK

continuum

The Continuum International Publishing Group
80 Maiden Lane, New York, NY 10038
The Tower Building, 11 York Road, London SE1 7NX

www.continuumbooks.com

Library of Congress Cataloging-in-Publication Data
A catalog record for this book is available from the Library of Congress

ISBN: HB: 978-1-4411-3339-7
PB: 978-1-4411-8820-5

Typeset by Fakenham Prepress Solutions, Fakenham, Norfolk NR21 8NN
Printed and bound in the United States of America

For Fred and Mary

CONTENTS

ACKNOWLEDGMENTS

The writing of this book has extended over a number of years, during which time I have enjoyed support and encouragement from many quarters. The initial framing of the project was helped immeasurably by the time and intellectual community afforded by two crucial fellowships. My first thanks go therefore to the Clark Art Institute, with its vibrant dialogue fostered by Michael Ann Holly, Mark Ledbury, and Gail Parker, and to the Henry Moore Institute, where I greatly enjoyed the opportunities to interact with Jon Wood, Martina Droth, and Penelope Curtis. I have also benefitted from various forms of research assistance provided by Montserrat College of Art, including a sabbatical leave from my teaching duties. In particular I would like to thank Laura Tonelli, Dean of Faculty, and Stephen Immerman, President, for their support, and I owe a debt of gratitude to the many colleagues who took over my academic duties while I was away. Nor would this book be possible without a publisher, which it found with the encouragement of Francisco J. Ricardo, who is both a long-time advocate for this work and editor of the series within which the book appears, and Katie Gallof, Acquisitions Editor at Continuum.

I am grateful for the opportunities I have had to present aspects of this material in the context of conferences and symposia, and for the valuable feedback that has been part of that process. I also appreciate the many people who have been willing to discuss the book as it has developed. Several people read substantial portions of the text or responded at crucial points, and I therefore particularly thank Caroline A. Jones, William Kaizen, Rebecca Uchill, and Winnie Wong for their vital input. There are many other individuals have responded to sections of this project at different stages or have provided other important assistance during the research and writing, including: Rhea Anastas, Caroline Bagenal, Peter Chametzky, Lynne Cooke, Anna Dezeuze, Sandra Dijkstra,

Rebecca Duclos, Arindam Dutta, Susan Edwards, Frank Egloff, Jane Farver, Bettina Funcke, Scott Hadfield, Blyth Hazen, Masako Kamiya, Julia Kelly, Karen Kelly, Robin Kelsey, Colleen Kiely, Jim Koudelka, Pip Laurenson, Sarah Lowe, Joanne Lukitsh, Lúcia Matos, Terry and Sam Moriber, Mignon Nixon, Marcia Pointon, Kathy O'Dell, Robin Reisenfeld, Virginia Rutledge, Elisabeth Smith, Erik Thuno, Jane Tormey, Liselot van der Heijden, Gillian Whiteley, and Mechtild Widrich.

I would also like to express my appreciation to the artists whose work I discuss, particularly those who have taken the time to talk about aspects of their work with me over the years that I have been considering these issues. In addition, the images for this book have come from multiple sources, and the book in its present form would not have been possible without the help of many artists, artists' assistants, galleries, museums, art organizations, and others who provided images or helped direct me to their source.

I owe a tremendous debt of gratitude to my parents, Mary and Fred Buskirk, and my sister, Janet Buskirk, for all their enthusiasm. Finally, and most of all, I would like to thank Robert Moeller, whose insights and unfailing encouragement have played a crucial role in helping me bring this seemingly endless project to a conclusion.

Martha Buskirk

INTRODUCTION

It would be easy enough to dismiss the Brooklyn Museum's decision to honor the winner of *Work of Art: The Next Great Artist* with a 2010 solo exhibition as a craven publicity stunt, calculated to ride the slipstream of media exposure surrounding the Bravo network's art-based foray into the world of reality television. The work of Abdi Farah, the 22-year-old champion who had only recently completed his undergraduate art degree, did indeed seem a bit immature. But the idea of the museum survey as crowning achievement awarded (and only rarely at that) for a lifetime of artistic struggle and exploration had long begun to slip, with younger and younger artists feted under the rubric of the "mid-career retrospective." Collectors have likewise been eager to chase down new talent, in a feeding frenzy that has invaded the MFA studios of certain high-prestige schools known (in a self-perpetuating cycle) for their track record in launching art world stars. It was apparently coincidental, however, that the title Farah gave his assembled work, "Luminous Bodies," was based on a line from *The Empire Strikes Back*, returning it full circle to a 2002 exhibition at the Brooklyn Museum showcasing costumes and other props from the *Star Wars* cycle that was heartily criticized for its shallow populism. A rather defensive sounding introductory wall text insisted that "contests such as *Work of Art* are not unfamiliar to art museums," situating this morsel of twenty-first-century synergy as "a direct descendent of the juried-exhibition tradition" central to nineteenth-century salon displays at the Louvre.

Nor was the Brooklyn Museum the only art world institution marshaled to put its imprimatur on this freshly anointed luminary, since the jackpot included (in addition to a sizable cash prize) the honor of having a work put up for auction. "For an artist to go to an auction house," declares Chuck Close, "is a little bit like taking a cow on a guided tour of a slaughterhouse."[1] Try telling that to Takashi Murakami, however, described as a "habitué of the auction

circuit," or to Farah, still under the wing of Simon de Pury (who served as mentor to the contestants on *Work of Art*) when he made an appearance at the November 2010 Phillips de Pury & Company contemporary sale and saw his drawing, appropriately entitled *Baptism*, go for $20,000.[2] The idea of an auctioneer as a worthy guide for young artists could be written off as just another broadcast absurdity, were it not for the ascendant role of the contemporary art market, together with the increasingly dominant position of auction houses within that context. Despite the fact that Bravo's art "reality" was no less artificial than any of its television predecessors, the museum's willing collusion with this media-driven talent hunt does say something about the actual state of the art world.

By almost any measure, contemporary art has never had it so good. There are, even in the most conservative estimates, thousands of noteworthy galleries in large and small cities throughout the world devoted to its display, hundreds of museums with significant contemporary programming, as well as scores of biennials and art fairs. Large numbers of art schools and degree programs, as well as an increasingly significant international network, ensure a constant supply of new material, and a closely related array of curators, critics, and academic researchers make certain that the recent and not quite so recent is properly contextualized. A vital, if at times dizzying, eclecticism means that monumental installations coexist with gestures that have no physical presence; art made using traditional modes of address shares its audience with experiments involving both newer media and alternate systems of distribution; and works that speak directly and critically to contemporary social or political issues intermix and overlap with subtly nuanced explorations of form. The challenges presented by this diversity of practice are being addressed by an equally formidable and varied assembly of interpretive methods, ranging from the foundational texts associated with the still relatively young discipline of art history to the cross-disciplinary riches tapped by the theoretical turn in the latter part of the twentieth century. Nor are these analytic tools being deployed in only one direction, since artists are part of a dialogue that therefore informs production as well as interpretation.

Yet somehow all is not quite right. Developments during the last century made it abundantly evident that romantic notions of autonomy and art for art's sake were not only impossible to sustain, but often declaimed in precisely those contexts where art

was being used for the least disinterested of purposes. It is difficult, however, not to see a certain irony in what seems to be a smooth segue from strategies of institutional critique, which were once capable of provoking discomfort and resistance through unwanted scrutiny, to the institutional embrace of artistic projects that knowingly highlight aspects of establishment protocol. Likewise, post-studio practices initially seemed like a bracing challenge to the old-fashioned figure of the lone artist in the studio. These alternative approaches have nonetheless opened onto the reestablishment of workshop-type enterprises designed to sustain both high production volume and the logistics of international artistic careers. Alterations in the labor necessary for art's creation play off of and mimic broader economic transformations, with much contemporary work produced through the combined efforts of numerous studio assistants and specialized fabricators, and frequently emerging from various forms of cooperation between artist and curator. Roles blur in other directions too, with artists responsible for the work, but often involved in establishing its interpretive context as well (once thought to be the moment when the critic was supposed to take up the task). Although art remains an idealized activity, it is also understood as a profession, and in increasingly obvious ways a business, particularly as practiced by star artists who preside over highly developed art product lines.

The contemporary museum, with its multi-faceted agenda, is central to this state of affairs but equally filled with contradiction. It is tasked with guarding cultural heritage and promoting scholarship while simultaneously serving as an entertainment and tourist destination. Museums preserve the art of the past even as they actively help produce the art of the present. The objects on display are supposed to be priceless, in the double sense of valuable beyond measure and withdrawn from the economies of exchange. Yet exhibition programming is often linked to strategies of collection building, and contemporary selections are driven by what commercial galleries have already put forward. It is also an institution in a constant state of flux, despite the venerable stability implied by a certain era of Western museum architecture. Related to the emphasis on the new is a constant process of reassessing how to present art of the past, with old and recent sometimes linked by invitations to artists to respond to collection dynamics. And even where a direct examination is not in play, contemporary

art's extreme variety carries suggestive echoes of one of the art museum's historic predecessors, the cabinet of curiosities, thereby drawing attention to the process of definition by which the art museum was set off from such other museum types as natural history collections, historical societies, or science museums.

Linked, inescapably, to these transformations, is the vastly expanded art market, which has proven itself capable of embracing not only unique objects, but all those less evidently rare or even tangible forms once conceived as resistant to art's commodification. The avant-garde's paradoxical, even destructive, success can be seen in the ways that dissent is not only embraced, but eagerly solicited—at least as long as it stays within certain bounds of good behavior and professional responsibility. In fact it has become painfully obvious that many of the very qualities that make recent artistic developments interestingly provocative can simultaneously provide the basis for cynical manipulation and instrumentalization. Too often there is a double agenda at work, with art based on a close mimicry of all manner of goods and services asserted as self-conscious critique, at the same time that such work is pursued in a highly businesslike fashion, with an eye to maximizing actual dividends. Yet, even in the face of the organization of art museums in conformation with business models, as well as resemblances between artistic creation and other forms of celebrity, branding, and commodity production, the notion of art as a privileged sphere of activity remains a dearly held and indeed essential tenet.

To the extent that the contemporary is taken as synonymous with the new, it is easy to fall prey to quick cycles of novelty and obsolescence. By contrast, this book takes a longer view, considering the interplay between art and institution in light of earlier forms of interdependence. It is impossible to talk about art without considering how it is shaped by the present context of its exhibition and dissemination. And, given that recent art builds on a long history of highly specialized conventions, an analysis of the contemporary has to be grounded on what has come before. Nor can the field of activities identified with the art world be considered in isolation from many other closely related practices. Finally, it is important not to allow the discussion of context to become an end in itself, with the result being an account that circles around the art in question without investigating it directly.

There is no single way to address these dynamics, but the chapters that follow offer an interweaving of telling examples or

situations that highlight shifting relations between artist, institution, work, and audience. One line of inquiry concerns the history of the museum, and how our contemporary experience is built upon, but also departs from, conventions developed in relation to earlier forms of art. Another unpacks the fortunes of the work of art as such, with a focus on how it is constantly defined and redefined in relation to the demands (and desires) of the many interested parties involved in its existence over time. The last part of the book takes on links between market and exhibition circuit, looking for interesting ways to talk about the corrosive impact of art as a growth industry, including the paradoxical claims emanating from a professionalized avant-garde. Over the course of the book, an examination of how distinctions between production and reception blur in the context of museum and conservation practices opens onto an analysis of the many ways that contemporary art has become deeply embedded in an expanding art industry.

Enter the institution

What city can aspire to world-class status without a museum of contemporary art? But does the ubiquity of such institutions necessarily make the concept any less peculiar? It wasn't too many decades ago that artists were mounting vigorous arguments against the museum and its impact on the art it housed. The museum as mausoleum was a common critique. And only a few centuries ago the museum barely existed as a concept, much less as the governing model for how works of art are expected to be viewed. Because the public art museum's establishment is a fairly recent phenomenon, dating largely to the eighteenth and nineteenth centuries, the survey-type institution has a significantly shorter history than many of the objects it houses, meaning that much of the earlier work has been in some sense appropriated as part of its entry into the museum. But, if the initial history of the art museum was one of decontextualization, with objects made for purposes radically different than disinterested contemplation wrenched from their religious or ceremonial settings and obliged to serve new gods, it is another matter entirely when such institutions become filled with work made with the viewing and ownership conditions of the museum as an underlying assumption.

Early twentieth-century avant-garde movements were forward looking by definition, generally with little use for those monuments of the past interred in dusty museums. Even when New York's now venerable Museum of Modern Art was founded in 1929, a sense of incompatibility between museum and modern was evident in Alfred Barr's well-known image of the collection as "a torpedo moving through time," with the nose always progressing, and a corresponding proposal that older works be sold to other museums to make way for the new (which of course never happened).[3] By the twentieth century's end, however, the vast expansion of museums of modern and contemporary art was accompanied by a somewhat paradoxical return of the antiquarian, not as a figure of ridicule, but as a guise taken up by artists turning their attention to histories of both objects and institutions. A burst of renewed interest in the earlier cabinet, with its admixture of natural and artificial curiosities, has been part of a broader engagement with a multiplicity of object types and associated patterns of collecting.

Artists play a key role in forging links between separate collection types, and Fred Wilson's 1992 *Mining the Museum* is particularly well known in this respect for its pioneering demonstration of the potential marriage of conceptual art and material culture through his rearrangement of the Maryland Historical Society's holdings to highlight previously overlooked evidence of African American and Native American histories. The expanding popularity of such interventions indicates the appeal of using artists to shake up the art museum's traditional order, with unexpected juxtapositions disrupting the authority of previously instituted narratives (though curators are increasingly taking up the charge themselves, rather than relying on artists to exercise such creative license). Curators solicit, in fact expect, the unexpected when they unleash an artist to respond to an existing collection, with artists invited to provide a counterpoint to the ostensibly neutral chronological order associated with the establishment of art museums as public institutions.

For collections associated with an individual, by contrast, neutrality is generally not an issue. Private cabinets were inseparable from the antiquarian interests of their owners, not just in the composition of the assembly, but in the link between the objects and the collector as story teller, guiding the experience of visitors

to the collection.[4] The historicist agenda associated with public museums, however, eradicated such antiquarian eccentricities in favor of an apparently authorless narrative, predicated on the unfolding of different periods and regional styles, which posits the examples in the specific collection as fragments of a larger, siteless totality. Without turning public collections back to private hands, planned disruptions generated by artists' interventions reintroduce something akin to the individual owner's personal engagement, as the permission granted to artists to manipulate, arrange, and tell unexpected stories resembles the authority typically exercised by a private collector over his or her possessions.

Of course the institutional narrative associated with traditional survey collections was never the least bit objective, examined for elided ideologies of race, gender, or class. In its early incarnation, the public museum was charged with helping to transform royal subjects into citizens through an experience of art that would no longer be synonymous with a visit to the king. But the idea of education, linked to the goal of providing alternatives to other more debauched forms of recreation, opens onto readings of the museum as an engine of social control.[5] Nor can autonomy claims for the objects in art museum collections be sustained—which should hardly be surprising, given that this ideology of aesthetic self-sufficiency depended upon the context of the museum narrative for those assertions to be forwarded in the first place. Despite the long association between ideas of autonomy and the history of the museum, the relative synchronicity of their appearance suggests that there has always been a built-in contradiction. As Douglas Crimp has so persuasively argued, statements defending art's autonomy often functioned as ideological smokescreens, helping obscure the late-twentieth-century museum's relationship to wealth and power, the impact of patronage, and the organization of the institution along business lines.[6] And, in recent years, the ability of museums to absorb, even foster, what once appeared to be critical discourse has helped align the institution with a larger marketplace for culture often described in terms of an experience economy.

Even the phrase used above, "contemporary museum," is open to a double reading. There is the twentieth-century phenomenon of museums specifically devoted to modern and contemporary art, but there is also the inescapable fact that all museums are contemporary in the sense that the access to the past they seem to promise

is firmly rooted in the present tense of the viewer's experience. The story told by the overall arrangement of the collection often promotes an illusion of permanence, of fixed identities and meanings adhering to the objects thus arranged. But this history—the narrative suggested in the encounter with the collection at any given moment—is subject to a constant process of revision. Another chronology, the tale of how the collection has been presented at successive points, is the saga of the museum's instability, evident in the sequence of different hanging schemes, each with its own proposition about the objects thus contextualized. No order can ever be definitive, given inherent tensions between the overall message of the museum's arrangement and contextual information relevant to specific objects—the significance of which becomes especially apparent when a work's situation in the museum's present narrative is interrupted by inconvenient news about illegal excavations or shady provenance history.

The gradual transformation of institutional critique into invited collaboration reflects the fact that neither museum strategies nor artistic responses have remained static. It is equally interesting, however, to note the degree to which resistance and embrace have operated in tandem. The counter-museum stance articulated in the context of Fluxus or in the writings of Allan Kaprow and Robert Smithson appeared at a time when museums were reorienting their exhibition programs to encompass art of the present. Quite obviously the critique of the museum was linked to a certain fascination—evident, for example, in Smithson's association between museum and tomb, at the same time that he was paying close attention to natural history collections (where many displays are quite literally dead).[7] And witness, as well, the 1969 action staged by the Guerilla Art Action Group (GAAG) in front of the Metropolitan Museum to coincide with the opening of Henry Geldzahler's controversial *New York Painting and Sculpture: 1940–1970*. Calvin Tompkins, writing for the *New Yorker*, described an invasion of this staid institution by swingers in see-through blouses and a rock band performing in front of Frank Stella's paintings, even as the event was simultaneously protested by GAAG with a sidewalk drama-tization of an artist being pelted by drinks and canapés.[8] In the case of the GAAG action, the small demonstration in front of the museum was greatly overshadowed by the number of artists who joined the party inside. But an even more significant development

in the decades since has been the art museum's eager embrace not only of the portable objects that filled the Met's early manifestation of contemporary painting and sculpture, but even the type of intervention mounted outside on the sidewalk.

Made in the museum

Two exhibitions at Iris Clert's ground-breaking Paris gallery staked out certain extremes that have held true for many of today's museum interventions. Presenting nothing but the gallery itself, stripped down to bare, whitewashed walls, Yves Klein's 1958 *Le Vide* was nonetheless a major event, attracting a huge crowd eager to enter the otherwise empty space and partake of blue cocktails that Klein had spiked with a medical dye that would discolor their urine for days. In turn, Arman's 1960 *Le Plein* (Full Up) packed the same space so completely with rubbish that the exhibition could only be viewed as a solid, standing on the street and looking at the accumulated mound through the gallery's picture window. Considering the art museum's historic raison d'être, founded upon the preservation and fetishized display of highly prized objects, it is striking what an extensive tradition has developed of emptying out the displays in the name of art, or filling the galleries with a wholesale accumulation. For artists who have taken the former tack, sometimes the absence of art on the walls is exactly the point, while at other times static objects are superseded by experiences that play to senses other than sight. There are plenty of examples of excess as well, with all manner of material, sometimes in dizzying abundance, presented under the general auspices of installation art.

Such intrusions are often eagerly solicited by curators and their respective institutions, suggesting an almost masochistic attraction to willfully resistant work as well as dramatic evidence of changing institutional priorities. In this respect the Guggenheim that summarily cancelled Hans Haacke's 1971 exhibition is and is not the same institution that happily collaborated in the 2010 presentation of Tino Sehgal's *This Progress*. The logistics involved in hiring and training the teams of performers (interpreters, in Sehgal's terminology) who engaged visitors in tag-team conversations on the general theme of progress are clearly of a very different order

than presenting rotating displays of objects. And there is the added twist that Sehgal not only forbids photographic documentation, but refuses to employ any form of written instrument in the transmission of the work—relying instead on oral contracts and instructions. In his rejection of such records, Sehgal has insistently slammed shut a back-door approach to performance and related practices, where claims about the work's immediacy have coexisted with widespread dissemination through enduring documentation. Yet the point-by-point refusal of key institutional conventions has clearly not dampened interest in his constructed situations, given that Sehgal was the youngest artist to be accorded the entire Guggenheim rotunda. In fact his gaming of conventions clearly appeals to curators and other professionals steeped in their daily practice. Nor have his gambits precluded marketability, evident in his represen-tation by one of New York's leading contemporary galleries, or the fact that the second work shown at the Guggenheim, his 2003 *The Kiss*, was on loan from the Museum of Modern Art. By selling rights to the situations themselves, rather than related documentation or video, Sehgal's ostensibly resistant work has in fact helped to extend the ways performance-based work can be marketed and collected.

In their turn, large-scale works have inspired ever-expanding spaces of display, as part of a cycle that then challenges artists to find new ways to fill these vast containers. But a significant presence can be achieved by various means, as Olafur Eliasson demonstrated with his 2003 *Weather Project*, when he took over the Tate Modern's massive Turbine Hall with nothing but reflec-tions, light, and mist. A mirrored ceiling completed the artificial sun generated by a half-circle of lamps mounted on the adjacent wall while simultaneously reflecting back the fog-shrouded viewers cavorting on the floor below. And the possibility that such spaces are participating in a form of arms race, with each side (artist and institution alike) escalating to ever larger scale, might be one way of reading Dominique Gonzalez-Foerster's 2008 *TH.2058*, for the same venue. In the context of her evocation of the future, fifty years hence (when the artist posited that London's inhabitants might need to use the hall as a refuge from an incessant deluge that would also cause its urban sculptures to grow and swell), already monumental works by Louise Bourgeois, Alexander Calder, and others became even bigger in replica versions that loomed over her gridded play between refuge shelter and reading room.

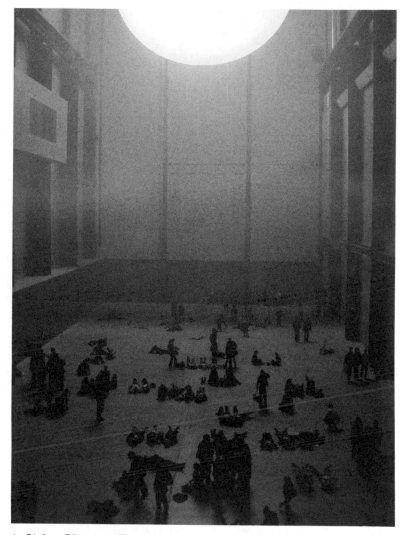

1. Olafur Eliasson, *The Weather Project*, 2003. Monofrequency lights, projection foil, haze machine, mirror foil, aluminum, and scaffolding, dimensions variable; installation view, Turbine Hall, Tate Modern, London. Courtesy the artist, Tanya Bonakdar Gallery, New York, and neugerriemschneider, Berlin. Photo: Jens Ziehe.

2. Dominique Gonzalez-Foerster, *TH.2058*, 2008. 3 reproduced sculptures (125% of original size) or 6 reproduced sculptures in original size, LED Screen, 229 shakedown beds, approximately 10,000 science-fiction books, sound, approximately 100 × 22 × 20 meters; installation view, Turbine Hall, Tate Modern, London. Courtesy 303 Gallery, New York.

The larger the project, however, the more that can go dramatically wrong, as the Tate found in 2010 when it had to close public access to Ai Weiwei's field of millions of individually fashioned ceramic sunflower seeds because of dust generated by friction as they rubbed together under the weight of people's footsteps. But the intensive logistics, as well as potential pitfalls, in the process of turning huge spaces over to monumental projects are most dramatically illustrated by the implosion of *Training Ground for Democracy*, Christoph Büchel's ultimately unfinished installation for MASS MoCA, which devolved into a bitter and protracted legal battle between artist and museum. As per now standard procedures, the museum was charged with the logistical and financial support needed to realize the vision of the invited artist, which in this case involved a setting in which viewers could play out different roles and tensions associated with democratic society, in the context of a spatial arrangement inspired by simulated environments used in military training. Working toward an opening that was initially slated for December 2006, the museum assembled such key items as an entire movie theater, two-story house, mobile home, multiple shipping containers, various vehicles, and many tons of other material. Yet there were also elements that hadn't been procured, and the museum's instance that the airplane fuselage on Büchel's list would take it too far over budget became part of a larger conflict that extended to funding as well as control over creative decisions in a situation where a significant part of the fabrication was delegated to the museum.

The conflict laid bare a fine but nonetheless important distinction: for an institution to take responsibility for a significant share of a work's creation is not the same thing as creating a collaborative work. Among Büchel's grievances were decisions being made by members of the museum staff during construction, without sufficient consultation with the artist—a tension that was only exacerbated when the museum continued to work on the project in Büchel's absence. Even more striking, however, was the museum's controversial decision, once the exhibition was officially canceled in May 2007, to go to court in a bid for legal authority to show the unfinished installation that Büchel had already disowned—a course of action that brought a cascade of negative publicity and which the museum abruptly reversed, despite an initial court victory, when it proceeded to disassemble the installation without official public display in September 2007.[9]

Regardless of the potential fault lines revealed by this conflict, there is certainly no sign of museum production abating—particularly as it dovetails with the installation-heavy approach favored for biennial-type exhibitions. The reasons why museums get into the business of producing the work on display are, however, many, ranging from presenting work created specifically for the site to the desire to exhibit otherwise unavailable historical examples. Nor is it particularly remarkable, despite the traditional importance of original objects for the art museum's mission, to encounter exhibition copies of contemporary work. Once ephemeral or otherwise experimental phenomena, made with little concern for posterity, are judged historically important, such replicas can give the work a tangible presence in the embodied version of history told via museum-generated historical surveys.

It is equally true, however, that a great many of the paintings and sculptures in survey collections were no more created for the museum than these recent forms, only becoming paradigmatic museum objects through their display in an institution conceived and designed to present them as such. But, despite the underlying premise of the museum, providing a vision-centered experience does nothing to guarantee that museum audience members will actually stop and look. The literature on museum management abounds with statistics on the short period of time (generally measurable in seconds rather than minutes) visitors are likely to accord to the vast majority of works on view. As destination points for the secular ritual of tourist pilgrimage, museums may have replaced religious or cult value with exhibition value (pace Walter Benjamin), but that does not necessarily add up to a leisurely examination of objects already familiar from reproduction.[10] Museum success can amount to a kind of failure in this regard, as the fame, along with marketing, responsible for drawing crowds to a particular exhibition or object can make the work both literally and figuratively difficult to see.

Contemporary art's expanding reach has to be understood in relation to a broader project of art promotion. Many have identified the 1976 opening of "The Treasures of Tutankhamun" at New York's Metropolitan Museum of Art as the beginning of a new era of museum spectacle, but Alan Wallach posits the Met's 1963 Mona Lisa exhibition as the true inauguration of the blockbuster. Drawing over a million visitors in a single month, the exhibition's appeal was nonetheless also a failure of sorts, with any type of

extended ability to commune with the object at the center of all that fuss ultimately foreclosed, despite its much touted presence.[11] And one has to wonder, in the same vein, just what exactly the six million or so annual visitors who make the pilgrimage to the Mona Lisa at the Louvre actually see as they herd past Leonardo's painting, surrounded by milling crowds and protectively encased behind bullet-proof glass. The Louvre's decision to hang the Mona Lisa alone on its own wall constitutes a tacit acknowledgment of how little attention is accorded to the works that once hung around it, and in that respect how irreparably this particular object's renown has interrupted the historical narrative within which it would otherwise be situated.

3. View of the crowds around the Mona Lisa at the Louvre, June 2008. Photo: Masako Kamiya.

While the Mona Lisa dates to the first decade of the sixteenth century and is mentioned in early literature, including Giorgio Vasari's *Lives of the Artists*, it did not begin its true ascent to notoriety until the mid-nineteenth century. In that sense it only became a masterpiece as such some time well after its entry into

the Louvre. (Even the term masterpiece, now so securely associated with this painting, acquired its own amended meaning around the same time. Formerly a work produced to qualify for the status of master within the guild system, the masterpiece of the romantic era took on a new mythic status.[12]) For this work and so many others, the general emphasis on a specific point of origin in its dating draws attention away from the impact of later interpretations—the ensuing stories, or histories plural, as the production of the work's meaning unfolds in the temporal space between origin and successive moments of reception.[13] In his 1817 history of Italian painting, just prior to her full stardom, Stendhal didn't hesitate to question the Mona Lisa's lack of eyebrows; but it is not clear how many of the painting's current visitors even get close enough to fully examine her features and, for those who do, whether they feel authorized to find fault with this object of touristic desire.[14] The painting has been both made and unmade by the museum, with the latter apparent in the tension between the present circumstances of the work and qualities it is supposed to convey, despite one's actual viewing experience. Nor is this process confined only to works subject to frenzied attention, since they provide just one example of the obstacles that potentially impinge upon a viewer's ability to access the qualities a work is reputed to embody.

It is not so much that contemporary practices have destabilized artistic conventions associated with the museum; rather, the eclecticism of recent work, including art now produced in active collaboration with museum exhibition programs, has helped highlight a process of constant evolution that already existed. Shifting conceptions of art are reflected in altered collection arrangements and hanging schemes, including the salon-style approach that went out of fashion early in the twentieth century but has been resurgent in recent years, or the question of white versus richly colored walls, which has been subject to similar tidal pulls. Witness, too, the abrupt shift in fashion away from plaster casts. Yet another complication to the story can be found in the connections historians have drawn between the nineteenth-century history of art museums and related modes of display or address found in world fairs, commercial arcades, and the newly emergent department store. Plus there is the clear parallel, emerging in the twentieth century, between the role of the artist's studio name

in authorizing the work and the importance of brand image or identity in the larger universe of consumer goods and services.

"However a problem is solved, the solution is false," writes Adorno in an oft-cited essay on the museum, where he suggests that the only thing more distressing than the loss of a work's original surrounding would be an attempt to create a false approximation— paintings presented in a baroque or rococo castle, for instance, or, in a parallel example, the fetishism of using original instruments in performances of Bach.[15] For him, the afterlife of the artwork implies a form of destruction, as dislocation from the moment of origin is the basis for its ongoing efficacy. But, while he notes the tendency to relegate "every work of art to the museum, even Picasso's recent sculpture," he does not articulate the next step, where museum procedures and art making become so intertwined that the works starts and ends in the museum, with no relocation as part of the process.[16]

For just about any object, the museum in some sense creates the work. Museum manufacture is, however, quite literally true for many forms of contemporary art where institutions actively collaborate with artists in the process of organizing, staging, and documenting their site-dependent or event-based projects, with the works therefore linked to the museum from their inception. As part of the increase in art production that has accompanied (and indeed far outpaced) museum growth, the already large volume of work created in artists' studios for museum-style conditions of exhibition has been supplemented by an expanding band of itinerant post-studio artists who transform the site of exhibition into the space of assembly. The assimilation of earlier avant-garde gestures has also opened the way for new generations of artists who often walk a fine line between critique and entrepreneurial profession-alism as they realize their mutual undertakings with curators and institutions.

The museum as mass medium is Andreas Huyssen's characteri-zation of the institution that has emerged, not from the museum's triumph over the avant-garde, but a form of reversal, which he characterizes as the pyrrhic victory of the avant-garde over the museum.[17] Nor does it seem entirely accidental that the blockbuster strategy has come to resemble, in certain key ways, what should be its polar opposite: the recent event and situation-driven works championed by Nicholas Bourriaud under the banner of relational

aesthetics, which de-emphasize the object in favor of audience experience and participatory exchange.[18] While Bourriaud draws a contrast between the continuous availability of art objects and the establishment of ephemeral situations, where the artist summons the audience, museum success, in the business sense, is predicated on parlaying the cult of the original into selling the museum as overall experience and the visit as event. The willing embrace of an expanding definition of art within the galleries is only one aspect of a multi-part institutional agenda encompassing merchandise operations, live music, film, family days, singles nights, and a whole host of other functions designed to make the museum into a full-service culture and entertainment destination.

Art and commerce

When Damien Hirst's *For the Love of God*, his infamous diamond and platinum skull, went on display at the White Cube Gallery in London in 2008, people lined up to get a brief glimpse of the heavily guarded bauble. If one wanted to give the work the full art-historical treatment, one might choose to discuss it in relation to the earlier cabinet of curiosities, with its sometimes startling mix of natural and artificial wonders. Or, given the wow factor of its £50 million asking price, it could be dismissed as yet another brilliant publicity stunt in a career filled with such maneuvers. It is also part of an integrated market strategy ranging from high-end prints to posters and t-shirts. There are plenty who would dismiss Hirst out of hand, and even if one grants him a certain historical significance in the context of the young British artist phenomenon, it is difficult to overlook his frequent recycling of earlier works. By most quantitative measures, however, his success is unquestionable—with his work represented by top echelon international galleries, collected by major museums, and bought by wealthy collectors whose ranks he has joined as a multi-millionaire. If this represents a certain pinnacle of artistic achievement, what does it say about the current state of art?

The possibility that an everyday object might become a work of art merely through the artist's declaration, posited by Duchamp via the readymade in the 1910s, and the further option that the work

need not be identified with a physical object at all, as elaborated most consistently in conceptual practices of the 1960s and 1970s, would both seem to be major turning points in the shift away from a notion of art based on assessments of style or the presumption of an innate connection between work and artist. It is, however, not quite so simple, since a lot of the works in the museum that Duchamp helped to interrupt already resemble the readymade, in that their entry into the museum meant that they had been removed from an earlier use. Svetlana Alpers notes a similar move with respect to cultural materials, which can be transformed into objects of aesthetic contemplation as a result of the museum's emphasis on the visual, isolating and highlighting paintings and artifacts alike.[19] And, even in the context of painting, are those retasked portraits encountered in the museum as examples of canonical artists' works really so radically different from Duchamp's redesignated objects, given their general realignment from paintings *of* a particular subject to works *by* a noteworthy artist?

"Use a Rembrandt as an ironing board." Such is Marcel Duchamp's suggestion for a reciprocal readymade, in the companion notes for his *Large Glass*. Most obviously it is a direct inverse of his procedure of taking an everyday object out of use and, by declaring it a work of art, setting up the conditions whereby it might indeed enter art history as such. Yet the notorious Rembrandt Research Project (RRP), with its agenda of vetting the authenticity of all paintings ascribed to the Dutch master, has demonstrated the high stakes resulting from another form of declarative statement with the potential to change the status of an object quite dramatically without altering its physical presence. Although the destination of such Rembrandt favorites as the *Man with the Golden Helmet*, cast out of the oeuvre some time ago, or the *Polish Rider*, questioned by the RRP, is more likely to be museum storerooms than ironing boards, the attendant controversies show how much money as well as prestige is riding on these secondary judgments. Matters of interpretation can be politely debated among scholars, but attributions are another story, and heated disputes about artistic authorship provide one more piece of evidence regarding what is at stake as art of the past is retrospectively assessed according to contemporary priorities. Connoisseurship would seem to privilege the object, but the radical shift in perception following a changed attribution confirms the importance of authorship as a function in itself.[20]

Author, designer, brand—the categories quite evidently overlap, since all are part of a crucial organization of both objects and desires, where pleasure in the thing itself is wedded to a shared recognition of cultural authority. Yet, even as workshop practices cause untold headaches for retroactive judgments about the authenticity of past art, it seems to matter little in the contemporary context whether a name denotes an individual creator or a corporate entity. In the present environment, strategies based on the readymade are hardly a disruptive force; rather, they have been smoothly integrated into a system where notions of style, and even production, have become increasingly inseparable from patterns of consumption.

Just as artists have been playing with modes drawn from non-art sources, so, too, have museums. Duchamp did not elaborate the further possibilities of the reciprocal readymade—use a Van Gogh as an umbrella; use a Munch as an inflatable plastic toy; use the Mona Lisa as a shower curtain or refrigerator magnet—but others have stepped up to the challenge of extending his idea, albeit via the reproduction, with these examples and so many more now found in museum gift shops around the world. Different types of objects have also made their way into the galleries, with the Guggenheim particularly notorious for an inclusive purview that has extended to the flip side of modernism in Norman Rockwell, and even further afield with displays of motorcycles and Armani fashion, in conjunction with forms of packaging and brand identity activated through its far-flung museum projects and partnerships. The spectacle of a now defunct Guggenheim outpost in a Las Vegas resort presenting an exhibition of motorcycles raised rather interesting questions about the role of an art museum within all of this. But, if artists can claim just about anything as art, maybe this is simply an example of museums getting in on the same act? And the connection between museum expansion and tourism, which itself has been described as the selling of an experience, helps make it seem like a mere hop, skip, and a jump from the visit to the survey museum to the foregrounding or framing of experience itself in the event-driven works championed under the banner of relational aesthetics.[21]

"How can we let works of art speak for themselves?" Such is museum director James Cuno's plaintive question in an argument for retrenchment to counter this very state of affairs.[22] Despite periodic aspirations, however, it is implausible that the museum

or any other context can be willed into neutrality. There is a back and forth process, as the work is inevitably defined or redefined in relation to the circumstances of its reception, even as that context is transformed in turn. And, in the contemporary setting, it is not art doing the talking, but artists, whose claims for their works are often parroted back in assessments of their efficacy. Frequently voiced complaints about criticism's diminished role have their obverse in various forms of direct engagement between artists and curators or collectors, in the context of a marketplace largely impervious to whatever critical caveats may still be lodged.

Clearly art cannot be isolated from the institution of the museum—developed to preserve and exhibit historical material, but also motivating the production of work made with the conditions of display as an underlying assumption, or even direct collaborative ventures between artists and institutions. While a comprehensive museum history is not the goal here, the first two chapters look at how contemporary art's diverse forms can be related to conventions established in response to earlier traditions. Different collection types are an important point of reference, as art's recent heterogeneity echoes the eclecticism of earlier curiosity cabinets, yet does so from the vantage point of the art museum's eventual separation from other related institutions. The first chapter uses the Victoria and Albert Museum as a fulcrum for considering how works based on a play with everyday objects draw attention to ways that this museum of art and design charted an alternate course from other survey-type collections, as well as how changing institutional narratives are a symptom of art's unstable relationship with the museum. This examination opens onto the second chapter's consideration of authorship over the assembly as a point of intersection between artists, collectors, and institutions. When consumption becomes a basis for production, there are varying reasons why collections by artists may or may not be treated as works, along with suggestive parallels with vernacular collecting practices.

Production and reception blur in other ways as well, as the construction of the work not only emerges from a process of negotiation between artist and institution, but involves a temporal dimension evident in the process whereby the work's definition is shaped in retrospect by the expectations of later audiences. An extended discussion of the multiple configurations of Allan

Kaprow's *Yard* in the third chapter raises issues that are relevant to many other ephemeral works that have been brought back to existence in recent years, as the exigencies of historical exhibitions have inspired museums to undertake the production of the work to be shown. Newly created works by already deceased artists, however, present only one of many challenges to our understanding of what constitutes the contemporary, and the fourth chapter therefore looks at the varied circumstances in which art is not just reassessed, but at times literally remade, as part of its interface with later audiences. Nor would it be wise to ignore the role of the market in the linked processes of rediscovery and refabrication. A great deal can happen in the space between initial conception and subsequent reception, with pressure to recapture temporary or even never realized works reflecting a later audience's reading of their historic significance. And artists are likely to be involved in the work's ongoing interpretation as well, from interviews and other contributions that establish its discursive field to controlling the circumstances of exhibition.

Recognizing that it is impossible to untangle contemporary art's current profile from exponential growth in both exhibition opportunities and market hype, the last two chapters address the impact of the current networked art world, from biennial circuit to auction house. It is clear that art is deeply enmeshed in a larger economy of branded goods and services, even as a belief in art's exceptional status remains central to its power to command sometimes extraordinary prices. Yet there is an obvious irony in the connection, starting with pop art, between rarified art market success and the use of imagery from everyday life. Contemporary art's international reach is likewise significant, as it has played out in such phenomena as the global Guggenheim or the art fairs and biennial-type exhibitions that have increased in frequency and geographic dispersal while relying upon an overlapping roster of artists chosen by an interconnected network of curators. The overlay of art and social scene, with artists, curators, dealers, collectors, and critics jetting off together to biennials and fairs in different parts of the world, presents ample grounds for cynicism. Yet it is equally true that the art world's expanded global reach has opened spaces for new voices and alternative narratives.

Perhaps the only point of accord in discussions of contemporary art is that there is no consensus. There is no shared or universal

standard of judgment and no comprehensive narrative, except for perhaps the grandest claim of all—that contemporary art has to be understood as a global enterprise. Nor is there any agreement about what form art should take, as well as how it should address its many audiences, even though the destabilization of art as a category has been accompanied by the artist's ever-greater prominence, exercising his or her authorial power within an elaborate complex of production and reception. And there is certainly no shared conclusion about what the term "contemporary" actually designates, despite the growth industry of art-world and academic professionals operating under its umbrella. What all of this adds up to is a complex set of relationships, even a process of negotiation, taking place in the intersection of the figure of the artist, the construction of the work, and the activities of the institutions responsible for presenting art to its different audiences. None of these are static, so articulating their interrelationship with one another, not to mention a much larger social and economic fabric, can only be accomplished partially, through telling examples and, just as often, points of tension that indicate non-synchronous expectations.

CHAPTER 1

Now and then

With all deliberate slowness, the images of brown fabric walls fade from one to the next, forcing attention to small incidents, including stains and patches, unprepossessing architectural details, the legs or edges of vitrines, an exit sign, and even a fly. The eighteen-minute film, Tacita Dean's 2007 *Darmstädter Werkblock*, is the artist's homage to the environment within which Joseph Beuys installed the suite of works known in their aggregate as the *Beuys Block*. The appearance of Dean's film in fall 2007 coincided with a moment when the museum was closed for renovations, with plans that included a controversial proposal (later rescinded) to restore the Beuys installation by replacing the brown jute wall coverings with white painted surfaces, and taking up the worn gray carpet in favor of parquet floors.

The restoration scheme posed a host of issues concerning what aspects of the architectural environment should be defined as part of this site-specific installation, with particular challenges presented by the yellow line that Beuys painted onto one area of the carpet. The museum's definition set the parameters for Dean's film as well, since for copyright reasons she was not granted permission to film the arrangements of objects, only the space around them—integral to the installation according to many, but not part of the museum's definition of the work, centered on the vitrines rather than the enclosure. Nor was the film Dean's only response. She also weighed in with an essay advocating the retention of the present wall coverings and carpet and allowing them to continue to fade naturally, rather than remaking the walls with a similar material

1. Tacita Dean, *Darmstäder Werkblock*, 2007. 16mm color film, optical sound, 18 minutes; installation view, Marian Goodman Gallery, New York. Courtesy of the artist and Marian Goodman Gallery, New York.

(faux, but a second choice since it would still retain a similar ambiance), or the museum's far more radical proposal to transform the context into a conventional white box.[1]

Beuys fans are especially passionate about the integrity of the Darmstadt arrangement because of the unusual opportunity he had to keep interacting with the installation after its initial 1970 appearance in the context of an exhibition of Karl Ströher's contemporary art collection. A number of the objects had been brought together by Beuys for a 1967 exhibition and then purchased in toto by Ströher as part of a transaction whereby the collector bought all the work that Beuys still owned, as well as right of first refusal for future production.[2] Typically the point of transfer, from artist to collector or museum, is a moment when something that might have remained fluid or provisional in the artist's studio is defined as finished, fixed. In relation to this evolving ensemble, however, Beuys was operating more akin a collector than a conventional

notion of the artist as the creator of individual, detachable works. Moreover, the move to the museum was in many respects a beginning rather than an end, since Beuys continued to work on the installation after 1970, despite the death of the collector in 1977 and the subsequent sale of much of Ströher's collection to another institution, and indeed until the artist's own death in 1986. The *Beuys Block* is therefore something of a hybrid, in that it is both a retrospective assembly of individual objects (many of which are relics from actions) and a single installation that continued to evolve as long as the artist was alive to intervene.

The long-term challenges presented by the *Beuys Block* relate to a larger set of issues addressed in other chapters of this book, including various points of overlap between artistic production and the collecting process, as well as questions raised by attempts to preserve or update aging works of art. Another striking characteristic of the *Beuys Block*, however, is its appearance in the context of a rather atypical museum, with a collection scope reminiscent of those early cabinets of curiosities that have proven so fascinating to recent generations of artists. Darmstadt's Hessisches Landesmuseum is a relatively unusual example of a general or encyclopedic museum, its broad scope suggesting a microcosm of the world with a mix of art, coins, weapons, scientific instruments, fossils, minerals, natural history specimens, and dioramas, which were not dispersed to separate institutions as part of the transition from private aristocratic collection to public institution. In this context, Beuys's arrangement of his own work in a series of glass cases plays in striking ways off of the natural history displays on the first floor.

Nature preserve

While encyclopedic collections are now unusual, references to various collection types, and to natural history displays in particular, abound in recent artistic practices. The sometimes remarkable admixture of materials entering art museums under the guise of contemporary practices contains suggestive echoes of the sixteenth- and seventeenth-century tradition of the aristocratic cabinet, with its inclusive purview. To the extent that the art museum emerged

from earlier wide-ranging collections, however, its formation was linked to their destruction, with component elements dispersed to such different institutions as natural history museums, historical societies, or museums of scientific instruments, each with its particular arrays of object types and collecting imperatives. In yet another turn, however, today's art museums have begun to fill with a newly eclectic variety—with the important distinction that these objects, made for other purposes, are on display because they happened to catch an artist's eye, and entry into the museum is predicated on their secure redesignation as art.

Dean's project draws attention to the continuing fortunes of Beuys's installation, as the significance of this now canonical work continues to be articulated by later audiences, with debates about physical preservation only the most visible aspect of a process of ongoing historicization. Yet, if the idea of looking at its context (explored by Dean through her focus on the walls within the installation) is expanded to the surrounding galleries as well, the extended definition of art that Beuys developed in the twentieth century can be viewed in relation to a much longer history, revealed in the status of the Hessisches Landesmuseum as an anomalous holdover that evokes an earlier conception of the relationship between art and the museum.

As it happens, the Hessisches Landesmuseum is the present home of a key artifact from American museum history. The story behind a mastodon skeleton that stands as a centerpiece of the natural history collection links this German museum, with its unusual intersections of art and artifact, to Charles Willson Peale's Philadelphia Museum, which was one of the first public museums in the United States. And, in contrast to Europe, where aristocratic collections formed the core of many of the museums established in the eighteenth and nineteenth centuries, museum development in the United States proceeded on a far more ad hoc basis, with the difficulties faced by Peale's enterprise foreshadowing tensions between education and entertainment that continue to be a major challenge, particularly for museums that rely heavily on private funding rather than state support.

Peale's encyclopedic museum, which he opened in 1786 and continued to develop over the next four decades, was an outgrowth of the painting gallery he had begun in conjunction with his portrait business. With its mix of natural history specimens and

2. Charles Willson Peale, *The Artist in His Museum*, 1822. Oil on canvas, 103¾" × 79⅞". Pennsylvania Academy of the Fine Arts.

painting, the museum was clearly the work of an artist with an extended job description as well as a strong interest in scientific discourse. One prelude to Peale's elaborate enterprise, with its intersection of art and science, can be found in his earlier copies of bones—some mysteriously large specimens he was asked to draw

for the benefit of a German professor unable to see them in person, and which excited such interest while they were at his gallery in 1784 that he was encouraged to collect other objects in this vein.[3] Important, too, was the collaborative nature of his endeavor, with the varied elements of the collection contributed by many different individuals who came to share the artist's enthusiasms. Finally there was the sense of wonder evoked by the natural history specimens, which was central to the museum's popular appeal.

The collection that Peale eventually installed in a suite of rooms in the Philadelphia Statehouse included an extensive display of bird specimens, arranged in accordance with the Linnaean classification system, but also drawing in the public via pioneering dioramas where he employed his own innovations in taxonomy, together with painted backdrops, to create life-like habitat arrangements. His idea of displaying the embalmed bodies of important men was never realized, but notables were represented through rows of painted portraits above the array of birds, as well as various sculpted busts and certain wax figures. Contributions of specimens came from many quarters, including a number from the Lewis and Clark expedition (with the natural history examples supplemented by Meriwether Lewis's donated clothing, displayed on a wax representation of the explorer), and Peale honed his expertise in dealing with the skins and sometimes living animals that arrived in this manner. By far his most popular display, however, was a mastodon skeleton, one of two that he excavated after reading an 1801 notice about a fossil discovery on a farm in New York State. His undertaking, one of the earliest US ventures of its kind, yielded important evidence in relation to the question then under debate about whether species actually become extinct (with the proof summed up by Peale's son Rembrandt, "the bones exist—the animals do not").[4]

Peale had the idea of making the natural history collection available to a general audience rather than having specimens stored away, accessible only to privileged viewers, and he furthered its appeal with his innovative habitat groups. Yet his ideal of access, dependent as it was on admission fees, was caught up in tensions between education and entertainment that have dogged museum history since its inception, particularly in the United States. In this respect, Peale's enterprise can be understood as a forerunner not only of more august art or natural history museums, but also

circus-style sideshow attractions. Nor is this an idle comparison, given that P. T. Barnum bought a number of his popular displays directly from the remnants of Peale's museum after its founder's death.[5] Indeed, the mastodon skeleton Peale had displayed to such acclaim was for a time thought to have been lost in one of two fires that consumed much of Barnum's collection (first his Philadelphia Museum in 1851, then his American Museum in New York in 1865). Yet it seems that the skeleton made its way to Europe around 1848, in the hands of speculators—where this important part of early American museum history was purchased for the Darmstadt museum, and where it eventually came to share institutional space with the significant artist-generated collection constituted by the *Beuys Block*.[6]

Even though Peale's enterprise inaugurated what became, over the next two centuries, an institutional growth industry, with museums of all kinds appearing in all kinds of places, its encyclopedic collection was in some respects already outdated, having been launched at a time when the enlightenment-style generalist was being supplanted by increasingly specialized divisions by discipline. And Barnum's presence in this narrative is indicative of a tension evident from the start in US museum history, where there was an uneasy balance between the goal of education (for which Peale argued strongly) and the need to attract an admission-paying public. In that respect, the mix of activities that tends to characterize the twenty-first-century museum as entertainment destination could be described as an old rather than new idea.

There is also something highly suggestive in Peale's wide-ranging interests. It is impossible not to make comparisons to contemporary artists who create works that draw upon the various different areas that coexisted within Peale's museum, but which were largely divided off from one another over the course of the nineteenth century. Allan McCollum's various natural history explorations have included casts of both dinosaur bones and of solid shapes formed by dinosaur tracks, along with multiples based on fulgurites (subterranean manifestations created by lightning strikes) and sand spikes (a specific form of concretion from California's Imperial Valley).[7] Mark Dion is also well known for his deployment of archeological procedures in the gathering of material and the cabinet-style displays that he has created to present his finds.

The eclectic pursuits of many contemporary artists do not constitute a return per se to the synoptic view of Peale, an educated generalist, whose displays reflected an ongoing process of discovery in which he played a role. But they are indicative of a shifting and somewhat amorphous job description, articulated in the wake of conceptual art and related strategies of institutional critique, according to which artists play new roles in forging connections across a separation of disciplines reflected (among other places) in distinct museum types. Dean's hybrid approach, relying on research and other collecting or archival procedures as the basis for her artistic production and related endeavors, is indicative of an open-ended definition of artistic activity. The artist may not be a generalist in the earlier sense, but often has opportunities to function as a roving consultant, crafting responses to the dynamics of a variety of situations.

Both apparent points of similarity and dramatically shifting historical coordinates make an examination of this early museum history relevant to a discussion of contemporary practices. And artists are actively investigating this material themselves. The fact that historical museum phenomena as well as diverse collection types constitute a subject of fascination, and often reference or emulation, for many contemporary artists is an interesting phenomenon in itself. But it is equally compelling to think about how strategies for the production of art relate to ongoing institutional practices and developments, including the various ways that museum conventions inform works of art that are made in response. The investigation also operates in reverse, as contemporary projects that open up the boundaries defining the work of art inspire a process of looking back, at specific episodes in the history of institutional development.

Seeing through the museum

A punctuation, a pause, an interruption, a respite—Cornelia Parker's 2001 *Breathless*, installed between two floors, at a midpoint within the British Galleries at London's Victoria and Albert Museum, is at once serenely elegant and quietly disconcerting. From below, flattened brass-band instruments with darkly tarnished undersides

appear to float, silhouette-like, within the circular opening between the two floors. From above, far more detail is highlighted by abundant natural light, including the intricate engraving decorating their silver surfaces and the forest of wires suspending each instrument from the room's ornate ceiling. Unavoidable from either side is the fact that these once functional instruments have been taken decisively out of use by the artist's destructive transformation—flattened, Parker informs us, by means of a hydraulic mechanism that once opened London's Tower Bridge.

3. Cornelia Parker, *Breathless*, 2001. Brass band instruments, flattened in an industrial press and suspended on metal wires, 500 × 500 × 6 cm. Courtesy the artist and Frith Street Gallery, London.

The decision to commission this installation, in the context of a museum devoted mainly to art and design, reflects a complex intersection of interests. While the V&A does not focus on contemporary art per se, it continues to collect recent material, some of which, particularly in the fields of photography and craft, would undoubtedly qualify as art. It also lists sculpture as one of its major areas, yet the emphasis on techniques of carving, modeling,

4. Cornelia Parker, *Breathless*, 2001. View from above. Photo: Martha Buskirk.

and casting reflects the museum's nineteenth-century mission to provide education to artisans, and stands in sharp contrast to the diversity of nontraditional methods used in the context of today's three-dimensional work. Parker's approach, based on a process of observation, collecting, and transformation of found materials and objects, therefore does not align with the museum's technique-driven conception of sculpture. Rather, her methods are closer to those practiced by the museum itself, in the overall assembly and display of the collection. In this setting, Parker's installation encourages a dual focus, on the ways that collecting traditions associated with the museum inspire her artistic process, and how this contemporary project encourages one to look back, seeing through her work to earlier moments in the museum's history, including the institution's changing relationship to the objects it has assembled.

The collection that unfolds in this retrospective view presents an interesting anomaly in comparison to other survey-type museums—neither entirely aligned with, nor completely separate

from, institutions centered on the fine arts. With its stress on design, the V&A was caught up in issues of art and commerce from its inception. There is a surprisingly smooth segue from production to consumption, as the early goal of instructing artisans through noteworthy examples of good design opened onto consumer education—which is also a point of intersection between the nineteenth-century museum and the emergent department store. Likewise, the V&A's mission of popular access made it a pioneer on various fronts, including refreshment rooms and the sale of reproductions, even as both education and entertainment were enmeshed in goals of social control. There is rampant evidence of empire, with material drawn from former British colonies laying bare connections between collection and conquest that underpin so many institutions. On the other hand, the fact that the V&A held onto its plaster casts, despite their general banishment elsewhere, points to one of the many ways its collecting agenda diverged from other survey museums that followed in its wake. And, finally, it is impossible to overlook the issue of sheer abundance, with the V&A's collection numbering some four million objects—some of which are isolated and highlighted, while many more are presented in packed displays that are impressive for the profusion of examples of any given object type. The V&A's distinct trajectory provides a useful foil against which to consider the operative assumptions governing institutions oriented more decisively toward the fine arts, particularly as various strands of contemporary practice have blurred distinctions between art and design anew.

Parker's work is installed at the corner point of the two-story, L-shaped sequence of galleries devoted to the V&A's collection of British material, in a space that functions otherwise as an information and media center, with various resources dotted around its periphery. Before and after, the British Galleries are densely packed with an array of objects, sequenced chronologically but also according to thematic groupings calculated to give new life to the eclectic holdings of this venerable institution. The 2001 reinstallation includes old favorites like Bashaw, a remarkably detailed 1834 polychrome marble sculpture of the Earl of Dudley's dog, or the Great Bed of Ware, from a sixteenth-century Hertfordshire inn and notoriously large enough to accommodate more than one couple. These and many objects previously not on display have been incorporated into a new and visually dynamic story, part of

an attempt to reverse the peripheral status the museum had fallen into during the twentieth century. Left behind is the idea that the museum caters primarily to antiquarians, as well as a much ridiculed Saatchi ad campaign that seemed to confirm a lack of confidence by promoting the venerable enterprise as "an ace caf with a rather nice museum attached."

The museum's early years present a very different story. When the institution then known as the South Kensington Museum opened on its current site in 1857, its emphasis on the utility of good design, along with innovations like evening hours (made possible by artificial lighting), free admission days, well-planned connections to the emergent rail network, and a prominent refreshment room made for ready popular success—in pointed contrast to the elite orientation of the British Museum and the National Gallery.[8] Its immediate precursor was London's 1851 Great Exhibition, or Crystal Palace, with its presentation of "The Industry of all Nations" arrayed throughout Joseph Paxton's dramatic glass and iron structure. Yet the fair already marked a crossroads of sorts, evident in heated criticism of its displays of industrial versions of luxury goods, which were decried for their abandonment of design principles, even as the move from hand craft to mass production helped pave the way for today's pervasive consumer economy.

The momentum of the fair prompted the formation of the Department of Science and Art, headed by Henry Cole, under whom the South Kensington was part of a multi-faceted mission to promote design education throughout the British Empire.[9] Built on land acquired with profits from the fair, the museum emulated its mix of art and industrial production, as well as its architecture, with an iron structure that gave the building the early nickname "Brompton Boilers" (in reference to its resemblance to steam boilers, and ignoring the attempt to annex the Brompton site to the more fashionable neighborhood to the north by dubbing it South Kensington). The South Kensington Museum in turn exercised a direct influence on other museums founded in the nineteenth century, including the Metropolitan Museum of Art in New York and Boston's Museum of Fine Arts (opened in 1870 and 1876 respectively)—with this early inspiration reflected in the MFA's long forgotten motto "Art, Industry, Education."[10]

During the twentieth century, however, the South Kensington, rechristened the Victoria and Albert, seemed to lose its way. While

museums formed in its wake turned decisively toward the fine arts, it continued to collect in the general areas of applied art and design, but with the educational mission deflected onto amassing rare or unusual examples, more likely to be notable for unique qualities than helpful as models for manufacture. Debates about mission are reflected in questions concerning how to arrange the collection, with the early goal of providing exemplars for artisans as well as industrial production creating the impetus for groupings by object type—in contrast to versions of stylistic as well as cultural or social history that might be served by a chronological display. Entering the twentieth century with curatorial departments divided into ceramics, woodwork, metalwork, textiles, and sculpture, the separations formed the basis for a 1909 rearrangement of the collection according to these categories that was criticized as outmoded as soon as it was unveiled. A post-World War II reinstallation of the galleries had it both ways, with primary galleries arranged by style, period, or nationality, complemented by secondary galleries emphasizing objects of a particular material. And a similar back and forth still holds true, reflecting a continuing tension about whether to emphasize formal and technical aspects of craft and style, or to embed the objects in a narrative that uses them to mark larger historical events.[11]

The V&A's British Galleries, unveiled early in the twenty-first century, help tip the balance in the direction of a chronological framework, presenting arrangements of period objects that, together with background information, allow the museum's curators to draw out cultural and historical connections that extend well beyond the framework of art and design. Situated in the middle of this sequential amalgam, however, Parker's collection of brass-band instruments evokes the assemblies of a single order of objects that remain in force elsewhere in the museum. By interrupting the historical trajectory of the British Galleries with her circular array of flattened brass-band instruments, Parker's contemporary work of art plays obliquely off of historical debates about collection order and rationale, in the midst of one part of the museum where chronology now reigns supreme. The work interrupts the historical progression, both literally and figuratively, temporarily suspending the historical narrative constructed in the surrounding galleries, and, through the evocation of display strategies associated with an earlier era, drawing one's attention to a different version of

museum history, evident in the process whereby each successive rearrangement of the collection effaces a previous generation's decisions about how to frame historical material.

As it happens, the V&A does possess a major collection of musical instruments, which have generally been presented together in their own galleries (a similar approach, in this respect, to many survey-type museums, where the musical instruments are displayed in isolated whirlpools, set off from the historical flow around them). Parker's work plays with and against the V&A context in other ways as well. Though she offers up a type of object that is extensively represented in the V&A, these particular musical instruments, associated with working-class brass-band traditions, had little chance of entering the museum without Parker's intervention. Education for the laboring classes may have been part of the original program, but what is on display has long tended toward the decidedly elite—the best, most elaborate, or rarest examples of any particular set of objects, associated through ownership with wealth and power. The humble origins of the instruments selected by Parker relate to her general interest in material that is well used before she takes it up. Collected as scrap from the British Legion, Salvation Army, and other sources, they were already in a decrepit state prior to her decision to finalize their destruction (with their fate, first written off and then crushed, suggestively connected via the brass-band tradition to a coal-mining industry long in decline).

There is nonetheless something transgressive about the willed destruction of cultural objects, even those already relegated to the second-hand or scrap market, a tension made that much more evident by their presentation in the context of an institution devoted to the preservation and conservation of the material under its care. Yet, even intact objects lose their function upon entering the museum—except in those instances where they were never really meant to be subject to much use in the first place. One might conclude that lavishly crafted furniture set off behind barriers or unbelievably ornate table settings now encased in museum vitrines have been taken out of service through their exhibition in a museum, but in other ways their purpose was already more ceremonial than utilitarian, so that one form of display has simply been replaced by another. Even the musical instruments in the V&A collection tend toward the ornate or decorative—qualities that make them interesting to look at, but not necessarily remarkable

5. Musical Instrument Collection, Victoria and Albert Museum, as installed March 2006. Photo: Martha Buskirk.

in the production of music. Nor is it surprising to discover that Parker is particularly drawn to the V&A's display of ironwork, with its stark aesthetic based on relatively direct technique and evident utilitarian purpose, rather than to the more highly wrought examples of craft in other parts of the museum, or the profusion of small-scale figurative works in the museum's galleries devoted to traditional sculptural techniques.[12]

Parker's assembly indicates how decisively contemporary sculpture has broken with the traditions once grouped under that term, as the elastic category within which much of her work might be understood remains only tangentially connected to the historical sculpture traditions represented in the museum collection. Indeed, many of her inspirations lie outside art traditions entirely. Regarding her non-engagement with such time-honored sculptural methods as carving, modeling, or casting, Parker has described feeling that "there was an awful lot of incidental technique out there in the world—you know, buses going over melted tarmac and making a mark, that sort of thing," and just wanting "to trap or harness

6. Ironworks Collection, Victoria and Albert Museum, as installed March 2006. Photo: Martha Buskirk.

that."[13] She is well aware of the implication of her move from an early process of forming sculptural objects to an engagement with found objects, "things that were recognizable, that had a history, that were loaded with associations," and has referred to her predilection for blowing them up or flattening them with steamrollers (both procedures she has used elsewhere) as a way of "trying to eradicate the overloadedness of these things, by killing them off, uniting them by one event ... imposed on them."[14]

"Every object tells a story." Or at least that's the claim made by an online project co-sponsored by the V&A that encourages members of the public to post anecdotes about their own prized possessions. Look a little further, however, and that assertion becomes immediately murky, given that it seems to be subjects rather than objects doing the talking. An otherwise undistinguished possession may be tremendously significant for a particular person, at a certain moment, yet its importance falls away once it loses that context. Parker's installation involves a similar move, essentially creating a fresh story for instruments where changes in ownership

result in a loss of knowledge about their long histories of use. Her presentation under new authorship includes her evocative yet potentially difficult-to-verify claim about how she crushed the instruments.

Within the context of the V&A, where the assemblies of objects by type were originally put forward as lessons in craft, meant to help inspire artisans hone specific skills, it is suggestive that Parker has responded to the overall dynamic of the collection itself, rather than to the lessons in technique that were supposed to be promoted by the individual examples. And the play of reference is that much richer for appearing in the context of a collection that is something of an anomaly—with its emphasis on design yielding a multi-faceted collecting agenda that overlaps with both art museums and historical societies, while aligning precisely with neither.

In *Breathless*, and throughout Parker's work, there is stark beauty in the outcome, but it is based on processes that often tip toward the consumption as much as the production side of the balance. The result is an aesthetic based upon a process of selection and further arrangement or manipulation—which also aligns her work to a certain degree with the form of authorship collectors often exercise over their accumulated objects. In this case the collector was Parker, not the museum, and their status as components in a work of art has brought these humble, and now decisively crushed, objects into an institution where working-class traditions have been largely overlooked. One can only imagine how the founders of the museum, with their commitment to principles of good design, would have responded to the inspiration that she took from the context. In Parker's sometimes destructive hands, the lesson of the museum has been deflected, away from the individual objects it houses, and toward the underlying procedures of collecting and arrangement.

Canonical replication

What to collect, why, and how to display it once it is there—these are basic questions any museum has to face, and the answers can change dramatically in response to evolving institutional missions and broader cultural shifts. Indeed, why separate art and design

at all? It is clear, after all, that the cultural hierarchies governing that division are hardly immutable—as indicated by painting's loss of assumed primacy in the heterogeneous contemporary context, along with its sometimes secondary position in relation to tapestry or fine metal work even in its Renaissance heyday. Art museums also have a long and complex relationship to copies, despite the close connection between museums and connoisseurship, with its emphasis on securely identifying originals and jettisoning other pretenders. The V&A, with its obviously hybrid collection, constitutes something of an anomaly, but one that helps draw attention to fissures within museums ostensibly devoted to the fine arts.

A plaster fig leaf is one of the more amusing oddities in a collection notorious for its eclecticism. Its origins go back to 1857, the year the museum was founded, when an eighteen-foot-high plaster replica of Michelangelo's David was presented by the grand duke of Tuscany to Queen Victoria. She sent it on to the museum, and upon viewing it there was so dismayed by the figure's larger-than-life-sized nudity that measures had to be taken, in the form of a corresponding leaf, which was sculpted and kept on hand, ready to be hung from hooks implanted in the plaster David whenever she might visit. Since then, however, the fig leaf has entered the collection as an object in its own right and features in museum literature as one of the focal points of the sculpture collection.[15] In contrast to the drapery painted onto Michelangelo's Last Judgment, this bit of retroactive decency has been far more easily removed. No longer needed for modesty, it has been displaced to a vitrine on the back of the pedestal, hidden yet nonetheless available for those with the tenacity to search it out.

This curious aside is part of a larger story about changing attitudes toward casts and copies, which includes not only shifting standards of originality, but also the fact that nineteenth-century art museums, through their role in the creation of such replicas, were also involved in producing the works on display. When the V&A opened at its current site, David had a prominent position in a room categorized as the art museum. Other surrounding displays included patented inventions, architectural casts, products of the animal kingdom (including a section devoted to food), and a collection of teaching materials and equipment. Art and science were therefore linked until the latter was sent off to a separate museum in 1909. And within the early art museum section, replicas were readily intermingled with what would later be sharply

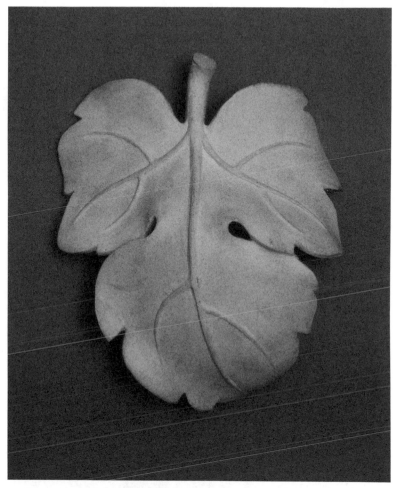

7. Fig Leaf for David, perhaps by the firm of D. Brucciani & Co., c. 1857. Plaster, 15½" × 11¾" × 6¾". © Victoria and Albert Museum.

distinguished as originals, and some on the museum's staff even questioned why originals should be purchased at all when less expensive reproductions could be had.[16]

The V&A's extensive collection of casts, now a rarity, provides a glimpse of the importance such objects once held—even as their relative absence from other art museums shows how dramatically and decisively they went out of fashion. Who would guess,

8. Fig Leaf for David, mounted on the back of David's pedestal, Victoria and Albert Museum. Photo: Martha Buskirk.

from its current orientation, that the Boston Museum of Fine Arts (MFA) sold off a bequest of oil paintings in order to purchase the display of casts with which the museum opened in 1876? Like many other nineteenth-century museums, the MFA once relied on casts to

present major masterpieces through reproduction. But those replicas were abruptly rejected from most art museum collections early in the twentieth century, as part of a shift of emphasis away from the educational value of comprehensive copy collections, to the cultural authority of rare or unique originals.[17] At the MFA, the reorientation toward old masters, and the exclusion of casts and copies, took a particularly sharp turn. In 1890 it boasted the third largest collection of casts in the world. By the 1920s, however, the MFA's Benjamin Ives Gilman had become well-known for his insistence upon high art as opposed to "gewgaws" and plaster casts—in opposition to a few hold-outs like John Cotton Dana of the Newark Museum, who, citing an "undue reverence for oil paint," continued to advocate for the educational use of plaster casts and other reproductions well into the twentieth century.[18] (And, more recently still, the twenty-first-century MFA has turned back toward its V&A roots by integrating displays of decorative arts into the painting galleries—a move that also makes it harder to distinguish between the galleries and the prominent gift shop spaces that surround them.)

9. Cast Court, Victoria and Albert Museum, as installed March 2006. Photo: Martha Buskirk.

The elaborate and often secretive policies regarding the sale of works of art from museum collections are reflected in the term used for such maneuvers, "deaccession," which veils the notion of removal behind an invented word that reverses the notion of acquisition, almost as if the object somehow backed out the door. But plaster casts lost their status entirely, mere replicas rather than art, and could therefore be disposed of far more cavalierly. At New York's Metropolitan, some of the unwanted casts were donated to the Art Students League and similar teaching institutions, others wound up in museum offices as decorations, while still more remained in storage until 2006—when the museum cleaned out the Bronx warehouse where they had languished with an "everything must go" sale at Sotheby's, auctioning off the lots without minimums for prices that ranged from $60 to $30,000 (with the high mark realized by two reliefs from the south frieze of the Parthenon).[19] However, the recent appearance of newly struck plaster casts, made from nineteenth-century molds, in the galleries of the Courtauld Institute of Art suggests that another shift of fashion might be in progress. Plus there is the added twist that a significant number of plaster casts that did survive the great sweep of the last century preserve details that have since eroded in corresponding originals, or in certain instances provide three-dimensional proxies for material that has been entirely destroyed.

Quite obviously, however, copies did not go entirely out of fashion, since the waning popularity of three-dimensional replicas within the museum had its obverse in the increasing use of photography to facilitate a different kind of assembly of reproductions, untethered to the physical confines of a particular collection. Plaster casts allowed museums each to present their own demonstration of the classical canon, in a uniformity that was disparaged by some as a form of ready-made museum; but the banishment of casts was hardly synonymous with the overthrow of art history's hierarchy of recognized masterworks.[20] Rather, the job of providing a definitive overview was displaced into the more amorphous virtual museum identified in André Malraux's *musée imaginaire* (or museum without walls, in the English version) with the weightlessness of the image. Thus the aspiration to a comprehensive overview of classical masterpieces through plaster replicas was supplanted by an emphasis on originals, even as assemblies of unique objects are destined to remain unmistakably fragmentary, since the holdings

of any individual museum, however well rounded, are inevitably partially in relation to the siteless totality of works known through their representation.

Just as museums were actively engaged in producing plaster casts from works in their collections, so too have they long been involved in creating photographic reproductions. Photographs of works of art are, however, generally not presented within the galleries, in contrast to the three-dimensional replicas once interspersed with originals. Rather, their secondary status anticipates today's displacement of reproductions into museum gift shops. And here the V&A was again ahead of the curve. For a few years starting in 1859, the V&A turned a space over the refreshment room into a sales gallery, where photographic reproductions, electrotype copies, and additional plaster casts were made available to the public for modest prices, in keeping with their educational purpose—an enterprise that came to an end not for lack of interest, but because the museum was overwhelmed by the number of orders placed for photographic prints.[21]

It is equally striking to note that, from the very beginning, the V&A's project included the creation of a photographic archive that extended well beyond simply documenting the collection. Charles Thurston Thompson, who was appointed superintendent of photography in 1856, is credited with overseeing the production of 10,000 negatives that record both the museum's own material and other works or architectural sites that were collected photographically.[22] Nor was taking these photographs a particularly straight-forward enterprise, given the bulky equipment, labor-intensive processing, and reliance on natural light associated with the wet plate negatives of the period—as Thompson's 1858 campaign to photograph the Raphael tapestry cartoons in the British Royal Collection demonstrates. The cartoons were loaned to the V&A starting in 1865, but he photographed them while they were still at Hampton Court, in a several-month operation that required the cartoons to be lowered one at a time, and only on perfectly rain-free days, into an exterior courtyard where they could be recorded under natural light with a specially built large-format camera.[23] Within the V&A collection, photography's potential double role, as a secondary form of documentation and as a medium of expression in its own right, was evident in the early decision to acquire decidedly artistic photography—most notably, seascapes and related images by Gustave Le Gray and a group of portraits by Julia Margaret Cameron.[24]

While the majority of Thompson's photographs are still valued primarily because of what they document, the retrospective view has clearly been swayed by the way contemporary artists like Louise Lawler or Thomas Struth have made museum conditions and displays the subject of their photo-based art. Observed through that lens, at least some of Thompson's images have the potential to be pulled onto the side of photography as (rather than of) art, and this temptation is particularly evident in the attention paid to a couple of 1853 photographs of a Venetian mirror owned by John Webb that capture Thompson's reflection, standing next to the box camera with which he is taking the picture. The interest in these photos is obviously not due to the mirror Thompson was laboring to document, but rather how he has immortalized the act of recording itself. And one of these photographs, transformed into a work of authorship, served as the first in a series of plates in the catalogue for the Museum of Modern Art's 1999 *Museum as Muse* exhibition, where it thus launched a narrative about works of art that focus attention on both museums and the objects they house.[25]

The drawing and redrawing of the borders around what belongs in an art museum, and constant changes to the arrangement of its display while it is there, demonstrate how time-bound the museum's devotion to timeless aesthetic values has always been. Seemingly plaster casts once looked a lot like art, then lost that status; yet the reverse can also be true, when something that wasn't thought to be art gains that standing. And, even as certain forms of reproduction were banished from museum galleries, others have taken their place, via strategies of appropriation that are threaded through art of recent decades. Moreover, the role of museums in creating the plaster casts on display indicates a complex history of museum production that extends far earlier than the recent site-specific projects, based on inviting artists rather than curating works, that have proliferated since the 1960s.

Currency

In addition to the already large number of museums that collect recent work, even more have embraced programs to insert contemporary projects into the midst of historic settings or assemblies,

10. Charles Thurston Thompson, Venetian Mirror, c. 1700, from the Collection of John Webb, 1853. Albumen print from wet collodion on glass negative. © Victoria and Albert Museum.

often in an apparent bid to bring an institution up-to-date. It is a strategy that in fact doubles the juxtaposition already implied by the viewer's experience of the past in the present. And, while the tactic may have originated to a large extent in modes of institutional critique associated with conceptual practices, its widespread adaptation demonstrates a broad appeal to audiences and museum professionals alike.

Witness, for example, the 2008 installation of a Jeff Koons retrospective in the halls of Versailles. A number of the juxtapositions were unexpected, even jarring, yet there was also something deeply appropriate about inserting these riffs on contemporary kitsch into the imperial ostentation of Versailles, as historic gilt was reflected and refracted in Koons' highly polished surfaces. One might actually argue for a certain inevitability to this move, viewed in relation to the trajectory of Koons' career—with his fitness for Versailles presaged by his updated version of topiary in the floral puppy he first erected at a Baroque castle in Arolson, Germany, to coincide with the 1992 Documenta 9 in nearby Kassel, or by a personal collection (courtesy the success he has enjoyed producing work for the contemporary carriage trade) where Jean-Honoré Fragonard enjoys pride of place.[26]

Institutional critique is certainly not the phrase that comes to mind to describe the appearance of Koons' work in this context, even though one could deploy associated terminology to argue that the installation indeed "reveals" or "exposes" something about both artist and setting through Koons' contemporary turn on aristocratic excess.[27] More to the point, the installation raises questions about what is now likely to be achieved through the popular gambit of inserting recent works into historical collections—either through invitations issued to artists to create a work for a particular setting or through curatorial acts of juxtaposition. "While reflecting on institutional parameters was once something the institution considered disturbing," Isabelle Graw has argued, "it is now accepted, welcomed, and even supported by many institutions, which actively invite artists to investigate them."[28]

Hans Haacke's central role in the history of institutional critique is ensured by his documented ability to push beyond accepted boundaries, as evident in the infamous 1971 cancellation of his exhibition at the Guggenheim, or the 1974 suppression of his *Manet-PROJEKT '74* by the Wallraf-Richartz Museum. But one can trace

11. Jeff Koons, *Rabbit*, 1986. Stainless steel, 41″ × 19″ × 12″; installation view, Versailles, Salon de l'Abondance, 2008. © Jeff Koons. Courtesy the artist. Photo: Laurent Lecat.

the fortunes of such critical strategies in the later history of Haacke's museum collaborations, including his 1996 *Viewing Matters* installation, curated from the collection of the Museum Boijmans Van Beuningen, or his 2001 arrangement of objects from the V&A at the Serpentine Gallery in an installation entitled *Mixed Messages*. Moreover, these invitations to artists to investigate museum underpinnings are being extended by curatorial projects that undertake similar maneuvers, with or without active artistic collaboration.

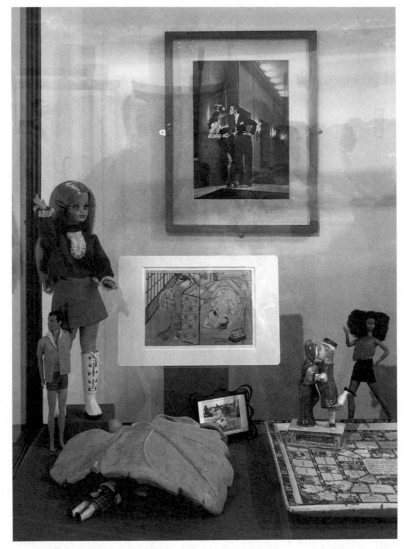

12. Hans Haacke, *Mixed Messages*, Serpentine Gallery, 2001. © 2011 Hans Haacke / Artists Rights Society (ARS), New York / VG Bild-Kunst, Bonn. Courtesy the artist.

The invitation issued to Haacke to work with the holdings of the V&A was part of a 2001 exhibition, *Give and Take*, mounted by the V&A in coordination with the Serpentine Gallery shortly before the opening of the new British Galleries and the attendant unveiling of Parker's work. The two sites mirrored one another, with contemporary works interspersed through the V&A galleries, and objects from the V&A collection presented at the Serpentine—a double move that was reviewed in the press as a form of revitalization for the floundering V&A that focused attention on otherwise overlooked treasures. And, given the important precedents in the history of artists' interventions into historical displays, it should perhaps come as no surprise that *Give and Take* was organized by Lisa Corrin, the same curator who worked with Fred Wilson on *Mining the Museum* in 1992.

For his arrangement of V&A holdings at the Serpentine, Haacke brought together originals and copies in various permutations, as well as highlighting evidence of cultural intersections throughout the collection, all presented in an installation that emphasized the V&A's resemblance to early cabinets of curiosities. Characteristic glass cases were filled with an assortment that ranged from sculptural objects (including the aforementioned plaster fig leaf in a case focused on various objects with erotic overtones) to dolls, photographs, and prints. Reflecting a conscious play across high and low distinctions, works by well-known artists were interspersed with anonymously made or mass-produced objects, and Haacke was also interested in drawing attention to the limits to the museum's inclusive purview, which includes Sevres porcelain and high fashion, but little in the way of workers' dishes or clothing; an international collection of artifacts, but also the world as refracted through the perspective of the British Empire.[29]

The idea that such critical perspectives might be not only palatable to the museum, but eagerly solicited, was confirmed by the fact that most of the juxtapositions on the V&A side were established by the curator, rather than by the artists. Other than Haacke's off-site installation, only a few works were commissioned for the occasion, perhaps most notably *Use Value*, a sound installation by Neil Cummings and Marysia Lewandowska that introduced noises from the museum restaurant, along with the disconcerting clatter of breaking china, into the Ceramics galleries. The majority of the works were selected by the curator for the play of references

already present—and for the ways that this multiplicity would open up new associations in the context of the V&A galleries. A banner by Xu Bing, originally commissioned for the Museum of Modern Art in New York, evoked the idea of cultural intersection by using an invented calligraphic sign system to slow down reading of the English translation of a Maoist phrase, "Art for the People." The discussion of Liza Lou's beadwork *Kitchen* in the catalogue provided an occasion for self-examination concerning the role of women's work in the fabrication of various applied forms represented in the collection and, more specifically, the surprising history of the mosaic floor in what was then the Fakes and Forgeries gallery, which was produced with female prison labor. Marc Quinn's series of life-size marble portraits of individuals missing one or more limbs drew attention not only to forms of ideal beauty associated with the classical tradition, but also to the frequently fragmentary state of the sculptures around which such discussions are centered. Koons' appearance at Versailles was foreshadowed by the insertion of one of his stainless-steel portrait busts in a V&A gallery devoted to Europe 1600–1800. And Hiroshi Sugimoto had an opportunity to have his photograph of a wax museum figure of Queen Victoria, part of a series of photographs consciously styled after painted portraits, presented in a museum named after his much mediated subject.

The fact that these works were amenable to such juxtaposition indicates a multi-stage response to the dominant role of the museum in the display of art. Even modernist work, despite attendant autonomy claims, can be understood as produced with the viewing conditions of public display as a default assumption (evident in the fact that initial function is not radically altered upon being deemed worthy of museum display). But there is an added twist when the work of art includes a conscious activation of quotation or layered reference, such that the histories of art associated with the museum are part of its subject. Under these circumstances, the curator's selection continues a dialogue with the museum that the artist has already built into the work.

Yinka Shonibare's 1998 *Mr and Mrs Andrews without their Heads* clearly does not depend on curatorial intervention to highlight its already extant play of reference. His three-dimensional reinterpretation of a well-known painting by Thomas Gainsborough dressed the familiar figures in clothing made from

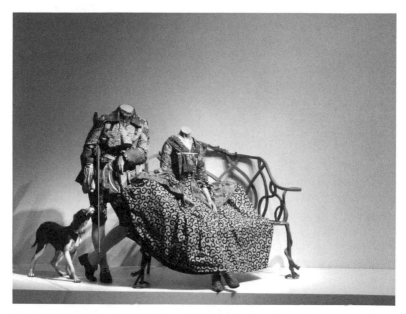

13. Yinka Shonibare, MBE, *Mr and Mrs Andrews without their Heads*, 1998.
Two life-size fiberglass mannequins, bench, gun, dog, Dutch wax printed
cotton costumes on armatures, 165 × 570 × 254 cm. © Yinka Shonibare.
Courtesy James Cohan Gallery, New York/Shanghai. Photo: Stephen White.

fabric patterns associated with Africa, with the added complication
that such fabrics emerged from a situation of cultural hybridity
that was a product of colonial trading practices. Shonibare's use of
this fabric reflects his awareness of its complex history, originating
in Indonesian batiks that were translated into Dutch wax prints,
then traded by the Dutch in Africa, where they influenced local
manufacture of patterns that are in turn worn extensively outside of
Africa as a mark of African identity. But the specific references take
on still more associations in relation to the legacies of colonialism
reflected throughout the V&A collections. That history is even
more evident in links between the institution's huge holdings of
South Asian material and its direct influence on their manufacture
through the export of its curriculum, including textbooks, models,
and other teaching material, to major Indian schools.[30]

The V&A's impact on production was also invoked, albeit rather
more obliquely, by the presentation of the first version of Roxy

Paine's *SCUMAK* (sculpture maker) in the Fakes and Forgeries gallery, which was then located just outside the Cast Courts.[31] What viewers encountered was a machine for the production of sculpture. But, in contrast to the facsimiles in the cast collection, these sculptural objects are abstract, even formless, as well as unique. The basic components of this mini-assembly line are a vertical reservoir and nozzle for the dispensing of synthetic sculpture material, a laptop computer programmed to run the equipment, and a horizontal conveyor belt. When set in action the machine extrudes successive streams of molten polyethylene, timed at intervals to allow the previous layer to harden, for an output of approximately one sculpture per day. Once each object is complete, the conveyor belt moves the sculpture out of the way to make room for the next day's mechanized labor. The outcome of this elaborate production method is a rather amorphous object, a mound of matter reminiscent of 1970s work based on the intersection of

14. Roxy Paine, *SCUMAK No. 2*, 2001. Aluminum, computer, conveyor, electronics, extruder, stainless steel, polyethylene, Teflon, 90″ × 276″ × 73″ © Roxy Paine, courtesy James Cohan Gallery, New York/Shanghai.

materials and process, but with the artist's action delegated to a purpose-built machine.

At an earlier moment it would not have been surprising to encounter a machine in the V&A, since they were part of the mix of objects shown before the science collection went to a separate home in 1909, and it is now London's Science Museum that houses an example of the pointing mechanism once used to create scaled-up or -down replicas of sculpture.[32] Similarly, the "industry of all nations" presented at the Crystal Palace included not only works of art, but products of industrial manufacture, and even displays of the machines whereby such goods were produced (though, as it turns out, fears about revealing trade secrets meant that many of those apparent pieces of equipment weren't actual mechanisms, the manufacturers having chosen to exhibit dummy versions).[33] The context of Paine's extended body of work likewise evokes the art museum's more heterogeneous predecessors, with their encyclopedic mix of natural and artificial forms, since his sculpture, painting, and drawing machines are part of an artistic engagement that includes carefully handcrafted plant forms that bring an illusion of nature into the gallery, as well as a series of metal trees that, when installed outdoors, invert the process by presenting an obvious artifice in the context of the natural flora to which they respond.

To the extent that any work takes on new associations when placed on exhibit, then those meanings are produced by their presentation in that context—and in that sense generated by the museum. But the display of Paine's *SCUMAK* turns the museum into the site of fabrication for objects that then re-enter the market system as independent sculptural works tendered under Paine's artistic authorship. Production is also linked to exhibition time. Rather than following in the tradition of the limited edition, with its predictable number of iterations, the open-ended series of unique objects produced by the *SCUMAK* is a direct function of the popularity of the machine itself as measured in public exhibition days.[34] Paine's machines may be inefficient when considered against the standard of modern industrial production—slow, erratic, and evidently absurd—but they are highly adapted to art production, using the installation to validate the objects, guarding against oversupply with their ponderous pace, and producing unique originals rather than editions through the unpredictability of the material form.

Paine's *SCUMAK* turns the standard operation of the museum on its head, producing machine-made yet actually unique sculptural objects that are created in the museum and then sent out into the commercial world, in contrast to the once useful objects detached from functionality upon their entry into the institution. Despite their unusual mode of production, however, the *SCUMAK* objects share an affinity with many other works of art that are shown in museums as part of temporary exhibitions and then re-emerge with their market value enhanced by their fleeting proximity to treasured objects removed from systems of exchange. It is worth noting, in this vein, that its V&A appearance hardly hurt the fortunes of Koons' 1986 *Italian Woman*—a stainless-steel bust that was lent to the V&A by a private collector for the 2001 *Give and Take* exhibition and subsequently sold in 2007 at Sotheby's for over two million dollars (though, given the prices Koons' work has generally commanded at auction, the V&A exhibition was certainly not the only factor).[35] And this dynamic was also the basis for criticism regarding the role of François Pinault (owner of the Christie's auction house as well as various luxury fashion concerns) as both a major financial backer of Koons' Versailles retrospective and lender of six of the works on display from his private collection.

The V&A plays an interesting and pivotal role in this history. Its mission included education for artisans, along with providing models for manufacture; yet social control was also part of the picture, since its address to a wide audience was married to the hope that it would provide an uplifting alternative to more debauched means of entertainment. And one has only to look at the V&A's roots in the Crystal Palace to see that the promotion of consumption as well as production was always implicit. Like museums, both world fairs and urban arcades exhibited luxury goods accessible to the vast majority only through the spectacle of their display, in what Walter Benjamin has famously characterized as "palaces of pilgrimage to the commodity fetish."[36] Claims of disinterested contemplation notwithstanding, recent examples of museum and market exchange are part of a long history that has inspired frequent comparisons between museums and department stores, not only in terms of display strategies (with museums taking lessons from the attractive presentations of commercial goods), but also education, since part of the early department store brief was to edify a consuming public to appreciate and know how to

comport themselves in relation to the displays of goods available for purchase.

For all the V&A's focus on craft, it participates with other museums in a general reorientation of artistic training, where education centered on apprenticeship in the techniques of the masters has been extensively supplanted by learning through looking—a process facilitated both by physical exhibitions and art's dissemination through reproductions. Further lessons of the museum can be found in the ways that artists play off of institutional strategies and associations. Not only do many artists enact their own processes of collecting, archiving, and display as crucial aspects of their production, but works that explore the interplay between art and commodity, or art and everyday life, take on still new significance when they cycle back into the museum. An extensive reliance on already made objects and forms in contemporary art integrates consumption into the heart of the production process, and also draws attention to the many ways in which art and commerce share a long, interconnected history in the museum enterprise. And, finally, the embrace of artists and works that highlight aspects of museum history or protocol indicates how a process of institutional critique can quickly shade into new forms of legitimization.

Collection order

An examination of museum history reveals a perennial state of flux; and in this context the heterogeneity of contemporary practices can be viewed both as a force that helps destabilize earlier categories and as a lens through which one can perceive tensions that have always been present. "The universal survey museum" is the label used by Carol Duncan and Alan Wallach in their groundbreaking essay outlining the ambition to present a comprehensive view in the context of the type of collection most closely associated with a chronological approach.[37] Yet, for all that this ordering principle may have seemed inevitable, at least for a brief moment, its emergence is historically specific, linked to transformations from private to public collections during the eighteenth and nineteenth centuries. Altered presentation strategies were related

to the isolation of different object types, with each sent off into its own preserve. In the process, art collections were increasingly arranged around a progression of geographically focused periods and movements (in obvious contrast to certain private collections turned public, where the taste and aesthetic of the individual collector owner has been frozen in place).

Changes in the royal collection in Austria present a telling example of the sometimes dramatic shifts motivated by evolving ideas about who or what senses the collection should address. One arrangement was carried out in 1720–8, and Germain Bazin describes it thus:

> Given black frames embellished with gilt rocaille, the paintings were treated as simple decorative elements; all the schools were mixed; format and subject, not quality determined the choice. Some masterpieces were omitted, others hung beside astonishingly mediocre paintings; baroque compositions predominated; to achieve an overall symmetry, there was no hesitation in cutting down or, as was more often the case, in enlarging the pictures.[38]

Forty years later, however, the collection was reinstalled in new quarters and according to very different principles. Paintings that had previously been enlarged were restored to their original size, and all were given simpler frames. More importantly, the works were arranged chronologically, with schools and works by individual artists grouped together. According to Chrétien de Mechel, who completed the reinstallation in 1781, the objective of a great public collection was "more for one's instruction than delight," and he argued that "one learns at a brief glance infinitely more than one could if the same paintings were hung without regard to the period which had made them … It must interest artists and amateurs the world over to know there actually exists a Repository where the history of art is made visible."[39] But not everyone in Vienna was happy to see the decorative replaced with the pedagogical; and a disgruntled contemporary commentator found that "One who desires to write an art history can enter [the museum] but the sensitive man is kept away."[40]

Yet, constant revisions to both museum histories and linked textbook accounts show how much even the supposedly neutral

chronological approach can be shifted by decisions about what to include or leave out. Witness the reappearance of salon painting in histories of the nineteenth century, announced with a flourish by the 1986 opening of the Musée d'Orsay in Paris, and presaged by the 1980 rehang of the Andre Meyer Galleries at New York's Metropolitan Museum of Art. Conservative complaints about undermining aesthetic standards were not without a certain irony, given that the move in question involved reintroducing work once dismissed as rearguard into what had become a canonical anti-academic story.[41] Yet, for some the realignment didn't go far enough, with the Musée d'Orsay criticized for overlooking social history from one side, even as it was decried for its postmodern revision of the canon from the other.[42] Equally attention grabbing was Gae Aulenti's adaptation of a former train station building, originally completed for the 1900 Universal Exhibition in Paris, which already presented a complex amalgam of iron and glass functionalism hidden behind an elaborate stone façade (a decision to hide the industrial architecture that stood in sharp contrast to the structural drama of the 1851 Crystal Palace). Modernist masterpieces did get their own conventionally neutral spaces within

15. Musée d'Orsay, Paris, with Thomas Couture, *Romans of the Decadence*, 1847, as installed summer 1999. Photo: Martha Buskirk.

enclosed side galleries set into the glass-vaulted train shed; yet the prominence of Thomas Couture's 1847 *Romans of the Decadence* within the main promenade was a sure sign of declining standards for progressive painting's tradition-bound defenders.

There were still more fireworks in response to the 1991 exhibition *The West as America* at the Smithsonian, where the curators had the temerity to incorporate artistically important paintings into an assembly that also relied on drawings, photographs, and sculpture to provide evidence for a critical examination of western expansion. It hardly helped matters that the commentary was at times heavy handed. Yet the fundamental challenge came from the notion that painting might be only one element in a larger visual culture—and, as such, part of a move from art history to social history, or even from art to artifact, with paintings cast back into the sea of objects and images from which they had been extracted by claims of aesthetic autonomy. Using painting as part of a story articulated through diverse forms of evidence, and a critical story at that, also amounted to waving a red flag at a moment when debate was already highly politicized in the context of US battles over public funding for the arts.[43]

The idea that paintings should be presented in relative isolation, hung in single, eye-level rows on pale walls, apart from decorative arts or period rooms, was itself a radical notion in its time. New York's Museum of Modern Art (MoMA) was certainly not the first institution to present its collection in this fashion, but Alfred Barr's embrace of the strategy, beginning with the museum's inaugural exhibition in 1929, played a major role in its eventual dominance. Barr's aggressive neutrality employed chronology and thematic sequencing (in conscious opposition to decorative ensembles dictated by the size of the work), and he further supported the notion of the work's autonomy with arguments in wall labels—a self-sufficiency therefore buttressed through contextual infor-mation. If there can be any doubt that MoMA's high modernist approach might establish a formal reading, rather than simply respect or respond to the aesthetic espoused by an object's maker, one need look no further than the 1934 *Machine Art* exhibition, curated and designed by Philip Johnson, with its privileging of form over function through aesthetically isolated displays of such objects as propellers, springs, ball bearings, and laboratory beakers.[44]

MoMA did seem to question its allegiance to chronological

order in a series of exhibitions leading up to the 2002 closure and relocation of operations for two years during construction of its Yoshio Taniguchi expansion. Upon reopening, however, the sequential approach was largely reinstated, at least for pre-1970 holdings. At the same time, there are interesting echoes of the V&A's divisions by object type in the separation of painting and sculpture's historical unfolding from other galleries dedicated to architecture and design, prints and illustrated books, film and video, photography, and drawing, according to boundaries that follow the museum's medium-based department structure (with the upshot that photography is allowed to keep company with painting only in very recent decades). Before one arrives at the histories told on the upper floors, however, one enters the museum through a large-scale atrium, where surrounding galleries present an admixture of contemporary forms that therefore precede one's experience of the earlier art above.

The Centre Pompidou also threw off chronology on a temporary basis with its 2005 *Big Bang* exhibition, applying the theme of destruction both to the overturning of previous collection order and as a thematic subset (with Destruction rubbing shoulders with such other equally broad categories as Construction/Deconstruction, Primitivisms/Archaisms, Sex, War, Subversion, Melancholy, and Re-enchantment). The appeal, but potential downfall, of such amorphous themes is the flexibility they allow for drawing comparisons, with the framework allowing connections that would be precluded by a strictly chronological sequence. Yet the results can seem arbitrary, particularly when they shade into the type of shallow formalism evident in Catherine Grenier's destruction subcategory, which turned from the dissolution of the figure to a conflation of such basically dissimilar objects as an architectural model by Herzog & de Meuron, a Piet Mondrian composition, a Donald Judd cantilevered stack, a Kasmir Malevich black square, and a group of Allan McCollum's black-centered plaster surrogates—their juxtaposition based on a shared use of geometry that apparently trumped profound differences with respect to historic origins and artistic agendas.[45] On the other hand, the possibility that a chronological approach could itself be newly subversive was posited by the Pompidou's 2009 *Elles*, which singled out the work of women artists in the collection for an alternate and tellingly

spotty narrative of twentieth-century art, told without having to be shoehorned into a male-dominated canon.

In contrast to both MoMA and the Pompidou, the Tate Modern, which opened in 2000 in a former power station transformed into a museum by Herzog & de Meuron, embraced a thematic approach from the start. The inaugural arrangement presented the collection according to broad topics based on the genre categories of an earlier era: Landscape/Matter/Environment, Still-Life/Object/Real Life, History/Memory/Society, and Nude/Action/Body provided the framework for a play across historical movements that had the added benefit of downplaying collection weaknesses (early twentieth-century modernism in particular) that would have been painfully obvious in a chronological progression. Yet this type of thematic approach lacks a sense of historical inevitability, perhaps accounting for a major rehang of the collection only six years later. Certain individual galleries returned to traditional movement divisions, while other rooms remained broadly thematic, and still others were narrowly focused on the work of one or two artists. Ongoing flexibility was clearly one benefit, since the subcategories can be changed out at will, without disturbing the overall rubric. And, in contrast to an apparently authorless chronological approach, the Tate lists individual curators for the galleries—with the clear implication that the sometimes unexpected juxtapositions reflect the divergent interests and tastes of those making the selections and arrangements.[46] But the immediately striking feature of the Tate Modern is the grand turbine hall, with its colossal space upping the ante for the large-scale contemporary projects experienced before one enters the permanent collection in the more traditional white cube galleries set into the floors above. In this context, as in the 2004 MoMA expansion, one therefore encounters the historical by way of the contemporary.

Barr's approach to MoMA's permanent collection galleries may have been based on an orderly, punctual unfolding of successive movements and styles, but an often-reproduced chart he prepared for his 1936 *Cubism and Abstract Art* exhibition already suggests the seeds of its undoing. Though he was only attempting to account for the development of European abstraction, lines of influence present a tangled web. More telling, however, was the introduction of certain non-Western or even non-art sources, set off via red boxes, with arrows indicating a model of one-way borrowing

that had a last, notorious gasp in MoMA's 1984 *"Primitivism"* *in 20th Century Art,* where a hierarchical conception of affinities presented Western artists mining riches there for the taking in tribal artifacts.[47]

Revisions to collection order in major Western art museums reflect stresses from within and without, as already tenuous attempts to create a systematic unfolding are questioned not only for what they exclude from the historical record, but how they move into the present. And there is no avoiding the backward pressure that contemporary art's increasingly global scope exerts on narratives of art centered upon European and US developments, as well as on the universal claims made for survey museums built from the fruits of colonial conquest. It is, however, more than just a matter of equal representation. The Pompidou's 1989 *Magiciens de la Terre* was in some respects a groundbreaking exhibition, with its even division between Western and non-Western artists. Yet, despite good intentions, its vision of a global village linked through the overarching themes of magic and spirituality produced a significantly asymmetric view of cultural exchange. An emphasis on non-Western artists who were true to their own cultural roots, rather than "contaminated" by a metropolitan engagement with non-indigenous traditions, meant that the underlying assumptions and selection criteria helped to maintain an inherently peripheral status.[48]

While the recent emphasis on global art, as opposed to world art, might seem like only a slight shift in terminology, it pits universal claims made from within Western art historical traditions against a multiplicity of both origins and outcomes.[49] The perspectives offered by international biennial-type exhibitions continue to raise new questions about how to reconcile the significance of local traditions with participation in a global dialogue about art. Quite evidently, the tremendous mobility of both art and artists undermines any attempt to retain coherent divisions by geographical region without, however, addressing underlying problems based on unequal access to resources and artistic training in different parts of the world.

In what is clearly designed to establish a new model of collecting (in evident contrast to the cultural imperialism, as well as outright conquest, reflected in the historical development of the British Museum or V&A holdings), the Tate Modern has announced

a global mission for the expansion of its contemporary collections. New and aggressive steps to extend its purview beyond Europe and North America are reflected in its creation of Latin American, Asia-Pacific, and Middle East North Africa acquisitions committees, each comprised of a mix that includes curators, collectors, and experts based in the respective regions.[50] Yet the type of art highlighted in the context of an increasingly international network of museums and related institutions is prey to conflicting forces—with the desired work somehow expected to be at once local and global in its address, and therefore perhaps actually neither.

It is equally interesting how much impact Western museum formation continues to have as an export model. Clearly the old framework of the universal survey museum, with the spoils of war and conquest incorporated into a history told from the vantage point of their significance for Western art, has a highly fraught relationship to global inclusiveness. But, despite their underlying paradigm problems, the major Western museums are rich in both physical holdings and cultural capital—including tremendous name recognition. "Brand" and "franchise" appear with great frequency in descriptions of the Guggenheim Museum's global ambitions, and the resemblance to a franchise operation is indeed striking, with the Guggenheim designation applied to museums largely paid for by their host municipalities or other regional entities, and operating expenses that include fees to the parent institution in exchange for revolving loans of certified Guggenheim artwork. The Guggenheim's success in Bilbao, with its destination building by a star architect, is evident in its role as a model for many other art-based bids for global recognition and tourist traffic.

Obviously art always has functioned as prize, spoil, or trophy, and the prestige of having a major museum—particularly one that is already a known cultural icon—is a logical extension. The further appeal of having a museum that tells the history of world art is evident in the deal to create an offshoot of the Louvre in Abu Dhabi. As part of the agreement, the Louvre was paid more than $550 million for the use of the name itself and is due to receive an additional $780 million for art loans, exhibitions, and management advice. But loans are only part of the picture, since there is a $56 million annual acquisition budget to build a permanent collection for what has been described as the Middle East's first universal

museum.[51] Moreover, the new Louvre, by Jean Nouvel, is part of an ambitious cultural development on Abu Dhabi's Saadiyat Island that includes a large Guggenheim museum complex by Frank Gehry, the Zayed National Museum (honoring the late leader of the UAE, H. H. Sheikh Zayed bin Sultan Al Nahyan), designed by Norman Foster and Partners, and a performing arts center by Zaha Hadid.

The Guggenheim's Abu Dhabi outpost follows the model of earlier partnership plans where the local government pays for the building costs and other expenses while benefiting from the Guggenheim's profile and collection depth. Plus there is an acquisition budget reported by Thomas Krens as half a billion Euros to develop the museum's own collection of contemporary art.[52] There are, however, a few interesting challenges specific to this context, including the need to avoid art featuring nudes to keep from giving offence in a Muslim setting. The enterprise was also threatened with a boycott by artists protesting working conditions at the site, with Emily Jacir and Walid Raad leading a campaign to refuse to participate with museum programming or allow their works to be bought for the collection unless reported abuses were corrected.[53]

The British Museum, though late to the party, also managed to snare a piece of the action via a multi-million-pound agreement with the Zayed National Museum, which involves lending artifacts as well as expertise to an institution where one of the planned thematic divisions is "the story of oil."[54] For this national museum, however, the collaboration's appeal is clearly not loans of Western art, but rather the prospect of tapping into the British Museum's extensive Middle East collections. It is therefore another turn on cultural imperialism, as the West's history of art is assimilated and reconfigured according to a different set of coordinates, in the context of an emirate that has become colossally wealthy as a result of the industrial world's oil dependence.

In the context of these evolving debates, the idea of entering the historical galleries through the contemporary becomes more than just an occasional accident of architecture. Changes in current art practices precipitate museum transformations, not just due to an ongoing desire to embrace the latest version of the new, but because of retrospective questions raised by the story's ever-changing end. The search for a single standard necessarily gives way to multiple, often nonsynchronous narratives about art, with varied approaches

to art's history linked to different conclusions about the present. The emphasis on recent practices also cannot be separated from the variety of purposes served by the display of art. References to the "Bilbao effect" tend to stress what having a destination museum can do for the surrounding area, with the experience of the art within the dramatic titanium walls sometimes sounding like a bit of an afterthought. Sponsorship of major biennial-type exhibitions is likely to emanate from similarly complex motivations, with the display of art helping to declare the worthiness of a particular institution or region to participate in an established international dialogue.

Ongoing changes to collection scope and narrative are obviously linked to transformations in the definition of art itself. Not only is the historical mutability of museum conventions highlighted by art made in direct response to institutional practices, but contemporary art is inevitably altered by its speedy assimilation. In a state of reciprocal dependence, art that emphasizes its circumstances of display, often through a combination of mimicry and resistance, has been embraced by curators who have their own motivations for enacting a process of institutional examination. It is impossible to think about contemporary art without taking into account the history of the museum—not the least because so many artists have turned their attention to this very subject, as well as to forms that potentially extend beyond the museum's purview.

Traditionally a major effect of the art museum has been to isolate and elevate the objects it houses. Yet that notion of separation is called into question by the increasing emphasis on the museum as a business, including mounting exhibitions that will be popular with the general public, providing significant ancillary activities around the galleries, and creating enclaves of exclusivity for potential high-end donors. The art museum's expanded compass is reflected in collaborative procedures for producing art, at the same time that it constitutes only one component of a tremendously interwoven system of exhibition and dissemination that also includes galleries, auction houses, fairs, and biennial-type events, each with its own dynamics with respect to the type of work likely to be highlighted or even generated within its precincts.

The widespread embrace of strategies of institutional critique indicates that the practice of drawing attention to these dynamics has neither a single purpose nor outcome. Rather, such gambits are

part of a larger process that encompasses both critique and accommodation, with elements of both often far too tightly interwoven to disentangle. To the extent that art is increasingly produced through collaborative ventures with museums, its integration into that context does not result in secluded isolation; rather, such artistic activities parallel the function of the museum itself, which plays an integral role in a burgeoning art industry.

CHAPTER 2

The collection

Shortly after midnight on March 18, 1990, two thieves dressed as policeman talked their way past security guards at Boston's Isabella Stewart Gardner Museum and proceeded to help themselves to the treasures within. Their remarkable haul of thirteen works, many crudely cut from their frames, included three Rembrandts (among them his only seascape), a Vermeer, a Manet, and five drawings by Degas. The museum does still have some major pieces, most notably Titian's *Europa*, but the art that disappeared that night left enduring voids. At some museums the notion of an empty space in the collection could be understood as a figure of speech; for the Gardner, however, it is literally true, since the installation is fixed in place under the terms of Isabella Stewart Gardner's will. As a result, empty frames left behind by the thieves continue to mark spots where paintings once hung.

Even before the theft, Gardner's personal order, with evidence of individual taste clearly reflected in her arrangements of objects, stood in sharp contrast to the chronological approach—a narrative without apparent authorship—associated with the establishment of public art museums in the eighteenth and nineteenth centuries. Obsessive attention to objects and their disposition is also the subject of an anecdote recounted about a visitor to Bernard Berenson's Florentine villa, who tested the importance of placement by slightly moving one of his figurines, only to find it returned to its exact position each time it was displaced.[1] Or there is the controversy surrounding the decision by the Barnes Foundation to relocate from Merion to Philadelphia, a move designed to increase

1. The Dutch Room, Isabella Stewart Gardner Museum, Boston. © Isabella Stewart Gardner Museum. Photo: Sean Dungan, 2010.

access to the art itself, at the expense of the site-specific experience of the installations dictated by the collector's eccentric pedagogical program.

Since most individuals don't have the wherewithal to turn their assemblies into shrines, such careful compositions usually die with the collector, as their objects are subsumed into other contexts. It can be equally disconcerting, however, when a collection that was dynamic, changing over the lifetime of its owner, is frozen in place, and Gardner's museum demonstrates some of the drawbacks to such monuments. In addition to the gap-toothed array left by the theft, the intermix of significant works with second-rate examples and even apparent fakes demonstrates the space that has opened up between Gardner's collecting heyday at the turn of the twentieth century and current aesthetic expectations. Yet those same peculiarities are the basis of the museum's appeal, and in many respects its ongoing relevance, as the collection's unexpected and personal arrangements suggest a form of authorship not all that different from many versions of contemporary artistic assemblage.

The blurring of boundaries between artist and collector turns on an understanding of consumption as a mode of production. An object's origin or initial form may be only the starting point for associations that adhere to it over time, as it is redefined through later use and its incorporation into new constellations made up of other similarly redirected material. The act of designation implied by the readymade ("this is a work of art"), with its power to transform the status of an otherwise humble object to an authored and potentially costly work, is part of a complex set of possibilities that includes historical objects valued because of their association with famous owners, works of art overshadowed by their identity as part of specific collections, or even the contemporary idea that one can express one's individuality through one's style of consumption. Further complications arise from the layering of authorship claims, with some exerting far more force than others (as in the difference between a work of art indelibly associated with a particular owner, and one where ownership history is treated as largely inconsequential). Likewise, even an authored collection may still draw much of its cachet from the attributes of objects assimilated into its system, in much the same way that consumer style often turns around the prestige associated with designer branding.

Arrangements

Two preserved collections in London, Sir John Soane's Museum and the Freud Museum, fixed in place at different moments, raise a host of issues via their immortalized displays, including evidence of shifting attitudes toward originals and copies, and the relationship of the collection to the life or achievements of the collector. They are similar to the extent that each presents multiple objects from different periods, and both sustain the collector's arrangements. Yet Soane's is a top-to-bottom array built into the fabric of side-by-side row houses he customized for that purpose, while Freud's collection was retained precisely because of its portability.

Soane's jam-packed installation, which fills to overflowing linked houses in Lincoln's Inn Fields, is at once related to his architectural practice—with a heavy emphasis on architectural casts and fragments—and something that exists in its own right

as an integrated artistic ensemble. One major centerpiece is the alabaster sarcophagus of the Egyptian Pharaoh Seti I, discovered by Giovanni Belzoni in 1817 and acquired by Soane in 1824 after the British Museum passed up its purchase.[2] There are also significant paintings, including William Hogarth's *Rake's Progress* (which, as it happens, functioned for Hogarth more as a kind of advertisement for the actual profit center, in the prints on the same topic).

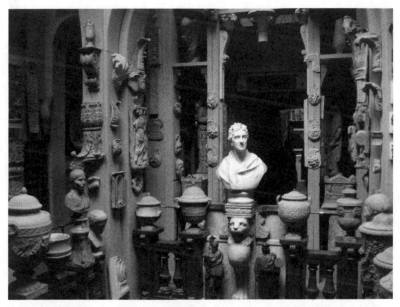

2. Central Dome, Sir John Soane's Museum, 13 Lincoln's Inn Fields, London. Photo: Martha Buskirk.

Soane's collection is equally notable for its mix of originals and copies, with some of the latter hardly insignificant. A plaster cast of Apollo Belvedere is notable in this regard: originally valued as a facsimile of this revered classic, it provides a three-dimensional record of what the sculpture once looked like, prior to the twentieth-century decision to remove restorations from the now-fragmentary original. Acquired from Richard Boyle, Third Earl of Burlington, who helped spearhead the Palladian revival in England, its significance for Soane is indicated by both its central placement and the challenges he faced bringing this large-scale cast into the collection

(including the need to open an external wall).[3] Plaster is not synonymous with copy in this setting, however, since there are also numerous original plaster models by Soane's friend, the neoclassical sculptor John Flaxman, which Soane purchased from the artist's relatives after his death.[4] And Flaxman was the source for one of the natural curiosities, a skeleton that shares the basement space anchored by the sarcophagus. Yet this object was almost ejected from the otherwise permanent ensemble, since it had not been paid for at the time of Soane's death, and museum trustees initially proposed to return it and an associated animal skull to Flaxman's relatives on the premise that these objects were not sufficiently connected to the collection the trustees had been tasked to maintain.[5]

The preservation of Soane's house was no accident of fate, given his role in instigating the act of Parliament that established it as a museum in 1833. It was, however, Soane's death in 1837 that fixed the arrangement in place, other than decisions made by the trustees as part of their mission to stay true to their interpretation of Soane's intent. In an essay on Soane's house museum, John Elsner emphasizes the transition from the living act of collecting to its embalmed opposite, the moment when "change is arrested and the museum begins."[6] Such is certainly the case for museums that enshrine a particular individual's collection, where the activity of arranging and rearranging is synonymous with that person's presence, and comes to an end with his or her demise. Soane's installation preserves an assembly where individual points of origin are read in relation to Soane's own historic moment, which, Elsner claims, creates a framework for "experiencing antiquity through modernity, the antique building as the contemporary architect's model, the modern world as a pastiche of ancient remains."[7] Yet, if the moment when Soane's collection was transformed into a museum is synonymous with being frozen in place by his death, the preservation of arrangements rather than objects is hardly true of museums in general, where successive installations of the collection constitute the dynamic that distinguishes the efforts of multiple, generally uncredited curators from the personal, even eccentric order characteristic of Soane's house turned museum.

The Freud Museum in London presents a different type of lure and challenge, since it is significant first of all as the physical environment fashioned by one of the most important figures in twentieth-century thought. The house functioned as a combination

work and living space, as well as the container for the extensive collection of antiquities moved from Vienna in 1938, when Freud fled Nazi occupation. Many of the objects would be interesting in their own right, as artifacts with varying degrees of significance and rarity, but their aggregate status as a collection amassed by Freud confers their enduring distinction as well as the reason for keeping the assembly intact. Even so, the transition to museum was gradual, since Anna Freud continued living in the Hampstead house. But she left the professional sections of her father's home basically untouched during her lifetime, and after her death in 1982 the preserved shrine officially became the Freud Museum.[8]

3. Freud's Desk and Couch, Freud Museum, London. Photo: Freud Museum, London.

One reason Freud was able to amass his sizeable collection was relatively low prices commanded by classical and Egyptian antiquities, even into the early decades of the twentieth century. Not only were many quite recently unearthed (and therefore new to market, despite their age), but methods of assessment and authentication were still being refined, in tandem with the increasing numbers of available objects and the wave of museum expansion dating from the nineteenth century. Several different kinds of history intersect in a collection of this type. There are the origins of the objects themselves, with the importance of this information confirmed by Freud's extensive collection of books devoted to relevant historical studies. Another narrative is constituted by the chronicle of when Freud acquired individual examples through purchase and trade, as well as changes in his collecting habits (including a move away from plaster casts related not only to Freud's increased economic advantage, but also his participation in a broader shift in taste). Then there is the appreciation of the objects as a group, experienced by viewers at the same moment in time, regardless of relative age or point of acquisition. As a collection continues to grow, each configuration replaces a previous present; yet one that is fixed in place arrests that evolution, such that any subsequent experience of the total ensemble seems to open up a window onto the point in time when change stopped.

Not surprisingly, literature on Freud's collection abounds with references to the archeological metaphor he used to express the subject's reconstruction of the past in the present moment. Even in the context of its original use, however, there was an incongruity between a science oriented toward material objects and an exploration of psychic life enacted via language.[9] In a further wrinkle, the preserved Hampstead shrine already amounted to a form of reenactment, based on repeating as closely as possible the arrangement of objects in Vienna. In London, the family's maid and Freud's son worked to duplicate the original placement of the artifacts, reinstating but also adjusting their presentation in a new space where the desk and couch had to share the same room. (By contrast, the competing house museum in Vienna, despite its status as the site where these displays were originally constituted, has to make do with photographs of Freud's furnishings.) Freud, after seeing his assembled possessions reconstructed in England, observed that "a collection to which there are no new additions is

really dead."[10] Not only did the reinstallation make the assembly seem finite, but any possibility of further change ended with Freud's demise the year after his move to London, at which point the reconstruction was definitively fixed, with its status as shrine further emphasized by the placement of Freud's ashes within one of the urns in his collection.[11]

In context

The other Freud museum in Vienna, in the original house, but lacking Freud's furnishings, has instituted an extensive exhibition program, including installations on site and the establishment of a collection of contemporary works of art that relate in some fashion to Freud's theories. In London, the arrangement of Freud's artifacts and Soane's even more conscious installation of his collection as a unified installation tap into another form of contemporary relevance, in their connection to recent works that respond to or participate in museum conventions. The idea that the museum itself might constitute a medium of artistic expression provides a key link to current practices.[12] Yet the procedure of inviting artists to interact with an existing museum takes a particular turn when the setting already represents an individual collector's vision or authorship.

Artists who have had the opportunity to engage with the Freud Museum in London have responded in various ways to the ambiguous interplay between Freud's contributions to the history of ideas and his assembly of objects. Although the psychoanalytic investigations and the collecting activities were in many respects separate endeavors—each with its own distinct library—the fact that both were the work of the same individual argues for their connection, and the artistic projects mounted at the museum have tended to emphasize this potential interchange by exploring the associations that an artifact can suggest or unleash.

Taking off from her stated belief "that any conscious configuration of objects tells a story," Susan Hiller drew upon her early archeological training (apparent particularly in her decision to employ standardized collecting boxes) to present a varied group of not especially valuable, but often personally significant, objects.[13] Her 1994 *At the Freud Museum* presented 23 such boxes in a

vitrine, and a subsequent expansion to 50 units was completed in 1996 under the new title *From the Freud Museum*. Even though the objects by and large did not originate in that context, and in the extended form had not necessarily even paid a visit, they remain part of a self-conscious dialogue based on confronting one collection with another via a process of displaying personal mementos or relics as anthropological evidence. It is also, as Sven Spieker observes, an arrangement that pits the rhetoric of the contemporary archive against earlier modalities, where there was "no clear distinction between fiction and documentation, between observation and fabulation."[14]

On the occasion of her 1999 interaction with the site, Sophie Calle took a more overtly provocative approach to a similar strategy, presenting various objects in conjunction with narrative labels recounting her own memories, both childhood and sexual. Her blending of autobiographical markers with Freud's collection included a wedding dress arrayed on the famous couch and a photograph of herself in Freud's overcoat.[15] And, given the nature of her work in general, it is hardly surprising that Sarah Lucas used her 2000 opportunity to interact with the museum to stage her own versions of somewhat raunchy sexualized objects. These included dining-room chairs dressed in gendered underwear and connected by a taut stretch of fabric, as well as a twisted mattress pierced by a long florescent fixture—all in a setting already inhabited by the oddity of Freud's unusual desk chair.[16]

A persistent but more diffuse engagement appears in Cornelia Parker's extended interactions. First there was *The Maybe*, her 1995 collaboration with Tilda Swinton at the Serpentine Gallery, where, for the duration of a week, the actress appeared, sleeping in a case, together with displays of relics connected to famous people on loan from different institutions. Along with an assembly that included a scrap from Lindbergh's plane, the preserved brain of Charles Babbage (inventor of the first computer), and the quill with which Dickens wrote *The Mystery of Edwin Drood*, there were the blanket and pillow from Freud's couch, which were more recognizable than many of the other relics due to their distinctive patterns.

That installation generated, in turn, a 1998 photogram entitled *Feather from Freud's Pillow (From his Couch)*, using a feather Parker noticed working itself loose from Freud's pillow, which she asked if she could have (part of a series of photograms of feathers

4 and 5. Cornelia Parker, *The Maybe*, 1995 (a collaboration between Cornelia Parker and Tilda Swinton). Matilda Swinton (1960–), and Freud's pillow and blanket from his couch. Courtesy the artist and Frith Street Gallery, London.

from equally specific sources). Then there was a group of drawings from 2003 entitled *Unconscious of a Monument*, made, according to the artist, using dirt from Freud's garden. The soil was acquired in the pursuit of another series, *Different Dirt*, involving artifacts found by amateurs with metal detectors in both the United States

and United Kingdom, which she purchased, documented, and then reburied in the opposite region. One of these, a "pain bullet" from the US Civil War (complete with tooth marks left by the individual who bit down on it, in lieu of anesthesia) Parker reburied in Freud's garden, thereby adding a permanent yet invisible, contemporary yet old, element to the collection.

6. Cornelia Parker, *Feather from Freud's Pillow (from his couch)*, 1998 (with thanks to the Freud Museum). Photogram, 63 × 63 cm. Courtesy the artist and Frith Street Gallery, London.

The artists invited to nose around Freud's house are presumably not subject to the frustrating constraints placed on typical visitors, who are kept to the center of the study in a small roped-off corridor, at a distance from both the desk and the famous couch, and thus

denied close inspection of most of the artifacts in cases around the room or spread out across the surface of Freud's desk. The possibility of examining individual objects, rather than simply taking in the assembly as a slightly distant whole, was, oddly enough, made possible for the general public only by an off-site exhibition drawn from the museum: *Freud's Sculpture*, at the Henry Moore Institute in Leeds, set up a desk-like viewing station, where one visitor at a time could take up something akin to Freud's own relationship to the objects on his desk.[17] At most times, and for most viewers, however, Freud's collection remains at a remove, to be appreciated only as an assembled totality, rather than for the individual qualities that presumably motivated Freud's pursuit.

While a great deal of effort has been expended on preserving Freud's collection, including its final arrangement, it is still just that—an assembly valued in its aggregate because of its association with the pioneering theorist of psychoanalysis. Soane's authorship is in many respects far stronger. Although his vast collection encompassed objects from multiple sources, his house museum was clearly conceived from an early point as an integrated ensemble. Soane fashioned an environment that was an extension of his primary practice, a form of architectural art. The museum clearly has a double appeal, offering potential insights to those motivated by an interest in Soane's work as architect, and a different sort of attraction for another audience fascinated by the complex installation, both as a counterpoint to modern museum conventions and for the areas of overlap with recent museum fictions by artists.

The trend of inviting artistic interventions in historical collections takes a particular, even peculiar turn, however, when the collection can be understood as a work in itself. While the Soane museum, unlike that of Freud, has not been the site of a regular series of contemporary projects, it played host to a 1999–2000 exhibition, *Retrace your Steps: Remember Tomorrow*, organized by Hans Ulrich Obrist, who was introduced to the museum by one of the artists eventually included. Obrist conceived the entire project as its own art form, with the artists' contributions encompassing, in addition to physical interventions, the exhibition title, the design of the poster and exhibition leaflet, an artist lecture, and individual postcards. As curatorial impresario, Obrist exercised a certain overarching authorship, not unlike that of Soane in his intersecting roles as collector, architect, and proto-installation

artist. Yet Obrist's characterization of the museum as medium as a basis for this intervention presents a certain ambiguity, given that the idea might apply in equal measure to the author of the original installation, to the artists invited to fashion work in response, and to the curator who instigated these later interactions.

Since Soane's ensemble has its own compelling internal aesthetic, it seems reasonable to ask why subsequent artists should be invited to interrupt his realized museum-as-work, even on a temporary basis. In fact the motivation was paradoxical: both curator and artists were clearly drawn to the installation because of its potential connection to recent practices. But the same argument could be marshaled for leaving the ensemble alone, out of respect for a form of artistic authorship celebrated by members of Soane's present-day audience. The larger issue at hand concerns the role of the artist in a continuum of activity that includes collecting and curating, with these overlapping roles helping to collapse distinctions between production and reception.

Artist, collector, archivist

Artists have long been collectors, acquiring works by other artists through purchase or trade, and bringing together varieties of objects, certain of which may serve as source material for their own creations. Some of these accumulations are better known than others, often due to accidents of fate: Rembrandt's collection is well documented in the 1656 inventory made when his possessions were sold as a result of bankruptcy; the scope of Andy Warhol's acquisitiveness was revealed by the 1988 auction sale of his voluminous hoard; and more than one scholar has seen fit to publish the list of books in Robert Smithson's library at the time of his unexpected death. Such collections are of particular interest when important connections can be drawn to the artist's work, or for the evidence of preoccupations that cut across the artist's production and consumption. Versions of collecting also lie behind twentieth-century collage and assemblage practices, with their reliance on found material that is nonetheless transformed through the creative process, while the readymade emphasizes the unaltered status of a singular object.

In a different version of artist as collector, however, the process of assembly, rather than serving as an adjunct to the artistic endeavor, in fact constitutes the work of art. This shift in art-making is deeply enmeshed in the role of the museum as site for display and, over the course of the twentieth century, increasingly the production of art. The presentation of collections of objects that an artist has simply brought together, without further intervention, contributes to an ambiguous overlap between artist and curator as well as artist and collector. In addition, the activities of hunting down, researching, classifying, and ultimately assembling groupings of objects is equally characteristic of popular collecting practices unrelated to artistic production; and unresolved questions about the status of certain artist-generated assemblies present further zones of ambiguity.

One important trajectory leads from the archival bent in conceptual practices of the 1960s and 1970s, through various forms of institutional critique, to a renewed attention to the objects collected in such contexts. A group of projects exhibited at Documenta 5 in 1972 under the heading "Museen von Künstler" provides a focused demonstration of the potential for overlap between artistic and curatorial activity. Then recent projects by Marcel Broodthaers, Herbert Distel, Claes Oldenburg, Daniel Spoerri, and Ben Vautier were shown alongside Marcel Duchamp's 1941 *Box in a Valise*, the miniature museum of his own work assembled by the pioneer of the readymade. Broodthaers' *Museum of Modern Art, Department of Eagles* appeared in its final incarnation, officially closed by the version on display at Kassel, where its juxtaposition with the first full realization of Oldenburg's *Mouse Museum* helped amplify telling intersections of museum, archival, artistic, and popular collecting practices.[18]

For its appearance at Kassel, Broodthaers' museum figured in two parts of the exhibition, with a display of photographs, frames, plastic plaques, and assorted documents in the section devoted to museums by artists, and a second text-based installation in a section devoted to personal mythologies. This official closing marked the end of a project that had gone through multiple permutations following its inauguration in 1968 as the *Musée d'Art Moderne, Département des Aigles, Section XIXème Siècle* with a display of packing crates and postcards of artworks in the artist's Brussels apartment, before moving backward to the seventeenth

century for a brief 1969 appearance in Antwerp also structured around packing crates and postcards. After that it returned to the nineteenth century, incorporating actual historical paintings on loan for Broodthaers' 1970 contribution to a group exhibition at the Städtische Kunsthalle in Düsseldorf. Three offshoots followed—involving a temporary beach installation, a play with the cinematic, and a declaration of bankruptcy—prior to its most elaborate incarnation in 1972, again in Düsseldorf, with a broader focus on the eagle from the Oligocene to the present realized through a display of more than three hundred objects, many on loan from 43 different museums and private collectors.

7. Marcel Broodthaers, *Musée d'Art Moderne, Département des Aigles, Section des Figures.* Düsseldorf Kunsthalle, 1972. © 2011 Artists Rights Society (ARS), New York / SABAM, Brussels.

If indeed, as he claimed, Broodthaers became an artist because he didn't have the resources to become a collector, then the creation of a work based on loans further confused an issue already ambiguous at the outset, when he transformed his own space from a site of production to reception for the first incarnation of the museum.[19] There is also a telling echo of the museum precursor represented by the cabinet of curiosities, its heterogeneous grouping of objects arranged according to the dictates of the generally aristocratic

collector. The motif of the eagle provided both the illusory unity of the display and the framework for its assembly of everything from works of art to natural history specimens, originals to mass-produced objects and reproductions. Broodthaers' museum was not only the work of the artist *as* curator—one operating through the other rather than as divided identities—but it also anticipated the ever-increasing tendency, in contemporary practices, for artistic authorship to provide the framework for introducing a range of object types once excluded from the art museum as part of its very definition.

A different kind of diversity held sway in Oldenburg's *Mouse Museum*, with its intermix of found, produced, and altered objects assembled by the artist in a mouse-shaped room. At the time of its Documenta appearance, the museum included a subset that was later split off and, for the project's 1977–8 incarnation, put on display in the separate *Ray Gun Wing* that he appended to a refashioned version of the mouse-shaped main building. The removal of the ray gun collection left the *Mouse Museum* with the following categories, in a division by object type that largely superseded the aforementioned distinctions between found and self-made: "Landscapes; Human beings; Food; Body parts; Clothing, make-up and adornment; Tools, simple to complex; Animals; Buildings, monuments and souvenirs; Money containers and practical systems; Smoking articles; Studio remnants and fragments; Objects added to the collection since 1972, not arranged according to the categories above."[20]

This somewhat incongruous list is reminiscent of Jorge Luis Borges' oft-quoted Chinese encyclopedia, where animals are divided according to such asymmetrical categories as "belonging to the emperor," "embalmed," "tame," etcetera. Of course Borges himself was no stranger to the play between found and invented, as evident in "The Analytical Language of John Wilkins," where the encyclopedia entry makes its appearance.[21] Its renown derives as well from the opening paragraph of *The Order of Things*, where Michel Foucault posited the absurdity of Borges' list as a challenge that he resolved by emphasizing its discursive status, as a series of juxtapositions that can only exist "in the non-place of language."[22] The fact that Oldenburg's categories are applied to physical objects does not, however, make them any less improbable, given the groupings that result from these divisions. In this respect the work

8. Claes Oldenburg, *Ray Gun Wing* (detail of interior, Vitrine IV), 1965–77. 258 objects, photographs; aluminum, wood, Plexiglas, 8' 7" × 14' 9" × 18' 8" overall. Collection Museum Moderner Kunst, Stiftung Ludwig Vienna, Austria; on loan from the Austrian Ludwig Foundation. © 1965–77 Claes Oldenburg.

plays off of earlier taxonomies, without contesting their obsolescence, in much the same way that contemporary artists have given renewed attention to the cabinet of curiosities, with its intermix of objects, but have done so from the vantage point of their division among different types of museum collections.

Another interesting phenomenon appears in Oldenburg's collection of ray guns, which ultimately expanded to include not just an already eclectic mix of mass-produced, hand-made (by himself as well as others), and happenstance objects (almost any sort of right-angle fragment that thus resembles a gun), but also ray guns "too fragile to move or fixed to sites," which appeared in a portfolio of photographs.[23] The idea that material forms might be collected photographically as well as physically is a significant point of intersection with projects oriented in relation to the archive—evident, perhaps most notably, in the sustained attention to different typologies of vernacular architecture within the expansive compendium of photographs by Bernd and Hilla Becher. At the same time, however, a conception of the archive predicated around an anonymously assembled compilation of information presents an important contrast to the notion of a personal collection, with its eccentricities—and underlying potential for authorship on that basis—connected to the taste or interest of a specific individual.

The tendency to collect according to specific categories, rather than randomly, is likewise an important basis for distinguishing between collector and obsessive hoarder. Certain collectors focus their efforts on a single vein, however obscure (swizzle sticks and souvenir buildings are examples that figure in one book on popular collecting habits), whereas others operate on multiple fronts; but even for collectors with interests in more than one area, the pursuit of specific sets of object types helps differentiate their actions from the more indiscriminate accumulator.[24] The larger the collection, however, the more its subcategories can become overlapping or incongruous. Witness, for example, Marilynn Gelfman Karp's documentation of her astonishing array of collecting activities, and the potentially arbitrary nature of her divisions when viewed in relation to Oldenburg's project, given that she has gun-shaped objects (potential ray guns, in other words) in her groupings of glass candy containers, figural pencil sharpeners, as well as caps and cap guns. She has furthermore extended her collecting reach in similar fashion to Oldenburg, with a category of lists and mental collections for things observed but not available for removal— some of which, including certain signs, leaf impressions in New York City cement, and objects embedded in asphalt pavement, appear as photographs in her book.[25]

Warhol is also right up there in this history. His 1969–70 *Raid the Icebox*, drawn from the storerooms of the museum at the Rhode Island School of Design (RISD), was an early instance of the now common practice of inviting an artist into the collection to peruse not only what the curators have considered suitable for display, but what is in the vault, out of sight. The plan, according to the RISD museum director, was to share the riches of the storeroom with institutions in Texas and Louisiana that lacked the same reserves, with the added twist of asking an important contemporary artist to do the picking. Yet Warhol's selection was decidedly at odds with a standard version of collection highlights—being notable for both what he did and what he did not choose. There were plenty of paintings, though generally earlier rather than recent; Native American blankets, ceramics and baskets were extensively represented, but he ignored Asian textiles; parasols, hat boxes, and shoes abounded, but no hats or dresses; and he scooped up a group of Winsor chairs that had been saved mainly to serve as spare parts. For many of the categories Warhol avoided making specific

choices by simply taking everything, including, most famously, over two hundred pairs of women's shoes—with the requirement that each have an individual catalogue entry forcing the museum to give these objects from their own collection, selected in volume by Warhol, a level of individual attention they had not previously been accorded.[26] The ostensibly unmediated relationship to the storeroom continued in the exhibition itself, as Warhol called for duplicating its mix of happenstance and utilitarian order by displaying the shoes in their original storage cabinet, presenting other objects in stacks, and offering many of the paintings simply leaned up against the walls with the sandbags used in storage to keep them from sliding. As in so many aspects of his production, Warhol's insistence on an apparent lack of intervention was precisely what gave the exhibition its specific character.

By the time he was invited to browse the RISD storerooms, Warhol was fully active as a collector himself, with a number

9. Installation view of *Raid the Icebox with Andy Warhol*, April 22–June 30, 1970. Courtesy the Museum of Art, Rhode Island School of Design Providence.

of parallels evident in his interest in Americana from folk art to furniture, along with Native American textiles, ceramics, masks, and metalwork—plus plenty of other groups of objects running the gamut from decorative art to evident kitsch, and of course those many, many cookie jars. A level of excess in danger of crossing the divide between collection and hoard is suggested by stories about purchases that jammed his cupboards without ever being removed from their shopping bags (somewhat akin to William Randolph Hearst's warehouses full of objects never removed from crates, which he therefore saw in photos) or descriptions of Warhol living in only a portion of his house once the piles of goods made many rooms impassible. Then there are the Time Capsules, which constitute Warhol's gesture of handing off the problem of sorting out his stuff to others, with the prescient notion that one decade's refuse could, if properly frozen in place, become another's valued evidence.[27] It is hard to ignore echoes of the Collyer brothers, who came to epitomize obsessive hoarding after the two were found dead in 1947 in a New York brownstone filled with 136 tons of junk of almost no value.[28] Yet the ten-day Sotheby's auction of Warhol's collection proved that quite the opposite was true of his stash, with the prices the objects might have commanded on their own only enhanced by the added association of Warhol's ownership.

Immediately after his death, the distinction between Warhol's work and his collection was sharply drawn by his executors, despite similarities implied by his photographic activities (the penis Polaroids, for example) and the echoes of *Raid the Icebox*—though the latter is itself not clearly defined as a work. More recently, potential connections have been reasserted by the Andy Warhol Museum's 2002 exhibition of former possessions in conjunction with his works, a show that required the museum to track down and borrow back many of the items that had been so dramatically dispersed (with acknowledgments to Sotheby's for helping with the retrieval of objects they had successfully sent out into the world not so many years earlier). One aspect, however, was simplified by the fact that a majority of the cookie jars had been bought by a single collector, who in turn loaned a large selection.[29]

Issues of authorship abound in relation to Warhol's work, and have only been exacerbated by the secretive and sometimes puzzling determinations made by the Andy Warhol Art Authentication Board, Inc., regarding acceptable degrees of delegation. There

seems to be no chance that the cookie jar accumulation might metamorphose into an official work; yet the idea that collecting and production are part of a continuum, particularly in relation to an artist involved in multiple forms of appropriation and transmission, opens onto larger questions raised by the blurring of art and life, such that the artist's entire existence can be articulated as a form of art project. Equally complex challenges are presented when objects are subject to an artist's claim or attention, but only for a limited time or specific purpose.

The artist as antiquarian

Stressing the intimate relationship between collector and object, Walter Benjamin described a double dynamic of engagement, via the historical artifact, where the object seemingly provides a sense of connection to the era of its origin yet is also inseparable from individual memories related to its acquisition and assimilation into the collection. Arguing that the "phenomenon of collecting loses its meaning as it loses its personal owner," Benjamin posits public access, despite the evident social good, as accompanied by an inevitable loss.[30] Particularly in survey-type collections, the imposition of a chronological arrangement is directly connected with the transition from individual aristocratic taste to the museum as public institution. Recent challenges to that norm, designed to interrupt or redirect its relentless and far from neutral progression, are therefore part of a complex interchange between private and public, evident most strikingly in artistic acts of collecting that refer to the earlier privileged form of the cabinet even as they are intended for public display.

A prospective benefit from inviting artists to sort through and rearrange a collection is the implementation of forms of presentation that the inviting curators either hadn't thought of or wouldn't feel at liberty to undertake themselves—including Scott Burton's display of only the bases from Constantin Brancusi's sculptures as his contribution to the first of the Museum of Modern Art's *Artist's Choice* exhibitions in 1989, or Louise Lawler's decision to emphasize a group of ceramic thimbles that had not previously been exhibited in their entirety for her 1991 *Connections* installation at Boston's Museum of Fine Arts.

10. Louise Lawler, *Connections*, November 17, 1990–March 3, 1991, Museum of Fine Arts, Boston (installation view). Courtesy the artist and the Museum of Fine Arts.

In relation to the objects that drew Lawler's attention, it is notable that the thimbles were already a collection in themselves, donated to the museum by Louise D. Alden in 1962, along with the cabinet she had used for their display; however, within the museum's overall hierarchy, they were, according to curator Trevor Fairbrother, viewed as "arguably 'minor.'"[31] In addition to presenting the thimble collection in its original cabinet, Lawler showed two photographs that she had taken at the nearby Isabella Stewart Gardner Museum just before the 1990 theft (*Does it matter who owns it?* and *Who chooses the details?*), a group of still-life paintings from the MFA's collection, a series of her own photographs that included images of museum works in storage as well as close-ups of individual thimbles juxtaposed with text, and a brochure that included an image of the thimbles packed for storage. By highlighting this particular set of objects, Lawler potentially drew attention to how, in their own minor way, the thimbles illustrate a problem posed to museums by donated collections, if the logic of an individual's private interests, whether in a range of works or a specific object type, fails to align with the museum's more canonical agenda.

It is equally interesting to consider how strategies of institutional critique associated with conceptual art have focused renewed

attention on material objects and their histories. Fred Wilson in particular is well known for his use of conceptual strategies to engage with material culture in the incisive rearrangement of the Maryland Historical Society that became his 1992 *Mining the Museum*. Functioning as an artist-researcher within the context of a historical society collection, Wilson was able to uncover previously hidden evidence relating to the region's African American and Native American populations. And even though his counter narrative relied entirely upon an already formed collection, the rearrangement unquestionably constituted an example of Wilson's work—in contrast to the ambiguous status of Warhol's *Raid the Icebox*. In fact, the rearrangement as a work of art derived its power from the very qualities that might seem to countermand that status, based as it was upon objects that had a long recorded history, prior to the artist's attention, in the context of a historical society with a hybrid collection ranging from artifacts valued primarily for their provenance to examples of art or fine craft where artistry and ownership vie for significance.

Stories told about or via artifacts are the basis for the historical society's appeal to a general audience, but can be equally compelling for artists interested in the opportunities thus afforded to redirect already rich or evocative histories. The double (and indeed doubled) appearance of a certain eighteenth-century teapot in two exhibitions that opened in 2003 could be taken as emblematic of this appeal. The teapot in question is not much to look at: an asymmetrical, bulbous pewter form with a simple wooden handle, it certainly would not stand out as an example of refined craft. Yet the tradition that it was owned by Crispus Attucks, an escaped slave who became the first revolutionary casualty when he was gunned down by British soldiers in the Boston Massacre of March 5, 1770, qualified the vessel for pride of place in an exhibition of New England antiquities. The circa 1740–60 artifact featured as the opening display in *Cherished Possessions: A New England Legacy*, a traveling exhibition showcasing 175 objects from the extensive collection of an institution now known as Historic New England (drawing upon a collection numbering over 100,000 objects in their storerooms and on display in historic houses maintained by the society).[32] And it made a second appearance, via plaster casts, in *Yankee Remix*, an exhibition based on inviting nine artists to create work inspired by the Historic New England collections,

11. Teapot that belonged to Crispus Attucks, Boston or England, 1740–60. Pewter and wood. Courtesy Historic New England.

which opened that same year at the Massachusetts Museum of Contemporary Art (MASS MoCA).

Historic New England's presentation, in the examples following the pewter teapot, tended toward the aesthetically exemplary, from elegant antiques to Bauhaus-era design, with the selections of paintings, photographs, sculptural objects, home furnishings, clothing, and jewelry including many items that could readily be described as art. Yet the narratives surrounding the material were consistent with a historical society agenda, emphasizing records of ownership (linked directly to subject matter in the case of portraits), and using those details as a springboard to make broader points about the social, political, and economic contexts of initial production and use.[33] The contemporary artists working from the collection were equally interested in the associated histories, but were not apparently drawn to objects that might, on their own, be received as art, choosing instead to build their works

in response to more eccentric selections of relatively mundane examples.

In her introduction to the MASS MoCA catalogue, curator Laura Heon emphasized Wilson's important precedent, with thematic connections particularly evident in Frano Violich's *Material Witness*, where cast versions of the Attucks teapot were incorporated in a multimedia response to his revolutionary martyrdom, and Lorna Simpson's *Corridor*, a paired film showing two narratives with a young African-American woman as the protagonist, one set in Historic New England's Coffin family house, originating in the seventeenth century, and the second in their 1938 Gropius House.[34] Strikingly, however, there was no consistent strategy or mode of response. Room-sized installations by Rina Banerjee, Huang Yong Ping, and Annette Messager echoed Wilson's strategy of working directly with historic artifacts—yet to different ends, as Huang's *Dragon Boat*, a newly constructed vessel filled with old trunks from the Historic New England holdings, amplified the theme of passage implied by their original function, whereas Messager's *Once Upon a Time . . . Four Stories* suggested alternate associations for rough-hewn cradles, beds, and tools, in tableaus that were made eerily uncanny by encircling animal forms being dragged around their perimeter by the a moving rope that also established a barrier between objects and viewer.

Zoe Leonard's *For Which It Stands* emphasized ordinary objects as well, but via their reproduction. Her assembly of thirty-two postcards, made from photographs taken by Leonard of collection objects and presented on a small rack in the center of the final room of the exhibition, was in some respects closest in scope to the showcase that the historical society organized from its own holdings, since the selections spanned several centuries. And there would have been no reason Historic New England's own exhibition couldn't have overlapped with Leonard's work, given her reliance on photographs. The objects that drew Leonard's attention, however, were more resolutely humble, even banal—though hardly random, given telling juxtapositions of guns, flags, bibles, and various images now recognized as stereotypes. Although she entered the process with the idea of selecting neutral utilitarian objects (rakes, hammers, pitchers, and the like), the material she encountered, set against the political climate of the time, caused her interests to shift, and she began to concentrate on objects she saw as "particularly American—each one symbolic of some aspect of the values, politics, self-image, or tradition of this country."[35] Her choices

12. Zoe Leonard, *For Which It Stands*, 2003. 32 postcards in open edition, steel postcard rack, plexiglass and wood money box. Postcards: 4" × 6"; rack 14" diameter, 72" high; money box: 40½" × 11½" × 8"; overall dimensions variable. Commissioned by SPNEA and MASS MoCA. Installation view courtesy the artist and MASS MoCA.

also tracked larger production shifts, with handcraft giving way to such familiar mass-produced objects as a paper Burger King crown, a 1970s GE microwave oven, a girl scout uniform, a boxed pair of Dr. Scholl's exercise sandals, or a Hood milk jug.

13. Zoe Leonard, *For Which It Stands*, 2003: individual postcards.

This unassuming miscellany somehow wound up in the Historic New England storerooms, and Leonard's decision to highlight that fact opens onto larger questions about why these objects and not others were extracted from cycles of consumption and obsolescence in the first place. While Leonard did not elaborate the objects' origins, her selection nonetheless drew attention to the paradox of the historical society's tendency to employ emblematic objects to typify daily life. Leonard's response also shifts the formula of the readymade—not introducing the quotidian herself, but rather drawing temporary attention to everyday objects that were already in a museum-type collection, yet likely to remain invisible without her decision to single them out by means of the equally unremarkable convention of a postcard display.

For some visitors, the card rack may have evoked the gift shops that spring up like mushrooms at the end of popular museum shows. For others, particularly those who found their way to the exhibition as part of a sightseeing trip to the Berkshires, there were certainly associations with tourism in general. Rather than being shoved between the hiking trail guides and the ranger station exit,

this lone postcard stand was isolated in the center of an otherwise empty gallery, within a museum devoted to contemporary art. Yet, despite a mode of presentation that emphasized the display's status as art, the postcards also fulfilled their traditional function, since they were available for 50¢ each. By using this familiar form, and including a payment box for those viewers who wanted to select from the display, Leonard brought together references to art, shopping, and tourism, thereby uniting key elements of the modern museum experience within the structure of the work, even as she also established an interactive situation that encouraged viewers to take away part of the art and continue their own process of collecting and juxtaposition.

In the context of Leonard's extended practice, this photographic act of assembly and dissemination—a photographic archive of already collected objects, destined to be further recontextualized by others—is continuous with a body of work informed by themes of obsolescence and transience, as well as a range of related approaches to the act of creation. A corollary to her photographic mining of humble historic objects is suggested by the array of used dolls that appeared in a 2000 exhibition titled *Mouth open, teeth showing* (the title taken from a category description used by doll collectors). In themselves, the individual examples would hardly have seemed worthy of attention were it not for the unexpected nature of their assembly, in a grid-based array that played the gendered character of the all-female dolls against the minimalist activation of space through their presentation in rows, standing directly on the floor. Thus the overall arrangement conferred a sense of significance greater than its unprepossessing components.

If the items in Warhol's collection gained value through their association with their former owner, Leonard made the process even more official by presenting her assembly as a work and selling it as such to Bill and Ruth True, who subsequently exhibited it at Western Bridge, their private-public exhibition space in Seattle. With the connection to the artist secure, the dolls are in no danger of being dismissed as a minor collection, akin to the thimbles Lawler highlighted at the Boston MFA. And once Leonard decided to transform the act of collecting into the creation of a work for public display, the assembled objects were no longer troublesomely plural, since they were transformed into component parts of a single entity. The fact that the work was then purchased for display

14. Zoe Leonard, *Mouth open, teeth showing*, 2000. 162 dolls, 45' 5" × 39';
as installed at Western Bridge. Courtesy the artist.

in a semi-public gallery indicates the distance separating both acts
of collecting (that of Leonard in assembling the work, and that
of the collectors who acquired the assembly) from the exclusive
relationship between collector and object assumed by Benjamin.

Works based on artifacts that already have a long history
prior to claims made upon them as art draw attention to various
different operations, artistic and otherwise. One is the associations
the objects may have for viewers, regardless of the artistic act—
resulting in connotations that can easily exceed the artist's conscious
consideration or knowledge, since they are based on the larger set
of cultural associations brought by others. The use of extant and
even already historical object puts the artist in the middle of a
relay, as he or she performs an act of interpretation through the
deployment of objects that are quite literally re-presented to the
gallery-going viewer. There are also crucial points of overlap with
many forms of collecting. As artists and collectors alike engage
in a self-conscious process of assembly, thereby laying claim to

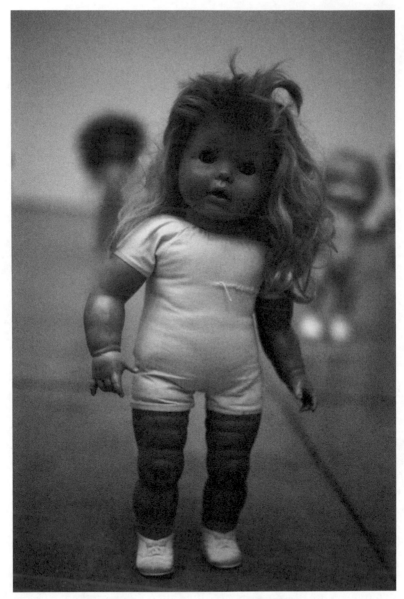

15. Zoe Leonard, *Mouth open, teeth showing*, 2000: detail.

phenomena that are not only already extant, but in many cases already collected, their overlapping operations raise interesting questions about what transpires when multiple narratives intersect, and potentially even collide.

Whose story?

David Wilson's Museum of Jurassic Technology has become a touchstone of sorts in museum literature, despite, or perhaps even because of, its indeterminate status. With its extended application of the rhetoric of objective description applied to an assortment of suggestively implausible exhibits, it presents a perfect foil for critiques of museum dynamics. In an extended account of his experience, Lawrence Weschler describes how his attempts to unpack this elaborate fiction were met both with a consistent earnestness (interpreted, interestingly enough, as a refusal to "break irony") and startling moments of historic or scientific verification for what Weschler was inclined to take as flights of fancy or invention. In particular, Weschler was amazed to confirm the existence of a certain African stink ant that can be infected by a fungus that causes both behavioral changes and the growth of a horn-like protrusion from the ant's head.[36] Yet the intermix of current scientific wisdom and fantastic extrapolation is hardly more far-fetched (depending on one's perspective, obviously) than the interpretation of biblical narratives underpinning the Creation Museum, which opened to major fanfare in Kentucky in 2007. There the massaging of scientific evidence required to put dinosaurs and humans on earth during the same era would certainly strike many as preposterous, but it is apparently accepted without irony by much of its target audience.

Not knowing exactly what one is looking at seems to be a fairly frequent condition of contemporary viewing. Is it art at all? The Museum of Jurassic Technology is a clearly authored construct, but it is not presented, at least by its creator, as a work of art. And, given the archival tendencies that appear with such frequency in contemporary art, how relevant are attempts to pin down the exact moments where fact-based constructions give way to flights of fancy? Distinctions between collection and archive are potentially

significant, given that the collection is much more likely to be identified with a particular individual (and subject to dispersal in his or her absence). The archive, whether one is discussing a particular repository or following Michel Foucault's use of the term to designate the entire system of knowledge at any given moment, is not authored in the same fashion.[37] This presumed anonymity has not, however, stopped artists from adopting archival forms as the basis for works of art—and indeed is in some sense its lure.

Ambiguity was very much part of the experience of *Mapping Sitting: On Portraiture and Photography*, credited as "A Project by Walid Raad and Akram Zaatari—Arab Image Foundation" when it was exhibited at New York University's Grey Art Gallery in 2005. Various display cases presented what appeared to be archival imagery, and the Arab Image Foundation in Beirut claims extensive holdings of professional and amateur photographs extending from the nineteenth century to the present. The exhibition in question highlighted four portrait types: passport and related ID photos, formal group portraits, "photo-surprise" images (candid shots taken

16. Walid Raad, *Studio Soussi portrait index, Saida-Lebanon*. 100 pages, ca. 150 portraits per page. 35 cm × 50 cm × 9.5 cm, collection FAI. ©Walid Raad. Courtesy Paula Cooper Gallery, New York, and FAI.

on the streets by photographers who then encouraged their subjects to purchase the results), and portraits by itinerant photographers. On the face of it, the degree of artistic intervention seemed relatively minimal, other than a video based on the photo-surprise imagery, with most of the photos presented in simple arrays. Yet Raad's extensive record of invented archival constructs inevitably invited extra scrutiny regarding whether this was indeed genuine historical material (not necessarily a bad thing). And alternately, accepting the material as minimally manipulated, standard-issue photo studio output raises another set of questions about the mechanism whereby attention from an artist known for archival fictions led to the presentation of actual vernacular forms in an art gallery context.

Raad's play with authorship has generally taken a different turn, with many of his individual efforts presented under the auspices of a fictional collective titled the Atlas Group. Nor does the material attributed to this source necessarily look much like art either. Although the overall context is Lebanon's recent wars, the purported documents often operate around the edges of this history. Under found documents, there is the low-resolution video attributed to Operator #17, purportedly a Lebanese security officer who, in the course of monitoring a seaside boardwalk in West Beruit via a remote security camera, chose to divert his lens to record each evening's sunset. Or there are the files of Dr. Fadl Fakhouri, an invented historian, whose contributions include still images (of medical office signs, or of whatever happened to be around at the many different moments when it seemed war had ended), as well as collages incorporating photographs of cars corresponding to makes and models used as car bombs. Yet, images showing where engines have landed in the aftermath of car bombs, brought together in *My Neck is Thinner than a Hair*, are culled from actual press archives. The mode of presentation is equally fluid, ranging from website to survey exhibition to a miniature museum (this last constituted by a comprehensive retrospective in the form of a miniaturized scale model).[38] Raad's double game points inward, via questions posed about the status of his plays with authorship, or the blurred line between found material and invention, but his fictions also return the viewer's attention outward, to the historical events from which they are extrapolated.

"Entanglement" is the term employed by Alessandro Balteo Yazbeck to describe his own equally hybrid process, moving from

research to often unexpected conclusions (manifest, for example, in his 2006 *UNstabile-Mobile*, based on his discovery of the pattern for a Calder-like sculptural construction in a map of Iraqi oil deposits). Once again, it was difficult to decide exactly what was on offer, under the title *pedacito de cielo (1998–2008)*, or "little piece of heaven," in a 2008 exhibition/installation at Harvard University's Carpenter Center. Presented, not coincidentally, in Le Corbusier's only North American building, the exhibition's subject was the play between geometric abstraction and modernist utopian aspirations in the artist's native Caracas during the 1950s through 1970s, a topic the artist explored through a combination of loaned

17. Alessandro Balteo Yazbeck, *pedacito de cielo (1998–2008)*, 2008. Installation view, Carpenter Center for the Visual Arts, Harvard University. Courtesy José Falconi.

objects and photographs. Borrowed or reconstructed works by Gego, Eugenio Espinoza, Gerd Leufert, and Antonieta Sosa were intermixed with documents relating to both art and architecture, including Carlos Raúl Villanueva's 1956 design of the Ciudad Universitaria de Caracas campus, now designated a UNESCO World Heritage Site.

Describing his role as "artist/curator," in relation to something he characterized as neither a solo nor a group show, but more of a collaboration, Balteo Yazbeck added a further wrinkle when he connected the project to the fact that his own educational background was steeped in European modernism, such that the Venezuelan context articulated through this research constituted a desired history, constructed in retrospect.[39] Even the work that was specifically his, two small mosaic pieces positioned on either side of one of Alejandro Otero's *Colorritmo* series, was fabricated from pieces of glass that had detached themselves from Otero's 1956 mural for the Ciudad Universitaria de Caracas (with other subtle plays evident in the visual echo between the *Colorritmo* and a Miguel Arroyo bench set on a low pedestal and dramatically lit, near a shelf with a book open to a page documenting damage to Otero's mosaics). The readings one might take from this project are both multiple and asymmetrical. With the evidence they presented of decay, the documents of Venezuela's modernist architecture gestured toward historical tensions surrounding and ultimately engulfing this utopian project. There was also an art-historical aspect, tracing a period of artistic experimentation that is increasingly well known, yet not fully incorporated into a narrative that still tends to be centered on US and European developments. And, drawing upon these multiple historical trajectories, the artist encouraged reflection on this period's contemporary relevance via the creation of a work that does not have a clear status as such.

"Why have curators lost the power to create art through the act of its exhibition," asks Boris Groys, "and why has this power passed to artists?" In contrast to the artist, who "has the privilege to exhibit objects that have not already been elevated to the status of artwork," if a curator exhibits a urinal, it will merely exist as an example, one that fails to be transformed from non-art into art by its display, and which will return to the world of everyday objects at the end of the exhibition.[40] Yet, Groys argues, this is a recent scenario, given the historic role of the museum and its attendant

curators in the redefinition of ritual or functional objects as works of art. In a further turn, however, he finds that the relatively new category of independent curator enjoys opportunities not available to museum-affiliated predecessors, traveling the world and organizing exhibitions "that are comparable to artistic installations, because they are the results of individual curatorial projects, decisions, and actions."[41] Something happens to the art that is subject to such maneuvers as well, since once the curator's vision prevails, the individual example has the potential to be reduced to the status of illustration or document within the larger project.

Massimiliano Gioni's *10,000 Lives*, for the 2010 Gwangju Biennale, was in many ways a perfect embodiment of Groys' analysis. Under a general rubric that emphasized the power of images (whether or not understood as art), Gioni assembled a mix that included works by prominent artists (some in turn based on forms of appropriation), documentary images, commercial photographs, and other artifacts. Pictures from the Tuol Sleng Prison in Cambodia, taken between 1975 and 1979 of people who were imprisoned and due to be executed, inspired Gioni to pursue "the idea of including other objects that are strictly speaking not artworks, but that I believe have an extraordinary intensity that needs to be preserved and shared."[42] A sustained documentary project of a different kind was evident in a series of photographs, spanning over sixty years, of Ye Jinglu, a Chinese businessman who sat for a formal studio portrait every year between 1907 and 1968. The result was an album that traces a single individual through years of remarkable historic change, and which owes its current visibility to its rediscovery by collector Tong Bingxue. Other assemblies where the identity of the collector competed with or overshadowed the creators of the objects themselves included a selection of Korean funerary sculpture from the collection of Ock Rang Kim and one of Warhol's time capsules, specifically number 27, which, rather than a more random accumulation, contained artifacts associated with the artist's mother.

It seems significant that these examples were already constituted as archives or collections before being selected by Gioni—and were therefore ordered, annotated, even to a certain extent authored, despite their lack of formal artistic attribution. Particularly telling in this regard was Gioni's inclusion of Ydessa Hendeles' 2002 *Teddy Bear Project*, a collection of photographs amassed by a

curator/collector who also owns many works of art by artists who have employed collecting or archiving strategies. In the case of Hendeles' own project, more than three thousand photographs, each individually framed, and displayed floor to ceiling in claustrophobia-inducing abundance, are unified by the appearance of a stuffed bear in some part of the image—and of course by the fact that they were hunted down and brought together by a single collector.

18. Ydessa Hendeles, *Partners (The Teddy Bear Project)*, 2002. Installation view, Haus der Kunst, Munich. Courtesy Ydessa Hendeles & the Ydessa Hendeles Art Foundation, Toronto. Photo: Robert Keziere.

Hendeles' tendency to curate her collection so as to incorporate the individual examples into a larger thematic construct was abundantly evident in the 2003 *Partners* exhibition that she organized for Munich's Haus der Kunst, where Hendeles combined objects with various kinds of authorship, juxtaposing works by a roster of contemporary artists with groupings of images by photojournalists, family snapshots, and found photographs—including *The Teddy Bear Project*. The installation also featured actual teddy bears, a rare metal wind-up toy of Minnie Mouse with Felix the Cat (collectibles owned by Hendeles), as well as an apparently sleeping

but in fact taxidermied dog that was a work of art by Maurizio Cattelan. These objects joined a variety of groupings, some created through repetition or by related thematics; others, such as works by Hanne Darboven and On Kawara, were inherently serial in their structure. Many of the juxtapositions also emphasized a subtext of twentieth-century violence that circled back, via a kneeling figure of Hitler by Cattelan, to the historic role of the Haus der Kunst as the institution that hosted the Nazi-era Great German Art Exhibitions. The accompanying exhibition catalogue likewise bore the imprint of a strong-minded curator-collector who used the forum to explicate her own response to an assembly of material notable for its diversity of authorship.[43]

In calling her own photo collections "projects," Hendeles has adopted an intrinsically ambiguous term already favored by artists for activities that may or may not be readily defined as works of art. Her carefully choreographed ensembles point to tensions embedded in art that plays with collecting or archiving found materials, particularly when that work is in turn assimilated into yet another collection based on an active interpretive agenda operating along similar lines. Clearly assemblies of vernacular objects presented by artists are only one manifestation of contemporary interest in this type of material. And it seems to be a natural extension that collectors and curators interested in works of art derived from vernacular forms may pursue their own agenda in the same area—with the result making it potentially difficult to distinguish between the activities of artists who function like curators in creating assemblies of objects or other material and the apparent inverse, a creatively inclined curator-collector.

During an earlier epoch of large-scale private collection building, paintings belonging to royalty were likely to be cut down or enlarged to suit the agenda of the assembly as a whole. While the physical object is hardly likely to be tampered with in a similar fashion today, there remains the issue of the interpretive context within which the artist's own declarations about the work share discursive space with other strong readings. The continued popularity of appropriation as an artistic strategy, as well as an ongoing enthusiasm for artist-generated museum fictions, therefore finds its corollary in the curator as author of a construct that interweaves works of art with other artifacts drawn from the larger realms of material or visual culture. Such assemblies, whether

long-term or temporary, do not efface the many previous (and often multiple) claims of authorship; rather, prior associations with groups of images or objects are incorporated into a new totality that is nonetheless posited as more than the sum of its parts.

Used paintings

Finally, in the midst of all these varied approaches to material culture, there is the matter of painting, as it was brought to the fore in a 2007 show at the Hispanic Society in New York. Wall after wall in the wood-paneled rooms usually devoted to the society's nineteenth-century collection were densely reinstalled with canvases belonging to a single individual. By a certain measure it was a collector with eclectic tastes, since the works varied greatly in the levels of skill and ambition they demonstrated. More striking, however, was the degree of sameness, since all depicted an identical subject. With the exception of a few quite literal reversals, all portrayed a single female head, painted in left-facing profile and draped with a red head covering, in front of a neutral, dark background. Numbering nearly three hundred, all were hand-made copies based on reproductions of a nineteenth-century painting by the French academic Jean-Jacques Henner depicting a fourth-century saint known as Fabiola. The unusual assembly undoubtedly presented a bit of a puzzle to the few visitors who came across it without forewarning. Most, however, would have known that they were encountering a project by the artist Francis Alÿs, in an exhibit co-sponsored by the Dia Art Foundation—even though this information is in itself far from sufficient to account for the issues raised by Fabiola's proliferation.[44]

The origins of Alÿs' large Fabiola collection date to 1992, when Alÿs noticed an odd coincidence in a Brussels flea market. Alÿs began his forays with the idea that he would assemble a nice group of major masterpieces through painted copies, but he instead happened upon two identical female profiles designated by the seller as Fabiola, and his quest was redirected: "Six months later I had acquired close to a dozen replicas of the veiled woman, whereas my masterpiece collection was still down to a couple of *Angelus* and a very laborious version of *Les Demoiselles d'Avignon*. Eventually

19. *Francis Alÿs: Fabiola.* Installation view, Dia at the Hispanic Society of America, New York, September 20, 2007–April 6, 2008. Courtesy the artist and Dia Art Foundation, New York. Photo Cathy Carver.

I swapped the Picasso for another *Fabiola.*"[45] Within the next two years he acquired 28, which he exhibited at Curare, in Mexico City in 1994. And by 2007, when the collection was shown at the Hispanic Society in New York, in a collaboration with Dia, it had grown to nearly three hundred examples, and it could have been exponentially larger still if he had been willing to include prints and other forms of mechanical reproduction alongside the handmade replicas.

Part of what Alÿs found striking was this demonstration of ongoing interest in a French academic painting that was obscure by art-historical standards. Harvested from flea markets around the world, the Fabiolas present inescapable evidence of popular traditions, even as the descent into the second-hand marketplace has stripped the individual objects of much of their specific history. The multiplication also indicates the importance of reproductions in the dissemination of the image, given the disappearance of the original painting by Jean-Jacques Henner sometime after it was exhibited in the 1885 Paris salon.[46] What's significant is the dominance not

only of painting, but painting as image making. Fabiola's mass reappearance indicates both her ongoing attraction for the faithful of many countries and the continuing significance of linked representational traditions that have charted their own course—not contesting the modernist framing of the twentieth century directly, but simply ignoring it. Equally noteworthy is the enduring practice of the painted copy, long after its apparent banishment from the artistic mainstream by the latter part of the nineteenth century. Even though the motif is based on a reproduction, the decision to paint evidently represents an opposing desire, in the midst of the mass produced, for all that the traditional, hand-made art form evokes.

In the case of the Fabiola paintings, it took the interest of an artist whose itinerant practice can far more readily be understood as an offshoot of conceptual and performance strategies to direct renewed attention, at the turn of the twenty-first century, to the history of Fabiola and her subsequent representations. As a result, paintings that might not be thought of as art on their own have gained renewed attention from an artistic project that itself might or might not have the status of a work. And to the extent that they have become more closely associated with Alÿs than with their original makers, these second-hand paintings raise the question of how much space really separates the traditional medium of painting from the twentieth-century legacy of the readymade.

Nor is Alÿs the only contemporary artist to be drawn to vernacular painting traditions. Many commentators have compared the process of exploration underpinning Alÿs' often open-ended activities to the deliberate aimlessness of the Situationist dérive, yet less attention has been paid to the connections that might be drawn to Asger Jorn's realization of the Situationist concept of détournement via crudely rendered insertions into second-hand paintings. Conceptually driven forms of engagement with popular practice or taste also include John Baldessari's *Commissioned Paintings*, made by "Sunday painters" asked to copy photographs of fingers pointing at everyday objects that Baldessari provided, and Vitaly Komar and Alexander Melamid's composite paintings resulting from their analysis of surveys of collective taste in different countries. These projects tacitly acknowledge the ongoing primacy of painting in the popular imagination, long after its critical and institutional dethronement in the contemporary art world.

The indefatigable interest that amateurs have retained in this medium (together with the varied results) is equally well represented by the collection that Jim Shaw assembled and exhibited under the title *Thrift Store Paintings*. This project arguably offers one of the closest parallels, with respect to object type as well as source, to Alÿs' Fabiola assembly; however, the vernacular painting that piqued Shaw's interest was not the obvious copy but, rather, earnestly undertaken portraits, animals, and multifigure scenes, as well as what might best be described as the amateur surreal. Shaw set himself a maximum price of twenty-five dollars, which did not seem to curtail his collecting activities, perhaps because he was generally uninterested in anything that seemed too skillfully executed.

20. Jim Shaw, *Thrift Store Paintings*, 1991. Installation view, Metro Pictures. Courtesy Metro Pictures.

Subsets can be identified, and there is clearly a certain aesthetic at work, which Shaw himself described as an initial pursuit of "ugly portraits or paintings that were unintentionally fucked up," as well as a general engagement with "slightly lurid" content.[47] Just over a hundred examples were shown in Los Angeles in 1990, and almost two hundred at the New York gallery Metro Pictures in 1991, with Shaw's own sizable compilation supplemented by loans from other

like-minded collectors. Notwithstanding the obvious connections to Shaw's other forms of artistic expression, the collection was not clearly defined as a work, nor was the exhibition for sale, despite its display in a commercial gallery.

It is not typical to refer to used paintings, in the way one speaks of other second-hand goods, but it would potentially be appropriate given how, in the almost century-long interval since Duchamp's provocative claim via the mass produced, we have somehow come full circle, to hand-made paintings as readymades. Paintings that may or may not be art are part of a spectrum that includes projects by artists that may not be works. The transformation initiated by Duchamp's readymade, and continued in a myriad of contemporary practices, involves a change of emphasis, away from the physical origin of an object, in favor of later acts of designation or recontextualization. In this process, the activities of making and collecting potentially converge, such that the work of art based on procedures of assembly and display may be difficult to distinguish from the collection as personal monument.

How do you keep your collection from being broken up? One strategy is to be so rich that you can dictate its disposition, via your bequest. Another is to be such a brilliant thinker that your environment will be preserved in your honor. For those lacking Gardner's wealth or Freud's genius, an alternate gambit might be to call it a work of art. Of course this stratagem is not so easily pulled off either, since there has to be some manner of sustained engagement to effect the turn from merely claiming that something is art, to its reception as such (long ago diagnosed by the founder of the readymade when Duchamp spoke of the "art coefficient" in the creative act, operating in the space between what the artist intends and the spectator perceives).[48]

Today's open-ended definition of artistic activity can stretch to encompass all variety of hybrid projects that might not otherwise have an obvious home. Yet the act of classifying a multivalent project as art can be a form of containment that safely allows wide-ranging references to be read at a secondary level, as a comment on the structure of communication itself. And when the work of art is based on the artist's own process of observation, the artist assumes an aspect of the viewer's role as well. In the process, objects are redirected via later choices, made by subsequent receivers, who may or may not be functioning as authors. Yet the fact that many

of the objects thus presented would have been unlikely to qualify for admission to galleries and art museums, in the absence of such artistic attention, has not diminished the importance of the artist. The idea that a work's value is based on an object's sure connection to an original moment of creation, tied to a particular place, time, and individual, has therefore given way to a far more paradoxical logic.

The practice of consumption as a form of production indicates the significance of reception in the process by which a work's identity is established. Artists who construct their work via collecting or assembly have in effect adopted institutional procedures as the basis for their act of invention—a turn on art as a museum practice that reveals deeply rooted overlaps between art making and institutional priorities. Creation that is based on a process of redefinition hints at potential malleability in the work itself, such that a continuing process of assimilation and interpretation plays an extended role in production that does not come to a punctual end with an artist's initial gesture. The possibility that the artist's act of selection will constitute a new interpretation of an already extent object points to a dynamic that remains in play, as later audiences continue to bring new readings to work already founded on that very process.

Who gets to claim the status of artist, and which of the artist's activities are defined as art? Artists and non-artists alike seem to be busy collecting a great variety of objects. The shift from artist *and* collector to artist *as* collector may seem slight, yet the space between those descriptions opens onto many other points of potential overlap or slippage suggested by such related composites as artist-curator, or collector-author. The play with already extant objects calls attention not only backward, to their previous history, but also forward, to an ongoing exchange between consumption and production taking place both within and beyond an evolving definition of the work of art.

CHAPTER 3

Kaprow's vector

Ruminating on Jackson Pollock's legacy, following his death in 1956, Allan Kaprow was both elegiac and subversive. Looking past Pollock's elaborate surfaces, and the modernist readings they inspired, he focused on the process of creation, presciently finding, through his identification with the act of painting by an artist who famously worked "in" his canvas, the dissolution of modernist categories, and indeed art as a distinct sphere of activity in general.[1] During the years that followed, Kaprow's unfolding critique of art and art-making took him ever further away, first from the object, then from events that might devolve into spectacle, and finally from almost anything understood as a bounded activity, much less as art presented for static display.

Some fifty years later, and shortly after Kaprow's own passing, a traveling retrospective of Kaprow's work presented multiple strategies for dealing with his evasions, essentially circling around work that remains elusively beyond the museum's grasp. Voluminous documentation appeared in rows of horizontal display cases, supplemented by films or videos generated as part of the happenings and other event-based work. Many happenings were reinvented, with new versions scattered throughout each community. Within the museum walls, Kaprow's lifetime insistence that his environments change as his own concerns evolved was carried on by turning them into collaborations with curators or other artists who took up the process of transformation. "Look at the documentation and reinvent the pieces" was Kaprow's charge to later generations, as recounted by Paul McCarthy.[2]

1. Allan Kaprow, *Yard*, 1961, reinvented for *Allan Kaprow—Art as Life*, Van Abbemuseum, Eindhoven, 2007. Courtesy Allan Kaprow Estate and Hauser & Wirth.

2. Allan Kaprow, *Yard*, 1961, reinvented for *Allan Kaprow—Art as Life*, Museo di Arte Contemporanea di Villa Groce, Genoa, 2007. Courtesy Allan Kaprow Estate and Hauser & Wirth.

The gap between the documents in the display cases and the reconceived environments was in some sense a brilliant demonstration of the divide separating the museum's early twenty-first-century audience from these historically important works originating during the previous five decades. The split reflected a desire to be true to two conflicting agendas—a devotion to points of origin, and respect for the stated philosophy of an artist dedicated to thwarting this archival impulse. Seeing contemporary artistic interpretations of such key works as the 1960 *Apple Shrine*, 1962 *Words*, or 1963 *Push and Pull* (the last already an oblique homage on Kaprow's part, indicated by its subtitle *A Furniture Comedy for Hans Hofmann*) made for an interestingly diverse experience, but radical reinventions also willfully frustrate the retrospective desire that exhibitions of this sort usually fulfill.[3] The result was a survey that not only presented new and potentially unexpected versions of historical works, but one where the different venues all had their own character, based on how the works were conceived for each site.

The restaging of Kaprow's 1959 *18 Happenings in 6 Parts* was the odd exception to the rule, meticulously re-enacted in accordance with the documentary record (and with the literal remake justified by the existence of this detailed documentation).[4] A new viewing public had the opportunity to witness a studied attempt to channel the consciously anti-theatrical gestures of an earlier avant-garde, and the experience, at least to this member of the New York audience, indicated a double removal: the viewers were separated from the performers in a way Kaprow would later reject for his participatory happenings, plus the entire event generated an acute awareness that, through the restaging, even the spectators were playing a role in a revival production. One learned from the remake, as one would learn from reconstructing the scene of a crime, but there was no going back, no way to experience as new an event so thoroughly historicized (a problem Kaprow certainly recognized). The happening also had a greatly expanded audience for its multi-city tour, playing to many sold-out houses, as opposed to the spotty attendance suggested by empty seats visible in some of the photos from the original 1959 event.

Kaprow's prescience, in his essay on Pollock, about the breakdown of distinctions between different forms of artistic activity, was accompanied by an equally sharp appreciation of

the contradictions inherent in operating across the boundaries between art and everyday life. Where art has imitated life, its historical significance has the potential to set up the reverse: "All snow shovels in hardware stores imitate Duchamp's in a museum" was Kaprow's assessment by 1972.[5] And Kaprow recognized an inherent contradiction running through the work of his contemporaries in the 1960s and 1970s, as "those who consistently, or at one time or other have chosen to operate outside the pale of art establishments ... have informed the art establishment of their activities."[6] While he saw a debt to Marcel Duchamp's readymades as part of the history his happenings shared with later conceptual art, earthworks, and body art, he did not necessarily employ the same strategies to convey the work.[7] In fact Kaprow became increasingly suspicious of the relay function of photography, whether as a stand-in for the otherwise ephemeral or a template for its reconstruction.

The retrospective was hardly the first time that Kaprow's work had been remade, however, meaning that he actually had many opportunities to develop tactics to frustrate the impulse to produce simulations of non-repeatable situations. Such strategies are also bound up in his sustained critique of the museum; yet Kaprow's insistence that his early environments not simply be remade, as interest in his work grew, meant that he remained deeply enmeshed in a dialogue with museum curators. His insistence on an open-ended conception of production also draws attention to the related issue of how a work's ongoing history shapes our reading of what we take to be qualities inherent at its point of origin. There is a great deal to be learned from the saga of *Yard* during the four decades immediately following its initial 1961 appearance, as Kaprow's life-long insistence on his own process of reinvention yielded multiple versions of a work that nonetheless continues to be identified by later audiences with the photographic records of its initial installation.

Photographic memories

There can be little question that Kaprow's 1961 environment called *Yard* is now firmly ensconced in the history of the postwar

avant-garde, with this early installation by an artist who was a central figure in the development of happenings significant both for his use of everyday materials and his efforts to encourage audience participation. Yet there are many assumptions operating in the presumed familiarity the work enjoys, including what it means to base our understanding of this ephemeral installation

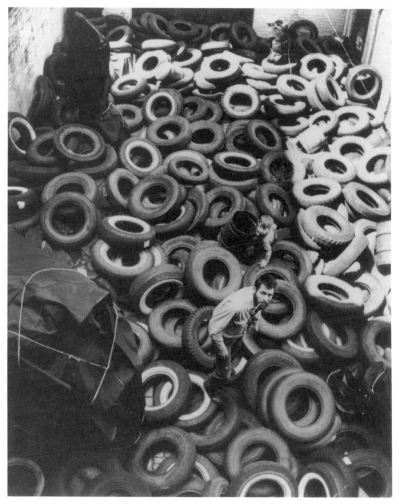

3. Allan Kaprow, *Yard*, 1961. Courtesy Allan Kaprow Estate and Hauser & Wirth. Photo: Ken Heyman, licensed by Woodfin Camp Associates.

on the evidence provided by an extensive series of photographs of the environment that Kaprow created in 1961, how *Yard* achieved its status as one of Kaprow's best-known works, and the identification of *Yard* with the 1961 configuration given Kaprow's commitment to refashioning the work for its appearances in subsequent exhibitions. It is therefore crucial to examine both the role of the photograph in allowing Kaprow's subsequent audience partial access to a work tied to a particular place and time, and the operations of authorship over the work's extended history.

Despite, or perhaps even because of, his suspicions about the impact of photography as well as the entry of the work into the context of the museum, Kaprow's ongoing engagement with both draws attention to how the circulation of reproductions helps secure the identity of a work through various physical configurations. This key example suggests some of the potential issues in play as now canonical site-specific, performance-based, or otherwise ephemeral works of the 1960s become part of a retrospective project. Specifically, the ongoing history of *Yard*, which can be traced through the process of definition suggested by publications and exhibitions subsequent to the *Yard*'s initial appearance in 1961, demonstrates important tensions in the work's historicization, as well as its life-long connection to Kaprow. The fortunes of this environment also point to a broader series of questions about the shifting significance of an avant-garde gesture as it moves from relatively humble initial statement to canonical status, drawing attention to operations that may be less noticeable when associated with the assumed continuity of a self-contained physical object.

For ephemeral activities or environments, a diverse array of information may be employed in the retrospective reading of the work by an audience not present for the initial gesture. Such material can include plans for the work, supplementary data prepared for the initial audience, photographs and other audio or visual records of ephemeral events or arrangements, retained physical elements (for example, the encased relics preserved from Chris Burden's early performances), the artist's own statements, and accounts by others recollecting the experience. Brian O'Doherty, who also paid early attention to the far from neutral dynamics of the "white cube," has asserted that "avant-garde gestures have two audiences: one which was there and one—the rest of us—which wasn't." This "original

audience," he continues, "is often restless and bored by its forced tenancy of a moment it cannot fully perceive," and therefore "in advance of itself," in relation to a work completed through memory or rumor, and with the aid of photographic evidence, years later.[8]

The dynamic at play received a telling demonstration in Silvia Kolbowski's 1998–9 video installation, *an inadequate history of conceptual art*, where viewers encountered an out-of-sync juxtaposition, in adjacent rooms, of video images of speakers' hands and audio descriptions of striking encounters with a range of ephemeral works. The 22 artists thus recorded were requested to present their recollections without mentioning either their own names or identifying information associated with the works they described, and they were also asked to rely completely on their memories, rather than research. Thus Kolbowski, while holding onto her role as artist, annexed research methods associated with history and criticism. Yet the obvious inadequacy indicated by the title— particularly evident in the vague or tentative descriptions—drew attention both to the obvious limitations of eye-witness reports

4. Silvia Kolbowski, *an inadequate history of conceptual art*, 1998–9. Video loop, 55:00; Sound loop, 1:59:59. Courtesy the artist.

and the inherent fallibility of the memories thus recounted.[9] At the same time, the descriptions do have the power to convey a sense of scope or duration, in potential contrast to the impression of a frozen moment potentially conveyed by photographic images.

The promulgation of the work through a few iconic images can help erase rough edges that might seem goofy or amateurish to an initial audience. And of course the photograph is likely to play havoc with more inchoate memories, a process familiar to anyone whose recollections of the open-ended experience of a trip are first reorganized around, and eventually reduced to, little more than the evidence provided by a haphazard collection of tourist snapshots. The memory of seeing any work of art, with the full variety of effects discovered in its physical presence, may be gradually corrupted by the introduction of the reproduction—a potentially reversible process for art that one can revisit, and a more definitive reduction for one's recollection of the ephemeral. Taking the implications of this process one step further, Mignon Nixon makes a provocative connection, in her analysis of the dynamics of unconscious desire she finds in Kolbowski's *inadequate history*, between strategies associated with conceptual art and the role of the screen memory—that photo-like image that can so convincingly provide evidence of an event that may or may not have even occurred.[10]

The increasing popularity of the happenings during the 1960s forced Kaprow to consider the danger of their transformation into spectacle, evident not only in sometimes sensational media coverage, but also in the impact of documentation on the event itself, as the temptation to act for the camera externalized the experience of the immediate action.[11] Recording devices were allowed to remain only if they were integral to what was happening, with photography incorporated, for example, in his 1968 *Transfer*, as participants posed with stacks of barrels that were successively painted and moved from site to site, or, from that same year, in *Record II*, as university students in Austin, Texas, interacted with the rocks in a quarry and then circulated photographs of the activity the next day. Taking a different tack, the staged photographs used as illustration for his 1975 publication *Air Condition* (which evoke the intervening conceptual engagement with the snapshot) function as instructions rather than records in the context of increasingly low-key and often private activities that, once realized, are known through the fragmentary verbal accounts or "gossip" that Kaprow

turned to in the place of the false transparency of other forms of documentation.[12]

Step right in

Yet that would all come later, not at the time of the initial appearance of the happenings and environments during the late 1950s and early 1960s, but as Kaprow became known for such work. So it is important to look back to the earlier moment when *Yard* was first created in a courtyard adjoining the Martha Jackson Gallery as part of a 1961 exhibition entitled *Environments, Situations, Spaces*. This was the third in a group of exhibitions that broke with Jackson's established focus on contemporary painting in order to showcase experimental work incorporating a wide variety of materials—and it thus brought art more commonly associated with downtown venues to a gallery operated out of a town house on New York's upper east side. *Environments, Situations, Spaces* was preceded by two 1960 exhibitions entitled *New Forms—New Media* 1 and 2, which brought together a range of assembled constructions. Kaprow was represented in the first 1960 exhibition with a collage-based work; and he was also present as the author of a short catalogue essay, "Some Observations on Contemporary Art," where he anticipated the possibility that "These agglomerates may grow, as if they were some self-energized being, into rooms-full and become in every sense of the word environments where the spectator is a real part, i.e., a participant rather than a passive observer."[13]

Kaprow had by this time already produced his first environment at the Hansa gallery in 1958, but with *Environments, Situations, Spaces* this ambition was realized in the context of a group endeavor that required the gallery space to be divided into different areas and handed over to the six artists who participated in the 1961 show. Not only did Kaprow fill the entire space of the courtyard behind the gallery, but he temporarily swallowed up the more traditionally modernist sculptures already on the site (later identified by Kaprow as works by Barbara Hepworth and Alberto Giacometti), which, hidden behind protective coverings and tied up like packages, remain visible in photographs only as an amorphous

presence punctuating the sea of tires.[14] In addition to Kaprow's *Yard*, the 1961 exhibition included an untitled installation by Robert Whitman, Jim Dine's *Spring Cabinet*, a work by Walter Gaudnek called *Unlimited Dimensions*, George Brecht's *Iced Dice* (a realization of his *Chair Events* score), and an early version of Oldenburg's *Store*, with the various painted reliefs hung close together along a wall in a configuration that Oldenburg described as "a kind of mural," in contrast to the full environment he would create in the subsequent and better known version of the *Store* that opened downtown later the same year.[15]

This 1961 exhibition has been described as important, radical, even a landmark. Yet at the time it was part of a rather brief digression in the programming for this particular gallery that inspired relatively short and indifferent descriptions by the few critics who saw fit to review the show, and a response of a rather different kind by a neighbor who (either not recognizing the tires as art, or not caring) lodged complaints that forced Jackson's nephew to go to court to contest the resultant fine.[16] The only review in the art press was Jack Kroll's paragraph in *Art News* on this exploit by the "Happening Boys," whom he related to Gregory Corso and Yves Klein, but deemed regressive by comparison.[17] And none other than O'Doherty, writing about the exhibition for the *New York Times*, might have been illustrating his later hypothesis about delayed understanding with a description of incomprehension that included his failure to find information identifying the artist responsible for "what looks like candy wrappings removed from gigantic toffees, and strung up on thick, inelegant strings" (presumably Oldenburg's *Store* mural), and no indication that he was even aware of the tire-filled courtyard.[18]

Nonetheless, for Kaprow *Yard* was a work that he would later term a "signature" piece—with evidence of its importance for him suggested by its well-known juxtaposition in his 1966 book *Assemblage, Environments and Happenings* with a photograph of Pollock in the act of painting—a pairing that creates a visual echo of the arguments he had outlined nearly a decade earlier in his essay "The Legacy of Jackson Pollock." Moreover, the prominence of the work is certainly due in large part to the extensive series of installation photographs by Robert McElroy and Ken Heyman from which the images in the book were selected. *Yard*, as known through these photographs, has been contextualized, in retrospect,

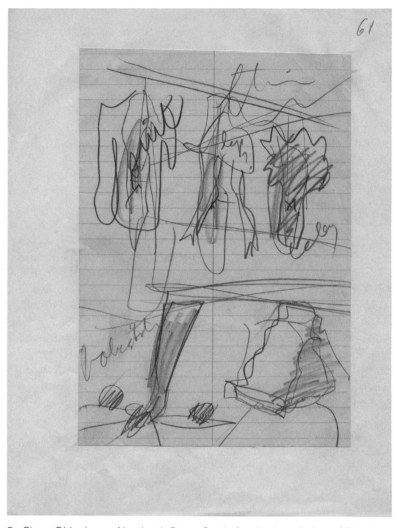

5. Claes Oldenburg, *Notebook Page: Study for the Installation of The Store at the Martha Jackson Gallery, New York*, 1961. Pencil on steno paper, 8⁷⁄₁₆″ × 5⅞″ on sheet 11″ × 8½″. Collection Claes Oldenburg and Coosje van Bruggen. © 1961 Claes Oldenburg.

as one of a key series of environments that opened onto Kaprow's articulation of the happening. And Kaprow's attention to securing *Yard*'s renown is consistent with a kind of avant-garde professionalism already evident in conjunction with the 1959 *18 Happenings in 6 Parts* at the Reuben Gallery, with its controlled choreography of an audience dotted with art-world notables.[19] Accounts of a disagreement between Kaprow and Oldenburg around the time of the Jackson Gallery exhibition present another demonstration of the perceived stakes in the sometimes competing attempts to define the emerging aesthetic forces of the period.[20]

Given Kaprow's later ambivalence about photographic documentation, it is worth considering the structure of *Assemblage, Environments and Happenings* with respect to the role of the photograph generally and its presentation of *Yard* in particular. The book is divided into three sections, the first, beginning without front matter or preamble, with a succession of over a hundred photographs devoted mainly to environments and happenings by Kaprow and others. The sequences of photographs in the first section are punctuated by different combinations of all black or white pages, as well as pages with just a dot in the center, and Kaprow orchestrated the photographs with rather cryptic words or phrases in a much more prominent type than the small captions that identify each image. Not until the second section, Kaprow's text, does one encounter a title page and publication information; and the survey text is followed by a third selection of more than forty individual happenings presented through a combination of photographic documentation and various text-based scripts, scenarios, or instructions.

Within the first section, it is only after the twentieth page that Kaprow presents, under the heading "Note on the Photographs," a couple of short paragraphs about the overall structure, beginning "Photographs of art works have their own reality and sometimes they are art in turn. Those taken of the subject of this book tend to be particularly free. They refer to their models, but strangely, as would a movie taken of a dream, stopped at unexpected intervals." Their order is not chronological, but rather, he suggests, one that will inspire reverie.[21] *Yard* makes its appearance in the conclusion to the first section, as part of a progression, following the last all monochrome break on pages 128 and 129, that builds up to the tire environment through a number of other works that could be

described as thematically or materially related. This final sequence begins with a page spread that juxtaposes George Segal's 1962 *Bus Driver* and Oldenburg's 1961 *Foto-Death* happening. Next, two views of Jim Dine's 1960 *Car Crash* appear adjacent to a view of Oldenburg working on his *Store* (captioned as environment in progress). These are followed, in succession, by Kaprow's 1962 *Courtyard* happening (with it swinging tire) on two pages; then *Courtyard* again, opposite Robert Rauschenberg's 1959 *Monogram*; Dine's *Car Crash* again (this time in rehearsal) opposite the first appearance of *Yard*, in a photograph that presents Kaprow himself front and center; then *Yard* again, with Kaprow throwing one of the tires, together with another view of Oldenburg working on *Store*; the well-known juxtaposition of Pollock at work (labeled in the caption as "environmental painting") with *Yard*, again, this time including Kaprow and his son; and, as the final image in the book's first section, *Yard* for the last time alongside the back of the first page of the text section, which is set off by a black dot as well as the brown paper used for that part of the book.

A second invitation to step right in (repeated from the opening pages of the book) takes the reader into the text section. But it

6. Allan Kaprow, page spread from *Assemblage, Environments and Happenings*, 1967. Courtesy Allan Kaprow Estate and Hauser & Wirth. Photo of Jackson Pollock painting by Hans Namuth, 1950, ©1991 Hans Namuth Estate, licensed by Center for Creative Photography; photo of *Yard*, 1961, by Ken Heyman, licensed by Woodfin Camp Associates.

also appears, tellingly, below a photograph of *Yard* that has a compositional structure familiar from certain German romantic paintings, where a foreground figure seen from behind encourages us to identify with the act of viewing—though of course with the twist that what we are thereby encouraged to experience photographically is an environment meant to be entered and actually completed through participation rather than disembodied sight. In fact, the black and white photographs of *Yard*, seemingly more than similar documents of the happenings, promote the illusion that one can understand the work through these visual records—along with the assumption that we are indeed talking about a work with a continuous identity. "In answer to their appeal, the plastic arts have produced their printing press," wrote André Malraux in a description of how sculpture is more likely than painting to be conveyed effectively by black and white photographs—a point that seems to apply equally to an understanding of the impact of the photographs of *Yard*.[22] This environment clearly partakes of sculpture's susceptibility to the photograph, despite a quite literal effacement of the more self-contained exemplars already in the courtyard.

While Kaprow's increasing fame as the originator of the happening would undoubtedly have ensured attention to his environments, it is also evident that Kaprow, as the author of the history presented in *Assemblage, Environments and Happenings* through images and words, took the opportunity to consolidate the importance of an early environment and therefore to ensure it a presence not immediately secured by its initial physical form in 1961. It is equally striking how Kaprow used his selection of photographs to support the case he had already laid out with the 1958 publication of "The Legacy of Jackson Pollock." There Kaprow's description evokes both his experience of Pollock's early exhibitions and the power of Hans Namuth's photographs of the painter in action: "I am convinced that to grasp a Pollock's impact properly, we must be acrobats, constantly shuttling between an identification with the hands and body that flung the paint and stood 'in' the canvas and submission to the objective markings, allowing them to entangle and assault us."[23]

Kaprow's lesson took the form of a prediction of a different kind of art: "Pollock, as I see him, left us at the point where we must become preoccupied with and even dazzled by the space and

objects of our everyday life, either our bodies, clothes, rooms, or, if need be, the vastness of Forty-second Street."[24] And, looking back ten years later, he reiterated the idea of the emergence of his own and related practices from abstract expressionism, suggesting that the "preponderance of fragile, soft, and irregular materials" in early environments and settings for happenings were an outgrowth of the "sprawling, limitless impulses" of the earlier movement.[25] It is therefore significant that Kaprow's book presents a comparison between a photograph of Pollock in action, within the space defined by the horizontal canvas before it goes up onto the wall, and a photo of an environment meant to be entered that shows Kaprow himself as participant. Whereas the possibility of entering into the horizontal canvas was, with rare exceptions, Pollock's alone, Kaprow was occupying a position that he envisioned for others. Yet the historical distance gives them a greater equivalence, in the impossibility of experiencing either position other than through an imaginary traversing of the photo.

What the identification of this work with the series of 1961 installation photographs masks is the degree to which Kaprow defined *Yard* and his other early environments as ongoing works that he insisted upon reconsidering each time they were exhibited. To the extent that *Yard* was not fully appreciated at first, only gradually achieving its status as a "signature piece" for Kaprow, it can be understood against many other tales of initial incomprehension later replaced by close attention and high regard. In this familiar story, the work is understood differently by successive audiences, with its acknowledged significance transformed by subsequent readings. Yet Kaprow's *Yard* presents an added element, in the form of an environment that has been realized at a number of uneven intervals, and one where both interpretation and physical configuration alter over time. Indeed, *Yard* is not simply a 1961 work, but an environment with a surprisingly extended history that spans five decades and three continents, with reappearances in contexts that include solo shows, thematic exhibitions, and retrospective surveys. While all of these reinventions provide important indications of Kaprow's evolving thought process, there is a certain culmination point in the version realized for the 1998 *Out of Actions* exhibition at the Los Angeles Museum of Contemporary Art, when Kaprow's insistence on reinterpretation was argued explicitly in the correspondence between artist and curator.[26] Yet,

even before the MOCA exhibition, Kaprow had already created nine earlier versions of the work, each under somewhat different circumstances.

Yard, redux

The first reappearance of *Yard* was in a survey of Kaprow's work organized by the Pasadena museum in 1967 (thus one year after the publication of *Assemblage, Environments and Happenings*)— with the familiar image of Kaprow and his young son peering up from the sea of tires featured both on the cover of the catalogue and on a two-page spread where it was juxtaposed with the image showing the participant's back in the foreground. Kaprow declared his ambivalence about this museum project with a statement on the third page of the catalogue in which he associated the museum with a "reek of holy death," even as he acknowledged its practical function, in the absence of other "agencies or means for otherwise making art accessible to the public." He also indicated a plan to "camouflage the museum environment as much as possible," which he achieved at the Pasadena museum in part by having the walls covered with tar paper.[27] And it was on the occasion of this exhibition that he produced his last major happening, *Fluids,* for which he used the museum as an agent to create an off-site work in the form of large-scale rectangular ice constructions built and left to melt at various sites throughout the region.

The Pasadena exhibition therefore marks the point when *Yard*'s identity began to bifurcate, with Kaprow involved in its ongoing permutations as he reconceptualized the work for different venues, even as it continued to be known largely through the same set of fixed historical images. Moreover, the Pasadena catalogue structure is repeated in many subsequent publications, where the work included in the exhibition is reconfigured to varying and sometimes radical degrees even as the environment is reproduced, both in the catalogue and many press accounts, with the 1961 installation views. This temporal lag reflects the logistical difficulty of documenting a work made on site for publications that are prepared in advance, but the practice also contributes to an overall

tendency to revert back to the 1961 photos as a basis for defining the work.

After 1967, *Yard* moved overseas for the 1971 *Happenings und Fluxus* exhibition in Cologne, with its configuration hinted at by a drawing used as a wrapper for the exhibition's checklist, followed by its inclusion in a 1981 exhibition called *Schwartz* in Düsseldorf, and *Kunst wird Material* in West Berlin in 1982. Then in 1984 it appeared in New York for the Whitney Museum's *Blam!* exhibition, where the early importance of the Jackson Gallery show was affirmed by the inclusion of five of the six artists from *Environments, Situations, Spaces* as key players in the now historical story of the transition from pop to minimalism. In addition to *Yard*, for which Kaprow took advantage of the basement well of the Marcel Breuer building to create a confined piling of tires with strong visual similarities to the original courtyard configuration, the exhibition included a version of Oldenburg's *Store* where the now-valuable objects loaned from various individual and institutional collections were set up in a partial approximation of the storefront installation, as well as examples of works by Brecht, Dine, and Watts that were either borrowed or newly reconstructed for the exhibition.[28]

For another exhibition only two years later, a 1986 survey of Kaprow's work at the Museum am Ostwall, Dortmund, *Yard*'s new configuration was uncharacteristically reproduced in the catalogue, presumably thanks to the flexible publication format offered by its loose-leaf binding—though even here the new version was in a supplement at the end, secondary to the 1961 installation shots in the body of the text. After that it turned up at a 1990 biennial in Sidney, organized around the theme of the *Readymade Boomerang*, where Eleanor Heartney described how its location, visible from the gallery through plate-glass windows, emphasized "a certain Minimalist elegance of the tires and their arrangement."[29] And the very next year, on the occasion of the 1991 *7 Environments* in Milan, *Yard* underwent its most radical transformation, with the pile of used tires and oil barrels replaced by orderly racks arranged in front of hot pink walls, and a Fiat parked square in the middle.

Kaprow took the occasion of the 1991 survey of his environments to create new versions of other such often reproduced environments as *Apple Shrine* and *Push and Pull* in forms that bore an equally tangential *visual* relationship to their initial

7. Allan Kaprow, *Yard*, 1961, reinvented for *7 Environments*, Fondazione Mudima, Milan, 1991. Courtesy Allan Kaprow Estate and Hauser & Wirth. Photo: Jeff Kelley.

presentation. The series of shifts, Jeff Kelley suggests, conveys an acknowledgment of the intervening three decades, as "bohemian street junk was replaced by synthetic materials and standardized, easily consumable units; cardboard, chicken wire, broken glass, and tar were largely supplanted by rolls of carpet, etched glass, sheets of plastic, and walls of silk."[30] Some of the material differences were inevitable, and point outward, to the shifting time and place within which each installation was realized (for example, the use of a smaller Italian tire, in contrast to the American castoffs with which the work was initiated), and others might even be considered within an expanded definition of style. Kaprow's 1991 interpretation of *Yard* presented a very different aesthetic of arrangement; yet it does retain an element of viewer interaction, with the 1961 possibility of tossing about the randomly piled tires replaced thirty years later by an absurd version of a more practical act, that of attempting to change a tire on the immobilized Fiat jacked up in the middle of the surrounding racks. At the same time, evidence of the visual distinction between the first versions of the environments and Kaprow's 1991 conceptualization was provided

by blown-up photographs of the initial configuration, such that, in *7 Environments*, the juxtaposition of the photographs and reconfigured 1991 installations brought into the exhibition itself the contrast usually present between catalogue and specific example.

It is also evident, from the correspondence relating to the appearance of *Yard* in the 1998 *Out of Actions* exhibition, that the obvious contrast between the 1961 photographs and the 1991 configuration of *Yard* was giving Paul Schimmel nightmares as he tried to organize a retrospective survey of performance-based practices—and therefore wanted to include the work familiar from the initial installation views that ensured its historical significance. What Schimmel most decidedly did not want was something like the version of the work in Italy, which, in his assessment, "looked like a car repair shop."[31] After much back and forth, what emerged was a free-standing configuration, encased by a chain-link fence enclosure erected in the parking lot in front of MOCA's Geffen Contemporary building, with audience participation incorporated via the invitation to enter as well as climb over the low fences separating the interior spaces.

8. Allan Kaprow, *Yard*, 1961, reinvented for *Out of Actions*, Museum of Contemporary Art, Los Angeles, 1998. Courtesy Allan Kaprow Estate and Hauser & Wirth. Photo: Alex Slade.

Kaprow's insistence on reconceptualization therefore introduced an added element in what was an already complex process of historical definition, as the work's reception history is inescapably intertwined with Kaprow's own process of reinterpreting his early gestures. Yes, *Yard* is a work that can be dated to 1961 and viewed as an outgrowth of the environments and events Kaprow had begun establishing in the late 1950s; and it is a work with an evolving existence that continues through its subsequent reappearances. But *Yard*'s later fame is also closely tied to its fortunes in 1966 and 1967, the years, respectively, of Kaprow's major book publication and the beginning of *Yard*'s museum career. In this regard, the process of definition that takes place retrospectively, after the work's initial appearance, intersects with and has to be understood as inflected by ideas articulated in the second half of the 1960s, including theories of authorship and, in the context of conceptual art, the expansions of artistic practice to include such secondary realms as archivist, critic, or historian.

Along the way

If the establishment of *Yard* as one of Kaprow's significant works can be dated not just to its initial appearance in 1961, but also to 1966 and 1967 as key years for the retroactive process of securing the work's importance, then it is equally important to consider the work's ongoing fortunes in relation to this slightly later historical moment. There would, of course, be countless ways one could take on this expanded task of contextualization, but one suggestive point of entry is provided by *Aspen*, "the magazine in a box," which was conceived as a kind of time capsule by publisher Phyllis Johnson. Kaprow makes an appearance in issue 6A, the performance art issue edited by Jon Hendricks and published in the winter of 1968–9, via a typescript of the instructions and notes for his 1963 *Push and Pull: A Furniture Comedy for Hans Hofmann*. But in many respects issue 5+6 from fall–winter 1967, which was billed as the minimalism issue and edited by none other than O'Doherty, provides a more suggestive backdrop, with critical and poetic texts, audio recordings, film clips, documents, and even the component parts for one do-it-yourself sculpture in a provocative

intermix that testifies to the editor's by then significant immersion in the avant-garde dialogue of the mid-1960s.[32]

One of the interesting issues raised by Kaprow's ongoing refashioning of his earlier work is the relationship of that trajectory to his renunciation of new work of the same kind. "Once, the task of the artist was to make good art," he asserts in the opening of his "Manifesto" of 1966; "now it is to avoid making art of any kind." As it happens, the main text section of *Aspen* 5+6 included an essay by Susan Sontag, "The Aesthetic of Silence," that addressed how the act of renunciation, in the examples of Rimbaud, Wittgenstein, and Duchamp, "imparts retroactively an added power and authority to what was broken off." She also cites John Cage to the effect that "there is no such thing as silence," and indeed Kaprow's later career, like that of Duchamp, shows ample evidence of the extensive activity that may indeed be hiding behind an ostensible renunciation.[33] The artist's own involvement in the further refashioning of earlier work is but one way that the act of making becomes enmeshed in what otherwise might be understood as secondary forms of contextualization. Kaprow would later refer to Duchamp's claim that the "creative act is not performed by the artist alone," and also credit Duchamp's influence for the development, particularly in the context of conceptual art, whereby "critical discourse is inseparable from whatever other stuff art is made of."[34]

Duchamp originally articulated the idea of the "art coefficient" in his 1957 statement "The Creative Act," a declaration which reappeared in this issue of *Aspen*, together with a selection from *A l'infinitif*, as a floppy phonograph recording of Duchamp reading these texts. Moreover, the same text section as Sontag's essay also included the first English language appearance of Roland Barthes's "Death of the Author," with its critique of the idea that an explanation of the work can be found in its producer, in "the voice of a single person, the *author*, 'confiding' in us."[35] The format of Duchamp's audio contribution to 5+6 notwithstanding, there are obvious parallels between the approach Duchamp pioneered with the readymades and Barthes's articulation of a text "as a multi-dimensional space in which a variety of writings, none of them original, blend and clash."[36] A pile of used tires might seem to fit rather nicely as a three-dimensional parallel to this proposition, sharing, as the tires do, the condition of the readymade, arranged

rather than formed by the artist, and carrying a host of associations through the prior familiarity of the object thus selected. And yet, as the far from quiet silences of both Duchamp and Kaprow serve to demonstrate, it is perhaps more a matter of redirection, where the author doesn't disappear, but instead moves over into activities that contribute to the further framing or interpretation of earlier gestures. The turn that Kaprow makes, and one that links his enterprise to the many ways that the definition of the artist and artistic activity were extended over the course of the twentieth century, is Kaprow's assumption of what had been secondary functions, applied by others to the process of defining or constructing the interpretive context for the work. Thus the role presumed for the reader is deflected onto the birth of the artist as organizer, critic, historian, or, as Kaprow would later describe himself, provider of services.[37]

George Kubler's "Style and Representation of Historical Time," the third text bound together with those by Sontag and Barthes in *Aspen* 5+6, points to the other important dimension implicit not only in the initial audience experience of Kaprow's spatial configuration, but also in its extended history. In his 1962 *The Shape of Time: Remarks on the History of Things* (which was read by a number of artists in the 1960s), Kubler had posited the work of art as "the residue of an event" and also a form of signal or relay that would inspire additional works and in turn be read through those subsequent acts.[38] Although Kubler does not make an appearance in the index to Kaprow's *Essays on the Blurring of Art and Life*, Robert Smithson was reading his work, and there is a suggestive echo in a comparison between museums and mausoleums that Kaprow made in a dialogue with Smithson and a statement by Kubler about parallels between tomb furniture and the museum that Smithson used as the epigram to "Some Void Thoughts on Museums" (a brief essay that appeared on the same page of *Arts Magazine* as the concluding paragraphs to Kaprow's "Death in the Museum").[39]

Kubler's contribution to *Aspen* returns to the specific problem of stylistic unity in the face of temporal overlays, such that "every work of art is a fragment of some larger unit ... a bundle of components of different ages." Yet, in the contrast Kubler puts forward between painting ("about the world of vision") and history ("about duration"), it is the comments about history rather than art that

could function as a direct description of the problems presented by the desire to remake Kaprow's ephemeral actions or arrangements. "Past events," Kubler asserts, "are no longer available to observation save as artifacts or contingent traces of the activity under study, which we can know only in documents, chronicles, and histories." If Duchamp as well as later conceptual practices took the artist into the terrain of the historian or critic, then it is perhaps fitting that Kubler's five axioms about historical duration resonate quite strikingly with Kaprow's approach:

I. Similar actions by the same agent cannot occupy the same time. If they do, the recipient is different and the action also.
II. No one agent can perform the same action more than once without ageing.
III. Actions can only be similar, but not identical, being different as to agent, or as to time, or as to location.
IV. Actions repeated undergo change.
V. The agent changes with each repeated action.[40]

According to Kubler, the challenge of duration is particularly telling in relation to the concept of style, which is, he argues, best suited to synchronous situations. It is therefore interesting to note how the early and eager adaptation of photographs as a tool for connoisseurship represents an attempt to defeat the problem of duration on the level of reception, characterized by Malraux as the "comparison of a present vision with a memory" prior to the widespread circulation of reproductions.[41] Yet Kubler is also addressing the issue of duration in production, not only through the incorporation of references drawn from different eras within any given work, but also as the artist moves through time and therefore necessarily returns to a problem from the perspective of a different set of coordinates.

Kaprow's remakes of *Yard* serve to dramatize this instability by introducing an aspect of change typically discovered in a comparison of works from an artist's different periods into a single work that is rendered inherently multiple through his intermittent exercise of authorial power. The 1961 photographs of *Yard*, while in large part responsible for the ongoing interest in this assembly of used tires, are therefore involved in a rather different operation than the use of photography in art history's comparative method,

and in particular for the imperatives of connoisseurship centered upon the identification of unique stylistic traits. Photographs of later installations indicate striking visual and structural differences among the temporally and geographically far-flung examples of what Kaprow nonetheless identified as ongoing interpretations of a single work. *Yard* is a continuous work to the extent that the variants were all initiated by the artist Kaprow—even as *Yard*'s various transformations over the years testify to the changing concerns of the individual occupying that proper name. Thus the photograph is part of a process that is both fixed and fluid, allowing comparison of the far-flung examples of a work that cannot be understood as singular, even as the work has, after each disturbance, largely settled back into its identity with the 1961 photographs.

"The viewer of today not only sees things in a different way but also sees different things," is Michael Ann Holly's succinct formulation in the introduction to *Past Looking*—within the context of a discussion of the deferred action whereby our understanding of the past is revised in light of the present. Yet Holly identifies this mobility in an analysis largely centered upon painting, where barring damage or radical conservation treatments one can assume at least a certain continuity in the physical artifact under reconsideration.[42] Work that has to be reinstalled or remade each time it is shown is to a certain degree more evidently subject to the passage of time, but in other ways able to evade this process of historical definition. Instead of a continuous physical object, relatively unchanged except for wear or conservation efforts, the work's appearance reflects an ongoing process of reinterpretation. Sol LeWitt also pointedly addressed the issue of physical contingency with the series of wall drawings begun in 1968, where he developed an explicit strategy for creating works based on a set of instructions carried out by others and remade each time the work is exhibited. In contrast to obviously conceptual works by LeWitt and others, however, where procedures for remaking are explicit in the original plan, impetus for Kaprow's remakes came after the first installation, with later interpretations emanating not from the single point of the initial proposition, but in the intersection between Kaprow's evolving motivations and a range of forces that includes the equally mobile series of curatorial contexts within which *Yard* has been summoned to reappear.

Intent

In the case of the 1998 *Out of Actions* exhibition, one interesting side effect of organizing a retrospective of performance-based works from the 1960s and 1970s was the motivation for the museum to go into the business of creating replicas. Another form of copy, the plaster casts once valued for their educational function, had long been banished from most museum collections. Here, however, the curator wanted a replica not to represent a canonical sculpture located elsewhere, but in order to display a by now canonical environment without a continuous physical existence. In a subsequent essay about *Out of Actions*, Schimmel recounted his difficulty as a curator of a historical exhibition when faced with Kaprow's insistence that the work reflect his ongoing interests as an artist. And the correspondence files related to this exhibition indicate that Kaprow was adamant that the work could not simply be remade from photographs.[43]

Kaprow's argument that the work had remained in flux left the curator in the bind of needing the artist's endorsement to create the work, but wanting something rather different than what Kaprow was prepared to authorize. Whereas Schimmel was not looking for a new work, Kaprow was not interested in creating a remake based on a close reprise of the 1961 photographs. However, the organization of the art museum around original works of authorship meant that Schimmel needed Kaprow's permission and participation, nearly four decades later, to reconstitute this historical work. One of the most striking points in the published account of the negotiation process connected to *Yard* is Schimmel's own assertion of artistic intent in his suggestion that the version of the work in Italy was inconsistent with *Kaprow's* original intention for the work. His description of the MOCA version made a similar claim: "With much discussion and a great deal of struggle, I convinced him to make a piece that I think also has only a passing resemblance to his original intention."[44]

In his comments on Duchamp's "Creative Act" (and with decided overtones of Barthes), Kaprow posited certain circumstances where the author would recede: "According to some of my friends, the freeways of Los Angeles are great theater, modern theater, with no beginning or end, full of chance excitements and plenty of the

sort of boredom we all love ... Their future as Readymade art depends on the reader."[45] When it came to the re-creation of *Yard* for *Out of Actions*, however, Kaprow was not willing to cede his authorial position to Schimmel, closely controlling the process of interpretation that is part of the reinstallation of the early environments, and even using his grip on their identity as another way of continuing his resistance to the mandates of museum contextualization. In this example, as in many others, one after-effect of the readymade is evident in the role thus opened for the artist to continue to establish the context for the act, not just at the initial moment of selection, but over time, in the ongoing process through which the work's significance is secured.

If earlier commission procedures were for a time supplanted by the romantic model of the easel painting, produced on an independent basis by the artist in the studio, then the increasingly popular procedure of inviting artists to create site-specific works for particular installations suggests a curious return—one that that entails logistics related to the former while still holding to an ideal of artistic independence associated with the latter. In the negotiations over the 1998 version of *Yard*, the curator's attempts to commission a work that in many respects already existed opened onto a process of interpretation where readings of a past point of origin were articulated in debates pointing forward, toward the outcome of the work's future reinstallation. Moreover, the prolonged, elaborate discussions between curator and artist demonstrate from a practical standpoint how nearby the artist may indeed be—not an imagined figure, to be discovered through the work, but a very insistent actual presence.

The issues raised by the intersection of authorship and photograph are important not only for *Yard*'s history, but with respect to work produced by many other artists during the historical period spanned by the multiple versions of Kaprow's environment. Kaprow's comment about the reading of the Los Angeles freeway as a kind of readymade, as well as an alternate idea for bypassing the gallery entirely and simply inviting spectators to the dump, evoke a well-known description by Tony Smith of his experience of the vastness of the newly built New Jersey turnpike or, even more apropos, the take on the industrial landscape articulated by Smithson in his 1967 *Artforum* essay "The Monuments of Passaic."[46] Smithson's published account of his discovery of

monuments in the residue of utilitarian forms describes a journey taken alone; when he went back later with friends, however, it hardly seems coincidental that he made one such trip in 1968 with Nancy Holt, Oldenburg, and Kaprow.[47] For the much larger audience that encounters Smithson's monuments only through the published account, however, the photographs give these immobile readymades a form of parity with other works represented in the imaginary museum of the reproduction.

It seems equally clear that the retrospective fortunes of Kaprow's work are only just beginning—with recent reinventions including not one, but three new versions of *Yard* created to mark the 2009 inauguration of a branch of the Hauser & Wirth gallery in the very same New York townhouse where the work was originally presented in 1961.[48] Recognizing the compound authorship that has replaced Kaprow's tight hold on interpretation since his death in 2006, Helen Molesworth, as guest curator for this reinvention, decided to invite three separate voices to produce versions of the

9. William Pope.L, *Yard (To Harrow)*, 2009. Mixed media; installation view, *Allan Kaprow: Yard*, Hauser & Wirth New York. Courtesy Allan Kaprow Estate and Hauser & Wirth.

work for an equal number of sites, each in response to a different aspect of *Yard*'s already manifold identity. The tire-strewn interior that William Pope.L created for *Yard*'s original site was therefore accompanied by two other new *Yards*: Josiah McElheny's photographic projection at the Queens Museum of Art and Sharon Hayes' intervention in the Lower East Side's Marble Cemetery.

Although the initial version of *Yard* got its name from its outdoor location, that exterior courtyard was built over long ago, and Pope.L's reinterpretation of *Yard* was an entirely interior affair that turned the building's first floor into an obstacle course of tires that rose to a climbable mound toward the rear. Viewers encountered a cave-like installation, the result of black plastic bags covering the street-side windows, and light emanating only from hanging red and white bulbs that switched on and off at disconcerting moments. In Pope.L's hands, Kaprow's goal of breaking down boundaries between art and life also took a decidedly macabre turn: instead of wrapped sculptures, there were stacks of body bags in a rack along one wall that Pope.L had filled with mannequin parts and Vaseline.

McElheny's contribution picked up on Kaprow's speculation about whether, instead of transporting the tires to Manhattan, he might have taken his audience to the junkyard, with a work that occupied a space between those two poles. Visitors to the Queens Museum were treated to a large-scale photographic projection of Willets Point, a nearby outpost of waste activity slated for eradication in favor of waterfront development, which McElheny stitched together from aerial photos shot from a helicopter. Hayes was the only one of the three artists to move decisively outside the confines of the gallery or museum. Marrying her engagement with the history of political sloganeering to the idea of the yard sign, she filled the relatively obscure Marble Cemetery with all manner of familiar textual flora, from election-campaign endorsements to sales announcements and trespass warnings.

Yard's prolonged history clearly has many implications for other practices. In particular, questions raised by the role of the photograph for Kaprow's later audience intersect with the widespread integration of photographs and other forms of documentation in contemporary art, where such uses are now established as a means to convey distant, private, or ephemeral works that the artist nonetheless defines as art.[49] And even Kaprow's strategies

10. Josiah McElheny, *Yard (Junkyard)*, 2009. Aerial digital photograph projected in high definition onto a 30 × 100 ft wall, Queens Museum, New York. Courtesy Allan Kaprow Estate and Hauser & Wirth.

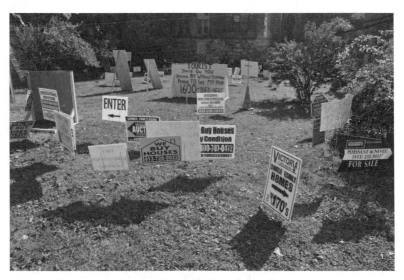

11. Sharon Hayes, *Yard (Sign)*, 2009. Installation view, New York Marble Cemetery. Courtesy Allan Kaprow Estate and Hauser & Wirth.

for resisting object making have been assimilated into an extended definition of artistic production centered around negotiated interventions. Kaprow concluded his 1971 essay "Education of the Un-Artist, Part I," with a plea: "Artists of the world, drop out! You have nothing to lose but your professions!"[50] His alternative, articulated in his correspondence with Schimmel, was to insist on his identity as a provider of service rather than a producer of objects. Yet the model of the service provider has proven compelling for artists engaged in performance practices that activate a relationship to a specific situation—including Andrea Fraser's attention to the rhetoric of the museum, or Carey Young's focus on corporate strategies.[51] With the institutional embrace of site-specific projects, the return of certain aspects of the negotiated commission is linked to the rise of a new form of artist professional who often works in close coordination with curators and a range of other experts necessary for the realization of any given work.

Perhaps the most compelling legacy of *Yard* can therefore be found in the irresolvable contradictions its extended history presents. The photograph records, isolates, and fixes a historical moment that cannot be retrieved—dependent as the event thus recorded was on the particular circumstances of place and time. But to the extent that the work it documents has an ongoing existence, the photograph falsely locks into place a conception of the work at a single, now inaccessible moment, even as installations identified as *Yard* and attributed to the artist named Kaprow have continued to reappear in a variety of guises. For this and many other works that do not have an enduring physical form, the photograph can function as much more than a secondary document that transmits information about an absent object bound by time and space. It provides the basis for the work's apparent continuity, with the reproduction enduring as the physical configuration comes and goes. Kaprow was insistent that he did not want new installations simply to recreate the photographs of the initial environment; yet without those same photos *Yard* would not have achieved its status as an important and seemingly familiar work, and Kaprow would not have had the opportunity to introduce strategies of resistance only made possible by the work's embrace. There is obviously no going back to recreate the circumstances that framed Kaprow's original undertaking, despite the expanding interest in participatory works witnessed by few in their first incarnation. Kaprow's

decision to consider the early works ongoing therefore addressed the ambiguity of trying to revive a gesture that the work's later audience, upon viewing the photographic evidence, wants to see retrieved yet also interprets as clearly dependent on its initial context.

CHAPTER 4

When is the work of art?

Perhaps this would be a good moment to revisit the very beginning of the art-historical narrative. An exceedingly long time ago some painting was done in caves in Lascaux, and the stunning depictions of animals arrayed across their walls have given the underground complex pride of place in the first chapter of today's art survey texts. The study of that early history—the attempt to understand the work's origin—lies rather precisely at the opposite end of the art-historical spectrum from the temporal zone in which this book is operating. But the accidental rediscovery of the paintings in 1940, after some 17,000 or so years preserved in a sealed cave, does fall squarely in the middle of the modern era. Moreover, their history following the re-emergence pulls them squarely into the postmodern, raising questions about the efficacy of attempts to recreate or simulate the experience provided by work so clearly defined by its relation to a specific place and time.

The postmodern experience in question is Lascaux II, a reproduction created in a cement structure and buried in a former quarry about 200 meters from the original cave, after Lascaux was closed to the public in 1963 to prevent further damage caused by humidity and contaminants associated with throngs of enthusiastic visitors. The second cave-like structure, which opened in 1983, reproduces

both the spaces themselves and paintings from the Hall of the Bulls and the Axial Gallery. This "faithful copy" was achieved with the aid of a device that recorded the position of approximately 2,500 points in the Hall of the Bulls, as well as stereoscopic photographs used to help visualize the reproduction of both the three-dimensional contours of the cave and the paintings upon those surfaces.[1] It is equally important to note that the endeavor has been a resounding success, with the more than a quarter million visitors it attracts per year making the fake cave the region's most popular destination.[2] Indeed, an important aspect of its appeal is the clarity of the recently painted images, undimmed by the passage of time (in sharp contrast to some of the original paintings still available to visitors in other caves in the area).

1. Interior of Lascaux II, August 2009. Photo: Chase Weaver.

The tale doesn't end there, either, since it seems there is yet another replica in play, produced under the supervision of Renaud Sanson, a theater designer who also worked on cave number two. This latest cave, announced in news stories starting in 2005, is supposed to be even more perfect than the last.[3] Not only does

Lascaux III rely on advanced technology—laser beam measurements, translated into digital information used to guide water jets in the carving of the blocks of polystyrene from which it is formed—but as a traveling exhibition, the new cave, freed from "its presence in time and space," will "put the copy of the original into situations which would be out of reach for the original itself," thus enabling "the original to meet the beholder halfway." Although Walter Benjamin's 1936 essay known in English translation as "The Work of Art in the Age of Mechanical Reproduction" was written before Lascaux was known to the modern world, his argument about the copy's mobility could, without apparent irony, be adapted as promotional literature for this new replica.[4] Whereas the initial substitution allowed tourists to the cave region in southwest France to fulfill some semblance of the desire to visit the area's most famous unseen attraction by going (almost) to the original site, this latest and reportedly more accurate replica is designed to allow the cave to hit the road, for a tour with an international itinerary. From cult value to exhibition value indeed!

The story of the cave's recent history raises a number of issues pertinent to a discussion of contemporary site- or event-based art. The first is the degree to which there may or may not be a lag between when a work is initially created and when it becomes a focus of sufficient attention to be understood as important or even canonical. Obviously, Lascaux is a rather extreme case—in fact just about as extreme as one could imagine—but it is perhaps not completely unrelated to contemporary challenges. Although now situated firmly at the start of our story of art, the cave paintings were still unknown, for example, to all the artists whose intersecting achievements Alfred Barr attempted to chart for his 1936 *Cubism and Abstract Art*, four years before its accidental rediscovery prompted a major revision to the history of art's opening chapter (with that history rewritten yet again after the 1994 discovery of Chauvet's far earlier images). The paintings also continue to be accepted as works of unquestioned significance, despite the fact that they are now inaccessible to all but a handful of specialists.

Even more relevant to questions about the ongoing life of installations and other situation-specific practices is the role of the reproduction in our familiarity with the work. Given the thousands of tourists Lascaux II provides with a semblance of the physical experience of this landmark, it is remarkable how few published

images of the facsimile exist. Photographs of the original, now inaccessible paintings abound, not only in the art history texts where they are to be expected, but even as illustrations in guidebook entries directing visitors to the remake. The experience of Lascaux II therefore involves a process of negotiation, whether conscious or not, between the fixed but inaccessible view of the work provided by photographs, and the lived process of moving through the reconstructed space, compromised by elbowing crowds, limited viewing time, and ultimately the interpretive decisions made in the process of creating the reconstruction. In addition, the spreading blight that caused the original cave to be sequestered from visitors may yet leave the two- and three-dimensional reproductions without any point of reference.

In his classic study of tourism, Dean MacCannell counters the association between tourism and inauthenticity with the more subtle argument that such journeys are indeed based on a search for the authentic (turning around the spot where something actually happened, or an object with specific historic associations), even as this very pursuit transforms the experience into its opposite.[5] A similar sort of conundrum emerges in relation to contemporary practices prevalent since the 1960s and 1970s, where performances, installations, and other ephemeral or malleable forms are known through documents that purport to record essential information about the art, yet are unable to convey the experience of the work. In a related vein, the increasing importance of electronic or new media has been accompanied by the speedy obsolescence of many of the technologies central to such works.

Historical retrospectives devoted to postwar avant-garde artists and movements therefore often involve a process of circling around the work, presumed to exist somewhere between the experience of altered or reconstructed material on exhibit and the iconic photographs that make such returns obligatory. Recent decades have also seen the development of a vigorous market for photographs and video where the production of the document has become integral as an extension of the work. Both still and moving images, many of them large-scale, slickly produced, and issued in limited editions, use the notion of an original event as a reference point or justification. Yet that initial situation may be the tail that wags the dog, when the production of such documents becomes a motivation for creating the ephemeral work from which they draw their authority.

It is equally evident that there is a strong synergy between the agenda of art historians and curators, motivated to comb through the relatively recent past for artists and phenomena that have not yet been subject to retrospective scholarship or exhibitions, and the marketplace, where a search for the new encompasses not just the latest youthful creations, but also a whole host of rediscovered (and often freshly remade) versions of historical works. In situations where art deemed significant does not coincide with a tangible or enduring object, produced as a result of the artist's direct material manipulation, potential uncertainty regarding what might constitute the work is more than a stimulating theoretical problem. Ambiguity and malleability intertwine, as retrospective historical interest prompts both scholarly and financial investment in an extended process of production, with ongoing critical assessment inseparable from acts of interpretation that are the basis for the work's re-creation.

Residue

Even for works with a strong appeal to visual pleasure, a purely formal approach provides only a limited perspective (conservative institutional rhetoric notwithstanding). But an inherent insufficiency is particularly evident at either end of the chronological spectrum, with those supposedly self-contained, visually accessible paintings bracketed on the one end by such objects as amulets or saints' reliquaries in the early galleries, and fragments or documents relating to ephemeral practices as one moves through the twentieth century. These examples share an anti-connoisseurship deficiency, in that their significance is frequently centered upon assertions that cannot be verified by means of visual discernment alone, in relation to objects or images that stand as markers for much larger sets of beliefs or experiences present only in surrounding traditions. An obvious difference is that the early religious artifacts now on offer in museums were created at a point when such a fate would not have been imagined, whereas recent tokens and traces relate to practices made with full awareness, and often as a kind of counterpoint, to the mode of vision-centered experience associated with museum display.

In the case of interactive and performance work in particular, museums provide access, but at a price—and it is rare to see it so clearly laid out as it was in the Lygia Clark section of *Tropicália*, a 2005 exhibition focused on Brazilian culture and politics of the 1960s.[6] A series of tables presented the malleable objects Clark developed during this period. Plastic bags filled with air, water, and various objects were conceived to be picked up and manipulated. Hood-like masks made of fabric, and variously filled with seeds or incorporating mirrors, were designed to create different sensory experiences. Goggles, some for one person, some for two people to wear together, also used mirrors to fracture and redirect the participants' sightlines.

These modest objects followed upon her earlier *Bichos*, or *Animals*, a series of metal constructions begun in 1960 that were much more obviously sculptural, yet also intended to be manipulated, their hinged planes having the potential to assume a multitude of forms. Yve-Alain Bois has described the *Animals* as "inaccessible to anyone not engaged in combat with them, to anyone not unfolding them."[7] Yet such a program is (as he acknowledges) deeply incompatible with the ethos of the museum, where even the curators undoubtedly don white gloves when they ever so gently arrange these works for static display. The extensions of the body would make even less sense without the opportunity to interact. Writing in 1966, Clark's language was absolute: "We refuse the artist who pretends by means of the object to give a total communication of his or her message, without the spectator's participation."[8] Yet, expanding attention to Clark's work has turned the modest sensorial masks and goggles she created to foster such relations into valuable originals, far too precious to have them handled to bits by visitors to a multi-venue exhibition.

The *Tropicália* solution was to double the objects. The now esteemed originals were displayed in enclosed cases. Next to each, on the same table, was an exhibition copy that could be picked up and manipulated as the work was designed to be experienced. This practical response to an insoluble problem does allow two incompatible things to happen. The original is present, providing some sort of ineffable connection to the circumstances of its initial production. And something else akin to that object can be manipulated by exhibition visitors. It is, however, relatively unusual to see the star and understudy on stage at the same time—though this

analogy is not entirely apt, given that the two versions of Clark's constructions serve complementary functions that, taken together, might allow participants to approximate an experience once engendered by a single interactive object.

It would, at this historical remove, be almost impossible for any object to produce the sense of immediacy one imagines from published photographs and accounts, at the same time that such documents have played a key role in establishing Clark's fluid experiments as important contributions to the avant-garde canon (an admittedly paradoxical locution if there ever was one). And once that historically significant work becomes subject to museum display, there is a strong motivation to present it through objects rather than just documents. Yet there is still the central issue that Clark's works were never conceived for the vision-centered experience of the art museum. The inclusion is part of a two-sided process, with museums extending their exhibition programming to encompass the varied objects and gestures associated with twentieth-century avant-gardes, at the same time that such open-ended, even amorphous activities are inevitably tamed by the institutional embrace.

Increasingly frequent museum displays of mere residue are part of a larger dance of engagement and resistance. Self-consciously preserved relics, like those retained by Chris Burden from his actions of the 1970s, provide a channel by which certain works can be reabsorbed into collecting practices that their ephemeral nature seemed to contest (though in fact Burden's artifacts initially appealed more to artists than museums, with Andy Warhol and Jasper Johns both acquiring multiple examples out of a 1976 exhibition of these relics).[9] Furthermore, the ongoing historicization of performance and other ephemeral work of the 1960s and 1970s establishes models for subsequent practices, with their more unabashed emphasis on the document as museum object. The viewer's understanding of such relics is not centered on visual information, but rather on their purported relationship to events or situations beyond the exhibition's purview. And such traces evoke the eclecticism of the earlier cabinet as well. Akin to the garrulous antiquarian presiding over a personal collection, the individual or institution buying a performance relic or document acquires, by extension, some combination of right and obligation to recount the associated story (a narrative already dictated by the artist,

however), in order to provide a context for the isolated remains on offer.

Play it again

There is the preliminary set of impulses by the artist, prompted by any number of forces, and probably gestating for a difficult-to-discern period of time. While some of these may be cited in an artist's statements about the work, it would be hard to imagine a truly exhaustive articulation. Then there is the work's initial realization, which, particularly for installation or situation-specific art, has often been significantly shaped by the exigencies of the moment, including what types of physical space, material, or technical resources were available. That configuration may have been documented, perhaps haphazardly, perhaps extensively, and such records are sometimes joined by sketches or other planning documents prepared in advance.

In the aftermath there is the question of what physical components have been retained, their degree of stability as objects or technologies, as well as the role of the document in disseminating the work. There is also the evolving relationship of the particular example to an understanding of the artist's overall production and to the ongoing historicization of the period or movements with which it is associated. The subsequent desire to see a work again—which often extends to art that is known only through documents—is further intertwined with various economic reasons why it might be advantageous for a work to be understood as extant. In other words, a great deal can happen in the gap between production and reception.

One key issue concerns whether the work as such is identified with a physical object or an idea. While this possible shift in emphasis is foregrounded in many versions of conceptual art, it has broad application to a range of situational or participatory works. The prospect that each artist can make his or her own determination about how to define a work's identity is thus both an effect and one of the enabling conditions of contemporary art's extreme heterogeneity.

Some of these issues are evident in relation to the participatory

works that Yoko Ono created in the 1960s. *Painting to Hammer a Nail* and *Ceiling Painting (Yes Painting)* were both shown in Ono's 1966 Indica Gallery exhibition in London, and photos from that event, including one of Ono herself at the top of a ladder looking through a magnifying glass at the word "yes" in small lettering

2. Yoko Ono, *PAINTING TO HAMMER A NAIL*, 1961/1966. © Yoko Ono. All Rights Reserved. Used by Permission. Photo: John Bigelow Taylor.

PAINTING TO HAMMER A NAIL

Hammer a nail into a mirror, a piece of
glass, a canvas, wood or metal every
morning. Also, pick up a hair that came
off when you combed in the morning and
tie it around the hammered nail. The
painting ends when the surface is covered
with nails.

1961 winter

3. Yoko Ono, *PAINTING TO HAMMER A NAIL*, 1961 Winter, as published in
the first edition of *Grapefruit*, Tokyo, 1964. © Yoko Ono. All Rights Reserved.
Used by Permission.

on the panel suspended from the ceiling, suggest the type of inter-
action she envisioned. By the time those works were included in a
traveling retrospective that opened in 2000, however, any possi-
bility for physical interaction was clearly off limits, with the once
participatory objects now on pedestals or behind plexi. The photos
of earlier interactions indicate a possibility of exchange now past,
with the objects both elevated as historically significant and simul-
taneously presented as relics.

Yet the question of origin is even more complex. Despite the
fact that a certain amount of hammering took place in 1966,
Painting to Hammer a Nail is dated to 1961, since that is when

it originated as an idea (which was exhibited as a text in 1962), and the text-based version of the piece was also published in her 1964 book *Grapefruit*. The instructions are, however, notably open-ended:

PAINTING TO HAMMER A NAIL
Hammer a nail into a mirror, a piece of glass, a canvas, wood or metal every morning. Also, pick up a hair that came off when you combed in the morning and tie it around the hammered nail. The painting ends when the surface is covered with nails.
1961 winter[10]

According to Ono, the second step of wrapping hair was not followed by visitors to the Indica exhibition, and was gradually forgotten. Nor does Ono herself seem particularly concerned about the fact that the historic object is off-limits to physical interaction since, as she has suggested, you can still participate in your mind.[11] Moreover, a vision of mental rather than physical interaction is perfectly in keeping with her early description of the 1966 exhibition:

When 'Hammer a Nail' painting was exhibited at Indica Gallery, a person came and asked if it was alright to hammer a nail in the painting. I said it was alright if he pays 5 shillings. Instead of paying the 5 shillings, he asked if it was alright for him to hammer an imaginary nail in. That was John Lennon. I thought, so I met a guy who plays the same game I played.[12]

Lennon also told an interviewer about his experience of wonder upon climbing the ladder and seeing the word "yes"—and there is no need to recount the rest of that story, given how Ono's early career as an artist and member of Fluxus was for a time greatly overshadowed by the celebrity surrounding her relationship with the Beatles superstar.

In connection with this history, the idea that one is indeed in the presence of the very ladder climbed by Lennon does carry a certain cachet—even though we only have Ono's word for this fact, and she has indicated that in London she used a different ladder than the one she used earlier the same year for another version of the work in New York.[13] Ono has also created multiple versions of

Painting to Hammer a Nail, so the relic of the 1966 exhibition, accessible in the viewer's mind, has been frequently joined by other authorized versions where members of the audience can engage in the physical act described by the title. And the opportunity for participation can lead to unpredictable responses as well—as evident on the occasion of the work's presentation in the Seattle Art Museum's 2009 exhibition *Target Practice: Painting Under Attack 1949–78,* where visitors took the added liberty of using the available implements to nail personal mementoes and detritus to the wall surrounding the work (a version that made news when a security guard who was also a self-declared performance artist took it upon herself to intervene, by removing and sorting the offerings, and was fired for her action).[14] It would obviously be problematic to talk about *Painting to Hammer a Nail* as a single entity, given the multiple points of origin as well as the many forking paths in its subsequent history; yet the artist's own participation links them together, under her authority, as all constituting ongoing variations of the generating idea.

Various examples from *Out of Actions,* the 1998 exhibition of performance-based work that Paul Schimmel organized for the Los Angeles Museum of Contemporary Art, raise further issues concerning the project of recuperation discussed in the previous chapter in relation to Allan Kaprow's *Yard* and its long history subsequent to its initial 1961 appearance. Two works that originated around the same time, Ben Vautier's *Living Sculpture,* first created for the London Festival of Misfits in 1962, and Gustav Metzger's 1961 *South Bank Demo,* appeared as installations in the exhibition, even though they incorporated performance in their original realizations. In its first incarnation, Vautier inhabited his storefront window display for the duration of the festival (replete with a designated offering price of £250), and for the initial version of his work, Metzger largely destroyed three nylon tarpaulins with sprays of hydrochloric acid in front of an assembled crowd (visible in photographs taken at the time through the holes thus opened in the fabric).

The works also enjoyed varying degrees of previous existence. The 1998 version of the Metzger was the first remake since 1961, and in an account of the challenges posed by mounting the exhibition, Schimmel indicated that differences in appearance derived from weaker acid employed in the later instance.[15] What is less clear

from Schimmel's description is the degree to which the making of the 1998 version functioned as a performance, or whether the focus had entirely shifted to the creation of an object that could then constitute or represent the work for the purposes of this exhibition. It is also only because *Mortality Immortality*, the book in which Schimmel's account was published, appeared a year after the *Out of Actions* exhibition that it could include a photo of the object actually seen by viewers, rather than the original historical event represented by the photos in the exhibition catalogue. Obviously lead times make it difficult to publish views from exhibitions generally not yet installed at the time their catalogues go to press, but there is something more to this dynamic as well—a tendency to identify a potentially malleable work with a single or small group of iconic images, regardless of the variations in the objects or situations encountered by later exhibition viewers.

4. Ben Vautier, *Ben's Window*, 1962/1992–3. Mixed media, 125½" × 178½" × 108". Collection Walker Art Center, Minneapolis. T. B. Walker Acquisition Fund, with additional funds from Lila and Gilbert Silverman, 1993.

The Vautier had a more extensive intervening history, having already been remade for a 1993 Fluxus exhibition at the Walker Art Center, at which time its title changed from *Living Sculpture* to *Ben's Window* (a redesignation presumably motivated by its shift in status from performance to installation).[16] Although the 1992–3 version included some vintage items (as well as new additions, including a then contemporary boom box), its overall framework changed dramatically, since it no longer included the artist. Photos of the 1992–3 and 1998 versions indicate slight differences, so it is not too clear to what degree the 1998 re-creation duplicated the interim version (which did, however, appear under the 1992–3 title). Yet the interim version drops away in the caption from *Mortality Immortality*, which gives the date for the *Out of Actions* version as 1962/1998, even though it is also listed as a Walker Art Center acquisition in 1993.[17] A provocative subtext in all this is therefore the fact that the Walker helped to remake the work, then acquired it—which is an interesting curatorial strategy for getting the work you want for your collection.

A burgeoning vogue for re-performance has opened another set of options for the project of historical recuperation in museum survey shows. For his 1994 Guggenheim retrospective, Robert Morris took a significant step in this direction when he opted to present four of his performances from the 1960s via 1993 film versions that relied on new performers to recreate the earlier actions. In the case of his 1964 *Site*, originally presented by Morris and Carolee Schneemann at Stage 73 in New York, for the Surplus Dance Theater, and then at a number of US and European venues over the next year, the performance is best known through a series of iconic stills by Peter Moore and Hans Namuth showing a nude Schneemann in the guise of Manet's Olympia while Morris, in workman's clothing and wearing a mask that replicates his features, manipulates sheets of white-painted plywood.[18] The performance was also documented in a 1964 film by Stan VanDerBeek that was distributed in the 5+6 issue of *Aspen*.[19]

A film documentation of a performance is obviously very different than performing for film, however, since in the latter the discontinuous fragments of action only achieve unity as a result of the editing process. In contrast to the real time of the performance, the 1993 film re-creation of *Site*, directed by Babette Mangolte, took what Morris described as "hours and hours of rehearsing and

waiting," and it also went through a number of sheets of plywood (due both to multiple takes and an overall decline in wood quality since the 1960s). Yet, even as he emphasized the difference between film and performance (and despite the existence of the earlier film document), Morris pointed to the 1993 film as a source if someone should want to restage *Site*.[20] Thus the notion of going back to a 1964 performance takes a potential detour through another medium, via a re-creation almost three decades after the initial event.

Even with the freshly minted performance documentation, however, the Guggenheim's Morris retrospective took a relatively conventional approach to the enterprise of a survey exhibition, when viewed in comparison to an earlier exhibition at the Tate Gallery in London. When the Tate proposed mounting a retrospective in 1971, Morris countered the museum's traditional emphasis on original objects with an offering of photographic reproductions, refabrications, and a slide-show survey of his work, accompanied by three rooms that he transformed into a theater of audience participation via a plywood environment designed to promote interaction. Morris's emphasis on the viewer's bodily experience was a logical outgrowth of his varied engagement with minimalist objects, environments, and performance during the 1960s. Yet the exhibition was memorable, even notorious, for the aggressive response of the audience, unleashed from museum norms, which quickly reduced the installation to a state of near collapse and forced its closure only four days after it opened. [21]

But what a difference a few decades can make. In 2009 the earlier Tate installation, rechristened *Bodyspacemotionthings*, was recreated for the Turbine Hall of the Tate Modern. The objects were strengthened and reinforced, with underlying steel support structures and much more carefully finished surfaces to avoid the splinters that were part of the take away for many in the initial audience. The viewing public was completely different too—far more accustomed to the experience of the museum as decorous fun house and conditioned to line up politely to wait their turn to interact, under the supervision of museum guards who, rather than warning visitors not to touch, are there to tell them exactly how to do so.

Perhaps some visitors had already experienced the Turbine Hall as playground a few years earlier, sliding down one of the five

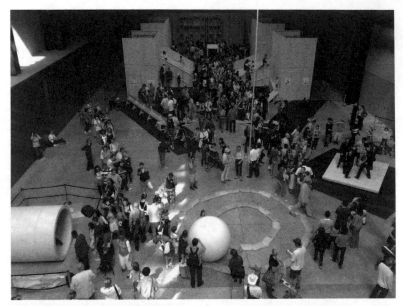

5. Robert Morris, *Bodyspacemotionthings*, 2009. Installation view, Tate Modern. © 2011 Robert Morris / Artists Rights Society (ARS), New York. Photo: Gilda Maurice.

spiraling chutes that comprised Carsten Höller's 2006 *Test Site*, where the idea that this was restrained, museum-based fun was enforced by the use of timed tickets for the taller slides. In any case, the reinstated Morris exhibition came off without a hitch. Yet it seems like a somewhat paradoxical endeavor to recreate a historic work with the clear intention that the contemporary audience should not have the same experience of the environment as the initial participants. Viewed from one perspective, the remake could be understood as the successful completion of an earlier work that was compromised by circumstances. Yet the reprise was also fully tamed, seeming neither radical nor particularly unexpected in its new historical coordinates.

For a time, museum literature focused with notable frequency on the problem of how to keep their potential audience from being lured away from the museum's authentic yet somehow unexciting artifacts by simulated settings such as Colonial Williamsburg. Perhaps these comparisons have become less numerous, however,

because art museums have figured out how to turn a spectacle themselves, becoming more adept at their own forms of simulation. In fact it has become remarkably common to find even live bodies on display, populating newly conceived versions of the old-fashioned *tableau vivant*. Visitors to the New Museum's problematic *Skin Fruit* exhibition in 2010 (curated by Jeff Koons from the Dakis Joannou collection) were, for example, periodically confronted by the performance of Pawel Althamer's 2005 *Schedule of the Crucifixion*—a wall-mounted cross fitted out with a small platform and leather arm straps, together with a ladder, which was ascended at intervals by a succession of loin-cloth-clad performers who thereby completed a living but strikingly tame version of this historically potent scene. Summer 2010 also presented New York viewers with far more extended feats of stamina in Tino Sehgal's *The Kiss* (his staged re-enactment of art-historical depictions of this act, with a revolving cast of nude pairs of actors semi-frozen in slow-motion emulation of successive scenes of canonical embrace) and Marina Abramović's MoMA retrospective, where, in addition to her own spectacle of endurance in the museum atrium, a series of early works (many initially created in collaboration with Ulay) were recreated by a cadre of performers, operating in tag-team fashion to keep the exhibition populated with embodied displays.

Obviously all works are subject to changing readings over time, as successive audiences bring different expectations to the viewing experience. Such problems are likely to be particularly extreme, however, for art that has to be reconstructed each time it is exhibited. The passage of time since the work's initial appearance is coupled with transformations in the interpretive context, meaning that the changing definition of the work's significance alters expectations in ways that will in turn influence how the work is reconstituted. And still other issues are raised by art focused around an interactive situation, where the wish to preserve original physical components can be pitted against the desire to continue various forms of audience participation.

Reconstructions are necessarily based on a constellation of statements and documents—with photographs and other information providing the source for both the re-creation of the work and critical interpretations that seek to articulate what type of experience it should engender for the audience. This process opens onto the issue of artistic intent, the reading of which becomes

particularly significant but also problematic when a work of art is not identified with an enduring physical object. Production and interpretation, rather than constituting separate realms of activity, become increasingly interwoven, since decisions about how to recreate ephemeral or situational work are motivated by an evolving understanding of the work's original significance. And the feedback loop continues, since each new version further alters the interpretation of the work, such that it is impossible to disentangle the history of reception from the production of what is there to be received.

Authority and desire

As situation-specific projects have become historically important, the mounting pressure, and desire, to have the work back so that it can be experienced again in the present has meant that institutions have increasingly gotten into the business of fabricating anew even certain examples of historical work on display. This approach is in some respects a logical outgrowth of the strategy, ever-more frequent since the 1960s, of inviting artists to create work for a particular context. Questions remain, however, about when it is acceptable to remake art and when not, as well as who should determine what form the remake should take. What the artist wants to authorize may be at odds with the curator's interpretation of a historical example. And posthumously created works raise still other issues about the delegation of artistic authorship.

Artistic appropriation is part of the mix as well, given the various forms of remaking that have appeared under the guise of another artist's authorship. Even artists not traditionally associated with this strategy have taken on the idea of the remake—as indicated, for example, by Abramović's 2005 *Seven Easy Pieces*, when she restaged (and in the process significantly reinterpreted) now seminal works from the 1960s and 1970s by Bruce Nauman, Vito Acconci, Valie Export, Gina Pane, Joseph Beuys, and herself, before large art-world audiences during seven sequential nights at the Guggenheim Museum. Or there is Sturtevant's play off of Duchamp's *1,200 Coal Sacks*, responding to an installation that Duchamp originally created for the 1938 Paris Exposition

Internationale du Surrealism. Sturtevant reinterpreted the work under her own authorship, first in 1973, and on various subsequent occasions, including a 1992–3 exhibition that traveled to a number of venues, a 2004 retrospective, and the 2006 Whitney Biennial. Sturtevant's version replicated Duchamp's mass of coal bags hanging from the ceiling and the lit brazier on the floor but replaced the pieces by other artists that had originally lined the walls of the group exhibition with her own versions of works drawn from Duchamp's oeuvre—in the process transforming the installation into a pointed homage to Duchamp rather than a strict historical reconstruction.[22]

6. Sturtevant, *Duchamp 1200 Coal Bags*, 1973/1992. Installation view, Museum für Moderne Kunst, Frankfurt am Main, 2004. Photo: Axel Schneider.

When the act of quotation or homage is not initiated by an artist, however, it cannot be so readily assimilated within a critical discourse about appropriation's challenge to originality. Witness in particular the discomfort generated by a somewhat different endeavor from 2006, the New York gallery Triple Candie's unauthorized homage to Cady Noland, which presented reconstructed versions of her work from the 1980s and 1990s under the title *Cady Noland Approximately*. Shelly Bancroft and Peter

Nesbett of Triple Candie gave as their reason the resurgent interest in Noland, coupled with the relative unavailability of her work (and the provocative gesture was consistent with their slightly earlier *Unauthorized Retrospective* of the equally elusive David Hammons, presented via displayed photocopies of his work). In describing their versions as "approximations," Bancroft and Nesbett acknowledged limitations based on a lack of full information about materials or dimensions, practical constraints with respect to technical expertise or money, or problems locating the same readymade elements. It was, for example, limited resources that led them to substitute painted MDF for ink on aluminum for their version of *Untitled (Brick Wall)*, whereas the availability of components motivated their reconstruction of *Stockade* using current walkers and stanchion bases—with the latter substitution to some degree in keeping with the fact that Noland herself had

7. *Cady Noland Approximately*, at Triple Candie, 2006, showing approximations of *Stockade*, 1984/1987/2006 (pipes, "readymade" sign bases, walkers, metal basket, exit signs, accounting ledger forms and plastic covers, leather key strap, 45" × 143" × 30" and *Untitled (Brick Wall)*, 1993/2006 (Paint on MDF, 49½" × 97½"). Courtesy Triple Candie.

8. *David Hammons: The Unauthorized Retrospective*, at Triple Candie, 2006. Photocopies of reproductions of art works by David Hammons. Courtesy Triple Candie.

produced 1984 and 1987 versions with slightly different elements. The reconstructions were realized in collaboration with a team of four artists (two of whom chose to remain anonymous), but the driving force behind the exhibition was the gallery itself, deflecting the act of appropriation away from artistic gesture to curatorial desire.[23]

For curators faced with difficult negotiations around borrowing or reconstructing specific works they want for an exhibition, the ability simply to make their own version might seem like a nice way to streamline the process. Generally such license is not an option. In the case of posthumous remakes, however, the artist's authority over fabrication or editions can also be legally delegated to the artist's heirs or estate. When such authority extends to the realization of works that the artist never had a chance to complete, it is particularly difficult to disentangle arguments about what the

artist would have wanted from an ongoing process of interpretation exercised by later audiences.

This aspect of Rodin's *Gates of Hell*, which Rosalind Krauss described as a multiple without an original, was part of her articulation of issues central to postmodernism's critique of originality. The specific occasion of her observations was the making of the fifth posthumous cast of the *Gates* for a 1981 exhibition at the National Gallery in Washington. Given the relatively recent dates on a number of the bronzes in the exhibition, and the fact that the cast of the *Gates* was made specially for that show, the notion of renewal suggested by the show's title, *Rodin Rediscovered*, took on decidedly interesting overtones. Krauss also managed to provoke a public exchange with Albert Elsen by positing the idea that this recent production might constitute the "making of a fake" due to the fact that the plaster on which it was based was neither finalized nor cast during Rodin's lifetime. Yet she pointed to an authority that does verify the work's authenticity, in the form of Rodin's bequest to the French state of the right to edition his work.[24] Thus the state had the authority to exercise an extension of artistic authorship with respect to this continuation of his production.

Moreover, this authority provided the financial basis for the Musée Rodin in Paris, and therefore made the museum dependent upon the ongoing production of new, posthumous originals of the work it is charged with preserving. While there have clearly been many forces at work in the various campaigns to cast the *Gates*, from the first ten years after Rodin's death, to the fifth at the time of the National Gallery exhibition in 1981, an obvious reason for wanting the work cast would be its central place in his production—and the consequent desire to have that crucial work present in a tangible, finished form. Nor does it seem coincidental that the fifth version, made for the National Gallery exhibition with Gerald Cantor backing, is now installed in the Cantor Arts Center at Stanford University, as part of a Rodin collection touted as second only to that of the Musée Rodin. Cantor had good reason to sponsor the production of this major work, since without the version of the cast made under his auspices his collection would have been notably incomplete.

In fact it is often a specific exhibition that generates the momentum to realize a major work, a dynamic that applies both to works created during the artist's lifetime and to posthumous

efforts. Witness, for example, the appearance of a pair of newly carved marble reflecting pools in front of the exhibition of Felix Gonzalez-Torres' work in the US pavilion at the 2007 Venice Biennale. Their creation was supported by various sketches drawn by Gonzalez-Torres for different versions that he did not have the opportunity to carry out during his lifetime, and another key factor was his overall reliance on conceptually driven strategies involving the delegation of production and installation decisions. According to curator Nancy Spector, however, the artist's plans had remained open-ended in significant respects, with neither the final dimensions nor white Carrara marble explicitly specified. Spector's desire to see the work realized was obviously connected to her close working relationship with Gonzalez-Torres during his lifetime, but the specific occasion was provided by this particular exhibition, which was in turn anchored by the major outdoor sculpture in front of the pavilion.[25]

The reflecting pools are only one example in an extended line of new works by sometimes long-deceased artists—all of which necessarily raise questions of both authority and motivation. Only two years before, another large-scale object entitled *Floating Island* was realized in conjunction with the Whitney Museum's 2005 Robert Smithson retrospective, on the basis of a drawing made by Smithson in 1970. Yet what exactly prompted the push to see the work realized after many years in limbo? Smithson's 1970 drawing, labeled "Floating Island to Travel Around Manhattan Island" indicated the schematic outline of an idea in which certain specific points are intermixed with far more generalized indications: labels indicate "weeping willow," "trees common to the region," "path," "bushes," "moss," "rock," "earth," "barge," "tug," and "NYC skyline," yet much is also left to the imagination as to how this concept might be finalized. The floating island's production was the result of a collaborative effort by multiple individuals and entities, including the Whitney, the Minetta Brook organization, the artist Nancy Holt (Smithson's widow and also his executor), and the James Cohan Gallery (the last being both the representative for the estate and the party responsible for raising or contributing much of the $200,000 needed to achieve the island's nine-day existence).

Had Smithson lived long enough to see the work constructed (and had he remained interested in its realization while pursing the additional work presumably cut short by his death in 1973),

9. *Floating Island*, 2005, based on a 1970 drawing by Robert Smithson. Photo: Martha Buskirk.

then he would have been able to fill in the various particulars left unresolved in the drawing through which he recorded his conception for this itinerant land mass. Because the drawing, read as a statement of artistic intent, is mute on significant details, many points remained open, including the need to figure out basic technical requirements and other decisions where its construction involved a significant amount of interpretation. Ultimate authority was maintained by Holt, who has been deeply involved in posthumously shaping Smithson's body of work. In addition to making final decisions about the trees, Holt exercised her interpretive mandate to insist that the work be attractive to birds, with a final scattering of birdseed only one of many details not explicitly specified in Smithson's 1970 drawing.[26]

In fact 2005 seemed to be a particularly good year for creating works from 1970, given the repeat visit that same year of Blinky Palermo's *Blue/Yellow/White/Red*, a wall painting that was originally executed for a 1970 exhibition that brought artists from Düsseldorf to the Edinburgh College of Art. *Strategy: Get Arts* (the

relatively awkward locution justified by its status as a palindrome) presented some works transported for that purpose, among them Joseph Beuys's 1969 *The Pack*, and many more that were made on site, including those within the entry and stairwell. Photos taken

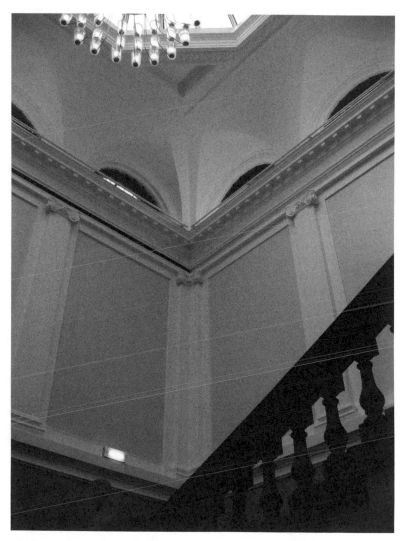

10. Reconstruction of Blinky Palermo, *Blue/Yellow/White/Red*, 1970, at Edinburgh College of Art, 2005. Photo: Martha Buskirk.

during the installation show Palermo high up on a rather alarming extension ladder, making his way around the moldings at the top of the stairwell space, in the course of painting the narrow bands of blue, yellow, white and red, one per wall, indicated by the work's title. Furthermore, anyone wanting to look up to see the Palermo first had to navigate past Klaus Rinke's water jets installed in the lobby and Stefan Wewerka's scattering of broken chairs on the staircase (made on site with help from participants who collaborated in the act of furniture demolition called for by the artist).

Like the other wall drawings or paintings Palermo created during his brief career, *Blue/Yellow/White/Red* was painted over after the exhibition closed, and could therefore only be imagined through photos (many of them in black and white) and Palermo's schematic drawings. More than three decades after its disappearance, however, the Edinburgh College of Arts embarked upon a scheme to bring the work back. The initiative, dubbed "Palermo Restore," was tasked with exploring the feasibility of reconstituting the wall painting—whether by somehow returning to the original, long buried under successive layers of paint, or remaking the work.

In some respects the conditions remained auspicious for its re-creation: the institution is still there and presumably performing largely the same functions as it did at the time of the 1970 exhibition, and the stairwell itself is physically intact, having thereby maintained its readiness, with a minimum of intervention or reconfiguration, to host the renewal of the primary color bands. Yet the contrast between the matter-of-course decision to paint over the original installation at the end of the 1970 exhibition and the considerable attention given to bringing it back points to the dramatically changed coordinates within which the work—which therefore has no possibility of being the same work—might be realized. Despite its monochrome surfaces, the original Palermo wall painting carried the mystique of the artist's own hand in its creation. Even if there were enough time and money to reveal that early layer of paint, however, there is the question of where the process of restoration would stop. Given that it played off the existing wall, perhaps retrieving the paint in the stairwell would be important as well? And what about the broken chairs and troublesome waterworks that contributed to the idea of an aggressive intervention? Nor was the initial work a permanent

project, so any decision to give it a more enduring existence would involve a radical change in the conception of the work.

One facet of "Palermo Restore" was a two-day conference convened to discuss the potential for reinstating the work. Yet participants were greeted by a surprise decision to take advantage of scaffolding already set up to repaint the interior of the stairwell, and have the Palermo reinstituted as well via a fresh application of color paint. Labeling the new bands of red, yellow, blue, and white a "reconstruction" to some extent evaded the issue of whether the anonymous application of the same basic colors, in the same space, actually constituted the work of art in question. To a large extent, however, applying a fresh coat of paint not only to the former bands of color but to the entire (and therefore now entirely pristine) stairwell simply confirms that the wall painting thus produced has no possibility of being the work once enmeshed in the context of a Düsseldorf art scene temporarily transported to Edinburgh. Rather, its new context is defined by current readings of Blinky Palermo, maker of various types of works, all of which are important to the present construction of the artist. The project therefore has as much to do with the early twenty-first century as it does with a temporary and long-effaced work of 1970.

At least there was an initial work of art to serve as a guide, however. By comparison, the realization of Smithson's *Floating Island* seems even more tenuously connected to the artist. Yet the urge to see it was only heightened by the experience of the Whitney retrospective and the overwhelming impression it conveyed of an incomplete project—curtailed in the sense that it presented the work of an artist just beginning to hit his stride, and also inherently partial as a museum exhibition, given the central role of key earthworks that were represented in the Whitney only through photographs as well as the various films that constituted a significant part of the exhibition.

Questions about why it seemed important to see the island were brought to the fore, however, by the fact that it was sometimes rather difficult to find. There had been warnings of potential delays in its scheduled rounds, and when it did not motor past the lower tip of Manhattan at its allotted time, the experience of scanning the expanse of sun-reflecting harbor looking for signs of a tugboat and floating trees suggested the inadvertent performance of another work—the sun-blinding effect Joseph Mallord William Turner

evoked in his 1828/37 *Regulus* (where he used the glare of sun and water to evoke the experience of a Roman general punished by the Carthaginians by having his eyelids removed). But luckily the wayward island did have several longer stops, including an appearance at a west side pier, where the extended viewing window gave the tugboat captain time to make it pirouette for the assembled crowd. And even though the status of the 2005 *Floating Island* seems ambiguous at best, tracking it down provided a certain sense of fulfillment after the necessarily incomplete experience afforded by the museum retrospective.[27]

It is also important to recognize that there are many additional ways, far more subtle in their operation than the creation of the *Floating Island*, by which the construction of Smithson's oeuvre has continued after his death—particularly via archival photographs related to his various projects that have been released, not just for scholarly purposes, but also in the form of editions, with images taken by him as well as others now absorbed into his authorship.[28] The broader issue raised by these editions concerns what to make of a dynamic where the complete works continue to be completed, in significant ways, after the artist's death. Of course it is also about money, both directly and indirectly, given the degree to which Smithson's oeuvre has been extended by posthumous editions of photographs of his work. There is no doubt that the island's nine-day journey helped publicize both the retrospective and Smithson's work in general, including recently minted photographs available for sale by the gallery representing Smithson's estate. There is also the unavoidable fact that the increasing availability, and visibility, of documents related to Smithson's various projects will continue to alter our conception of Smithson—with a desire to have a more complete record contributing to the interest in the work, but with the understanding thus produced reshaped by that desire.

The fabrication of Smithson's *Floating Island*, the reconstruction of Palermo's *Blue/Yellow/White/Red*, or the realization of Gonzalez-Torres' marble fountain all reflect the willingness to devote considerable energy and resources to the process of either creating or recreating work that might not have been subject to the same intense scrutiny had the artist lived longer, as well as the wish, when faced with this truncated production, to retrieve all that can be grasped in order to complete, in retrospect, a distressingly

incomplete project. The result is a multi-layered process of inter-pretation, where an assessment of what is important about an artist's work becomes the basis for an extension of its production, with changes to the body of work thereby contributing to a further process of reassessment. The work's present audience wants the work to be realized in order to experience it, yet the art thus created both conforms to and in subtle ways amends our present understanding of these historical projects. At its simplest, the idea that we will create the work because we want an opportunity to see it could be shortened to an even more concise bit of circular logic: we will create what we want to see.

Preservation (obsolescence)

Wholesale making or remaking presents a relatively obvious way that an artist's work may be shaped by retroactive imperatives; however, conservation practices in general involve a process of interpretation, where the goal of remaining true to the artist's original intent is framed by successive conceptions of the work. This process has the power, in turn, to alter expectations about an artist, particularly given the degree to which decisions may be driven by the prevailing aesthetic norms of succeeding eras. (It is important not to forget the now repudiated practices of adding missing bits to classical sculpture or extensively repainting damaged pictures.) With respect to contemporary examples, there are many ways that attention to the object itself, long associated with connoisseurship, is supplemented or sometimes almost entirely replaced by a focus on external statements made by the artist.

"The intentional fallacy" is the phrase enshrined by W. K. Wimsatt and Monroe Beardsley, in the context of New Criticism's emphasis on the importance of internal evidence contained in the work itself, "detached from the author at birth." Once out of the author's hands, they posit, the work lies beyond the author's "power to intend about it or control it," and belongs, instead, "to the public."[29] Yet, even if there is widespread lip service paid to the idea that a search for intent (including the notion that such state-ments provide a bridge to the artist's mind) reflects an outmoded romanticism, interviews and other statements by artists remain

central to the interpretation of contemporary art. To the degree that such declarations are understood as a performance of self, and therefore part of a larger discursive context (rather than as an assertion of essential truth), their appearance can be squared in some fashion with an anti-humanist stance. In many instances, however, expressions of intent are pursued with little reflection about what exactly is being requested when an artist is asked to define fundamental qualities of a work of art through a secondary statement.

In one major publication on the conservation of contemporary art, *Modern Art: Who Cares?*, terms like "meaning," "essence," and "intent" appear with some frequency, even though many of the works in question have been figured by critics as denying essence in favor of the simulacrum's play of decentered multiplicity. (Though granted how readily many works that were theorized as critiques of originality or authenticity have been absorbed into a market where such concepts have been maintained on functional or administrative levels, these returns need not be surprising.) And within the conservation arena, an assessment of intent is implicated in much more than a secondary critical judgment, since it can have far-reaching consequences for the treatment of the object itself. Hence the recent enthusiasm for direct contact between conservators and artists—in other words, a process of looking for evidence of intent by simply asking the artist for a statement of such.[30] The artist's declaration may grant permission for various procedures of replacement or reconfiguration, in the face of an increasing array of potentially perishable materials and technologies, or the re-establishment of an initially site-specific arrangement.

It hardly seems coincidental that this approach has gained adherents against the backdrop of a generally heightened interest in artists' interviews and other such statements, which are now deeply enmeshed in the discursive field within which critical assessments of the work take shape. Yet it is always important to ask what authority is being consulted when these interviews are conducted, since the apparent goal is to get the artist to articulate something not evident in the work itself. One of the maddening, but also remarkable, qualities of interviews with Andy Warhol, for example, is his ability to stay in character—his consistent refusal to let down the façade, to step out from behind the curtain and tell the listener which part of his game is really serious. In Warhol's case,

his interviews can therefore be understood as an extension of his work rather than a commentary upon it, whereas the types of statements sought in the conservation context fall in the latter category. Should the interview subject be understood as someone playing the role of the artist (a constructed figure, therefore akin to Michel Foucault's author function)? And in the process, is it reasonable to expect the individual understood as the source of the art to be able simultaneously to stand outside it, in order to articulate an expression of intent in a form different than what is offered by the work in question?

An underlying temporal issue, evident in a tension between the moment of conception and an artist's involvement in the later history of the work, is equally critical. In *Modern Art: Who Cares?* the problem of this sort of lag is nicely addressed by the section on Tony Cragg's 1982 *One Space, Four Places*, regarding questions of how to stabilize or potentially replace a series of found and, by 1996, to varying degrees decaying objects strung together by the

11. Tony Cragg, *One Space, Four Places*, 1982. Mixed media; collection Van Abbemuseum. Courtesy Marian Goodman Gallery and Van Abbemuseum.

artist on welded iron frames. Discussing problems raised by having artists revisit their work, Jaap Guldemond emphasized the importance of an interview from the period of initial production, given the degree to which the artist's ideas may change over time.

When asked for his retrospective assessment, Cragg expressed similar reservations, indicating that his statement of intent would be irrelevant since his goals have been different at different times, and suggesting that the conservators should take responsibility for finding a professionally correct solution.[31] One of the interesting things about the use of the artist's statement in this case is Cragg's insistence that conservation decisions be made on the basis of an analysis of the work itself, rather than according to his directives; yet it took his directive to turn the attention back to the object in this fashion. This example from Cragg also indicates the larger challenge presented by the life of much contemporary work over time, where one often finds an inverse proportionality, with initially humble materials or gestures inspiring quite remarkable efforts to preserve bits of consumer culture flotsam and jetsam.

The Guggenheim's Variable Media Initiative is another project where the artist's interview plays a central role. The specific focus was motivated by the challenges presented by quick cycles of obsolescence for key components of technology-based works. One strategy, emphasized in a 2004 exhibition entitled *Seeing Double*, is emulation, where the original work is somehow recreated on newer equipment. Yet, for many works that took advantage of the new media of their era, an approach based on mimicking appearance but not underlying functionality would go against the very concept of the work. One example from the exhibition, Nam June Paik's *1965 TV Crown* (a television that he rewired to create a geometric oscillation on the screen through manipulation of the electron beam) was recreated with a contemporary television in 2000; but there was a general consensus that the work cannot be further migrated once cathode-ray tubes disappear completely.[32]

Another work included in the exhibition, Cory Arcangel's 2002 *I Shot Andy Warhol*, is even more specifically tied to a particular era of technology, already in a downward spiral of obsolescence when Arcangel took it up. In this case, the work involved a circa 1990 Nintendo Entertainment System, with a video game cartridge Arcangel hacked, leaving the principles of the game essentially unchanged, but switching the imagery to make Warhol the new

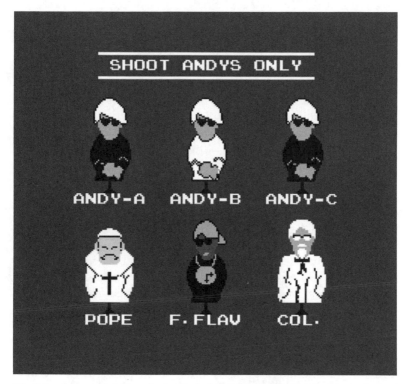

12. Cory Arcangel, *I Shot Andy Warhol*, 2002 (video still). Handmade hacked Hogan's Alley cartridge and Nintendo NES video game system. Courtesy the artist and Team Gallery.

target (within an array that also included the Pope, Flavor Flav, and Colonel Sanders), to be shot with a corresponding light gun. Arcangel draws a key distinction between a gallery display, where he would want the original Nintendo equipment, and the broader open-source culture of intervention and emulation, where others might continue to experiment with how the code could be modified or adapted to different contexts. And the reason we know exactly what Arcangel wants for the work in this case is because he has said so—in a 2004 interview that was part of the web-based record for *Seeing Double*.[33]

To the extent that the interview or statement serves as a guide to preservation as well as interpretation, it can be understood as extending the process of constructing the work that the artist has

already undertaken. And, if one follows this logic, conservators as well as curators, critics, and other art-world professionals participate in an elongated production process, thereby collaborating with the artist on the art presented under his or her authority. In this way, as in others, reception is inseparable from production that continues long after the ostensible moment of origin, potentially continuing to reshape the work encountered by later audiences. Such interventions hinge upon the related issue of who is authorized to speak for the artist. And it should also be recognized that many examples of contemporary art reflect the collective activities of assistants or fabricators, sometimes operating with a fair degree of autonomy, that are bundled together under the artist's authorship.

It seems equally clear that there is a fundamental contradiction in the search for original intent in order to preserve works where the longevity of the piece was not considered when it was first established. In other words, if the artist did not plan for the work to be a museum piece, then how can a claim against intention be lodged as the basis for its preservation? And a slightly different set of questions could be raised around issues of truth to original appearance versus respect for the natural properties of materials used by an artist, in situations where inherent material qualities can lead to dramatic alteration over time. Finally, there is the contradictory demand that an artist return to a past work, not to change it, but, rather, to make a series of new decisions about how to keep it the same.

From work to relic

To what degree is the audience supposed to look past a work's current state and somehow imagine the experience it should be having, if the object had remained unblemished by age as well as preservation strategies? And how does one determine when an object has decayed too much even to be considered a work? Some objects are relatively forgiving, whereas others have little margin of tolerance—evident, for example, in certain classic minimalist works or, more recently, in Jeff Koons' pristine examples of kitsch, where the impact is bound up with the presentation of an

immaculate surface that would be potentially compromised by any sort of patina acquired with age. For works that are altered, whether through a natural aging process or damage, the encounter can at some point shift from experiencing the work to witnessing a form of information, where a compromised object provides little more than a series of clues about how it might have once looked, often in conjunction with secondary documentation designed to convey another version of the same sort of data. Certain works are so transformed by time and circumstances as to raise the question, even though the object still exists, of how much change can be tolerated before it ceases to be a work and has to be reclassified as a relic.

One striking example is the 1963 series of murals Rothko painted for the Holyoke Center at Harvard University, using a form of red paint that turned out to be remarkably fugitive when exposed to the sunlight that suffused the penthouse dining room. In addition, there were tears in the canvas and other damage caused by accident or even outright vandalism to the unprotected surfaces. For all these reasons, the paintings were removed from their original installation and sent into storage in 1979, surfacing only briefly since in a 1988 show at Harvard, and a 2001 exhibition of Rothko's murals at the Beyeler Foundation in Basel. The alteration is particularly dramatic in the fourth and fifth panels, where the red has been entirely supplanted by shades of blue. Yet Carol Mancusi Ungaro, founding director of the Center for the Technical Study of Modern Art at Harvard and a leading figure in the study of conservation issues for contemporary work, has argued against dismissing them as relics, contending that they are simply an example (albeit an extreme one) of work that has faded or otherwise changed since its first appearance, but that may still be appreciated in its altered state.[34]

Under what circumstances might a work be remade, and what would be the status of the new object? And to what extent should an original object be put on display if preservation strategies are at odds with audience access (particularly evident for a material like latex, or certain photographic processes, where damage is significantly hastened by exposure to light)? Eva Hesse's work presents one of the more notorious examples of the potential consequences of experimenting with new materials, with long-term effects ranging from changes in color to far more drastic disintegration.

A round table in the catalogue for her 2002 retrospective grappled with these issues via a dialogue that included people who worked with Hesse in her studio, those who knew Hesse as friends, curators, and conservation experts. In her introduction, Ann Temkin suggested that the round table was made necessary by the lack of clear instructions from Hesse—with its mission apparently to replace the missing pronouncements by Hesse with a whole chorus of voices that could claim varying degrees of proximity to the artist.

One work too far gone to appear in the exhibition was Hesse's 1969 *Sans III*, comprised of latex and metal grommets forming a narrow row of box-like forms designed to hang in a single line between the wall and the floor, but subsequently disintegrated into separate and to varying degrees shapeless parts. For Bill Barrett, a former assistant to Hesse, a remake of *Sans III* would have the potential to show what Hesse had intended for the work, whereas he could not imagine showing what is left of the original object, except as a "study piece." He also posited different degrees of authenticity for remakes, suggesting that works initially made with the assistance of outside fabricators might be more validly remade (though with the caveat that the same fabricators used by Hesse should be employed).[35] Another work, *Metronomic Irregularity II*, has been refabricated on more than one occasion, seemingly because it has been judged too important not to exist. Or, as Sol LeWitt put it during the round table, "something ... is better than nothing," a contention that he amplified with the argument that the remakes provide an opportunity to see the work "freshly, and not as mummified remains."[36] Not surprisingly, however, there was no clear consensus about the status of the refabricated piece—including whether it could be sold by the estate as Hesse's work, or whether the remake (like the residue) should be understood as a study object rather than an official work.[37] Yet viewers presented with newly created "study objects" and substantially decayed examples alike are faced with the open question of how to bracket off the resulting impression—which would seem to involve bearing in mind that one's genuine encounter cannot be considered an actual experience of the work.

Seeing the work in the 2002 retrospective as it was installed at the San Francisco Museum of Modern Art inevitably involved a process of mental comparison, with no hope of encountering

the work suggested by often-reproduced photographs of *Sans II* and *Accession III* at the Fischbach Galley in 1968. Yet the steps taken to prevent further damage were in some respects as disconcerting as the work's material alteration—with *Accession*, for example, placed in the room in an approximation of the Fischbach configuration, yet entirely encased in a plexi box. Presumably one is supposed to edit out such protective measures, and imagine one's way into the experience one knows one is supposed to have (and it is therefore unsurprising that many of the photos released in conjunction with the exhibition showed the work without the protective case).[38]

"Museums are some of the worst offenders," says Robert Ryman about the general tendency to add protective barriers—and his response has taken the form of a preemptive notice attached to the backs of his canvases prohibiting the addition of "any element whatsoever, such as any sort of framing—either for protective or aesthetic effect," and indicating that, "if for any reason the painting cannot be installed exactly as the artist intends, then it is not to be exhibited."[39] Louise Lawler, on the other hand, has made such intrusions the subject of photographs that are part of her overall fascination with the different contexts within which art is both displayed and stored. Protective measures are a recurring theme, including a number of well-known works of art that have been set off behind barriers, or completely encased, with her images providing a subtle visual argument for the idea that such impediments do indeed transform the viewing experience. (And, given that our conception of the impact a work is supposed to have is often tied to certain iconic photographs of the work unencumbered by such measures, it is noteworthy that Lawler's counterpoint is mounted via the same medium.)

Consider the notion of misrecognition central to Arthur Danto's aesthetic theory, springing from his oft-recounted epiphany in front of Andy Warhol's *Brillo Boxes*, with the close resemblance between Warhol's silk-screened facsimiles and actual commercial objects suggesting a more pervasive breakdown of distinctions between art and everyday reality.[40] In the context of the 1964 Sable Gallery exhibition that spurred this line of thought, the boxes were simply arrayed in the space; but the intervening years have transformed these humorous provocations into rarified works of art that are often shown under close-fitting plexi shells. Protected from viewers

in this fashion, the four Warhol boxes captured by Lawler in her 2010/2011 *Plexi* are in no danger of being mistaken for actual cartons, despite the pseudo-casual stacking of the objects—and their changed status is only confirmed by an auction price of over two million dollars commanded by the specific set that she recorded.[41]

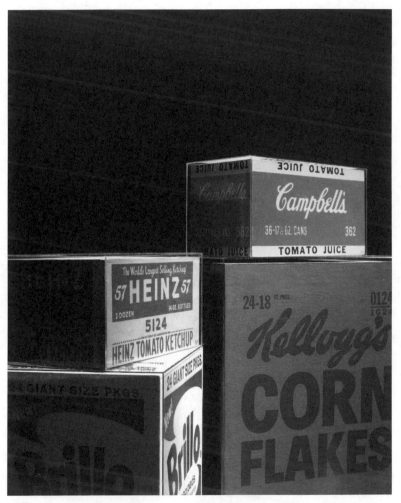

13. Louise Lawler, *Plexi*, 2010/2011. Direct cibachrome, mounted on 2″ museum box with ⅛″ plexi face, 51″ × 40¾″. Courtesy the artist.

Lawler recorded a similarly disconcerting effect in her 1998 *Painting and Sculpture*, where the plexi encasing Rauschenberg's *Monogram* creates a transparent barrier around a now subdued looking goat, or an earlier exploration of this same condition in her 1987 *Untitled*, where the animal is confronted with its reflected double. Given the fragile nature of Rauschenberg's early assemblies, such measures are perhaps inevitable, and can indeed be taken as signs of responsible stewardship over the pieces in question; yet, for an artist famous for his stated desire to work in the gap between art and life, this physical separation is inevitably linked to a sense of loss. Although a clear box around the object is by some measures only a slight change, it is just one of the incremental steps by which the viewer's experience of the work departs from some of the very characteristics that defined its initial reception. Or, alternately, it is simply the most evident marker of the art's dramatically elevated status.

And, finally, there is the question of what to do with the physical remains when a work is subject to such severe damage that its status as such can no longer be reasonably sustained. One highly charged example of this last problem was posed by the remnants of Alexander Calder's 1971 sculpture for the World Trade Center, his *WTC Stabile (Bent Propeller)*. The piece, which was installed in front of 7 World Trade Center, joined a list of artworks that includes a tapestry by Joan Miro, a wood relief by Louise Nevelson, and a sizeable collection of Rodin works in the offices of Cantor Fitzgerald, all of which were destroyed when the towers fell. Significant traces of only two of the major public works on the site survived the cataclysm. One, the sphere for the plaza fountain by Fritz Koenig, sustained damage that the artist did not feel could be reversed, and it has since been moved, in a still damaged state, to Battery Park to serve as a memorial.

Of the Calder, far less endured, and what does remain was preserved only because the artist's grandson made extensive efforts to get the construction crews on the site to watch out for the fragments. Apparently about half the material that made up the work was recovered. The grandson, Alexander Rower, who is also chair of the Calder Foundation, was quoted in 2002 press reports that he would want the piece restored if 85 percent of the material could be found. At the same time, others have maintained that the destruction itself carries such significance that the fragments of

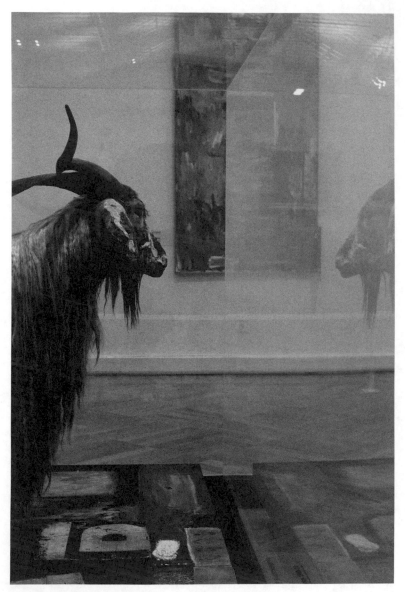

14. Louise Lawler, *Untitled*, 1987. Cibachrome, 27¾" × 39¼". Courtesy the artist.

this work should be maintained in their relic state. Given the total transformation to which the fragments would have to be subjected in order to be used to reconstitute the sculpture, it is not necessarily clear why they should be used at all, and why a certain threshold would have to be met for that use. In any case, plans to remake the work were subsequently dropped, leaving the fragments in the hands of the Port Authority, where they are part of a group of over a thousand preserved artifacts that derive their shared significance from how they were destroyed.[42]

Another relic is a bit more surprising, given that it involves a painting that was declared a total loss for insurance purposes even though the damage was less fully catastrophic. The work was one of the *Black Painting* series that Ad Reinhardt created between 1960 and 1966, using a five-by-five-foot format that is divided almost imperceptibly into a grid of nine squares. Like other monochrome or nearly monochrome works, these are paintings where the integrity of the uniform surface is central to their impact. In contrast to the reliance on industrial fabrication that characterizes many examples of minimalism, Reinhardt's works were brushed by hand, but both share the challenge a monochrome surface poses to localized conservation attempts. And Reinhardt's work presents the added fragility of a relatively matte surface achieved by leaching out much of the binder from his oil paints.

One example from this series was damaged while on loan during the mid-1990s. When conservation attempts proved unsuccessful, the insurance company paid off on the loss, and it was officially reclassified as an ex-painting. That left the AXA Art Insurance Company in possession of the remains, which the firm decided to donate to the Guggenheim Museum Study Collection, along with funding for a research project to analyze treatment options using the now decommissioned painting as the basis for this experimentation. In a further complication to the story, initial examination revealed that the work had been extensively repainted with acrylic in an earlier conservation procedure—meaning that its demise was actually incremental, with the prior loss of the surface Reinhardt had created brought to light by the further damage. Yet there is still the underlying fact that this painting, made by the artist, has been reclassified as a non-work for largely technical reasons.

15. *Imageless: The Scientific Study and Experimental Treatment of an Ad Reinhardt Black Painting*, 2008. Installation view, Solomon R. Guggenheim Museum, New York. © Solomon R. Guggenheim Foundation, New York. Photo: Kristopher McKay.

The extended effort devoted to the study of this work, however, reflects the importance accorded to Reinhardt's *Black Painting* series as a whole. And one wonders how firmly its reclassification will hold, given that the ex-painting was the focus of a 2008 exhibition at the Guggenheim Museum. *Imageless: The Scientific Study and Experimental Treatment of an Ad Reinhardt Black Painting* presented a painting that is officially no longer a work of art, on display in an art museum, yet presented there as a "study object." It is also hard to believe that the painting would have been so readily sacrificed if it were the only such work done by the artist, as opposed to the process of repetition dramatically evident in the final black square room of Reinhardt's Jewish Museum show in 1966. Indeed, discussions of the course of conservation experiments describe a process that will allow other similar works to be better preserved through the understanding gained from tests on the reclassified painting—with the obviously wounded canvas in this sense sacrificed for the good of the herd.

Present, absent

Regardless of the nature of the work in question, it is not uncommon to have the feeling that one is not able to access the same quality or intensity recounted by earlier viewers—with this sense of distance provoked by a whole host of factors that include changes to the object itself, transformed physical circumstances, and of course alterations in the expectations brought to the work by viewers. A sense of loss is, however, particularly pressing in relation to works designed to be ephemeral in the first place, and therefore accessible to later audiences only through documentation or reconstructions. But there are also instances where one is forced to conclude that no ideal moment of experience ever actually existed.

Members of an invited audience assembled on the lawn outside the Boston Museum of Fine Arts (MFA) in September 2005 came armed with varying degrees of advance information about the Zhang Huan performance they were about to behold. Some were aware of the call that had gone out for donated books or had heard about the curatorial scramble to find dog owners willing to volunteer their pets as participants. Others knew more generally about Zhang's reputation for solo feats of endurance as well as actions involving multiple participants. On this occasion, the audience had the opportunity to witness the naked, then partially clothed artist interact with an impressive heap of books in various ways—dragging a trail of books to a nearby flagpole flying an American flag and shimmying part way up, integrating himself into the tiers of the pyramid-like mound while assistants piled books upon him, climbing to its tenuous-looking peak, and becoming part of a large book worn open with his head sticking through an oval cut through its spine.

The performance of Zhang's 2005 *My Boston* took place outside the MFA at the same time that photographs from a previous performance at a German institution, his 2002 *Seeds of Hamburg*, from the Hamburg Kunstverein, were on display inside. The use of the museum as a venue for both production and display reflects Zhang's participation in an intersection of conceptual, performance, and site-specific practice, with the model of the itinerant artist as one of its operative terms. It is also interesting to think about this mode of intercontinental activity against the

16. Zhang Huan, *My Boston*, 2005. Performance, Museum of Fine Arts, Boston. © Zhang Huan Studio, courtesy The Pace Gallery. Photography courtesy the artist and The Pace Gallery.

backdrop of the global aspirations of the survey museum, including the sometimes uneasy place of non-Western art in its narrative structure. (In relation to this specific example, the Boston MFA has long been known for its strong Asian collections but acknowledged the existence of African art rather more recently.)

Despite stated reservations about the museum, Zhang's inclusion in P.S. 1's 1998 *Inside Out: New Chinese Art*, which presented documents from his earlier actions as well as his first US performance, set a pattern for subsequent performances, which by and large metamorphosed into museum-sponsored events.[43] The smooth assimilation of Zhang's work into this international dialogue nonetheless has the potential to mask the radical recontextualization of his practice, initiated in the context of Beijing's East Village, where the performances by Zhang and his contemporaries risked provoking arrests and confiscations. By his own account, however, Zhang turned away from painting (the focus of his early training) after he began to learn about avant-garde traditions in the US and Europe—though he has also insisted that his familiarity with related work by Burden and Abramović came a couple of years after his first performance in 1993.[44] While he doesn't say so, perhaps the importance of photography in the transmission of those earlier practices prompted his own care in documenting his activities—renting an expensive video camera from a TV station,

for example, to record his hour-long sojourn in a filthy public toilet for the 1994 *12 Square Meters*, where he was beset by flies attracted to the honey and fish juice with which he had covered his naked body.[45]

Staging the performances themselves in the museum, rather than exhibiting only documents, would seem to promise access to an immediate experience. Yet those lucky enough to be invited to the Boston event found the equation reversed. In the galleries, the sequence of still images from Zhang's *Seeds of Hamburg*, showing the artist in various positions within a mesh enclosure, his naked body covered in seeds that were clearly enticing to the pigeons released in the space, invited viewers to imagine an experience of duration and endurance through the unfolding and presumably unpredictable series of interactions the multiple views record. By contrast, the performance on the MFA lawn was unavoidably mediated by the process of documentation, since the action was far from smooth, and interrupted by frequent pauses that were essentially poses for the camera. The emphasis on performance as raw material for the photographs produced from it opened up the very real likelihood that the activity one might imagine from the still photos will be more compelling than the direct experience of the generating event—or a potential insufficiency of each, the photographs suggesting a rich series of actions nonetheless already past, and the performance compromised by the photographic intervention.

The very fact that this work was produced in the museum also speaks to a changing institutional landscape, altered by the assimilation of experimental work into its historical program (a process that frequently coincides with its market embrace). For performance-based work in particular, this extension of the museum's mission offers the possibility that the institution might play host to the work itself, rather than just documents and relics. Yet the reality that a work has been produced in, and with the active participation of, the museum does not in itself resolve potential contradictions that remain. Moreover, the evident ephemerality of performance is just one aspect of a larger set of challenges posed by art that has to be recreated or adapted to changing situations, as well as the related issue of physical objects that are transformed over time as a result of damage or inherent instability. In such situations, viewers are often faced with the job of navigating between statements

about the work's efficacy and present-tense experiences that can be significantly at odds with the idea that the work is supposed to embody.

Definitively unfinished

A somewhat different type of challenge appears when a work is never officially completed—with the questions such examples pose including the circumstances under which it is valid to exhibit fragmentary work. Marcel Duchamp provocatively declared his *Large Glass* definitively unfinished when he ceased working on it in 1923. In relation to most other works, however, there is the issue of when a manifestation crosses the line from raw material to art, with status questions only heightened when readymade elements are involved. For the Massachusetts Museum of Contemporary Art, this ambiguity became a pressing concern (and ultimately the subject of litigation) when an irresolvable conflict over *Training Ground for Democracy*, Christoph Büchel's ultimately unfinished installation that was supposed to open in December 2006, left the museum facing the question of what to do with residue that happened to include an entire movie theater, two-story house, mobile home, various vehicles, and stacks of shipping containers.

Overload in every sense was central to Büchel's agenda for the work. Taking inspiration from simulated environments used for military training, Büchel envisioned an installation for the museum's football field sized gallery that would be a site for audience role-playing with respect to the many different actions (participatory as well as potentially disruptive) that are components of a democratic society. And the list of materials Büchel needed to realize this vision was extensive, including, in addition to whole and partial buildings, such entries as a leaflet-bomb carousel, 8 voting booths, numerous used tires and old computers, 1,000 beverage cups from a race track, 1,000 feet of barbed wire, 12 grenades and 35 pounds of bullet casings, 8 body bags and 75 white protective suits, 4 prosthetic legs, decorations and campaign buttons from election rallies, a concession stand complete with popcorn and popcorn buckets, Christmas lights, 16 large bags of corn leaves and husks, and an airplane fuselage.[46]

During the initial phases of work in fall 2006, Büchel and various assistants were on site to work directly with the museum's team, but even then there were tensions over the decision-making process. In an internal email from October 2006, MASS MoCA director Joseph Thompson referred to his attempts to "move the project along" by "making a few decisions in [Büchel's] stead," and Büchel in turn complained about delays caused by having to redo parts of the installation that did not conform to his expectations.[47] Funding was also a major challenge, with the museum insisting that it was going way over budget, and therefore balking at Büchel's steadfast insistence on certain large-ticket items like the airplane fuselage.

After the opening had to be delayed past its original December 2006 date, however, the process broke down completely, with Büchel refusing to return until the museum agreed to meet key conditions, and the museum nonetheless continuing to proceed ahead with their own interpretation of his wishes. In a January 2007 email to Thompson with the subject line "thoughts on the Buchel Debacle," curator Susan Cross wrote, "MASS MoCA makes so much work here, that I think we tend to forget that whether we're doing the welding or not, there is an 'author'—an artist for whom we shouldn't make decisions."[48] As late as February 2007, however, Thompson was still telling his staff to continue working on components where they were "80% sure" they were following Büchel's wishes, even as his production manager protested that "Going ahead with some of these requests treads on ground that Buchel asked us to stay away from," and further, that "if the artist does not return, there is no artwork."[49]

Information revealed as part of the legal proceedings indicates that Büchel did not take a fee for himself, but expected the museum to pay his crew of assistants and to assume responsibility for all other aspects of the financing. In many respects the process was standard for this type of large-scale project, with the museum responsible for much of the actual construction and assembly, according to the instructions and specifications of the artist; but it was also atypical in the absence of a contract between artist and institution spelling out budget and obligations, and that lack of clarity only escalated as work proceeded.

The museum's requests for financial support from Büchel's galleries became one of the bones of contention, with Büchel insisting that they not tap this source, since half of any funds that his galleries advanced would be born by the artist (presumably

taken out of his share of future sales). On its part, the museum apparently entered into the project without having secured any external funding sources, and did request backing from Büchel's galleries, despite his objections. If galleries are often prepared to help fund museum projects by artists they represent, this willingness clearly reflects not only the value of the associated prestige, but also the fact that a certain amount of what appears in the museum often cycles back into the commercial world.

Although material from the work that the museum put into storage was not returned to Büchel until after the artist and museum reached a final settlement in late 2010, Büchel did conceive an alternate version of the work, *Training Ground for Training Ground for Democracy*, which was exhibited as an installation in the Hauser & Wirth booth at Art Basel Miami Beach in December 2007, acquired by collector Friedrich Christian Flick, and then donated with remarkable alacrity as part of a major gift to the contemporary branch of Berlin's Nationalgalerie (the Hamburger Bahnhof—Museum für Gegenwart) that was announced in February 2008.[50] At the same 2007 art fair, the Maccarone gallery helped fan the flames of press attention by exhibiting email correspondence between the artist and museum that laid bare the disintegration of the relationship.

Training Ground for Training Ground for Democracy provided some hints of the dense interface of political and cultural references that Büchel was hoping to achieve with the larger project. Organized in and around the tight confines of a shipping container, the installation presented a remarkable range of material. Voting, along with disenfranchisement, was one immediately evident theme, announced at the entrance by the juxtaposition of a US "vote here" sign and a bicycle hung, homeless-style, with stuffed plastic shopping bags, and continuing on the interior with examples of the Florida voting machines infamous for the hanging chads that allowed George W. Bush to claim victory in the 2000 presidential election. Other elements included (but were certainly not limited to) various televisions showing both cartoons and news broadcasts, American flags, children's drawings, multi-season holiday materials (a Christmas tree, Santa hats, and an array of fireworks), helium balloons, and within a chain-link enclosure on the second level (reachable by ladder), a bomb suspended over the festive but also grotesque remains of a holiday picnic made up mostly of processed junk food.

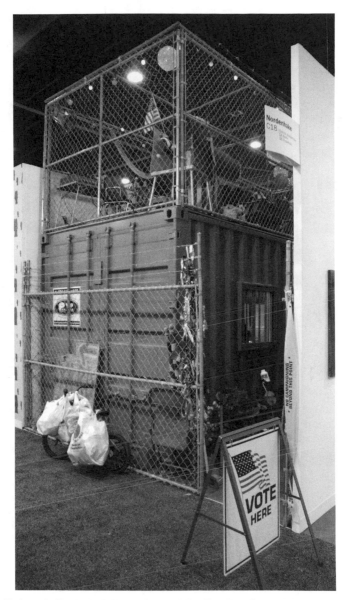

17. Christoph Büchel, *Training Ground for Training Ground for Democracy*, 2007. Installation view, Art Basel Miami Beach, 450 × 400 × 800 cm. Courtesy the artist and Nationalgalerie, Staatliche Museen zu Berlin / gift of the Friedrich Christian Flick Collection/DE.

18 and 19. Christoph Büchel, *Training Ground for Training Ground for Democracy*, 2007: interior details.

MASS MoCA, on the other hand, never progressed to the point of having a completed work, and, as the impasse became insurmountable, the museum was faced with what to do about the colossal unfinished installation occupying their major exhibition hall for months on end. Around the time the show was officially cancelled in May 2007, the museum threw up some tarps over parts of the accumulation and opened a show at the far end (*Made at MASS MoCA*) with documents of previous installations

that had not ended so badly. In the same May 22, 2007 press release announcing the cancellation of Büchel's exhibition and plans to open *Made at MASS MoCA*, the museum also divulged its surprising decision to file a lawsuit against the artist seeking permission to display the residue of the unfinished installation to the public.

Although the US District Court in Massachusetts ruled in the museum's favor in September 2007, the museum decided at that point to end its controversial quest to show the unfinished work, and, almost a full year after construction had begun, proceeded to empty out the gallery. According to the district court, "nothing in MASS MoCA's planned display of the unfinished installation would have violated Büchel's right of integrity, for the simple reason that no completed work of art ever existed … for the museum to distort, mutilate or modify." But the disassembly of the installation did not bring an end to the legal actions. In a partial reversal of the district court decision, the US Court of Appeals for the First Circuit found in 2010 that the moral rights protections of the 1990 Visual Artists Rights Act (VARA) could apply even to works that are not yet complete, and it emphasized, in particular, that the museum's continued modification of the installation, despite Büchel's objections, could be construed as detrimental to the artist's honor or reputation. Yet the appeals court also noted clear ambiguity about who could claim to own the work in its unfinished state, and therefore who had the right, under the US Copyright Act, to make decisions about its public display.

Legal scholar Virginia Rutledge has pointed out the irony of MASS MoCA's reliance on two different, mutually exclusive theories to argue against the artist's quest for VARA protection: first, that the materials themselves did not contain sufficient original expression for copyright protection, and second, that due to the collaborative process, MASS MoCA owned the work's copyright jointly with the artist.[51] Yet the artist's response straddled two positions as well. According to one way of thinking, the assembly was never art at all, since the artist disowned the unfinished installation. Yet it had to be understood as a work, albeit incomplete, for Büchel to make a legal argument that he should be able to prevent public display of its extensive material remains.

In retrospect

The Büchel installation essentially crashed before takeoff, never achieving liftoff as a realized work of art. Many other situations, however, are characterized by far more subtle tensions, which only become apparent over time, as ideas about a work's importance or impact begin to deviate in crucial respects from its physical configuration. While conceptual practices of the 1960s and 1970s made the potential divergence of idea and object an explicit part of their program, there are many other circumstances where the definition of the work is by no means a given. Related to this area of potential ambiguity are questions about how a work is constituted as such—including the initial act of creation and the artist's involvement in subsequent decisions. In particular, there is the issue of what happens in the space between what a work is presumed to communicate and a later audience's experience of a compromised original.

For work that enters a museum's purview, preservation is about more than simply stabilizing the physical object, since it also reflects a general goal of bringing all of the objects in the collection into a similar state, despite aging and histories of ownership that may have left some in very different conditions than others. In the process, evidence of an object's intervening history may be smoothed away in favor of the uniform neutrality of the now-standard pristine surface viewers have come to expect of museum material. And the degree to which art museums have been going into the business of making the work on display is equally striking—whether through the increasingly common procedure of inviting artists to respond to the circumstances at hand, or by remaking earlier works for retrospective exhibitions. Work that has to be reinstalled, remade, or otherwise transferred is both particularly subject to changing assumptions and, at the same time, able to evade history. Rather than being constituted by a continuous physical object, the work has to be established anew, and is therefore inseparable from an ongoing process of reinterpretation. And for work not planned as permanent, any decision to return it to a permanent existence involves a change in definition that is in some respects just as radical as the shift in status that jettisoned one of Reinhardt's black paintings from his oeuvre.

The other part of this equation is the audience, and it is inter-esting to note how statements by the artist that define the work, or indicate how it should address the viewer, can begin to slip, at times almost imperceptibly, into assertions about how the audience should expect to perceive it. Artists, historians, and curators all participate in different ways in a process of telling viewers what they should expect to experience—with a crude extreme particu-larly evident in certain heavy-handed forms of wall labeling. Yet the idea that an encounter might be free from all taints of secondary information is an obvious impossibility, as is a spectator without any frame of reference, since walking into a museum or gallery, or even the very act of deciding to look, already implicates the viewer in a long history of conventions.

Obviously a great deal of interpretation is taking place behind the scenes, as curators and conservators use assessments regarding what is significant about an artist's work in order to make decisions about the very objects that will then form the basis for the artist's continued reception. A larger set of questions concerns why these measures are being taken in the first place, which goes back to the issue of what we, the new audience for art identified with an earlier moment, want from the work, and how these expectations inevitably shape each new presentation of work shown to contem-porary audiences because of its perceived historical value. At issue is not just the artist's original intent, but rather an assertion about the work's importance bound up with its evolving present-tense significance.

There is a tightly bound circle of activities that includes the sometimes heroic measures taken to restore past works operating in tandem with the growing popularity of collaborative efforts between institutions and artists to create new works that are only likely to be realized with such support. A particularly striking aspect of all these ventures is the expenditure of tremendous energy and resources both into the preservation of past works (frequently in inverse proportion to the initial concern for longevity) and the creation of new work that could not be produced without institu-tional backing and collaborative effort.

Regardless of the nature of the work, assertions about meaning are inseparable from an extended process of reception. Yet claims made for art that is physically malleable further tighten the feedback loop, given the impact of such interpretations on future

configurations of the work in question. Ongoing investments in care and preservation are linked to this process of assessment as well, with the major initiatives taken in relation to certain works reflecting a vastly unequal distribution of interest and attention. Specific works are singled out for such treatment because of their perceived value (both monetary and cultural), but the equation works in reverse as well, since evidence of the work's importance can be found in the volume of resources poured into its preservation or re-creation.

Rebranding the readymade

In the video, a tastefully dressed woman enters a therapist's office and, after brief preliminaries, is presented with a series of slogans from major companies that she is asked to identify. She correctly identifies the first several entries ("Think different"—Apple; "Invent"—Hewlett Packard; "Imagination at work"—General Electric), but fails to make connections for others ("Change the way you see the world"—"no"; "Where imagination begins"—"not sure about that"). "How do you capture imagination?" is the final entry on the list, to which she responds "I don't know."

Carey Young's 2007 *Product Recall* evokes the classic psychoanalytic technique of free association, yet in a completely bowdlerized form, since the premise of an open-ended series of intuitive insights has been supplanted by a predetermined agenda based on right or wrong answers, in a scenario designed to demonstrate how the language of imagination has been claimed for promotional ends. With familiarity based on constant media repetition, the underlying strategy has more to do with Pavlovian conditioning than exploration, a marketplace version of basic animal reinforcement. And Young's version of this scenario relies on a knowing audience's double recognition, of corporate rhetoric and the psychoanalytic encounter, further nuanced by socio-economic clues provided by

the well-appointed therapist's office, marked by its refined juxtaposition of traditional patterned carpets and a classically modernist Le Corbusier recliner. With its subtle but pointed series of references and associations, however, the scenario also needs to be understood in relation to an already long history of artistic engagement with commercial imagery or strategies, including the absorption of each move in turn by the specialized market system of the art world.

1. Carey Young, *Product Recall*, 2007. Video (single channel: color, sound), 4:27 minutes; actor: Morgan Deare; camera: Peter Emery; sound: Dave Hunt. © Carey Young. Courtesy Paula Cooper Gallery, New York.

For Young, *Product Recall* is part of a longstanding interest in corporate tactics and language, based on a combination of mimicry and misuse that moves in and out of both art and corporate or commercial spaces. "I am a revolutionary" was Young's ostensible claim in a 2001 video-taped performance of that title—but with the declaration made visible as empty rhetoric through repetition, as she takes personal training from a corporate speech coach who helps her practice breaking down her delivery and intonation of the line in question. She has also created works using call centers, harnessed scientific expertise to calculate the commodity value of her body's constitutive elements, and collaborated with legal professionals to create pointedly coercive contracts between artist

and audience. In the case of *Product Recall*, the interweaving of art and commerce is further nuanced by the fact that the companies chosen by Young not only promote themselves with slogans evoking inspiration or creativity, but have all used various forms of art sponsorship to bolster their global branding and identity.[1] Young's turn on institutional critique brings home the point that it has become ever harder to distinguish between artistic activity and other forms of commerce or production, even as the residual separation is what gives works of art their cultural and commercial authority.

The relationship between art and commerce has to be understood as a constantly moving target, perhaps best envisioned in relation to Pierre Bourdieu's formulation of separate yet homologous fields, each operating according to its own continually evolving set of conditions, at the same time that they share structural parallels. Neither a modernist vision of advanced art as willfully aloof from the popular appeal of commercial culture nor the idea of a one-way process of referencing suggested by early readings of pop art has much to offer in the context of a commerce-driven art world that is shaped by the relentless pressure of stratospheric prices, even as it is revitalized by continual attempts to carve out small pockets of resistance, or at least critical distance.

While there can be no doubt that cultural engagement continues to reflect economic and educational disparities, it is difficult to make broad delineations in the context of a deeply engrained consumer culture that has produced a public highly attuned to commercial branding strategies across the market spectrum. Indeed, a demonstration of how much the coordinates have changed in recent decades is one potent message to be drawn from a contemporary reading of Bourdieu's classic study *Distinction*, with its exploration of correlations between class or educational background and cultural taste based on data from surveys carried out in France in the 1960s. Unsurprisingly, those with greater access to education, or cultural capital, were more likely to express an affinity for difficult works, where formal experimentation holds the spectator at a distance, whereas working-class respondents were drawn to conventional forms "based on the affirmation of the continuity between art and life."[2]

But Bourdieu was the first to recognize that these were hardly fixed categories, founded as they were on data reflecting a particular

cultural and historical moment in France, when already tenuous divisions based on social class or education levels had the potential to be trumped by generational differences. The fact that his description of working-class culture sounds a lot like the frequently espoused avant-garde desire to break down distinctions between art and life might suggest its potential to stand the hierarchy on its head. Yet what has emerged since the 1960s is far more ambiguous, as certain types of exclusivity are maintained, often based on the ability of insiders to read layers of subtle reference in what might seem to the uninitiated like absurdly simple forms or gestures. In these circumstances, distinction is likely to be asserted not on the basis of an ability to appreciate difficult or inaccessible work, but rather the capacity to find complexity in the nuances of context, despite superficial familiarity.

"Like a debutant who expects to remain inconspicuous by wearing blue jeans to the ball" was the analogy Leo Steinberg used to characterize the unexpected appearance of common imagery in Jasper Johns' first one-person exhibition at the Castelli Gallery in 1958 (with strong reactions to the show guaranteed by the controversial appearance of Johns' *Target with Four Faces* on the January 1958 cover of *Art News*).[3] As the stuff and imagery of everyday life continued to flood into the galleries, and eventually museums, in the context of 1960s pop art, a double read was both its cover and its success. The mass appeal of the commodity was essentially imported intact, yet its appearance in a different, presumably exclusive, context suggested that there had to be something more, with that notion of simultaneous resemblance and disruption as the basis for readings of pop art as critique rather than simple affirmation.

The old cliché about having your cake and eating it too would be one way to describe the play with commodity imagery. If its appearance was supposed to constitute a blow against rare art traditions, it certainly did not undermine the attraction of the work in the upper reaches of the art marketplace. The 1973 sale of work from the art collection assembled by taxi magnate Robert Scull and his wife Ethel was a clear turning point, drawing widespread attention for the remarkable appreciation of pop and related works via an auction that totaled over $2.2 million, and marking the beginning of pop art's ascent to super-commodity status. Robert Rauschenberg famously confronted Scull with a

shove and the complaint "I've been working my ass off for you to make that profit?" after seeing his *Thaw*, sold for $900 in 1958, go for $85,000 in 1973.[4] But other artists were quick to recognize the boost the auction sale would give to prices for their ongoing production. With Robert Scull's brash personality signaling a new style of collector for art drawn from popular forms, the auction was a leading indicator of a market shift fully realized in the twenty-first century, when totals from the contemporary category at the major auction houses began to surpass the impressionist and modern sales.

In an account published shortly after the Scull sale, Barbara Rose despaired over an audience driven to a cheering frenzy, like the spectators at a sporting event, or, in another analogy, casino habitués, "gambling with nothing more than cultural pretensions." But her harshest invective was saved for the collectors themselves, whom she equated with the ethos of their art: "The Sculls are in many ways pop creations, 'living sculpture' if you like. It is not true that Mrs. Scull looked like a taxi in her specially designed Halston dress with the company insignia emblazoned on her torso; however, she was a walking advertisement." The Sculls, according to Rose, "learned everything they know from Andy Warhol." They were "banal," "*nouveau riche*," and embraced the idea that they were "lowbrow, déclassé, grasping, and publicity-seeking"; they were also "vulgar, loud, and overdressed," and "in short, shameless."[5] Yet Rose also pointed to Robert Scull's shrewd backing of the Green Gallery, directed by Richard Bellamy, as a source for inside information, in the context of a networked art world where Rose found that she, too, had been working on behalf of the collectors by writing about the artists whose work had increased in value by such leaps and bounds.

That system of social and professional activity has continued to expand in proportion to contemporary art's economic significance, as the idea that there might be money to be made investing in recent work is linked to expanded professional support systems and the increased importance of high-profile celebrity artists. A slightly later (and less immediately visible) marker of art's increasing commercial importance can be found in the art advisory service that Jeffrey Deitch co-founded for Citibank in 1979, with the goal of offering expert art advice to clients interested in building their personal collections, including contemporary art. Later, during his

highly successful run as a dealer, Deitch also became an art-world version of a venture capitalist, setting up a syndicate during the early 1990s to fund the fabrication of Jeff Koons' *Celebration* series. Even if the Koons enterprise was financially ruinous in the short term due to the extraordinary production costs and challenges associated with making colossal, shiny monuments out of initially humble objects like a balloon dog or a heart-shaped pendant (not to mention the extensive workshop-style team Koons assembled to realize the related paintings), Deitch's investment was subsequently validated by the incredible auction success of examples from the series.[6]

Whereas the work of other artists associated with 1980s appropriation was initially theorized as a critique of originality or authenticity claims and, by extension, an art market based on those principles, Koons was never circumspect about his desire for a broad appeal. In a 1986 discussion held at the Pat Hearne gallery, which was excerpted in *Flash Art* under the title "From Criticism to Complicity," Koons described his work in terms of accessibility. "I tell a story that is easy for anyone to enter into and on some level enjoy," Koons declared, though he found no need for this to block others who might "continue to deal in an art vocabulary ... because by all means I am not trying to exclude high-art vocabulary."[7] In a provocative reversal of terms, Koons therefore did not rule out the possibility that his high-end commodities based on kitschy objects and imagery might be described as art, but he left it to others to make that argument.

Breaking down distinctions between art and everyday life turns out to be easily conflated with intersections of art and commerce—and the lines are constantly erased and redrawn in unexpected ways. Koons and Young are both part of a spectrum that has opened up since pop art, with that earlier act of dislocation (commercial imagery imported into spaces where abstract painting had only recently reigned supreme) giving way to today's far more fragmented field. Given that Marcel Duchamp also looms over the contemporary engagement with appropriated forms or rhetoric, it is perhaps fitting to invoke his concept of the infra-thin to ponder what residual separation may still hold between art and commerce. Young's activities, in her guise of artist as business-suit-clad creative consultant, can be closely aligned with the unconventional marketing strategies of a networked experience economy, even as

she holds onto the idea of using mimicry as a form of critique or destabilization. Koons operates at a different extreme, where both his imagery and his production methods suggest a strong affinity with other forms of commercial luxury manufacture and celebrity branding, even as the artistic distinction of his work is affirmed by the neo-liberal measure of stunningly high auction prices.

Pop & Co.

Pop art's deployment of already extant commercial imagery undoubtedly owes a debt to the early twentieth-century readymade, but the products that invaded the artistic sphere in the 1960s were familiar as branded merchandise precisely because they were part of a postwar consumer culture driven by aggressive corporate marketing campaigns. Applied to the business itself or the goods sold within, the brand is both an assertion of quality and an appeal directly to the consumer. A major attraction is the freedom from specific ties to place: national chains promise a predictable experience, and repetition of the goods sold within different stores offers further continuity as well as a basis for comparison shopping.[8] Just listen to Andy Warhol, connoisseur of consumer iconography: "You can be watching TV and see Coca-Cola, and you can know that the President drinks Coke, Liz Taylor drinks Coke, and just think, you can drink Coke, too. A Coke is a Coke and no amount of money can get you a better Coke than the one the bum on the corner is drinking. All the Cokes are the same and all the Cokes are good."[9]

Commercial ubiquity is potentially fleeting, however, as Ed Ruscha recognized when he emphasized the difference between the relative timelessness of still life's traditional apple and the contemporaneity, but potentially soon-to-be obsolete qualities of a product: "I mean, people in a hundred years from now will say, 'What is this little thing that says "Spam" on it? What's Spam?'"[10] Yet art can accord a degree of immortality to otherwise transitory forms of trade dress, with Warhol's image multiplication undoubtedly helping to sustain the appeal of what would now be described as classic Coca-Cola or Campbell's Soup packaging. And Ruscha accorded Spam a similar honor in his 1962 painting

Actual Size, where he played the representation of a 12 oz. Spam can, painted in the lower register carefully true to size (though with the added attribute of flames that make it seem to shoot across the field), against the large word across the top of the canvas. In this context, "actual size" was both a literal description and a reference to one of the restrictions Ruscha placed on his representation of objects during this period. By contrast, words were for him a subject that had no specific dimensions: "What size is a word, after all? Is it six-point, is it twelve-point, or is it as big as the wall?"[11]

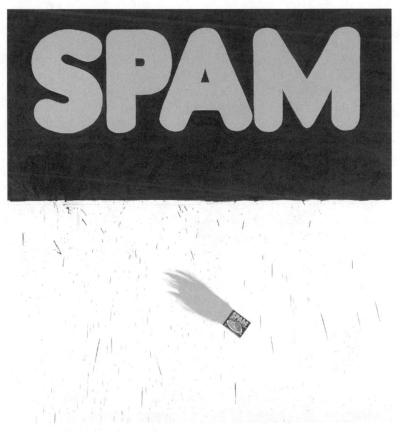

2. Ed Ruscha, *Actual Size*, 1962. Oil on canvas, 67¹⁄₁₆" × 72¹⁄₁₆" © Ed Ruscha. Courtesy Gagosian Gallery.

For later audiences, appreciating a work based on commercial imagery reflects parallel tracks, where the relative familiarity (or obscurity) of a product motif will alter how viewers react, in ways that are to some degree independent of the general reception accorded to the artist's work. In the case of Spam, Ruscha was obviously far too pessimistic in his prediction of its disappearance, given that the name has come to stand for so much more than the trademark for a particular brand of tinned ham. Introduced in the 1930s, the foodstuff gained its initial renown from the millions of pounds shipped as part of World War II rations and aid programs. And broader popular culture associations were already present when the artist turned his attention to the icon. Walter Hopps, discussing *Actual Size* with Ruscha, connected the Spam, "flying through space like a rocket," with the early astronauts "referred to as being in a can of Spam up there in space."[12] Even as consumption of the product remains significant primarily in regions of the world without reliable refrigeration, Spam's appearance in one of Monty Python's best-known segments, its immortalization as the name given to the proliferation of unwanted commercial email messages, and its return engagement in the Monty Python musical *Spamalot* have ensured a familiarity that far outpaces current market penetration.[13] Another way of looking at the contrast Ruscha established between the actual-sized representation and the looming text above is therefore as an evocation of the potential difference between a specific example of this product and the tremendous recognition enjoyed by the brand name itself.

Claes Oldenburg's 1961 installation and performance known as the *Store* provided a different sort of demonstration of how a fascination with the consumer marketplace might extend well beyond the goods themselves. The alternative retail environment, created in a storefront on Manhattan's lower east side, was fully stocked with unexpected versions of such familiar items as shirts, tennis shoes, or the piece of cake that Oldenburg seems to be about to present to the viewer in one of the iconic photos of the artist in the installation, all made from plaster-soaked muslin wrapped over wire armatures and painted with brightly colored enamels. In fact the objects were for sale to anyone with enough foresight to pay a significant premium for nonfunctional versions of otherwise familiar goods: inelegant store-style prices (as opposed to the tasteful, rounded-off numbers favored by galleries) ranged from $21.79 for an oval

photograph to $899.95 for a free-standing bride manikin, and total sales amounted to $1655 against expenses of around $400.[14] Only a couple of years later, Gerhard Richter and Konrad Lueg made their own foray outside the gallery system when they used the Berges Furniture Store in Düsseldorf to present their 1963 *Living with Pop: A Demonstration for Capitalist Realism*. Under the banner of capitalist realism (an obvious play off of the socialist realism that dominated Richter's early East German training) they thus took over the West German furniture department store for a single evening event that filled the space with a series of different interventions in the displays of domestic furnishings, establishing a progression that culminated in a presentation of the artists as living sculptures, mounted on chairs raised on pedestal-like platforms.[15]

On Richter's part, however, this performance was a relatively isolated intervention by an artist much more identified with painting (and in that sense traditional gallery objects), while his partner in the endeavor went on, under the name of Konrad Fischer, to become one of the major German art dealers associated with contemporary art of this period. And Oldenburg's *Store* remained tied to his gallery, which paid half the expenses and received a one-third commission on the portion of sales that exceeded Oldenburg's share of the operating costs.[16] Moreover, the next appearance of his store-like works was in a more traditional exhibition space, with his 1962 Green Gallery show juxtaposing small plaster and muslin sculptures akin those sold at the *Store* with giant stuffed fabric versions of familiar objects.

Nor is it difficult to find evidence of limits on overt forms of commerce within spaces devoted to the display of art. While working in New York during the 1960s, Yayoi Kusama began receiving attention for works that departed from pop art's engagement with the everyday by defamiliarizing common household objects through the application of a dense field of phallic protrusions. Invited to participate in the Venice Biennale in 1966, Kusama elaborated on this strategy of repetition by creating a site-specific installation entitled *Narcissus Garden*, made from 1,500 mirrored plastic balls distributed in an outdoor area of the Biennale grounds. The potentially interactive nature of the work did not stop there, however. Short on funds (in part because of the fact that her work had not been embraced by the increasingly enthusiastic market for American pop art) she posted signs that offered the silver balls for

sale at the price of two dollars each—an act of explicit, low-level, street-vendor-style commerce so horrifying to the Biennale organizers that they called in the police to tell her to stop.[17] In other words, there's refined art-world trade, which might involve works that make products their subject while mystifying the actual act of exchange, and then there is another, more evidently commercial kind, found in museum gift shops of course, but generally excluded from exhibition areas.

Pop art may have introduced a profusion of commodity images into the privileged realm of high culture, but despite certain actions that extended into other commercial zones, it did not follow that the selling of the work of art would actually function like a straight-forward retail transaction. For many of the best-known examples of pop art, the relationship to the gallery continued along traditional lines, with references to real-world commodities presented in the context of a different kind of marketplace, where the exceptional status of art was paradoxically upheld by its substantial market success. In fact the traffic in art became ever more specialized, even rarified, because of price increases driven by pop art's popularity. Until 1973, for example, the Whitney Annuals and Biennials offered the work on exhibit for purchase, with little concern about insulating the museum from an occasional modest sale, and David Deitcher links the end of that practice to the altered commercial terrain following new records for contemporary art realized by the Scull auction in fall 1973.[18]

Prices that seemed remarkable in the early 1970s were only the beginning of an exploding market that has fueled a vast expansion in all areas of contemporary art production and exhibition. To take just one example, witness the changing valuation after one of Oldenburg's commodity-like creations left the *Store*. Jean and Leonard Brown bought a sculptural object called *Yellow Girl's Dress* from the storefront installation, where it had a list price of $249.99, and eventually sold it at a 1998 Christie's auction for $244,500 (a remarkable enough appreciation). Only ten years later, however, in the run-up of art prices just before the stock market nosedive that fall, the same work went on the block again at the Sotheby's spring 2008 auction. With a pedigree dating back to what the catalogue described as "the celebrated storefront installation that combined art, commodity, and commerce," the work lived up to its billing by fetching $1,721,000.[19]

Part of the story of the contemporary art market is the continuing appeal of pop art and its progeny (with Koons fulfilling his billing as Warhol heir not only through his imagery, but also his auction success). Yet pop art needs to be understood less as a direct model than as an early stage in a fascination that has multiplied and fractured, in the hands of artists well aware of both art-world trends and larger market strategies. The ongoing fascination with the marketplace continues, but a lengthening history of artistic engagement with issues of commerce and associated means of distribution has motivated contemporary artists to fashion increasingly targeted responses to both art-world and general consumer practices. Nor is it possible to make a clear distinction between affirmation and critique, as long as the work in question continues to be distributed through art-market channels.

Young is certainly not the only contemporary artist to make work that plays off of a hyper awareness of brand identity shared by both artist and audience. But, in contrast to the heyday of the commodity image in the 1960s, contemporary investigations of this terrain often yield works that are vastly divergent in terms of medium and formal approach. Louis Cameron, for example, clearly shares Young's interest in the construction of brand identity, but he has zeroed in on color rather than language as the basis for work that evokes minimalism and pop art in equal part. A series of paintings takes its cues directly from the squares or circles of color located under the flaps of packaged goods, in a form of found abstraction based on a side-effect of the printing process used to produce colorful packaging. The resulting paintings offer apparently abstract color arrays, yet the recognition factor invoked by the interplay between color choices and the product names he uses as titles demonstrates how deeply all aspects of branding are imprinted on a consuming public. Or there is his 2005 *Universal* video, in which a mesmerizing dance of black and white vertical bands is at once abstract and highly specific, since the rhythmic structure is derived from a seemingly unending sequence of bar codes, each dissolving into the next with an inexorable logic.

When Oldenburg opened his East 2nd Street *Store* in 1961, it was surrounded by the full range of sometimes eccentric mom and pop enterprises that prevailed in the neighborhood. But the intervening half century has yielded a far more homogeneous

3. Louis Cameron, *Universal*, 2005. Digital video projection, 20-minute loop. Courtesy I-20 Gallery.

retail environment, with private commercial spaces anchored by international chains serving as focal points for leisure activities centered on consumption. Guy Ben-Ner's 2007 *Stealing Beauty* responds to this altered landscape by making clandestine use of Ikea home sets as both subject and vehicle for a humorous guerilla riff on domestic space. In the resultant video, he and his family enjoy an extended dialogue about private property in the midst of the very public setting of the store during business hours. As shoppers wander through (or peer curiously at the camera), the artist and his family inhabit various sets, acting out scenes that are often stitched together from multiple locations because filming was truncated when they were discovered and kicked out by store employees. The settings may resemble familiar interiors, but the objects carry visible price tags, and little is actually functional, with absurd juxtapositions carried through to the sound track, where ambient store announcements combine with an overlay of dubbed effects, such as the burble of running water when they manipulate non-functional faucets in a pantomime of domestic activity.

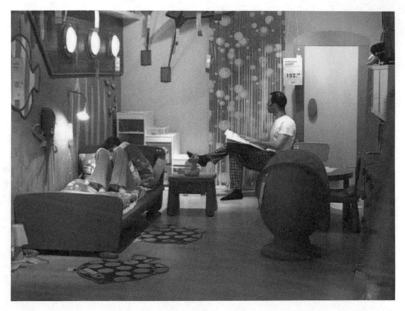

4. Guy Ben-Ner, *Stealing Beauty*, 2007. Single channel video, color with sound, running time 17:40 minutes. Courtesy Postmasters Gallery, New York.

Channels of consumption remain another source of fascination. Rather than renting a storefront to sell his hand-made versions of consumer goods, Conrad Bakker has pursued all range of possibilities in today's marketplace. His summer 2002 *Untitled Mail Order Catalog* used the twentieth-century version of a siteless commerce to take his stand-ins for various consumer gadgets directly to the public, via a catalogue that was fully operational as a means for ordering the hand-made product equivalents, even as it also has to be understood as an artwork in itself. For a three-quarter-scale model of a 1969 Pontiac GTO Judge, created in 2004, he advertised in newspaper and web-based car sites, offering the artist-made version at the bluebook value of its referent. Or there's the *Untitled Product Distribution Network*, consisting of an unabashed version of a pyramid scheme centered on the multiple iterations of a bottle-like hand-made object, supported by a related advertising scheme and even a somewhat roughly hewn version of a standard-issue folding table when he presented the product objects in an exhibition context.[20] He is also concerned with the mechanisms

and boundaries of the art world, including the creation of paintings of *Artforum* ad pages that are priced, as paintings, according to the magazine's going rates for ad pages (in 2007 apparently $5,200 for a full-page color ad), or his use of images associated with an eBay auction of a copy of Ruscha's 1968 book *Nine Swimming Pools and a Broken Glass* as the basis for paintings that he then cycled back through eBay.

5. Conrad Bakker, *Untitled Mail Order Catalog*, 2002. Courtesy the artist.

Bakker's play on Ruscha speaks to complex relationships among different spheres of activity, as well as changes in status that may develop over time. For Ruscha, his inexpensively produced books reflected a conscious decision to look for alternative forms and means of distribution, counter to both limited editions and the closely related tradition of the artist's book. Douglas Crimp has recounted his amusement at coming across Ruscha's 1962 publication *Twentysix Gasoline Stations* in the transportation section of the New York Public Library collection—an anecdote he recounts in order to suggest how their potentially indeterminate status was part

of their achievement.[21] Yet the first editions of these publications have become increasingly precious, in conjunction with their perceived importance as part of Ruscha's proto-conceptualist emphasis on information rather than object.[22] Bakker's subsequent discovery of *Nine Swimming Pools* for sale on eBay, and his decision to make its appearance there the subject of a new work sent out through the same site, is both an artistic homage to Ruscha and a further exploration of how art can take advantage of alternative circulation channels.

The possibility that art might be able to move through various distribution systems—and that it might not be recognized as such, at least by certain portions of its audience—has greatly increased in the context of the transformed media environment of the late twentieth and early twenty-first centuries. Dara Birnbaum's pioneering exploration of the now common gambit of appropriating and remixing television footage is telling in this regard, particularly her groundbreaking 1978–9 *Technology/Transformation: Wonder Woman*. At

6. Dara Birnbaum, *Technology/Transformation: Wonder Woman*, 1978–9. Single-channel video, 5:50 minutes. Courtesy Marian Goodman Gallery.

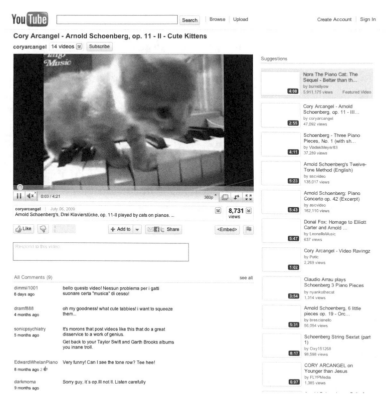

7. Cory Arcangel, *Drei Klavierstücke op. 11*, 2009. Single-channel video from a digital source. Courtesy the artist and Team Gallery.

the time that she began to explore this material, her desire to bypass gallery display and present the work in the context from which it was derived—the aspiration to "use television on television"— was largely thwarted by the medium's centralized distribution structure.[23] In an era before home recording became a widespread option, Birnbaum also had to rely on industry contacts to provide her with the pirated footage she used for her work. But the terrain has changed dramatically, with respect both to access to media-based material and the potential for its dissemination. "The fact is," Cory Arcangel observes, in a conversation with Birnbaum, "that you can put anything up on the internet and there will be five people who want it, no matter how weird or obscure the information."[24]

A lot more than five people have generally been attracted to Arcangel's YouTube offerings—particularly his mash-up of piano-playing cats, edited into an approximation of Glenn Gould playing Arnold Schoenberg's 1909 *Drei Klavierstücke, op. 11* (the composition that marked Schoenberg's decisive abandonment of tonality in favor of the 12-tone scale). While the incongruous combination reflects Arcangel's musical training, it is also an homage to the many random YouTube offerings that are, in his estimation, as good as his favorite examples of video art.[25] One wonders how many people who come across this mash-up recognize or care why a compendium of found cat footage has been spliced together in this fashion.[26] Others in his audience will certainly appreciate the creative irreverence without feeling any need to look to the gallery context to pursue such interests. Arcangel's own general category of "things I made" encompasses works shown in galleries, writings, performances, and such web-based larks as his 2009 *"working on my novel"—Great Twitter searches Volume #1* and 2011 *"follow my other twitter"—Great Twitter searches Volume #2*, both of which provide an ongoing live feed of tweets that include the phrase in question.[27]

With their numerous forms of engagement all along the production and distribution food chain, these and many other recent examples suggest a multi-layered awareness—of pop art as a historical precedent for an engagement with the everyday through the commodity, but also the changed art and media terrain of the present. Sky-high art prices of recent decades have been buoyed not only by pop art's continued popularity, but also the absorption of a whole host of practices, in an embrace that extends even to conceptual strategies initially imagined as resistant to market forces. Although art continues to inhabit a specialized market niche, evidence of broad similarities with other goods and services sold on the basis of celebrity or designer branding are difficult to overlook. And spheres that overlap can potentially clash as well, particularly when work that involves a conscious play with authorship over found material brushes up against alternate claims made against the same formations. Responses to everyday objects or imagery are intrinsic to many avant-garde strategies that have crossed, blurred, or otherwise called into question the line between art and life. Yet it is striking how thoroughly the idea of everyday life has become infested by commerce, with familiar objects or

images playing double roles as commodities, and authorship claims echoing the intellectual property interests that underpin much post-industrial economic activity.

Readymades belong to everyone®

While it has yet to be widely acknowledged as such, a certain culmination point for art production actually took place in 1961. That was the year Piero Manzoni created an 82 × 100 × 100 cm iron and bronze cube with the upside-down inscription *Socle du Monde* (Base of the world) and, through this simple act of inversion, declared the entire planet earth as his work. How can any smaller assertion made over found objects or situations be judged more compelling than Manzoni's trump card? With the possible exception of some flags and debris left behind on the

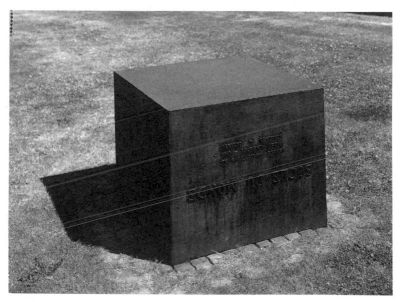

8. Piero Manzoni, *Socle du monde*, July 4, 1961. Iron and bronze, 82 × 100 × 100 cm. HEART, Herning Museum of Contemporary Art, Denmark. © 2011 Artists Rights Society (ARS), New York / SIAE, Rome. Courtesy Fondazione Piero Manzoni, Milano.

moon and mars, all subsequent projects (artistic or otherwise) should potentially be understood as unintentional collaborations within Manzoni's global, evolving work. But of course there were a few other claims on the everyday before Manzoni's, including Duchamp's readymades in the opening decades of the twentieth century and Robert Rauschenberg's combines at its midpoint. And by now there is a large supply of such gestures, with familiar material reoriented to varying degrees and thereby presented under new authorship.

"Readymades belong to everyone®" was the name given by Philippe Thomas to the public relations agency that he created in the mid-1980s, as part of his bewildering and elusive oeuvre, in a bit of corporate play that he augmented with the addition of a registered trademark symbol to the phrase. Evoked, in the combination of inclusive-sounding rhetoric and a mark of legal restrictions on use, is the manner in which corporations are adept at evoking concepts of freedom precisely in order to influence, even direct, consumer behavior. The gambit relates as well to questions of ownership and authorship that run through Thomas' work. His 1985 *Sujet à discretion* (Subject matter at your discretion) presented three visually identical photographs of a seascape, the first identified as anonymous, the second labeled a self-portrait by the artist, and the third as a self-portrait by the collector of the work. A 1988 ad indicated his willingness to sell authorship of his works. And his 1991 exhibition *Feux pâles* (Pale fires, a pluralized homage to the Vladimir Nabokov novel) presented a Carl Andre-like sculptural installation incorporating a rectangular area of parquet floor that made oblique reference to the commercial activities of the museum by offering a specific area for sale, designated by a sign reading "Parcelle à céder" (Lot for sale).[28] With many of his works and texts officially assigned to his collectors or sponsors, sorting out his already diverse production is a challenge Thomas consciously presented.

If pop art drew attention to the surface of corporate culture—to the glistening sea of consumer imagery designed to spur consumption—artists associated with conceptual art and its offshoots have focused attention on deeper structures of authorship, in ways that indicate parallels between artistic claims on the everyday and corporate bids to assert ownership over multiple forms of discourse and information. Thomas' public relations ploy

is but one of many plays with the bureaucracy of authorship to emerge from practices grouped under the conceptual art umbrella.[29] A few years after Manzoni put all of earth on a pedestal, the N.E. Thing Co. (or NETCO), the corporate identity of Iain and Ingrid Baxter, made more modest claims on segments of the same terrain in the United States and Canada. Photographs and maps from 1968 and 1969 document their *Quarter Mile N.E. Thing Co. Landscape*, with roadside locales marked with signs first alerting drivers that they are entering a N.E. Thing Co. landscape, then commanding that they start and stop viewing. The rhetoric is familiar, from notices warning of construction work or other types of hazards, but the obvious irony has to do with the artistic declaration made in relation to an otherwise unmodified landscape.

By indicating an entire quarter-mile stretch as their readymade, they refer to the traditional use of landscape as an art subject, yet they apply their frame to terrain that appears strikingly unexceptional in photographic records of the work—neither scenic nor degraded, and in that respect precisely what one is likely to drive past without noticing, on the way between acknowledged sights. The other part of the claim is the use of a mock-corporate imprimatur that they applied to multiple aspects of their existence. Employing their Vancouver-area home as their corporate headquarters, they joined the Vancouver Board of Trade and used their corporate identity to embark on various activities, both art related and not (with sponsorship of a Pee-Wee hockey team an example of the latter).[30]

There is a suggestive echo of Robert Smithson's 1967 "The Monuments of Passaic," which focused attention on the industrial landscape, marked by pumping derricks and drainage pipes, as an alternative version of the monument. He, too, zeroed in on a sign marking the landscape, one that "explained everything" by designating it as an example of "your highway taxes at work."[31] More importantly, the landscape he chose was one already heavily altered by human presence, but likely to be ignored precisely because of the evidence of intervention. And despite Smithson's distrust of what he described as a form of mystification, "turning a urinal into a baptismal font," he engaged with the language of industry evoked by Duchamp's notorious plumbing fixture via photographs that set these manifestations out from their surroundings, without an accompanying move into the gallery or museum.[32]

The act of staking an ownership claim over that which already exists can be understood as a form of artistic provocation that raises questions about the definition of art itself, but it is also a corporate strategy, evident in controversial patent claims made on rainforest plant species and other forms of biopiracy, where ownership declarations over genetic material can impair both traditional agriculture and ongoing scientific inquiry. Artistic gestures that assert ownership over the everyday are strikingly prescient and, in their playful absurdity, have the potential to draw attention to broader transformations in the economic significance of intellectual property. But it is also notable how these same provocative gestures, once judged historically important, may themselves be protected with surprising vigor.

No discussion about reframing the everyday would be complete without mention of John Cage's 1952 composition entitled 4'33". Its first performance is one of those notorious avant-garde events, well-known in its aftermath even though initially bewildering. Referred to colloquially as Cage's silent piece, it was actually anything but. David Tudor marked the three movements, lasting 30 seconds, 2 minutes 23 seconds, and 1 minute 40 seconds respectively, by closing the keyboard cover at the beginning of each and opening it at the movement's end. In the intervals while the cover was closed, the audience was treated to the ambient sounds of wind in the trees surrounding the Woodstock concert hall, raindrops, the rustle of Tudor turning the pages of the sheet music marked with blank bars of musical notation, and the noises associated with their own puzzled and increasingly impatient presence.[33] What the assembled crowd most definitely didn't hear was nothing, despite the absence of the expected musical notes from the piano—and indeed the piece was part of Cage's own process of exploring the idea that there is no such thing as silence. In removing the piano's sound, he drew attention to the whole overlooked cacophony lurking in the background.

While the initial audience has been reported as generally befuddled (despite the fact that they were present to attend an evening of avant-garde music), that early incomprehension is part of the work's subsequent fame. References to the composition abound, even though, as Liz Kotz points out, it is generally known through description rather than performance, with many areas of ambiguity in its origins despite its subsequent notoriety.[34] It is

equally true, however, that the canonization of 4'33" as a milestone in the story of the postwar avant-garde has been accompanied by its increasing value as intellectual property, protected as such by the Cage estate. And that has led to certain unexpected developments in the subsequent history of the piece.

A form of homage was offered by songwriter Mike Batt, who included a one-minute silent composition on the album *Classical Graffiti*, recorded with the Planets, which he playfully credited to Batt/Cage. The attribution prompted a notice of infringement from the MCPS (Mechanical Copyright Protection Society), along with an initial charge of over £400, which the MCPS collected on behalf of the music publishers that represent the Cage estate. Batt was amused, but also serious about the potential royalty costs. As he told a reporter from the *Telegraph*, "I remember saying to them, look, it's very clear that you cannot copyright a piece of silence— there's too much of it about!"[35]

One wonders what Cage himself would have made of the authorship claims being asserted (and protected) in his name, as well as the idea that a composition consisting of duration rather than notes should trigger automatic music royalty protection. Perhaps something of his spirit prevailed, however, since the copyright dispute was settled out of court. In conjunction with the agreement, not only did Batt agree to make a substantial payment to the John Cage Trust, but both compositions were performed in a rented London recital hall, with Batt leading the Planets in his *A One Minute Silence* and a clarinetist performing Cage's 4'33" by raising and lowering the instrument to mark the intervals of the movements. Since the resolution of the initial conflict, Batt has registered multiple copyrights on silent compositions of lengths varying from a second to ten minutes, including two that bracket the original at 4'32" and 4'34". "If there's ever a Cage performance where they come in a second shorter or longer," Batt asserts, "then it's mine."[36]

A classic scenario pits the high-minded artist protecting his or her work against cheesy commercial exploitation. But when artists draw from the everyday, it becomes a bit tricky to claim that further manifestations, commercial or otherwise, should not resemble the work of art. Koons' balloon dog sculptures are signature works for the artist, but part of the appeal is obviously the fact that they are colossal versions of a common carnival trick, made familiar by

numerous clowns and other itinerant entertainers. It was therefore a bit of a stretch when his representatives sent a cease-and-desist letter to a store selling balloon dog bookends. Rather than being intimidated, however, the store responded to the letter with legal action of their own, filing a motion for declaratory judgment that began, "As virtually any clown can attest, no one owns the idea of making a balloon dog." Koons' claim definitely did not play well in the court of public opinion, but it is not clear how it would have fared as a legal matter, since he wisely dropped the threatened suit, with the only concession from the store being that they would not promote the bookends with reference to Koons' work.[37]

Another dust-up, again articulated as a conflict between art and other forms of commerce, was initiated by the artist Jack Pierson, who is known for photographs that demonstrate a semi-autobiographic engagement with vernacular imagery and for what he characterizes as word sculptures, made from constellations of found lettering. "Beauty," "fame," "the world is yours," "heroin," "solitude," "you rotten prick," "another night," and "melancholia" are among the words and phrases he has constructed from deliberately mismatched fragments of commercial signage. If one marker of the work's success is the critical response, another is Sotheby's contemporary sale in May 2007, where Pierson's 1992 *Almost*, comprised of painted plastic and metal letters spelling out the work's title, sold for $180,000, well above its already commanding $100,000–$150,000 estimate.[38]

At some point in 2005 Pierson was alerted to the appearance of a similar strategy at play in the Barneys Co-op stores, where window dresser (and Barneys creative director) Simon Doonan had used letters in a variety of sizes, materials, and styles to decorate the walls of the stores, above the clothing displays, with the words "courageous," "contagious," or "outrageous." In the context of the Barneys displays, the commercial lettering went with the deliberately bare-bones industrial styling of the Co-op stores in general, with décor based on clothing racks made from minimally transformed lengths of industrial pipe and unshielded fluorescent fixtures hanging from chains for lighting. The whole look was part of a consciously hip and less expensive (though hardly cheap) offshoot of the pricy retail establishment.

According to Doonan, Pierson contacted him during the summer of 2005 and requested that he take down the Co-op displays

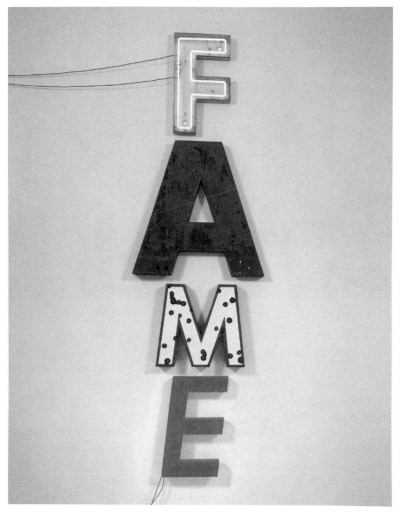

9. Jack Pierson, *FAME*, 2005. Plastic, metal, wood and neon, 160" × 45" × 4", vertical install. Courtesy Cheim & Read, New York.

because of their resemblance to Pierson's word sculptures—a request Doonan declined. Citing his own long history of using found material as well as a lack of familiarity with Pierson's work (other than certain of his photographs), Doonan was hardly prepared to concede sole rights to the use of mismatched signage

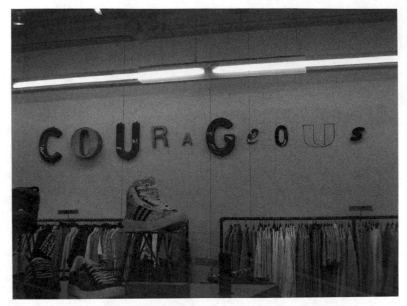

10. Barneys Co-op display, New York, May 2006. Photo: Martha Buskirk.

to Pierson. Then, in March 2006, as Pierson was about to open an exhibition at the Cheim & Read Gallery, John Cheim sent out an email message to multiple recipients referring to the Co-op décor as "forgeries," and "formally weak, plagiarized versions of Jack Pierson's work."[39]

Not only has there been a long history of interplay between art and commercial design (including a tradition of artists moonlighting as window dressers), but there was an obvious irony, hardly lost on Doonan, in Pierson's attempt to use a mode of art-making founded on a shift from quotidian to art world as the basis for asserting control over the wider commercial sphere as well. Doonan, a frequent writer as well as designer, proved an adept critic of Pierson's priority claims, finding no reason that "the option to place a monopoly on a found object would automatically fall to an artist over a window dresser," and also applauding him for his economic sense: "As a capitalist, I say *ka-ching!* Good luck to you Jack! Since those found letters sell on eBay and at the flea market for an average of $12, your profit margins are better than anything we are able to achieve at Barneys."[40] In Doonan's ironic reading, Pierson's

success is evident in his ability to trump even Bloomingdales with the ultimate market cachet of the artist's name brand. Nor was he the only one to note that the protest carried the side benefit of generating publicity for the exhibition—which indeed it did.

The art of the ad (two views)

The strategy of moving outside the gallery, into different types of commercial space, has become so pervasive that even just one specific aspect of this redeployment—artists making use of billboard space—has been sufficiently widespread to merit an exhibition devoted to examples of the practice.[41] But the May 2006 display of Mike Kelley's work on a billboard in New York's Chelsea neighborhood was something else. The ad for Phillips de Pury & Company's spring contemporary auction was a logical piece of targeted marketing, aimed not at the public at large, but at a specific segment that would be in the area to peruse the large number of galleries dotting the district. The billboard, just north of the corner of Tenth Avenue and Eighteenth Street, featured Kelley's 1991 *Ahh...Youth*, a photo sequence of seven close-up portraits of hand-made stuffed animals and one rather homely yearbook photo of the artist himself.

The featured work by Kelley is part of a larger set of explorations that involve applying conceptually inflected procedures of collecting and archiving to found material, including childhood toys that, in Kelley's hands, take on dark, often perverse overtones. In many respects Kelley's gesture was both simple and modest, from the selection of humble, used examples of hand-made stuffed animals to highlighting their peculiar features by recording their appearance in 24"x18" cibachrome portrait photos. The implication that their eccentricity might equate them with misfits or loners is reinforced by the juxtaposition with his own less-than-flattering yearbook image, squarely in their company. The objects Kelley chose for these portrait-like photographs are also clearly recognizable as hand-made, in contrast to the general abundance of mass-produced toys. One assumes that they were created for someone specific, but that can only be a guess after they are absorbed into the second-hand marketplace where Kelley has found much of his material.

11. Phillips de Pury billboard advertising Mike Kelley's *Ahh ... Youth*, 10th Ave.
and 18th Street, New York, May 2006. Photo: Martha Buskirk.

Kelley's prominence in the art world would alone have been
enough to ensure that his work was recognizable to the billboard's
intended audience of art-world cognoscenti, in the context of a
district transformed into an up-market art shopping mall by the
concentration of galleries. Yet the photos carry another set of associ-
ations, since the most inexplicable of these examples of popular
craft, an orange crocheted creature with antennae and painted facial
features that somehow add up to an expression of alarm despite
the red arc of a smile, also appeared on the cover of Sonic Youth's
1992 album *Dirty* (along with additional images from the series as
an interior fold-out). These photos, based on objects harvested from
one region of everyday life, then transformed into art through the
alchemy of Kelley's process of selection and recording, had therefore
already taken a turn through a different zone of media culture before
being featured on a Manhattan billboard targeted at a specialized art
audience. The result is a possibly ironic, but hardly tongue-in-cheek,
use of a mass-market advertising forum to promote a high-value
work of art based on previously humble objects.

Another element to this story is the lofty prices commanded by contemporary art by the turn of the twenty-first century, with photography's lack of inherent uniqueness presenting no obstacle to interested collectors. Phillips de Pury, the auction house handling the photographs, has been more specifically focused on contemporary work than the dominant Sotheby's or Christie's, attempting to court that market with a branding strategy emphasizing a fashionable, hip image. It also wasn't the work's first time at Phillips de Pury. A November 2004 sale of the Lambert photograph collection set record prices for the medium, including *Ahh...Youth*, which more than doubled its $150,000–$200,000 estimate by selling for $411,200. By May 2006, collectors were willing to go even higher, undaunted by the fact that both Phillips de Pury and Christie's had examples from the edition of ten for sale in their May auctions. And, in a highly unusual example of market efficiency, *Ahh...Youth* achieved the same final price of $688,000 at both houses (notable, too, as setting a yet another new auction record for Kelley's work).

Kelley was not, as it happens, the only artist to feature on a New York billboard that spring. Even in the absence of promotional copy identifying their origin or purpose, large-scale images of women's high-heel adorned legs, cropped at the ankles, that appeared around the Chelsea gallery district in March 2006 were readily identifiable as the work of Marilyn Minter for anyone immersed in contemporary art (particularly given her simultaneous appearance in that year's Whitney Biennial). With their high-gloss combination of fashion fetish and a generous splattering of mud, they were part of a distressed glamour iconography developed by Minter in paintings and photographs that suddenly seemed to be ubiquitous. A similar series of paintings from the year before zeroed in on a model's dirty heel, perched on a metallic and rhinestone-encrusted Dior mule that was identifiable, even for those not in the know, by the Dior name legible on the sole of the shoe in some of the works. The paintings were also closely related to images she created for fashion magazines, with a major difference (other than context and medium) being the use of mud rather than water as the substance splashing across the glamorous gams.[42] Sponsored by the non-profit organization Creative Time, the outdoor billboards could therefore be understood as a perfect vehicle for an artist who has always straddled the commercial and fine-art worlds.

12. Marilyn Minter, *Shit Kicker*, 2006 (billboard). Courtesy the artist and Creative Time. Photo: Charlie Samuels.

Nor were the billboards Minter's first foray into explicitly commercial space in relation to the fine-arts side of her work. A much earlier example was the television ad time she purchased in 1989, ostensibly to promote her *100 Food Porn* exhibition at the Simon Watson gallery. Riffing off late-night spots promoting 900 numbers for phone sex, her ads, run during David Letterman, Arsenio Hall, and Nightline broadcasts, depicted an ambiguous sequence of paint being applied with a brush, other studio views, stretched canvases in the process of installation, and a newspaper with an advertisement for the *100 Food Porn* exhibition, interrupted by a fish that is suddenly flopped down on and then wrapped in the paper. The paintings thus promoted generally show hands manipulating different types of provisions—arguably nothing out of the ordinary, yet inescapably suggestive, with long red fingernails grasping a banana or a bunch of asparagus, handling food that is being skewered or penetrated by a knife, or releasing substances that ooze and spurt. Viewing is partially interrupted by the painted screen of dots, evoking both pop-art precedents and the printed page. And the series is bracketed by far more specifically pornographic images Minter painted during the late 1980s and early 1990s to decidedly mixed reactions—all part

of a multifaceted engagement that combines the seductive allure of the painted surface with different threads of commercial or mass-media imagery.

Minter's foray into the world of television advertisement followed her discovery that prices for spots during late-night shows were actually lower than full-page art magazine ads.[43] Yet there can be little question that the ad failed to do the job usually assigned to the format, of presenting a clear and simple message. Nor, since it aired only a few times, could it become familiar in the manner of a standard ad campaign, through relentless repetition. In fact it is difficult to imagine exactly how many people would even have registered its existence, were it not for later appearances, shown by Minter in lectures and available on YouTube.[44] The archived clip also indicates a nice bit of luck in relation to actual food ads, with the appearance following Arsenio Hall preceded by a spot for M&Ms (too much of a coincidence, given the artist's own initials, and prior paintings of this very subject?) and, after Letterman, one for cheese ravioli. Although it remains an open question how truly functional the spots were as promotion for her exhibition, Minter's ad becomes a kind of work itself, interesting for her willful misuse of the conventions of the medium.

Perhaps this failure as advertisement might be read as a reaffirmation of the boundaries that remain between art and other areas of commerce, despite frequent incursions. Yet in some respects Minter was simply ahead of the curve with her *100 Food Porn* ad. A subsequent video offering, her 2009 *Green Pink Caviar*, seems to have hit all bases. According to Minter, "I was shooting stills of models with long tongues swirling and sucking bakery products from under a pane of glass. I wanted to make enamel paintings along the idea of 'painting with my tongue.'"[45] And indeed she did produce the series of paintings using enamel on metal, a medium that allows Minter (together with studio assistants) to translate photographic source material into paintings that show traces of the hand quite literally in the enamel dotted on with fingertips, but with a high-gloss finish that, viewed from any distance, also evokes the licked surface ascribed to certain nineteenth-century academic painters.

An initial low-resolution video of the subject inspired her to create a professional, high-definition version that depicts, in extreme close-up, lips and a tongue licking green and pink ooze

from a sheet of glass separating the camera from the mouth. A one-minute clip (described as a trailer) made a popular appearance on YouTube, where it served as advertising for gallery exhibitions in New York and Los Angeles featuring the closely related paintings and photographs. In addition, the trailer joined other actual movie advertisements when it appeared before midnight screenings at the Sunshine Cinema in New York, in coordination with her New York exhibition at Salon 94. The full eight-minute video was shown on one of the multi-media billboards that now grace Times Square, as part of a 2009 video exhibition entitled *Chewing Color*, curated by Minter and again sponsored by Creative Time, that included works by Minter and two other artists. Not long after that it was taken up by Madonna, as a backdrop to her opening song "Candyshop" on her 2009 "Sticky & Sweet" tour. And for those who found themselves needing their own, home version of the work, Minter made it available on her website for the mass-market (rather than art-world) price of $35, in a release that included her earlier *100 Food Porn* ad.[46]

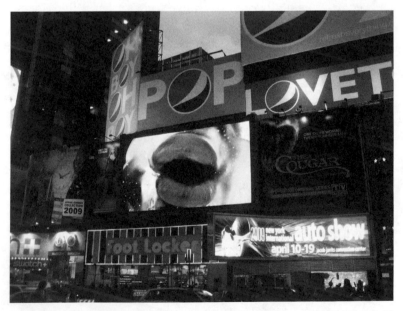

13. Marilyn Minter, *Green Pink Caviar*, 2009. Single-channel HD video, 7:45 minutes, exhibited in Times Square. Courtesy the artist and Creative Time.

The multi-media fortunes of *Green Pink Caviar* indicate a crossover appeal, with Minter's high-end gallery work as only one aspect of her production as well as audience. Perhaps it therefore should not come as a surprise to discover that her work has made another kind of television appearance, as a form of art product placement within the sets for the TV series *Gossip Girl*. The various forms of potential synergy were indicated by a 2008 *InStyle* magazine feature that provided both a 360 degree view of the apartment belonging to one of the series characters (Serena van der Woodsen, to be specific) and links to how one could buy the look—including anything from a white sofa to wire side tables from the living room to a Jessica Craig Martin photo of decked-out attendees at a fancy benefit party, or, from the bedroom, clear plastic lamps, silver vinyl pillows, and a Minter photograph.[47] The art, as it turns out, was placed in the series by the Art Production Fund, a New York-based non-profit with the stated goals of helping artists to realize difficult-to-produce works as well as exposing new audiences to contemporary art. And the Minter image on the bedroom wall was related to another Art Production Fund effort: a Minter beach towel that sold for a mere $50. For a limited time (as the marketing proclaims) it was even possible to buy the Minter towel from Target, along with others in the series by such blue-chip artists as Cindy Sherman, Julian Schnabel or Ed Ruscha.[48]

Minter's ability to cross boundaries is in some sense a reflection of her own double background, in the gallery world and also fashion photography. Yet it speaks as well to the permeable nature of what once might have been understood as boundaries separating different spheres of cultural production. Such interwoven activities force the question of what, if anything, distinguishes art from a whole host of other creative endeavors, whether promotional in nature or not. As viral marketing and other targeted interventions have become the hallmark of sophisticated commercial strategies to harness systems of communication and immediately exploit emergent trends, an immense amount of energy is being poured into efforts to game the system and achieve specific marketing goals in the process. In this environment, it becomes an interesting exercise to try to articulate distinctions between creative marketing and the work of artists taking up such methods. The questions are made only more insoluble when the artworks in question overlap with other forms in both subject and means of distribution, and

as art that can be read as a critique of commercialization is itself commercially successful.

Synergy: art and handbags

Although our recent era of art-world excess was only temporarily subdued by the economic downturn of 2008, the changing fortunes of the Chanel mobile art pavilion testify to the fact that there was at least a brief moment of panic. Zaha Hadid's spaceship-like mobile exhibition venue was designed to present artworks inspired by a particular Chanel quilted bag with chain strap, the classic 2.55 (thus named because Coco Chanel created it in February of 1955). With a vaguely nautilus-shaped fiberglass form, the pavilion was created to be disassembled for easy shipping during a tour of fashion hot spots that began in Hong Kong in April 2008, then moved on to Tokyo, before reaching New York that fall. Conceived by Chanel designer Carl Lagerfeld, and harnessing the architectural super-stardom of Hadid as well as the international roster of artists who accepted the invitation to be inspired by a handbag, the project was rather obviously emblematic of a particular form of avant-garde meeting (and being subsumed by) multi-national luxury brand decadence.

Examples of the twenty handbag-inspired artworks ran from the specific, as in Sylvie Fleury's *Crystal Custom Commando*, an oversized quilted handbag, à la Oldenburg, with an interior compact incorporating a video of Chanel handbags being used for target practice, to the more general, evident in Tabaimo's video installation *At the Bottom*, with an array of ambiguous, dream-like images that Jean Moreau's audio guide related to the secrets lying at the bottom of a well, or the bottom of a bag. In another exhibition, perhaps the work might have been spun as some form of critique, however attenuated. But, given the context, there was no avoiding the obvious fact that the whole thing was a particularly ornate marketing strategy for the luxury brand. The pavilion's appearance in New York's Central Park prompted critics to question the use of public space for this purpose (doubts that were not assuaged by Chanel's substantial payments to the Central Park Conservancy and the city).[49] It also turned into a bit of stunningly bad timing,

with its debut in a slowing economy, and its New York appearance during fall 2008 coinciding with outright freefall. Arrangements to go on with the show in London, Moscow, and Paris were abruptly scrapped, and new plans were announced for the mobile pavilion to be immobilized, sans art, on the site of a Chanel factory outside Paris, and used for temporary exhibitions.[50]

The mobile pavilion is only one example of a highly developed dialogue between high-end art and fashion, where it is difficult to see the artist's role as anything but co-opted—just another version of window dressing for the luxury market. (Or one can simply let go of any intervening avant-garde aspirations and view this segment of the art world as a corporate update of eighteenth-century court culture's Rococo fripperies.) In Paris, the intertwining of art and fashion is equally striking at the Louis Vuitton flagship store that opened on the Champs-Elysées in fall 2005.

Known as the Espace Louis Vuitton, the dramatic renovation was punctuated by art commissioned from an international roster, including a wall installation by James Turrell and a "sensory deprivation" elevator designed by Olafur Eliasson, as well as a top-floor art gallery. Vanessa Beecroft got in on the action, with a performance/installation deploying her signature nearly-nude models arrayed throughout the shelves of the atrium, where they were entwined seductively with the firm's bags and luggage, and for the gallery's inaugural exhibition, a series of photographs employing multiple nude women posed to form different combinations of the LV logo initials. For a 2006 exhibition that presaged the later Chanel project, both Fleury and Hadid were among nine well-known figures invited to take artistic inspiration from iconic Louis Vuitton bags.[51] The situation could be described as win-win for both the artists and the fashion house, with artists having the opportunity to present works in a prominent site, and the luxury brand burnishing its image of elite sophistication—just as long as one doesn't mind the conjoining of branding strategies by artist and corporation alike.

Around the same time as the opening festivities for the Louis Vuitton flagship in Paris, visitors to a remote region of Texas were presented with a different sort of demonstration of the art and fashion nexus. The occasion was the Chinati Foundation's annual fall open house, and the main focus was the museum created by Donald Judd on the site of the former Fort D. A. Russell army

base in Marfa, Texas. Instituted after Judd's death in 1994, the Chinati Foundation open house draws art aficionados from far and wide to this distant but increasingly chic destination. In fact the remote location of Judd's retreat (a three-hour drive from El Paso, the nearest commercial airport) has not kept the art world away, with both temporary visitors and new urban transplants drawn to Marfa.

The main attraction is provided by the former army warehouses, set on a large tract of land that, starting in the 1970s, Judd transformed into permanent exhibition spaces where he featured his own work and that of certain other artists in dramatically repurposed industrial buildings. However, art pilgrims who made their way to the Chinati Foundation festivities in 2005 were also invited to attend the opening of Elmgreen & Dragset's *Prada Marfa*. "Opening," in this case, was something of a misnomer, however, since the whole point of the project was the creation of a hermetically sealed retail simulation. What appears to be a free-standing

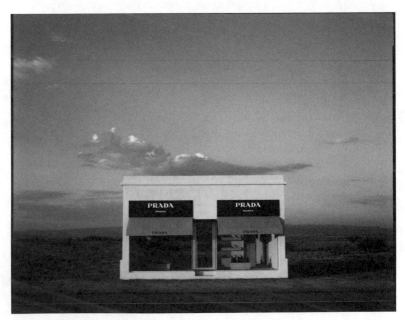

14. Elmgreen & Dragset, *Prada Marfa*, 2005. Courtesy Ballroom Marfa. Photo: James Evans.

Prada boutique rises up out of the desert, without warning or any sort of commercial context, next to a remote stretch of highway about 35 miles outside of Marfa. The shelves and pedestals are lined with genuine Prada shoes and handbags, yet the building is a closed container, a luxury display offering no possibility of entry or purchase.

The roadside oddity was the work of the Scandinavian collaborative team of Michael Elmgreen and Ingar Dragset, operating under the corporate sounding imprimatur of their combined last names, and with sponsorship from both Marfa and New York art organizations. Nor was this the first fashion-house reference to appear in the sometimes prank-like work of the duo, whose earlier interventions included a 2001 sign in the window of the Tanya Bonakdar Gallery, on the occasion of their first solo show at the venue, announcing "Opening Soon Prada" (believable enough, in the context of the gentrification following the art-world move to Chelsea, for the gallery to receive calls asking for the details about the new store), or a 2004 animatronic sparrow, on its back and apparently trapped and dying, inside one of the ground-floor windows visible to passersby on the north side of the Tate Modern. Their idea for *Prada Marfa* was that it would function as a kind of time capsule, with shoes and handbags from the 2005 Prada line frozen at a particular moment, within an adobe building that would gradually succumb to the elements.

Taking as its subject a brand associated with urban sophistication, and indeed almost a uniform for a certain segment of the art world, the Elmgreen & Dragset mock boutique also draws attention to changes overtaking Marfa as it is transformed into an art-world destination. Nor was it a project they could have realized on their own. The duo brought the idea to the Art Production Fund (the same New York organization responsible for the Minter beach towels), which in turn solicited the collaboration of Ballroom Marfa, a contemporary art space in the targeted region. The directors of the latter helped locate likely sites, including the one eventually settled upon, which, despite the name, is actually located closer to the town of Valentine. In addition, the artists had the cooperation of Prada. Although the Art Production Fund directors have insisted that it would have been a conflict of interest to ask Prada to sponsor the work (i.e., pay for it directly), the company helped the artists match the look of existing stores, gave permission

to use the logo, and donated the goods to be displayed—twenty sets of Prada shoes, and six handbags.[52]

Only three nights after the official debut (during which everyone remained politely outside), however, someone pried open the building, presumably by attaching a chain through the door to a truck, and made off with the goods, leaving behind a spray-painted editorial comment, "dumb" on one side, and "dum-dum" on the other. Since this was not the gradual decay the artists had envisioned, the display was reconstituted, with a security system added to the mix. The shoes were easy enough. Only the right shoe from each pair had been on display, so they were able to go back to the same shoe boxes and replace them with the matching lefties. And Prada was prevailed upon for a new supply of handbags (though rumor has it that these were cancelled for good measure, via holes punched through the bottoms to make them unusable). Luckily the vandals didn't return for the mates, and the aging was allowed to commence, in a process that has inspired more benign interactions—including shoes deposited on a nearby fence or in the doorway, as well as a tradition of leaving trinkets or notes on the ledges along the sides of the building.

It might be possible to make a claim for this work as a form of critique. It does potentially draw attention to the function of fashion within a particular socio-economic segment of society by displacing the store-like construction from its normal habitat, within the high-end shopping districts of certain internationally significant cities, and locating it literally in a desert. One can also connect the work to the tradition of the readymade. But here the Elmgreen & Dragset artistic claim has been applied to objects already heavily designed and branded, produced by a corporation happy to cooperate with their reframing as art. The work is certainly both amusing and unexpected; but there is an open question of how much more one can read into it, given the symbiotic relationship between Prada's hip market image and its willingness to be the subject of art that turns on a form of inside joke.

That Prada should be sympathetic to such a project is not surprising, given the particularly strong art and fashion linkage associated with this house. In addition to the art-world popularity of Miuccia Prada's minimalist designs, Prada is deeply intertwined with the contemporary scene in numerous other ways. Programming

at the Fondazione Prada of Milan has included, for example, a
1997 Dan Flavin exhibition curated by Michael Govan, who was
then the director of the Dia Center for the Arts in New York. Not
only was Dia involved in the early history of Judd's Texas project,
but one of the lures drawing people to Marfa (in addition to the
permanent displays of Judd's own work) is a large-scale instal-
lation of Flavin's work completed in 2000. And Prada has been
the subject of other art as well, including three large-scale photo-
graphs produced by Andreas Gursky between 1996 and 1998 that
show what appear to be store displays, but are actually specially
constructed shelves, photographed with Prada shoes, other clothing,
and in the last instance completely empty (with hardly coincidental
evocations of minimalism). Art, architecture, and fashion collided
in yet another way in 2001, with the opening of Prada's New York
flagship (or, in Prada language, its epicenter), designed by Rem
Koolhaas and built for a reported $40 million in a Soho space
that had been occupied by the Guggenheim's downtown branch
before the museum became financially overextended during the
1990s.

It is one thing for artists to create works that respond to fashion
(however co-opted that act is likely to be). It is still another for
artists to function directly as designers, thereby blending the cachet
associated with each sphere of activity. This potentially complex
dynamic is intimated by *Artforum*'s September 2003 cover, with
an image from Venice, during the 2003 Biennale, of an African
immigrant selling knock-off versions of Takashi Murakami's Louis
Vuitton bags. Murakami was officially represented at the Biennale
in Francesco Bonami's painting show, "Pittura/Painting: From
Rauschenberg to Murakami, 1964–2003," at the Museo Correr.
However, *Artforum* critic Scott Rothkopf was far more impressed
by the ubiquity of a different aspect of Murakami's work, in the
form of the immediately popular bags that resulted from the
collaboration between Louis Vuitton designer Marc Jacobs and
Murakami using Murakami's colorful reinvention of the well-
known LV logo-print fabric. The desirability of the bags was only
confirmed by the speed at which they were subject to counter-
feiting, with the genuine versions at the official Louis Vuitton store
just off of St. Mark's Square surrounded by similar-looking knock-
offs hawked by street vendors plying their goods while trying to
keep one step ahead of the law.

15. *Artforum* cover, September 2003. Courtesy *Artforum*.

The *Artforum* cover can also be read as an oblique reference to Fred Wilson's play on the subject. As the official United States representative to the Biennale, Wilson chose to explore the role of Venice as a crossroads, in a process of cultural exchange that included important connections to Africa. The overall exhibition title, *Speak of Me as I Am*, was taken from one of the lines made famous by the title character in Shakespeare's *Othello, the Moor of Venice*, and representations of black Africans in Venetian Renaissance paintings were a major focus of Wilson's installation. But Wilson was also interested in drawing out connections between historic and present-day Africans in Venice, and he succeeded in raising hackles with a riff on the intersection of counterfeit goods and race via his presentation of a display of handbags, as if for

16 and 17. Fred Wilson, *Speak of Me as I Am: Sacre Conversazione*, 2003. Acrylic-painted cast resin mannequins, handmade fabric, metal, various objects, custom-made handbags and sheet, dimensions variable. Installation and exterior view, 50th Venice Biennale, 2003. © Fred Wilson. Courtesy the artist and The Pace Gallery. Photo of window: R. Ransick/A. Cocchi; photo of handbags: Larissa Harris.

sale, just outside the pavilion. The bags were actually made from the same fabrics that had been used to clothe a series of mannequins based on figures in paintings from the Academia that Wilson had arrayed in a picture window on one side of the United States pavilion, but they certainly evoked more pedestrian commercial knockoffs.

Rather than hawking the bags, the Senegalese man playing the role of bag seller functioned more as a guard, and was invited by Wilson to use the opportunity afforded by curiosity about the bags to talk about the Senegalese presence in Europe. Critics of the piece, however, particularly in the popular press, suggested that Wilson, as American representative and subject of a solo exhibition in the US pavilion, had insulted his own country, Venice, or both, with this play on street-level commerce.[53] Even though the handbags were not really for sale (in contrast to Kusama's silver balls), the performer presenting the bags to Biennale visitors all too clearly evoked actual peddlers, many of them African immigrants, and their unofficial presence throughout the city. Certain component elements were already there—Murakami's presence within the galleries, and the handbags based on his fabrics (both real and counterfeit) that were ubiquitous throughout Venice—but Wilson's crystallization of these references still succeeded in transgressing some residual boundary.

Murakami has also presented art audiences with displays of handbags for sale. Yet his version of this situation would be difficult to read as any form of critique. Instead, his contribution took the form of a genuine retail experience—though not without its own attendant controversy following the news that the traveling retrospective of Murakami's work due to open at the Los Angeles Museum of Contemporary Art in 2007 would include a Louis Vuitton sales room focused on products made from LV logo fabric designed by Murakami. Perhaps it would have been possible to frame the insertion as a performance/installation, in that sense akin to Wilson's Biennale vendor or Oldenburg's much earlier *Store*. And Jacobs did indeed make such a claim, telling Sarah Thornton that "it's not a gift shop—it's more like performance art," and further, that it was "as much an artwork as the art that went into the bags."[54] But it was also a fully functioning LV boutique selling both bags and painting-like objects (that is, bag-patterned canvas stretched over stretcher bars)—with the latter selling for $6,000

for the first 50 in the edition of 100, and $10,000 for the rest. In contrast to the handbags from the same material, which could be had for less than $2,000, the canvases were not much of a bargain in terms of workmanship; but of course the bags were mere luxury items rather than limited-edition works of art.

18. Louis Vuitton store at the Brooklyn Museum of Art, 2008. Photo: Martha Buskirk.

The Louis Vuitton boutiques at the MOCA and Brooklyn Museum venues also included exclusives: for MOCA, a keepall sold nowhere else (leading to reports, in the blogs of fashion devotees, about special trips to LA just to buy the otherwise unavailable bag), and at Brooklyn, products in the monogramouflage pattern that could be purchased at the museum in advance of their wider appearance in Louis Vuitton stores. And the Brooklyn Museum did Marie Antoinette proud with their innovation for the exclusive opening-night ceremonies during April 2008, filling the area in front of the museum with a staged version of the stalls lining New York's Canal Street, in an evocation of a neighborhood once filled with counterfeit Louis Vuitton products, prior to a

police crackdown urged by the LVMH parent company. At the Brooklyn museum, however, the bags on sale in the mock-shabby stalls were the real thing, at full, luxury prices.[55]

Perhaps the only thing truly unusual about the boutiques included in the two Murakami exhibition venues was the placement within the galleries, rather than at their endpoint, where many museums have taken to selling not just catalogues and related publications, but a whole range of art-based trinkets. And here Murakami was once again way ahead of the curve. In its MOCA configuration, the retrospective included a display of approximately 500 products (t-shirts, figurines, etc.) produced by Murakami's Kaikai Kiki corporation, many of which were for sale in the museum gift shop. In comparison to the handbags in the LV boutique, the gift-shop products were a bargain—though only in relative terms, given that the going rate for a relatively diminutive furry Murakami sunshine pillow was $49. The clothing and accessories worn by exhibition visitors, as well as the voluminous amounts of merchandise being toted out (with many customers obviously strategizing to break

19. Kaikai Kiki Co. products at the Brooklyn Museum of Art, 2008. Photo: Martha Buskirk.

up their purchases so as to acquire the maximum number of Murakami printed shopping bags as well), confirmed Murakami's excellent grasp of how to turn all strata of his audience into both viewers and consumers of his work.

No doubt there's a well-established tradition of commodity imagery in American pop art, embodied paradigmatically by Andy Warhol's images of iconic products like Campbell's Soup or Coca Cola, and Warhol's engagement with their brand image was later embraced by many of the companies whose classic logos Warhol helped achieve that status. The Warhol estate has also entered into licensing agreements for a wide variety of Warhol merchandise (including a 2006 Warhol-themed holiday campaign, "Happy Andy Warholidays," for Barneys, spearheaded by Simon Doonan).[56] But for all his market rhetoric as well as acumen, Warhol never made himself into a wholly rounded commercial enterprise, with a complete product line. Whatever tension there may have been in Warhol's gallery presentation of trademark logos associated with goods found on supermarket shelves, that friction had entirely dissipated by the time Murakami showcased his redesigned LV logo in his Superflat Monogram paintings in 2003 exhibitions in Paris and New York (at Galerie Emmanuel Perrotin and Marianne Boesky Gallery, respectively), just as his version of the LV monogram was making its handbag debut. Not surprisingly, Murakami has also greatly refined Warhol's factory model, with fully staffed studios in both New York and Japan ensuring that the physical versions of artworks designed on computers can be made to order at the most convenient location.[57]

Murakami is equally adept at providing work that hits all price points. There are the large-scale figures, in proportionately small editions. The 1997 *Miss ko²*, for example, exists as a limited-edition sculpture of the waitress in a skirt short enough to reveal her white panties (an edition of three, with two artist's proofs, of the 100-inch-high acrylic, resin, and fiberglass figure). Then there is the 1999 edition of two hundred 20-inch-high versions, likely to command dollar amounts in the low five figures at auction. And ultimately there's the two-inch version of *Miss ko²* produced in the thousands for Murakami's 2003 *Superflat Museum*, which featured other small-scale versions of his sculptural work as well, including his *DOB* and *Flower Ball*, presented in a cardboard box replete with brochures and chewing gum, and sold at Japanese

convenience stores for 350 yen (then equivalent to approximately $3.50).[58] Nor has the existence of the smaller versions created a drag on the market for the high-end works. Within the retrospective, Murakami's 1998 *My Lonesome Cowboy*, a large-scale sculpture of a naked boy with cartoon eyes, twirling the output of a colossal ejaculation like a lasso, was presented opposite its evident counterpart, the 1997 *Hiporon*, who appears to be skipping a rope-like arc emanating from her massive breasts. While the retrospective was at Brooklyn, *My Lonesome Cowboy* also went on the block at Sotheby's spring 2008 sale, where it went for over $15 million (well above its estimate of $4 million, and without ever having to leave the museum, since the work on offer was a different example of the multiple).

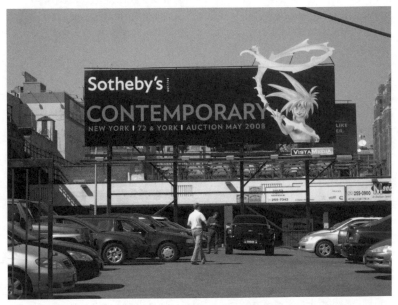

20. Sotheby's billboard advertising Takashi Murakami's *My Lonesome Cowboy*, 10th Ave. and 18th Street, New York, May 2008. Photo: Martha Buskirk.

One take on Murakami's extended production is to argue that it reflects a lack of hierarchy in the Japanese context, where historically fine art has not been sharply distinguished from forms of applied art. Yet the ongoing blurring of such boundaries, evident in

a multivalent synergy between art and designer products, prompts a more cynical reading of the artist as just one more form of celebrity branding, in the context of a market where consumption is guided by name-brand cachet. Nor is Murakami alone, since one can cite many other examples of art product lines, as well as venues for their sale. Deitch got in on the game, in collaboration with Paper Magazine, setting up the Deitch Paper Art Store as a temporary boutique at the Art Basel Miami Beach art fair in 2006, ostensibly modeled on 99 cent stores, but offering art goods at all sorts of prices, including Tracey Emin's costly bags for Longchamp, Koons' slightly more affordable skateboard, or Minter's previously mentioned beach towel. The Art Production Fund promotes its wares as well, with their website offerings supported by such high-profile displays as their own Armory Show booth in 2010 and 2011. Many of the same goods are also for sale at Damien Hirst's Other Criteria shops in London and at the version of the store operated in collaboration with the Gagosian Gallery in New York.

The fact that such products are for sale in museums, art fair booths, and gallery-sponsored store-front locations forces home

21. Art Production Fund booth, 2010 Armory Show. Photo: Martha Buskirk.

the interwoven connections between the market and event-driven art culture of recent years, which have helped push the breakdown of barriers between art and life in the direction of art as lifestyle choice. There is nothing inherently wrong with trying to bring art to new audiences, or with producing affordable versions of an artist's work. Prints and other multiples have long served that function, as have reproductions in museum gift shops. Yet there is something unsettling about the convergence of forms, with art playing off of commodity, as a response, perhaps even critical at times, yet just as often slipping into art as status symbol or luxury good, pure and simple.

Value added

In Duchamp's notes on the readymade he imagined its paired opposite, "Use a Rembrandt as an ironing board." In today's art world, however, the apparent reversal is no longer particularly straight-forward—or theoretical. The gift shop reproductions discussed in this book's introduction are one potential variant on this idea. Or there is "use a Gerhard Richter as a coffee table," which could describe Martin Kippenberger's contribution to this proposition, realized in his 1987 *Modell Interconti*, made by employing a small 1972 gray abstract painting by Richter as a table top. But the fact that the resultant table was a genuine Kippenberger sculpture as well as a repurposed Richter painting has presumably kept the owner of the work from subjecting it to much everyday wear and tear.

Simulated readymades present a different complication, with high-value replicas of familiar forms having the potential to turn a spotlight on the sometimes surreal excess of the contemporary art world. But what of the added wrinkle of using a Robert Gober dog bed as exactly that? Joe Scanlan, in a critique of the conspicuous consumption implied by art that masquerades as design while not actually being used, makes passing reference to the opposite, a Chicago couple who allowed their Weimaraner to sleep in their Gober sculpture. Since Scanlan doesn't identify the collectors in question, it is not possible to ascertain whether this is the same rattan and fabric object, Gober's 1987 *Untitled (Dog Bed)*, that

was put up for auction at Christie's in 2002, where it was given an estimate of $350,000–$450,000 and ultimately sold for $229,500 (nor is there any way of knowing whether the small breaks in the wicker and the areas of "slightly soiled" fabric mentioned in the auction house condition report contributed to the lot selling for below its estimate).[59]

A far more extravagant and ultimately more interesting act of conspicuous yet strangely humble consumption can be found in another pseudo readymade—the imitation/actual Piccadilly Community Centre that Christoph Büchel established throughout Hauser & Wirth's normally magisterial London gallery complex in 2011. Büchel's top to bottom redecoration (which included the construction of a false floor) transformed the interior into a highly realistic equivalent of the well-worn, inelegant spaces one might expect to find in a building housing community functions and activities ranging from computer and knitting classes to senior speed dating or pensioners' fencing. Signs for payday loans and a booth with conservative party information, along with a simulated squat on the top floor, suggested a pointed intersection of economic and political forces. But one of the more remarkable aspects of the project was an outreach effort that insured its heavy use by community members who either didn't know or didn't care that the whole thing was the work of a well-known artist.[60] Not only did the installation expose an obvious need for this type of space, but the appeal to a non-art audience, drawn in by the uncanny resemblance to an actual community center, was also a major point of distinction between this project and various social situations associated with relational aesthetics (discussed in the following chapter), with their tendency to address primarily art-world insiders.

The underlying economics of the community center endeavor are equally notable, however, given how much it undoubtedly cost to completely transform the gallery building into its visual opposite, down to the well-worn carpeting and outdated décor (and then back to gallery again, at the end of its two-and-a-half-month run). Apparently very little was specifically for sale, other than the mock squat installation. But, given Hauser & Wirth's status as one of the top-echelon international galleries, evidently the no-expense-spared effort to temporarily convert the building into something that looked like the result of happenstance utility fits a business

22. Christoph Büchel, *Piccadilly Community Centre*, 2011. Installation, Hauser & Wirth, London. Courtesy the artist and Hauser & Wirth.

model that includes an extended project of demonstrating the historic significance of the artists and estates it represents. (This is, after all, the same operation that celebrated the inauguration of its New York outpost by inviting William Pope.L to fill it with used tires for the homage to Allan Kaprow discussed in Chapter 3.) As with other top-tier galleries, dramatic even if not necessarily saleable gestures in the public exhibition spaces help to promote the real profit center represented by the deals taking place behind the scenes.

What is striking in these examples is not only the play with the everyday, but the way such gestures have been absorbed into an art market that has somehow become that much stronger, having realigned itself on principles that don't depend on traditional evidence of skill or rarity. But one element that certainly has not gone away is the emphasis on the artist's name as a means of affirming the importance of a range of objects and situations. This principle still holds true, even in relation to Büchel's community center, since, despite the fact that it was not necessarily recognized as an authored work of art by many who took advantage of its programming, another more specialized audience was aware not only of this specific simulation, but also its relation to the history of Büchel's large-scale installations. An equally important part of the extended context is therefore an art market where activity at the upper end has proven remarkably impervious to economic downturns, particularly for highly desirable works by top brand artists.

If artistic skill was once understood to be the basis for the mysterious alchemy whereby artists transform relatively humble materials into sought-after masterworks, the readymade's emphasis on authorship claims alone changed the equation. Add in already valuable raw materials and the artist's multiplier effect is potentially even more conspicuous—a proposition amply demonstrated by the convergence of extravagance and hype in Hirst's *For the Love of God*. The platinum skull studded with diamonds garnered massive publicity for its £50 million asking price, and still more when it was reported to have sold to a consortium that included Hirst as one of its members. It is the type of hybrid object that might once have been at home in the early cabinet of curiosities, yet its breathtaking price tag (a fourfold increase over what it cost to make) was clearly based on the value of Hirst's artistic brand.

Despite the public claim that the glittering bauble was sold, the widespread assumption is that there was no sale—which would leave Hirst on the hook for the £14 million worth of materials that purportedly went into its creation.[61] But some of his sunk costs have presumably been offset by profits in the related prints (including some high-end examples complete with diamond dust, and priced accordingly), as well as signed posters, t-shirts, key rings, and even a pencil version (a relative bargain at just over £2). Quite obviously Hirst has not left the project of making popularizing knock-offs in the hands of the museums. His Other Criteria shops in London (and operated within the Gagosian shop in New York) sell a range of art-related objects and editions by Hirst and others, in the process helping to blur any residual distinctions between the limited edition and pure merchandise.

Hirst's extended product line might help account for his forceful response to a 16-year-old graffiti artist who goes by the name Cartrain. The teenager drew Hirst's attention in 2008 when he began

23. Gagosian shop and Other Criteria, 988 Madison Avenue, New York, interior, April 2010: Warhol products in foreground; Jeff Koons puppy vases on shelf; Damien Hirst butterfly beach chairs on left. Photo: Martha Buskirk.

24. Gagosian shop and Other Criteria, exterior view. Photo: Martha Buskirk.

hawking collage-based works incorporating images of Hirst's *For the Love of God* for £65 through a web-based gallery site. Hirst (via the copyright society known as DACS) responded with a cease-and-desist letter threatening a copyright lawsuit and demanding that Cartrain turn over both the original designs and all profits from their sale. The irony of the situation was hardly lost on the British press, given that the proceeds Cartrain forwarded to Hirst amounted to some £200, whereas Hirst's lifetime art sales have been estimated in press accounts at a million times that amount.[62] Hirst may once have claimed a renegade mantel for himself, but his copyright response was typical corporate behavior, like Disney with Mickey Mouse, not only in the tenor of the demand, but also the evidence of his ability to pay for the exercise of such vigilance. As far as talent for generating publicity is concerned, however, Cartrain is on a fast track to rival Hirst—evident not only in the initial collage work, but also his much-publicized theft of a box of pencils from Hirst's *Pharmacy*.

Hirst's 1992 *Pharmacy* installation plays off of the notion of the readymade, both in the individual medicine packages that line the shelves and in the entire space, which creates the illusion that one has

somehow wandered into an actual apothecary shop situated in the midst of an art-gallery setting. For those attuned to this history, there is an obvious echo of Duchamp's 1914 *Pharmacie*, which was one of the artist's assisted readymades (and lightly aided at that), created with the addition of two drops of color that Duchamp dotted onto the horizon line of an inexpensive commercial landscape print. The small insertions of paint are understood to refer to the bottles of colored water that once functioned as a form of advertisement or signage in old-fashioned pharmacy windows. And this is where the connection to Duchamp's readymade is most evident, since the counter in Hirst's installation presents the viewer with a row of colorful bottles, filled with a sequence of green, yellow, red, and blue liquid—though their association with the four elements, earth, air, fire, and water, also relates to Hirst's ongoing engagement with cycles of life and death (a theme suggested even more explicitly by the elegant but ominous insect-o-cutor suspended from the ceiling in the center of the space).

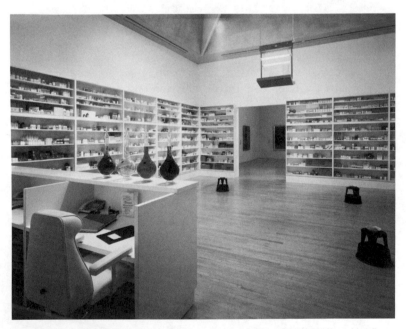

25. Damien Hirst, *Pharmacy*, 1992. Mixed Media. © 2011 Hirst Holdings Limited and Damien Hirst. All rights reserved, ARS, New York / DACS, London. Photo © Tate, London 2011.

Visiting Hirst's installation at the Tate Modern in 2009, Cartrain decided to "borrow" a box of pencils from the casual yet pristine desk within the mock-druggist interior. Pursuant to what he saw as a joke, he made up a fake police wanted poster calling for information on the whereabouts of the missing pencils. Newspapers also reported a ransom demand (the pencils in exchange for the work surrendered in the copyright dispute), with a deadline of July 31 or "the pencils will be sharpened." But neither the Tate nor Hirst seemed to be laughing, and the police arrested both the teenager and his father (the latter reportedly suspected of harboring pencils valued by the press at £500,000, an assessment that placed Cartrain's act "among the highest value modern art thefts in Britain").[63] The once common pencils, identified as Faber Castell Mongol 482 series, are indeed now rare, having been discontinued in the wake of a series of mergers and consolidations in the pencil industry. Yet their new proclaimed value derives not from scarcity induced by corporate production decisions, but their role in Hirst's installation, the value of which is now pegged at an estimated £10 million.

"Would you commit two persons to bridewell for a twig?" asks Henry Fielding's squire in *Joseph Andrews*. While out for a country amble, Joseph not only cut down the twig in question, but handed it to Fanny, who thereby stood charged with aiding and abetting the crime. "Yes," responds Fielding's lawyer, "and with great lenity too; for if we had called it a young tree, they would have been both hanged."[64] The object of Fielding's famous satire was a draconian eighteenth-century penal code that made numerous crimes against property, including cutting down saplings, punishable by death. Given Hirst's response to Cartrain, however, it is entirely possible that he might decry the relative restraint of the current British legal system.

What is the artistic mark up, or value added? When Daniel Spoerri created an alternative grocery store in 1961 filled with packaged food stamped "Attention—work of art," he maintained the same prices that the objects would have commanded in their original context.[65] But there is no firm guide as to price once an object is redefined as art. The urinal that Duchamp turned on its side, signed with a pseudonym, and submitted to a Society of Independent Artists exhibition in 1917, is perhaps the most famous example of the everyday transformed through the artist's process of selection. Given the historic significance

of the work, perhaps it shouldn't be surprising that two examples from the authorized replicas of Duchamp's *Fountain* (produced in an edition of eight in 1964, after Duchamp's lost 1917 "original") fetched over a million dollars each when they came up for auction at the turn of the twenty-first century.[66] At issue, however, is far more than the simple act of selection. Equally significant are artificial limits on production, combined with the distinction associated with the artist's name.

Konrad Fischer, who followed his department store performance with Richter by opening a prominent gallery of contemporary art in Düsseldorf, understood this alchemy very well—as evident in an example of strategic reversal. Robert Ryman recounts how, when shipping works for a 1969 show of paintings done on paper panels, Fischer had the contents listed as "paper" rather than "art" in order to avoid import duties. Responding to a customs official who observed that it appeared to be expensive, hand-made paper, Fischer, apparently fast on his feet, countered with the further qualification that it was used rather than new. Its designation as "used paper" led Ryman to speculate about other possibilities: "Since that time I have wondered about the possibility of paintings being defined as 'Used Paint.' Then there could be 'Used Bronze,' 'Used Canvas,' 'Used Steel,' 'Used Lead.'"[67]

"Used diamonds," on the other hand, tend to maintain their allure regardless of context. Press reports about *For the Love of God*'s much-publicized appearances in Amsterdam and Florence (at the Rijksmuseum and Palazzo Vecchio, respectively) indicate that potential venues for the tour were somewhat limited due to security and insurance requirements. There are higher priced works of art—strikingly evident in the various sales records set and broken by Warhol, Bacon, Rothko, Giacometti, and Picasso, including prices that have topped the hundred million dollar mark in recent years. But such works would not have an equivalent meltdown value. In other words, as Hirst was glad to point out, "the markup on paint and canvas is a hell of a lot more than on this diamond piece."[68] The more astonishing achievement, as Hirst clearly recognizes, is his ability to convert a whole host of objects and images into hot art commodities, with valuations only tangentially connected to the cost of the underlying materials.

Despite the hundreds of dot paintings that Hirst has created (or had made for him, since the paintings are produced by assistants), examples that have come up to auction have commanded upwards

26. View of the Rotterdam train station with a poster advertising Damien Hirst's Rijksmuseum exhibition, 2008. Photo: Andrew Black.

of $1 million each on a fairly frequent basis. Perhaps some of the purchasers have fallen in love with the aesthetic of a particular confluence of colored circles, but one has to assume that many others are motivated by a trophy collector's desire to have an example of Hirst's work from one of his well-known series. The paintings in question are sufficiently unique to satisfy art-market considerations, yet are highly recognizable as part of Hirst's line, with his branded art products helping to close the gap between art and other luxury goods (many produced with some degree of customization) that have intertwining roles in a system of status symbols or markers.

In fact the value of Hirst's artistic name brand was paradoxically demonstrated by the fortunes of his Pharmacy restaurant—which turned into a major financial windfall, despite its descent into bankruptcy, when an auction of the furnishings realized $20 million for décor over which Hirst had managed to retain ownership, notwithstanding his loss of the associated business. Hirst's remarkable market clout was equally evident when he cut out the dealer middleman and took his work directly to Sotheby's for a September 2008 auction that realized in the neighborhood of $200 million, in spite of intersecting with the beginning of the economy's precipitous slide. "I think it was an incredible conceptual gesture, not a sale," was Miuccia Prada's take on the event (regardless of her purchase of three major pieces to help round out her already substantial collection of the artist's work).[69] Hirst himself suggested yet another reading in a widely quoted statement describing the auction as a democratic way to sell his art.[70] To a degree this is true, since an auction is purely about money—with the work sold to the highest bidder—whereas skillful dealers help nurture an artist's reputation with careful decisions about who can buy important pieces. The auction house is therefore a democracy of sheer wealth, since anyone with enough financial resources can bid, whereas waiting lists and other placement strategies may mean that a collector is never even allowed the opportunity to acquire a coveted work from a gallery.

Of course Hirst would not have been in a position to take advantage of this forum had it not been for years of dealer promotion in concert with his own substantial market acumen. A stunning demonstration of the consolidated power of artist and dealer alike can be seen in the decision by Gagosian to begin 2012 with simultaneous exhibitions of Hirst dot paintings in all eleven of the mega-gallery's international outposts. Nor should one underestimate the importance of *For the Love of God* as a promotional tool for the rest of Hirst's line—since the appearance of the diamond skull one year before his auction sale shifted the overall coordinates, so that instead of being nothing more than a series of works based on repeating past strategies, they could be viewed as representative examples by an artist who had just created a stunning new magnum opus. And the auction houses also helped pave the way, with an emphasis on contemporary art that has been characterized by Christie's auctioneer Christopher

Burge as "turning from being a wholesale secondhand shop into something that is effectively retail."[71] Not only have auctions been a major force in driving art prices to stratospheric levels, but their increasingly prominent role in the market for contemporary art set the stage for a perfect union in the Hirst sale, with pure market fed by pure product.

The notion that the artist's name can function like a brand, and that there is an increasing convergence between artistic and designer product lines, is an unavoidable conclusion, at least with regard to certain segments of each market. Artistic plays with authorship depend on a secure system of attribution and valuation that is deeply enmeshed in a larger, celebrity-driven designer culture. But, consistent with Bourdieu's conception of separate yet homologous fields, the overlaps have not yet led to a complete amalgamation, with the different spheres continuing to operate with their own specific dynamics and only partially intersecting circles of cognoscenti. Indeed, their overlay can still bring out telling points of tension or discontinuity. Writing about Wilson's handbag provocation at the Venice Biennale for the *New York Times*, for instance, Carol Vogel described the bags in question as "generic"—neither designer bags, nor counterfeits.[72] They were in fact hardly lacking in authorship, given that they were part of Wilson's work and were made from the same fabrics used to clothe the mannequins Wilson had arranged in the window above; but they were apparently generic in the sense that they were not designer-branded luxury goods. Like both designer products and many works of contemporary art, the actual fabrication of the bags was outsourced to skilled professionals. Yet the lack of direct participation in physical production was not the issue. The offhand reference suggests that artistic authorship over these handmade bags might seem less consequential than the designer names attached to their luxury market counterparts.

There is also the matter of just exactly what buyers of designer products and art alike are paying for. Part of the brilliance of the LV marketing strategy has been convincing consumers to spend big bucks on printed canvas accessories with the type of slick finish that might, if one didn't know better, be described as vinyl, that déclassé leather substitute. Even Jacobs, despite his status as creative director at Louis Vuitton, has baldly acknowledged that "the brand is the product being sold."[73] Yet fashion connoisseurs

pride themselves on being able to differentiate between true luxury merchandise and counterfeit on the basis of differences in workmanship (in a process that, though applied to commercial goods, is not completely dissimilar from the search for the artist's hand as a mark of authorship). But there have been cases where the fakes are truly indistinguishable from authorized products, since they come from the identical source. Consider, for example, reports of a 1997 raid on Italian leather makers creating unauthorized versions of Chanel, Prada, and Dior bags in the same workshops commissioned to produce official versions.[74] There are obvious similarities to the artist's edition, in the importance of authentication provided by either corporate inventory control procedures or the artist's signature. On the art-world side of the equation, the fragility of the whole system is made particularly (and often painfully) evident in the plummeting value of works stamped "denied" by the Andy Warhol Art Authentication Board, Inc., with that sense bolstered by seemingly arbitrary demarcation lines drawn through Warhol's hands-off production practices.[75]

To some ways of thinking the very notion of an art market remains fraught with paradox. In a well-known appraisal of the avant-garde's detachment from ruling-class elites, Clement Greenberg found it to have "remained attached by an umbilical cord of gold."[76] And Bourdieu has characterized the trade in cultural objects as "a commerce in things which are not commercial."[77] When Jasper Johns' 1958 *Three Flags* sold to the Whitney in 1980 for $1 million, setting a new record for the work of a living artist, Johns was reportedly amused, telling the *New York Times* that the price "has a rather neat sound, but it has nothing to do with painting."[78] In Deitch's estimation, however, Hirst has erased any such distinction. "More than any artist," according to Deitch, Hirst "has used the market as a medium," and in the process has "achieved a lot of cultural influence and power by using the market so cleverly."[79]

In her book *High Price*, Isabelle Graw argues that economic success has come to denote artistic significance. But even where value is indicated by the market rather than critical approbation, she asserts, a retroactive art-historical gloss is an important insurance policy. For Graw, John Currin is a prime example of an artist who enjoyed success with limited critical support; but, after his move from the Andrea Rosen gallery to Gagosian, his perceived

importance was propped up with a gallery-produced monograph.[80] Not coincidentally, the appearance of *For the Love of God* at the White Cube gallery was accompanied by a publication of the same name, subtitled *The Making of the Diamond Skull*, which included a laudatory essay by Rudy Fuchs. The subsequent pint-sized version of the work (Hirst's 2008 *For Heaven's Sake*, first shown in the inaugural exhibition at Gagosian's new Hong Kong branch in 2011) has likewise been celebrated with a catalogue text by Francesco Bonami. It therefore hardly seems coincidental, somehow, that the Fuchs essay has been excerpted on Hirst's Other Criteria website as advertising copy for the high-end prints based on *For the Love of God*.[81]

A turn to the everyday may once have served as a way of pushing back against rare art traditions evident in a tremendous reverence for venerable examples of used paint on used canvas. But the introduction of commercial imagery into the art world has been readily absorbed by a market that is now a driving force in shaping contemporary art's production and reception. In this context, the reappearance of painting is not a simple return to an earlier medium, particularly within the workshop production employed so successfully by Hirst, Koons, or Murakami, where it is merely one element within art product lines created by celebrity artists who have managed to establish such brand equity that almost any new work is likely to be quickly snapped up, even in the face of outsourced fabrication or tepid critical responses. Yet it is Murakami, even more than Hirst, who has closed the gap between celebrity artist and celebrity designer, hooking into a hyper-awareness of designer goods that operates across many markets and economic strata.

"The art world used to be a community," Deitch opines, "but now it's an industry." Certainly Deitch himself has contributed to that turn, with his early art investment venture and such later endeavors as his artist-based foray into reality television.[82] But he is just one player in a far-reaching market expansion, where an engagement with contemporary art ranges from passion to status symbol for an expanding pool of collectors. As dealers and collectors look avidly for the next new thing, the feeding frenzy can lead to artists being caught in a quick cycle of approbation and obsolescence. The sidelining of criticism also contributes to a situation where there are few buffers between art creation and

the taste of wealthy collectors who, together with dealer-advisors, drive the market. The art world still attracts plenty of idealists, yet activity in this context, including artistic creation, is increasingly framed in professional terms. Under these circumstances, market success too often becomes a goal in itself rather than a lagging indicator of artistic significance.

CHAPTER 6

Mobil art services

Depending on how you look at it, the 6th Caribbean Biennial, organized by Maurizio Cattelan and Jens Hoffmann in 1999, has received either remarkably little or a surprisingly large amount of attention. Rather than the extensive array of artists, sometimes numbering in the hundreds, at other biennial-type exhibitions, this one's roster was limited to Olafur Eliasson, Douglas Gordon, Mariko Mori, Chris Ofili, Gabriel Orozco, Elizabeth Peyton, Tobias Rehberger, Pipilotti Rist, Vanessa Beecroft, and Rirkrit Tiravanija. From no fewer than ten different countries in the Americas, Europe, and Asia, they presented a cross section of the international contemporary art world, as well as a particularly cutting-edge subsection thereof. The relatively young band of artists would have been known to art-world cognoscenti, and the substantial, even stellar careers all have continued to enjoy confirms the grouping as serendipitous as well as prescient. They also epitomize the range of art forms that dominate the contemporary art world, from painting, sculpture, and photography to performance, video, site-specific installations, and participatory situations. One imagines a vibrant dialogue across divergent practices.

Perhaps not surprisingly, given his double role as artist and curator, Cattelan has described the event as a creative act. "There is something extremely romantic in our gesture: a certain grandeur and insanity, too—if that's what you expect from art," Cattelan claimed in the exhibition catalogue. "In a way this biennial is our arena, the place where we throw our frustrations and tensions and happiness. It is not an opportunistic move: it is an act of

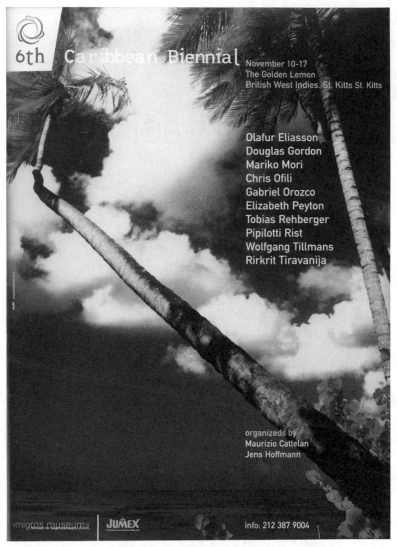

1. Advertisement for the 6th Caribbean Biennial, *Frieze*, November/December 1999. Courtesy Marian Goodman Gallery.

generosity." Yet Cattelan also indicated an adherence to well-established patterns: "We started out by studying what a biennial is: well known artists, ads in magazines, a catalogue, a press office, a curatorial project, invitation letters, curators, guests. And

then we produced it exactly as it is."[1] Full-page advertisements in the November 1999 issues of *Flash Art*, *Frieze*, and *Artforum* promoted the exhibition in a trio of publications that serve as the cool insider mouthpieces for the art world.

Given that the biennial was scheduled for November 10-17, the ads left precious little time for anyone to make travel plans. In point of fact, however, actual attendance was hardly the goal. Though the press release touted "a major international contemporary art event open to the public," complete with panel discussions and organized excursions, those who took the bait were made to feel distinctly unwelcome at the party. Despite the usual apparatus of press announcements and promotional copy, this was a biennial with no art, and therefore no role for viewers. Instead, the artists cut to the chase—pure vacation and social event, akin to the opening festivities of any major exhibition, but without the pesky need to look at art between cocktails.

Recounting her experience for *Frieze*, Jennifer Liu was definitely not amused, suggesting that the contradiction between ostensible openness and actual exclusivity meant that "something was being got away with, that the public was being played for suckers." In fact the closest thing to a public presence was the rather small press contingent (two writers and their two friends), for whom documentation was apparently off limits. "The organisers, at certain artists' behest, asked that much of the material gathered by the press, specifically video recordings, be suppressed," Liu recounts, judging this "A surprising hypocrisy for an impish act of art world sabotage, supposedly anarchic at its core." Writing for *Artnet*, Ann Magnuson reached a lighter but hardly less cynical conclusion: "in this new millennium of sexy, celebrity-driven news, isn't the artist more important than the art? Isn't the work just something that sits behind you like a disposable prop while you're posing for your *Vanity Fair* photo spread?"[2]

The biennial eventually acquired a thematic title, *Blown Away*, in honor of the hurricane that barreled through toward the end of the week, but there is still the basic question of how to frame this act. In an interview from the time, Hoffmann described an event with a decidedly ambiguous status: "There will definitely be no biennial-like exhibition but nevertheless I would not see it as an art project. It is very much in-between. I would like this biennial to come out as complex as life itself."[3] Looking back, however, he had

a somewhat different take on what he subsequently characterized as "an exhibition-as-artwork," putting quotation marks around his function as "curator" in relation to this "piece of humorous institutional critique."[4]

The suggestion that this Caribbean boondoggle could be construed as a critical act reflects a degree of audacity in itself. Obviously it does highlight central aspects of the art world— the social dimension of the globetrotting biennial culture, the emphasis on artist over, or even as art, and the publicity apparatus surrounding art-related activities. Hoffmann's reference to institution critique also says something about the current status of this strategy, which is invoked in countless situations where revealing institutional mechanisms hardly constitutes a disruptive gambit. Taking the social dimension of the intercontinental art world to a parodic extreme might be construed as a critical statement, but it can also be read as excess, pure and simple.

Art and act

Designating the whole Caribbean extravaganza as a work of art authored by Cattelan is a way of containing ambiguity, although it leaves open a number of questions. One is the status of the prank, and how to respond to a seemingly ironic gesture that is part of a long trajectory. It would be easy enough to run aground on the issue of how much deeper meaning to read into Cattelan's irreverent activities. But he is hardly alone in this respect. Marcel Duchamp's readymades set a fine precedent for an artistic gesture wherein one person's reading of significance only adds to the sense felt by others that they are being taken in, not only by a joke, but a joke embedded in a conspiracy on the part of those who insist on weighty import. Any such list would also have to include Andy Warhol and Jeff Koons, each polarizing to varying degrees, particularly around the level of critique that can be read into their respective embrace of the commodity image.

So how seriously should one take Cattelan's prank-filled practice? Presaging his ability to solicit financial support for the Caribbean escapade, he established and secured funding for the Oblomov Foundation in 1992 for the purpose of granting ten thousand

dollars to an artist on the condition that he or she not make art for a year (money that he turned around and used to transplant himself to New York after he failed to award the grant). Invited in 1993 to participate in the Venice Biennale, he essentially sublet the space he had been allotted, selling it to an ad agency that used it to present a perfume ad. But he garnered far more attention with the sale of his space than he likely would have for any but the most amazing work of art, so the irreverent lark was also clever career positioning.

Cattelan's history of playing games with the market system includes his 1995 demand that dealer Emmanuel Perrotin wear a pink penis/bunny costume for the duration of his first solo show at the Paris gallery, taping Massimo de Carlo, his Milan dealer, to the gallery wall in 1999, his 1996 theft of another artist's show that he presented as his own at the de Appel Foundation in Amsterdam (narrowly avoiding arrest after the police were called by the artist whose work was boosted), copying Carsten Höller's exhibition in the gallery next door for his 1997 show at Perrotin, or the life-sized Picasso puppet that he introduced for his 1998 Projects exhibition at the Museum of Modern Art. And he clearly understands the value of the coup de theatre, given the attention he garnered for his 1999 sculpture *The Ninth Hour*, depicting the pope struck down by a meteor.

It would definitely be possible to craft a reading that has it both ways—Cattelan's work as prank, but also the basis for a serious critique of the dynamics of an art world within which his impish antics have made him one of the best-known artists working today. Nor have his exploits hurt his bottom line. In Isabelle Graw's assessment, Cattelan has been "especially skilled at transforming symbolic capital accumulated in the world of biennials into economic capital."[5] Clearly he has been laughing all the way to the bank, particularly since 2004, when the marketability of his art was confirmed by auction sales where examples of his sculptural work went for over two million dollars at all three of the major houses.[6]

Then there's the issue of a smooth flow between artistic, curatorial, and other organizational activities. Teaming up with curator Massimiliano Gioni and writer Ali Subotnick, Cattelan has been involved in still more art-world insider jokes. *The Wrong Gallery* began in 2002 as a fake doorway in Chelsea (strategically proximate to the Andrew Kreps Gallery). A revolving series of exhibitions mounted in the shallow space behind the locked glass

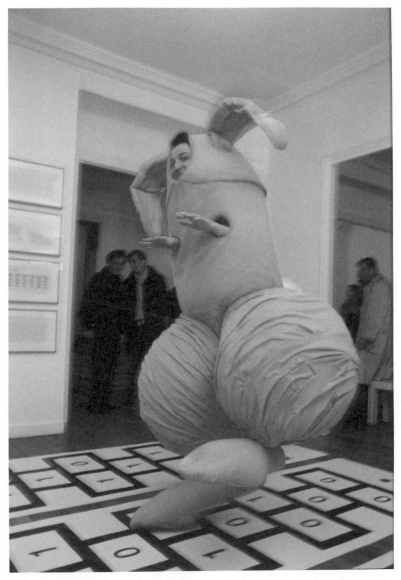

2. Maurizio Cattelan, *Errotin, le vrai lapin*, 1995. Costume, color photograph,
86½″ × 47¼″ × 23½″. Courtesy Galerie Perrotin, Paris. Photo: Marc Domage.

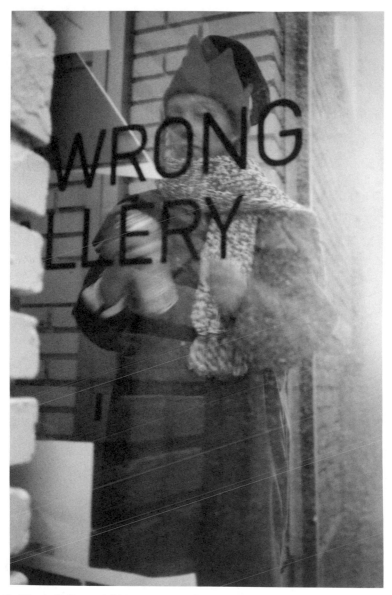

3. Wrong Gallery exhibition of Paul McCarthy and Jason Rhoades, *Humpback (The Fifth Day of Christmas)*, from the *"13 Days of Christmas Shit Plugs"* series, 2002. Santa Claus, angel, ribbon, shit, December 12, 2002–January 17, 2003. Courtesy Marian Goodman Gallery and Hauser & Wirth, Zurich.

door, or occasionally in its immediate vicinity (including Lawrence
Weiner's text piece on the sidewalk in front, or the elf-costumed
performer cleaning the inside of the open door for Paul McCarthy
and Jason Rhoades's contribution) quickly came to define a
veritable who's who of the contemporary art scene. In 2005 the
whole thing was relocated to the Tate Modern, where the trio
retained control over exhibitions mounted within, and its reach
was extended still further by a companion publication, *The Wrong
Times*, as well as a small-scale multiple.

The same triumvirate has initiated a fake Gagosian Gallery
in Berlin, co-edited an annual magazine-style publication called
Charley, and curated an actual biennial—the 4th Berlin Biennial,
Of Mice and Men, in 2006. The pseudo Gagosian enterprise was
in fact an offshoot of the real biennial, a kind of laboratory that
they envisioned as more spontaneous and (despite the appropriated
name) more fully their own curatorial enterprise.[7] (Nor would it
have been much of a stretch to imagine that a subsidiary of that
international gallery venture had really landed in a city that was
already hosting one of the Guggenheim's branch operations.)

The work of this particular trio is part of a larger phenomenon,
evident in a multitude of exhibitions and related events or activities
instigated by an overlapping roster of international art-world
types, and presenting institutionally savvy projects that play across
various disciplinary boundaries. If artists make repeat appear-
ances, so do certain curators, including Hoffmann, Hans Ulrich
Obrist, Maria Lind, Hou Hanru, Okwui Enwezor, Uta Meta Bauer,
and Nicholas Bourriaud (whose relational aesthetic postulate has
been a highly visible lightning rod for discussions of the larger
phenomenon). Nor is it particularly uncommon for artists to act
as curators, or to double as writers—with Phillipe Parreno and
Liam Gillick particularly notable for their frequent contributions
to exhibition catalogues of their peers.

One thing can lead to another, sometimes in quite dizzying
fashion. Take, for example, *No Ghost Just a Shell*, initiated in 1999
by Parreno and Pierre Huyghe when they purchased the rights
to a cartoon-like figure from an agency in Japan. The character,
which they dubbed AnnLee, had been developed for the manga
market, but as a minor figure who therefore had no fictional story
associated with her. Playing with questions of authorship as well
as ownership, they set out to liberate the figure by inviting other

artists to become involved in filling out her history. The thematic of a life inseparable from media and corporate interests is set out in a poster by the Paris design studio M/M, where text that seems to be in the process of overwhelming the timid-looking creature replaces the word "shell" with the well-known logo for the petroleum company of the same name. In a series of videos—many of which were the work of a circle of already frequent collaborators, including Parreno, Huyghe, Tiravanija, Gillick, and Dominique Gonzalez-Foerster—AnnLee questioned the separation between virtual reality and other modes of existence, engaged with the history of time travel, and delved into her own newly formed dreams. The project expanded across other forms as well, including posters and wallpaper, sculpture, music, a magazine, and even a coffin (the last being one of Joe Scanlan's DIY coffins made from IKEA closet parts).

In many respects the purchase of a specific character was little more than a jumping-off point, particularly since AnnLee's video image varied quite dramatically. A 3-D modeling process Parreno and Huyghe developed to animate AnnLee (utilized by some of the other collaborators as well) resulted in a video appearance that is surprisingly different from the wide-eyed, vaguely sad two-dimensional image that they initially acquired—with that divergence particularly evident in Parreno's *Anywhere Out of the World*, where the 3-D version introduces herself to viewers, recounting the history of her purchase and reflecting on her awareness of her own condition, while holding up her manga image.[8] For Huyghe's *One Million Kingdoms*, by contrast, she appears in a linear rendering, a glowing but also translucent figure who transverses a simulated volcanic landscape based on an area in Iceland that played a part both in the Jules Verne story about the journey to the center of the earth and as the location where astronauts practiced in advance of the first lunar landing. The project was brought to a conclusion of sorts in 2002, when, in an obviously paradoxical play on self-determination, Huyghe and Parreno transferred copyright in the character to AnnLee herself. Her demise was also marked by a fireworks display, *A Smile without a Cat*, which presented AnnLee's image literally flaming out by way of a finale.

For Huyghe, the AnnLee exploration was a natural extension of questions raised by other works, where a precipitating observation has opened onto investigations of authorship as it cuts across

4. Philippe Parreno, *Anywhere Out of The World*, 2000. 3D animation movie transferred onto DVD, sound Dolby Digital Surround, blue carpet, poster, 4 minutes. Courtesy Friedrich Petzel Gallery, New York.

not just art, but also a complex media environment—including his 1995 *Blanche-Neige Lucie*, which featured Lucie Dolène, the French singing voice of Disney's Snow White, in a work that involved reasserting her claim over her own vocalization; or his *Association of Freed Time*, for the 1995 exhibition "Moral Maze" at the Consortium, Dijon, which he established as means to extend the scope of the exhibition to include an open-ended conception of production. And he has been equally partial to acts of renunciation, evident particularly in his 2006 *Disclaimers*, where he employed white neon letters to extend his earlier engagement with Disney image production by declaring "I do not own Snow White" and responded to John Cage's famous claim to an interval of silence with "I do not own 4'33"."

The idea of artistic and curatorial collaboration also merges with an extended conception of participation, including a certain apotheosis of this idea in the 2003 *Utopia Station* curated by Molly

5. Pierre Huyghe, *One Million Kingdoms*, 2001. Video, 6:45 minutes. © 2011 Artists Rights Society (ARS), New York / ADAGP, Paris. Courtesy Marian Goodman Gallery.

Nesbit, Obrist, and Tiravanija for the Venice Biennale (a project that, in addition to the physical realization in the Arsenale section of the Biennale, has also included an online archive of the many posters contributed by different artists and an ongoing series of lecture-based events). According to Nesbit, "A station is defined as much by its activity as by its things. It is a place to rest, reconsider, ask all the questions, eat, sleep, learn, and watch."[9] In the context of the exhibition, flexible structures by Tiravanija and Gillick were therefore designed to allow for various user configurations, in response to organized programs as well as more open-ended rest or contemplation. The stated goal of the curators to "incorporate aesthetic material ... into another economy that does not regard art as fatally separate" was also realized by such contributions as Superflex's Guarana Power stand, promoting a soft drink created in collaboration with Brazilian farmers as an alternative to multinational corporate control over guarana production and distribution, or Atelier van Lieshout's environmentally responsible outhouse.[10]

6. *Utopia Station*, Venice Biennale, 2003. View showing seating designed by Liam Gillick. Courtesy Tiravanija Studio. Photo: Liz Linden.

Not surprisingly, one of the sources of inspiration for this endeavor was Jacques Rancière, whose work on the politics of aesthetics, as well as his *Ignorant Schoolmaster*, have become touchstones in the art world based on his vision of the dissolution of distinctions between professional and amateur, along with his evocation of an engaged spectator in the context of an anti-hierarchical "distribution of the sensible." Within *Utopia Station*, an obvious articulation of the desire to alter the status of the viewer was evident in the structures designed by Gillick and Tiravanija to be mere vessels, awaiting the activities and spontaneous dialogue brought by audience participants. Yet, because most of the organized presentations took place during the opening, later visitors were confronted with a chaotic armature that did little to engender the depth of engagement envisioned by the organizers. Once the vernissage crowd had dissipated, Atelier van Lieshout's nonfunctioning toilet and the litter of empty Guarana Power bottles surrounding Superflex's unmanned kiosk were only two of the more visible indicators of the problem of duration posed by the many months during which viewers would be circulating through the space, without the benefit of the intensity or sociability of the opening festivities.[11]

In this respect it is telling that Rancière's conception of an "aesthetic regime of art," with its balance between an emphasis on art's singularity and an assessment of a breakdown of distinctions (not only between artistic genres, but also between art and life), does necessarily favor situation over object.[12] Moreover, his account of this regime's predominance, which he identifies primarily with the last two centuries, coincides rather strikingly with the era of the art museum, with its roots in enlightenment ideals and goals of public access to what had once been identified with aristocratic privilege. In fact a 2004 lecture subsequently published as the title essay in *The Emancipated Spectator* could be taken as a counterpoint to a reading of Rancière's work as the basis for expressly interactive projects. "The collective power shared by spectators does not stem from the fact that they are members of a collective body or from some specific form of interactivity," he insists, emphasizing instead "the power each of them has to translate what she perceives in her own way."[13] Even in the face of more traditional objects, the role of the spectator is hardly passive, with the act of looking or listening "requiring the work of attention, selection, reappropriation" (a process of engagement with an attendant political efficacy).[14]

The perceived failure of *Utopia Station* in the context of the Venice Biennale—particularly the suspended half-life that followed the chaotic but energetic opening events—raises larger questions about what it means to situate such experiments within the setting of an exhibition space. On the one hand the biennial platform offers an opportunity to reach a large, international audience; yet a mode of address based on open-ended interaction runs the danger of failing to communicate in the context of a type of space historically organized around focused visual experiences. One might also ask to what degree a situation designated as interactive could be understood as redundant in relation to the extended framework of experience already activated by the visit to the exhibition as a whole.

Such questions were hardly resolved by *theanyspacewhatever*, a 2008–9 exhibition at the Guggenheim that promised an important summation of a whole series of interlocking projects. Cattelan, Tiravanija, Parreno, Huyghe, Gillick, and Gonzalez-Foerster were joined by Angela Bulloch, Jorge Pardo, Carsten Höller, and Douglas Gordon, working both individually and in collaboration,

to create a retrospective that was also a newly conceived, site-specific installation. Beginning with Parreno's marquee structure brightly illuminating the museum's front entrance or Cattelan's Pinocchio figure floating face down in the lobby reflecting pool, and culminating with Bulloch's night sky in the center of the spiral's domed skylight, the bottom-to-top installation was punctuated not only by different types of insertions, but also potential interactive situations. The latter included Tiravanija's media lounge (a somewhat immodest affair, where viewers could relax on pillows and watch interviews with artists in the exhibition) and an espresso bar & cinema lounge by Tiravanija and Gordon where visitors could sip from free coffee while lolling on beanbag chairs and taking in a selection of once controversial avant-garde films. Huyghe contributed an event, *Opening*, involving viewers wearing headlamps to illuminate the space during the inauguration of the exhibition and twice more during its run. And a privileged few who knew to make advance reservations were able to spend the night in the museum, sleeping in Höller's revolving bedroom set.

7. Philippe Parreno, *theanyspacewhatever Marquee—Guggenheim*, 2008. Acrylic, steel, LEDs (light-emitting diodes), incandescent, fluorescent, neon lights, 30" × 192" × 192". Courtesy Friedrich Petzel Gallery, New York.

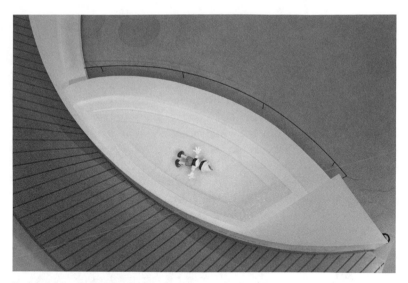

8. Maurizio Cattelan, *Daddy Daddy*, 2008. Installation view, *theanyspacewhatever*, Guggenheim Museum. Courtesy Marian Goodman Gallery.

The title was based on Gilles Deleuze's investigation of cinematic interstices: non-rational links between shots, which, through their independence from narrative, open onto an infinite number of connections, in a "pure locus of the possible."[15] Perhaps not coincidentally, Deleuze's any-space-whatever (espace quelconque) was itself inspired by analyses of urban zones that people pass through, as points of transit between places perceived as significant. A deep understanding of museum structure and rhetoric clearly informed *theanyspacewhatever*, which, rather than interrupting a museum narrative, attempted to set up a new series of relationships through an elaboration of incidental elements (the point of entry, wall text and signage, benches, lounges, and even the walls themselves) reconfigured as the main attraction.

The overall effect was far more structured, even choreographed, than the collaborative chaos of *Utopia Station*, with moments of playful humor evident particularly in the oscillation between labeling and mislabeling in the hanging metal text sculptures by Gillick. Yet this lightly decorated variation on the gambit of emptying out the museum was not in itself particularly revolutionary, given the already long history of such gestures. "Sitting

on a beanbag in an installation in a biennial may have been a
novel experience for art viewers in the '90s," John Kelsey opined
in *Artforum* (perhaps a bit generously with respect to the gambit's
impact at any point), but concluded that "in New York in 2009,
after paying fifteen dollars at the door, one couldn't help but count
the whateverminutes ticking by ... and anyway the downward
pull of the ramp was stronger."[16] In fact the espresso bar was only
slightly displaced from the Guggenheim's own similar operation,
the museum café that has in recent years been situated in the third
level of the circular space adjacent to the main spiral. And the
museum already is a social space, not only within the galleries,
but also in the many areas that surround the art (part of an
emphasis on shopping, dining, and related entertainment that
has been motivating an ever-greater percentage of service versus
gallery space in new museum construction). Turning the galleries
into lounge and refreshment spaces simply mirrors the museum's
extended business model; and once the art itself duplicates such
ancillary functions, it no longer serves the same role of focal point
or draw for the entire package.

Equally obvious, for anyone following the discussions
surrounding these artists, was the framework of relational aesthetics,
theorized by Bourriaud as a shift of emphasis away from the artist's
production decisions and to the total set of social relations or
exchanges engendered by the work's reception. Bourriaud cites
his own 1996 exhibition *Traffic* as a moment of crystallization—
presenting Tiravanija, Parreno, Gillick, Huyghe, Cattelan, and
Beecroft, among others. Yet his stress on situations where the artist
summons the audience (in contrast to the open-ended possibilities
for paying a visit to an object) is clearly centered on Tiravanija's
work, particularly the meals that he began organizing in galleries
in 1992.[17] "Lots of people" is frequently cited as one of Tiravanija's
key specifications, and indeed the experience would have little
resonance without the interaction the cooking is meant to facilitate.

Bourriaud defines relational art as "a set of artistic practices
which take as their theoretical and practical point of departure
the whole of human relations and their social context, rather
than an independent and private space."[18] One might counter
by questioning why private spaces would somehow be excluded
from the whole of human relations. More important, though, is
the type of public space within which these practices are realized.

Tiravanija's meals and related installations are generally hosted by galleries or other art institutions. A reference to the local "bum" population discovering a well-furbished tent that he exhibited at the Walker Art Center in 1995 is a rare indication that the audience for his free food and unrestricted shelter extended to those for whom it might fulfill a genuine need, with most accounts describing an essentially insular dialogue among art-world insiders.[19] When he built a low-power television station for his 2005 Hugo Boss Prize exhibition at the Guggenheim, it therefore seemed somehow appropriate that federal communication laws made it necessary for this model of community self-expression via homemade communication devices to broadcast its signal only within the museum walls.

There has also been an interesting interface between Tiravanija's sociable art situations and the various forms of social media that have emerged in the two decades since he began serving up his meals-as-art. In an account of the initial 303 Gallery exhibition in 1992, Jerry Saltz's description of a "place for sharing, jocularity and frank talk" also referred to his "amazing run of meals with art dealers," including David Zwirner and Gavin Brown. By the time of his 2011 soup kitchen installation in the context of *Fear Eats the Soul*, Tiravanija had moved his operation up the gallery food chain to Gavin Brown's Enterprise. Moreover, those who wanted to lunch with Saltz did not have to depend on chance; they merely had to follow his tweets (and ideally blog about the experience afterward).[20] Even though new channels of publicity (and two decades of increasing fame on Tiravanija's part) had clearly expanded its potential reach, however, Tiravanija's soup kitchen still seemed to serve mainly to an art-oriented audience.

In creating a genealogy for relational aesthetics, Bourriaud cites various earlier avant-garde interventions that emphasized actions as opposed to (or at least in addition to) the production of objects—particularly dada and the situationists—even going so far as to suggest that relational art reconciles earlier situationist strategies with the art world.[21] Yet the situationists renounced art production precisely because it was irreconcilable with their critique of spectacle-driven commodity culture. Nor did dada and situationist actions use the museum as a platform—indeed, far from it. And it is not the least bit clear why the art Bourriaud has promoted under the relational aesthetics banner would escape from

9. Rirkrit Tiravanija, Soup kitchen for *Fear Eats the Soul*, 2011. © Rirkrit Tiravanija. Courtesy the artist and Gavin Brown's enterprise, New York.

Guy Debord's critique of the spectacle simply because it involves participation that is, to a very limited degree, open ended. On the contrary, Bourriaud's reference to the artist as "entrepreneur/ politician/director" delineates a project that is hardly at odds with economic efficiency; in fact it is firmly rooted in today's service-based paradigm.

Pine and Gilmore's *Experience Economy* is another frequent point of reference in discussions of recent post-studio, situation-based work. Adding to the chain that goes from commodities in the form of raw material, to goods manufactured from those basic commodities, to the service economy that provides consumer interface, they extrapolate a fourth term in the form of an experience economy that is based on the sale of experiences rather than just goods. One of their prime examples is theme restaurants, where one goes not simply, or perhaps even mainly, for the food; instead, the lure is the surrounding activities, spectacle, and enter-tainment. And they frame this experience economy as the creation of memories over and above the acquisition of goods.

Clearly much of the work that has been promoted under the relational aesthetics umbrella can be related to this paradigm. One doesn't visit the exhibition for the objects, but rather for what is happening throughout the space, including interactions among audience members. But one could also argue that this is merely a matter of creating a division or hierarchy among different types of experiences. Why does being entertained by the trappings of a thematic dining context constitute an experience, as opposed to the act of eating itself? For someone engaged with taste, food can indeed be meaningful and memorable. And isn't looking an interactive process? Doesn't one have a relationship with the objects one views in an old-fashioned museum? Why should some works (based on changing environments or interactions) be synonymous with the idea of having an experience, in contrast to an individual's response to a static object? Rancière's counterpoint to formulations that posit the spectator as a passive figure obviously comes into play here. Equally relevant is Claire Bishop's critique of relational aesthetics as a "creative misreading of poststructuralist theory." Umberto Eco's conception of open work, she argues, emphasized an ongoing process of interpretation, as opposed to Bourriaud's stress on art that is itself "in perpetual flux."[22] Rather than an open-ended model of reception, Bishop's argument suggests, Bourriaud actually favors specifically delimited situations where the framework for engagement is planned or produced by the artist.

Then there is the matter of the interplay between work and leisure time. Going to openings, noshing with collectors, chatting with curators, hanging out with artists—all of these are important parts of the art professional's current job description. Witness how many of the conversations in Obrist's colossal interview compendium seem to have been conducted in the course of plane rides, with curator and artist both literally and figuratively headed in the same direction.[23] A desire to be part of this scene, and to hobnob with artists, is likewise a significant attraction for collectors of contemporary art. It is therefore not surprising that Bourriaud's relational model privileges the art opening—resulting in an emphasis on social function hardly at odds with the general dynamics of the art world.[24] And there is a similar level of convenient overlap with contemporary art world business-as-usual in Bourriaud's glorification of the figure of the nomad (whether artist or curator) in his more recent claims regarding what he posits as "Altermodern,"

both in the Tate Triennial exhibition and catalogue of that name, and in his 2009 book *The Radicant*.[25]

Art that is event centered is obviously much more amusing, however, if you are invited to the party. Only the opening-night crowd has the opportunity to see Beecroft's static performances involving partially clothed women challenged with the endurance task of standing as objects of display for the period of the event while also being filmed for the video destined to be viewed by the rest of the work's audience. Similarly, when Huyghe and Parreno's AnnLee project flamed out via the 2002 fireworks display that lit up the skies over Art Basel Miami, it was specifically the privileged set that flocks to such art fairs that had the opportunity to experience the live version of the final stage of this critique of the commodified image. Much of the work promoted under the relational aesthetics rubric loses a great deal of resonance after the initial celebration is over, due in large part to the uneasy compromise between the single event and the long duration of the exhibition. And clearly the quality of any sort of work focused around sociability depends on who else is there—a problem all too apparent for later Venice Biennale visitors who happened across the armature of the 2003 *Utopia Station* and found a somewhat disheveled hang-out area rather than the density of exchange reported out from the opening festivities.

If participating in an exchange with other audience members is defined as essential to the work, then there is bound to be a sense of loss, even futility, to seeing its physical components without that give and take. Yet there are plenty of misanthropic types among the art-going public who don't particularly want to talk to someone else while viewing art, and it is therefore interesting to consider interactive situations that might be valid (even if radically different) under varying circumstances. David Hammons' 2002 *Concerto in Black and Blue* would be one candidate. For this exhibition at Ace Gallery in New York, the walls were bare, the lights were out, and even the skylights were covered over, leaving the space completely empty and dark. Visitors were able to make their way through the murky interior using miniscule LED flashlights that emitted pale blue beams. Reports of the opening describe a dynamic experience, with hundreds of individual rays of light moving through the engulfing space. On a quiet weekday, however, it was possible to spend one's entire time completely alone in the darkened interior of the imposing series of interlinked galleries, and this experience was

10. Philippe Parreno and Pierre Huyghe, *A Smile Without a Cat*, 2002. 35mm color film. Huyghe's work © 2011 Artists Rights Society (ARS), New York / ADAGP, Paris. Courtesy Friedrich Petzel Gallery and Marian Goodman Gallery.

equally compelling, precisely because it was completely solitary as well as open-ended with respect to how much time one wanted to spend in the strangely cavernous spaces.

Or consider an entirely different relational demographic—not the interconnected biennial circuit, but the equally networked

skateboard culture that Jeffrey Deitch frequently showcased in his New York galleries. Deitch has described an initiation into these circles through Barry McGee, whose 1999 exhibition, "Buddy System," attracted the biggest opening-night crowd Deitch Projects had experienced up to that point. The creation of objects that might appear in a gallery is only part of an extended array of activities emanating out from the ubiquitous skateboard, including graffiti, music, and an associated club scene. Deitch went on to provide the perfect relational aesthetics equivalent for this subculture with his 2002 *Session the Bowl*, an exhibition centered upon a wooden sculptural environment designed by SIMPARCH as a skate bowl, which was even more wildly popular than the McGee exhibition, attracting a constantly changing cast of participants, many of whom treated it as a form of performance space.[26]

A 2004 traveling exhibition, *Beautiful Losers: Contemporary Art and Street Culture*, along with a related movie, documented the phenomenon, tracing a scene that tracks apart from the mainstream

11. *Session the Bowl*, 2002, Deitch Projects, 18 Wooster Street, New York. Courtesy the artists and Deitch Archive. Photo: Tom Powel Imaging.

while being sustained by an alternate economy—with financial rewards not only from art-world absorption, but also from work for skateboard companies, design projects ranging from music promotion to clothing lines, and transitions from street verité to filmmaking success. It is therefore an alternative lifestyle choice that finds support in an alternative lifestyle marketing network.

What the slacker skateboard culture and the more esoteric relational aesthetics equivalent have in common is a valorization of experiential situations that turn out to be not particularly subversive in the context of a larger marketplace driven by viral marketing, branded personalities, and various forms of "in-the-know" status symbols. While setting up spaces for exchange is a noteworthy goal (and indeed would, in an ideal world, be a fundamental element of the cultural fabric), it is hardly revolutionary in itself. Nor is it necessarily a critical act to turn the activities associated with leading a creative life in the context of a globalized network—dialogue, socializing, and travel—into art's primary function.

Art and life(style)

A cynical turn on the perennial avant-garde goal of breaking down distinctions between art and life appears in the guise of artist as high-end lifestyle consultant. Consider, for example, the critically lauded cooperative activities of the Bernadette Corporation, which have included club promotion, fashion design, filmmaking, and a collective novel attributed to their subsidiary identity of Reena Spaulings. The various permutations have been read as an edgy play on the culture industry. Yet the use of the ancillary name for Reena Spaulings Fine Art, an enterprise with an uncanny resemblance to an actual art gallery, suggests how notions of critique might all too easily segue into simply "doing business as," or d/b/a, in the legal parlance used to refer to a situation where the name under which business is being transacted is not the same as the legal name or names of those conducting the enterprise.

Despite the pervasive nature of the strategy, there can still be unresolved questions about what exactly is on offer when an artist is invited to respond to a situation rather than present an object.

Taking as given the potential redefinition of the artist as service provider, Andrea Fraser has pursued various implications of this proposition. On the practical level, there is the matter of how to negotiate compensation for interactions with institutions that have not customarily been organized around the idea of paying fees to the artists whose work they exhibit. Another issue concerns how to prevent project-based work from turning artists into "functionaries of 'client' organizations." Interestingly enough, Fraser invokes the notion of autonomy in her analysis of this situation—not the traditional museum conception of a purportedly self-sufficient object, but instead the goal of artists to operate with "relative freedom from the rationalization of our activity in the service of specific interests," despite working with institutions.[27]

In presenting her vision of artistic services, Fraser has emphasized a purist stance, arguing against collecting fees from an institution and then turning around and selling offshoots of the project-based work (which is indeed a common gambit, and one that potentially puts non-profit museums in the role of covering production costs for work that winds up in the commercial marketplace). And tensions around payment for artistic services point to larger contradictions evident in the notion that devotion to art should constitute an end in itself, rather than an openly commercial enterprise. Another intangible at play is the fact that many contemporary collectors who acquire more traditional objects are buying into the opportunities thus afforded to mingle with artists and partake in the ambience of creative glamour associated with an art-centered social scene.

Fraser managed to achieve significant notoriety when she took the social aspect of the art world to what could be described as a certain logical extreme with her 2003 *Untitled*—a sixty-minute video documenting Fraser having sex with a collector who had paid for the privilege of entering into a contractual arrangement with the artist to participate in the work in question. But even in far less publicized cases, the interface between an artist's art-as-life project and evident pursuit of commercial gain can provoke resistance. Witness, for example, the used clothing store operated by Christine Hill in Berlin, which was open for business there in 1996–7, before being relocated to Kassel as part of Documenta X. Akin to Oldenburg's 1961 *Store*, Hill's used clothing enterprise was both installation and performance, with Hill inhabiting

12. Christine Hill, *Volksboutique Franchise*, 1997. Installation view at Documenta X, Kassel, Germany. Courtesy Galerie Eigen + Art Leipzig/Berlin and Ronald Feldman Fine Arts, New York. Photo: Uwe Walter.

the shop and initiating often open-ended conversations with her potential customers—a process turned into a requirement for the Documenta version, where the individual items did not carry price tags.

In Hill's hands, the line between art and various forms of service-based enterprise becomes almost infinitely thin. Yet she found complaints about the commercial nature of her Documenta installation a bit ironic, given that it was situated directly opposite a Jeff Wall work (with audience members perfectly willing, apparently, to accept Wall's adaptation of the commercial form of the light box, in the larger context of an ostensible play with photographic versions of history painting that has generated works which have been highly successful in the art marketplace). And there have been other moments of opposition as well, including one museum that rescinded Hill's production fee when it discovered that her project, in the form of a vending machine, was actually making a slight profit, or complaints about the $12 levied for participating in her

1999 *Tourguide?* piece in New York, even though she was charging what she determined was a standard rate for such services.[28]

Residual tensions aside, it is clear that Hill's work is part of a far-reaching redefinition of art that allows everyday operations to revel in the quotidian while simultaneously being marked out via their declaration as art. Hill also forces renewed attention to the frequently mystified interdependence of art and commerce. In Berlin, Hill's store was open only a few days a week in a relatively obscure location. But, unlike most hole-in-the-wall operations, this one had a historical afterlife because of Hill's simultaneous definition of the store as art—with a further blending of roles when she refers to her retail establishment-*cum*-artwork as a curated space. Asked by an interviewer about the project's status as a Beuys-style social sculpture, operating somewhere between life and art, Hill's response evoked the declarative act behind the readymade: "It is obviously 'my fault' that all of this work is being perceived as art, because I have chosen to call it that."[29] It seems equally significant, however, that Hill has presented her various interconnected series of enterprises, including collecting, archiving, performance, and installation, under the umbrella of her Volksboutique label. Her self-conscious play with this second framework of identity for her extended project shows very clearly that it is only a small step from author-function to brand.

For the 2007 Venice Biennale, Hill took her emphasis on process even further, documenting her life-as-art in the form of a datebook-style publication, *Minutes*, displayed at a reading table in the exhibition and also distributed as a published book. With its recursive structure there was a suggestive echo of Christian Jankowski's 1999 *Telemistica*, a video piece in which Jankowski presented footage of his calls to five televised Italian fortune tellers, asking them to predict the future of his work for the Venice Biennale. His first question is whether he will be able to find people who will help him to complete his project (with the answer indicated by the video presence, providing the medium through which the work has been realized, far more than by the prediction for future success she makes based on her cards). Further conversations address audience response, and his artistic success in general, in conversation with fortune tellers who show varying degrees of knowledge or ignorance about the art event in which they will eventually be featured through their participation in the televised exchange. In Hill's case the format itself (that of a

13. Christine Hill, *"Minutes"* from *Volksboutique*, 2007. Installation at the Venice Biennale. Courtesy Galerie Eigen + Art Leipzig/Berlin and Ronald Feldman Fine Arts, New York. Photo: Uwe Walter.

14. Christian Jankowski, *Telemistica*, 1999. Single-channel video, 22 minutes. Courtesy Studio Christian Jankowski.

traditional day planner) was more old-fashioned, but the result was equally self-referential, since it presented the artist's record of social networking, planning, and logistics as the work itself.

One way of reading such work is to foreground the significance of the artist's act of designation. This is not the retrospective operation indicated by Michel Foucault in his essay "What is an Author?," where he poses the question of how to treat such miscellaneous notations as appointments or addresses that may be interspersed with more obvious candidates for works of authorship in a writer's notebook.[30] Instead, it can be understood as an extension of the readymade gesture, with the artist declaring his or her every act as part of a larger project. Significantly, the artist has decided to enact this process of recontextualization in advance, as the basis for the creation of the work. In the process, the emphasis shifts from work to artist, engaged in a performance of self. What is fascinating about both Jankowski's *Telemistica* and Hill's *Minutes* is how both manage to turn seemingly peripheral concerns and activities into the work in question, and how this engagement with process or logistics draws attention back outward, to the networked system essential to an internationally mobile art world and the artistic careers that are inseparable from that apparatus.

It is also interesting how tenaciously the notion of the artist as solo creative genius holds, even in situations where there is clearly an extensive collaboration required to realize a project, or where the enterprise in question blurs distinctions between artistic production and such other creative economy categories as stylist or designer. This broader tendency was readily apparent when Tobias Rehberger achieved a milestone of sorts with his best in show award for *Was du liebst, bringt dich auch zum weinen* (What you love also makes you cry), the cafeteria he created for the 2009 Venice Biennale. According to the jury, the Golden Lion was based on "taking us beyond the white cube, where past modes of exhibition are reinvented and the work of art turns into a cafeteria. In this shift social communication becomes aesthetic practice."[31] The cafeteria followed upon other relational-type environments Rehberger had designed for open-ended use (for example, his red-carpeted roof garden, created for the University of Münster in conjunction with Skulptur 97). Yet Rehberger himself has insisted that his work is "more about differentiating between art and design, trying to define the differences rather than merging the two fields."[32]

15. Tobias Rehberger, *Was du liebst, bringt dich auch zum weinen*, 2009. Installation view, Caffètteria Biennale di Venezia, Palazzo delle Esposizioni. © Tobias Rehberger, 2009. Courtesy neugerriemschneider, Berlin.

Rehberger's distinction seems more plausible when design is the subject rather than the vehicle for the work. In a humorous comment on the status of certain iconic objects, Rehberger took design classics as the starting point for a series of chair sculptures from 1994 based on a game of translation that started with him drawing paradigmatic examples of twentieth-century furniture design from memory (examples by Breuer, Judd, Aalto, Rietveld, and Berliner Werkstätten), then handing the sketches off to carpenters in Cameroon to be fabricated on the basis of their interpretation of his already approximate images. "What is it about these objects that we find so amusing," asks Daniel Birnbaum, "the European pretensions they point up or the African 'difference' they seem to reveal?"[33] This variation of the classic game of telephone can be read as a riff on colonial relations, communicating something about global disparities, but there is also evidence of ingenuity in the modest materials used to realize the physical reinterpretations. And Rehberger did something similar with a series of classic cars, giving his memory sketches to Thai fabricators to create functional vehicles on their basis. In both cases, the results are at once familiar

16. Tobias Rehberger. Left to right: *Ohne Titel (Breuer)*, *Ohne Titel (Judd)*, *Ohne Titel (Breuer)*, *1994*, *Ohne Titel (Aalto)*, *Ohne Titel (Berliner Werkstätten)*, *Ohne Titel (Rietveld)*, all 1994. Installation view: *70/90 Engagierte Kunst*, Neues Museum Nürnberg, 2004. © Tobias Rehberger, 1994. Courtesy neugerriemschneider, Berlin. Photo: Neues Museum Nürnberg (Annette Kradisch).

and disconcerting, as the easily recognizable intersects with the definitely not quite right.

But what criteria should be applied in the cafeteria situation— visual interest, physical comfort, or even food service? Judging the space according to its function, one writer didn't bother with the quality of the cuisine (dismissing it as always dismal at the Biennale), but found that "the seats were uncomfortable, the air sticky and the visual experience a bit like being stuck in a youth culture centre decorated by an over-ambitious skateboarder."[34] It is also significant that the idea of partnership slipped away in the context of the award. Rehberger's working processes involve a combination of teamwork and outsourcing as a matter of course, and in some contexts the cafeteria was billed as a joint venture between Rehberger and the Finnish firm Artek. A congratulatory statement from Artek following the award finessed the issue, stating that Rehberger "collaborated closely with Artek using customized Artek furniture in an ingenious way."[35] In point of fact the firm does have a rather long and noteworthy history in the field of design, dating back to 1935 and the role of architectural

pioneer Alvar Aalto as one of its founders. As such, it draws upon a significant heritage of theory and practice regarding the synthesis of architecture, design, and everyday life. Rehberger's cafeteria-as-art built on these foundations, perhaps less as a designer (since the core design already existed), and more as a somewhat over-the-top decorator/stylist.

Nor was Rehberger the only artist to turn his attention to utilitarian spaces for the 2009 Biennale, since Pardo was responsible for the bookstore that year. Pardo and Rehberger's shared fascination with design is evident in the ways that both incorporate their own versions of functional objects, particularly lamps, into their work. And where Rehberger established a roof garden for Skulptur 97, Pardo built a redwood pier jutting out from the northwest bank of the Aasee for the same exhibition, creating a focal point for open-ended urban leisure that he envisioned as a lasting contribution to the local landscape. Architectural-style installations require substantial support, however, with the artist's studio operating like a small firm. Tellingly, the enterprise known as Jorge Pardo Sculpture has advertised at different times for a full-time resident architect, to "design & create sculptural & architectural projects from conception to modeling to construction," and a part-time pilot to fly a Cirrus SR22 on missions in Mexico and the United States.[36]

There is also the matter of Pardo's collaborations with other artists, both direct and after-the-fact. One can only speculate about what the artists in question might have thought of Pardo's 2004 reinstallation of the collection of the Fundació "la Caixa" in Barcelona, which presented works from the institution's collection of minimal art in a room dominated by rich orange-red walls (specified as machine-carved MDF) shaped with drapery-like undulations and also dominated by five of Pardo's large, chandelier-style lamps. In his own assessment of the project, Pardo distinguished his approach from that of a curator due to his employment of an aesthetic he described as opulent, even frivolous, in order to estrange the work from its tradition. His inclusion of his own hanging lamp constructions can also be understood as an extrapolation of his idea that it would be more interesting to use a Dan Flavin sculpture to light other proximate objects than to have the work as a primary focus of display.[37]

Yet Pardo's imagined repurposing of the utilitarian fixtures that Flavin divorced from function suggests a double reversal that

17. Jorge Pardo, Installation view, Collecion Fundació "la Caixa," Barcelona, 2004. Courtesy Friedrich Petzel Gallery, New York.

happens to reassert standard operating procedure for lighting fixtures. Moreover, although the setting of ornate lamps and undulating red walls was decidedly unexpected (one of his goals), the overall installation was clearly in danger of swallowing up the subtle austerity of the works arrayed around the room. Nor can one conclude that the aesthetic was motivated solely by his desire to shake up exhibition conventions associated with minimalism, given that he used a similar color scheme for the décor of the Mountain Bar, an establishment in the Chinatown area of Los Angeles that he opened in 2003 as a joint venture with gallery proprietor Steve Hansan.

A similarly dramatic departure from the white box characterized Pardo's design for the reinstallation of the Los Angeles County Museum of Art's Latin American collection, "Latin American Art: Ancient to Contemporary," unveiled in 2008. Given Pardo's Cuban roots, his contribution played a double role, as setting for the ancient works on display, and the installation itself as an example of Latin American work within that larger framework. According to LACMA director Michael Govan, the installation acknowledged the necessarily "fictional environment" of a museum display

of ancient culture, in an approach that would "give the objects integrity with a contemporary frame."[38] Writing for the *New York Times*, however, Holland Cotter described a setting that "doubles as a solo show for a contemporary artist, and looks like a nightclub interior," finding the curvilinear display walls, draped green fabric, and "zany little chandeliers" ultimately counterproductive, despite the potential to lure the audience into the space, because "the art itself is hard to see."[39]

18. Jorge Pardo, Installation view, "Latin American Art: Ancient to Contemporary," Los Angeles County Museum of Art, 2008. Courtesy Friedrich Petzel Gallery, New York.

The idea that lighting, in particular, would be an impediment to viewing carries its own irony, with the added twist that Pardo blurs the very definition of "art itself" by illuminating historical objects with lighting fixtures that he also defines as works. And even though Pardo may be functioning as architect or designer, he still holds onto an artist's prerogative—evident in his complaint about a proposal from the architectural firm Herzog & de Meuron to use some of Pardo's art lights in a restaurant, while having the

temerity to ask for changes. For Pardo, it was a travesty to ask him to provide a work of art (regardless of its visual and functional resemblance to a lamp) in a different color.[40]

Pardo gave Dia's now defunct Chelsea space an equally striking makeover. Redirecting Richard Gluckman's stark play on warehouse functionality, Pardo redid the entire first floor with colorful tiles on the floors and running up the support columns. In the bookstore, his approach was a decided success, turning the space into an attractive lounge and meeting spot, complete with literature and even a viewing station for the Electronic Arts Intermix videos for sale. But the tiles extended through the entire first floor, including the exhibition space, so that once Pardo was done, every later exhibition was necessarily a collaboration—though this was apparently fine with Gilberto Zorio and Gerhard Richter, the only two artists to engage in a significant way with the

19. Jorge Pardo, *Project*, 2000. Dia Center, 3 parts: lobby, bookshop, gallery, overall dimensions 108′ × 108′. Courtesy Friedrich Petzel Gallery, New York.

first-floor gallery before the entire building was decommissioned as a Dia space.

When it comes to blurring art and life, however, Pardo's domicile is difficult to surpass. Invited to exhibit by the Los Angeles Museum of Contemporary Art, Pardo was uninterested in a standard survey, and instead proposed that the museum collaborate on the building of a house. More specifically, this was to be Pardo's house—on display for a brief time to museum visitors in 1998 and then transformed into a fully private abode once the exhibition was over. In other words, it was the opposite of the typical house museum, which generally transitions from individual dwelling to public museum, rather than the reverse. As Barbara Steiner saw it, "his house is neither a house, nor an exhibition, nor a sculpture. It is instead a discursive object that has no absolute value, although it acts as a catalyst to provoke an endless series of new responses and questions."[41] Of course it could also be read as a clever caper—and

20. Jorge Pardo, *4166 Sea View Lane*, 1998. Museum of Contemporary Art, Los Angeles. Courtesy Friedrich Petzel Gallery, New York.

a form of aesthete's revenge, where the museum has not only been prevented from isolating aesthetic objects from everyday use, but has even been rendered instrumental in facilitating the artist's life-as-art project.[42]

There is plenty of room for cynicism in relation to the overlay between art and design—though perhaps the difficulty is not so much the specific examples (since Pardo has indeed created some quite remarkable architectural spaces), but rather some of the claims made for its transgressive artistic power. Thus the issue is not the design itself, or even the potential blurring of distinctions between design and art. Instead, the problem has to do with the pursuit of one-of-a-kind gestures that stand in sharp contrast to the utopian ideals articulated in relation to early twentieth-century avant-garde projects, or even the more limited promotion of aesthetic principles associated with mid-century initiatives like the Museum of Modern Art's "good design" exhibitions.

A concept's success can also become a key factor in undermining its status as a viable alternative gesture—as evident, for example, in the contrast between a certain visionary fervor in Andrea Zittel's initial impulses and the eventual absorption of her work by both museums and the art marketplace. According to an oft-told tale, Zittel created her first A-Z personal uniform to solve a practical problem. Working in an art gallery, she faced the challenge of how to dress for this image-conscious setting within the limited resources of her modest salary. Responding to an environment rampant with designer labels, she created her own uniform, to be worn daily for six months at a stretch. It was, by her estimation, a form of public art that involved substituting her self-generated look for the evidence of status asserted by high-end fashion. She took a similarly inventive approach to her living environment, figuring out how to exist with maximum efficiency in small spaces that amounted to no more than a hundred or two hundred square feet. Even her corporate-sounding identity, "A-Z Administrative Services," was driven in part by practical considerations, as she needed an official-sounding title when she began contracting with fabricators and other professionals to help realize aspects of her work.[43]

Zittel's substitution of her own custom-designed environ-ments and clothing for corporate products clearly evokes earlier

utopian projects, particularly the arts and crafts movement around William Morris in the late nineteenth century. But, as Trevor Smith has pointed out, the socialist utopia Morris envisioned, based on altering the means of production to abolish alienated labor, stands in marked contrast to Zittel's emphasis on personal self-awareness.[44] And the distinctions around outcome are even deeper. The insurmountable problem faced by Morris was price, with industrial pastiche much more cheaply produced and sold than his hand-crafted alternatives. The contrast between Zittel's humble inspiration and the subsequent dissemination of her work is far more extreme, since high price is less a function of production expenses than of the fact that her initially utilitarian impulses have been translated into museum-worthy works of art that are sold according to the rarified criteria of the art market.

21. Andrea Zittel, *A-Z Carpet Furniture: Bed*, 1995. Wool and synthetic wool blend carpet, 96" × 96" (on wall). *A-Z Carpet Furniture: Drop-leaf Dining Room Table*, 1997. Nylon carpet, 78" × 120" (on floor). Installation view, Albright-Knox Art Gallery, Buffalo, New York, *Critical Space*, October 6, 2006– January 7, 2007. © Andrea Zittel. Courtesy Andrea Rosen Gallery, New York, and Albright-Knox Art Gallery, Buffalo. Photo: Biff Heinrich.

Consider the *A-Z Carpet Furniture*, which "combines the aesthetics of a decorative wall hanging with the design of a rug" in a manner that is described as "at once luxurious and practical."[45] The designs are both elegant and playfully austere; but their claimed functionality is a bit far fetched. With schematics of various setups—tables, beds, living-room furniture—they supposedly allow a space to assume those various purposes, and can hang on the wall when not in use. But the idea is central, since it seems unlikely that a collector able to pay upwards of $10,000 for such a rug will leave it on the floor, or spend long stretches of time squatting over a semi-abstract image of furnishings.[46]

Likewise, her living units were inspired, according to Zittel, by residing in a small, chaotic space, with their compact design providing a nucleus of order and clarity. For collectors like Eileen and Peter Norton, however, they are undoubtedly more about an idea of efficiency than the fulfillment of a need. Moreover, if a collector were to decide to take up the challenge of existing within the confines of one of these living units, it would be a form of reverse extravagance, since the evidence of wear and tear would reduce the value of the art. And not surprisingly, when Leonora and Jimmy Belilty decided to dispense with their 1994 *A to Z Living Unit*, it was hardly treated like residue of a remodeling job; rather, it sold at a 1999 Christie's auction for $57,500.[47]

The contrast between initial inspiration and later significance is most obvious with the personal uniforms. What began as a modest alternative to designer-based displays of status has morphed into an even more elite marker in the form of an original Andrea Zittel outfit. Anyone now looking to commission a personal uniform is acquiring a work of art by a well-known artist. Therefore the garment in question is much more exclusive than all but the most extravagant couture. Wearing the uniform constitutes a kind of devil-may-care ostentation (as opposed to practical frugality) in one's willingness to subject a unique work of art to the accidents associated with daily life—but with the payoff of having one's cutting-edge taste recognized by others who travel in the same circles. Rather than escaping the designer sign system, the personal uniform ascends to a position at the top of the pyramid, with exclusivity marked both by the severely limited numbers of custom outfits and the insider knowledge required to appreciate the clothing's artistic pedigree.

22. Andrea Zittel, *A to Z Living Unit Customized for Leonora and Jimmy Belilty*, 1994. Steel, wood, mattress, glass, mirror, lighting fixture, stove, oven, fabric, 36¾" × 84" × 38" closed; 57" × 84" × 82" open. © Andrea Zittel. Courtesy Andrea Rosen Gallery, New York. Photo: Ernesto Valladares.

There is undoubtedly a utopian dimension to Zittel's project, both in her own lifestyle choices and in the open-ended events, under the title High Desert Test Sites, emanating from her studio in Joshua Tree, California. Yet the distribution of her wares as art suggests that her work functions more as concept than model. There are also shades of the counter-utopia that appears in the total lifestyle associated with a number of contemporary designers and their extended product lines (the Ralph Lauren lifestyle, for instance, with clothing complemented by furnishings, bedding, and all manner of home decoration). While Zittel's work emanates from interesting and idealistic impulses, its art-market success suggests how easily a critique of consumption can be reabsorbed into that system.

In the context of the nineteenth-century arts and crafts movement, the Bauhaus, de Stijl, or Russian constructivism, total design schemes were part of visionary, even utopian agendas, with

changes to the physical environment envisaged as part of an altered way of life. And there are plenty of other examples of life as a form of aesthetic project, ranging from the urban flâneurs celebrated by Walter Benjamin, who countered urban efficiency with their aggressively unproductive gesture of walking turtles, to the inter-weaving of art, celebrity, parties, and gossip that is part of the Warhol phenomenon.[48] In fact it is striking how many aspects of recent practice can be traced back to Warhol, including the artist's function as production manager, overseeing a range of goods created in his or her name, or the artist as celebrity spokesperson, incorporating those goods into a lifestyle that serves as a marketing tool for the entire line.

The presentation of the self as brand can be read as a comment on the cultural obsession with such labels. Yet that notion becomes a bit attenuated when the alternative to designer goods turns out to be either a high-priced work of art or a version of the artist's life as sponsored project. It is equally noteworthy how success-fully the art world has absorbed challenges to its conventions, thus turning the notion of critique into a potentially marketable badge of honor. As in the culture at large, works that reveal the mecha-nisms whereby status is achieved and maintained are all too easily absorbed by an audience that is prepared to buy into the game with a knowing wink. The countless times over the course of the last three decades when David Letterman has directed his camera crew to reveal the cue cards from which he delivers his lines has hardly diminished his popularity by revealing the manner in which the show is constructed; rather, the gesture appeals to television viewers who understand themselves as sophisticated enough to take their pleasure without falling for an apparently seamless illusion. Revealing the support systems behind artistic careers can be equally non-disruptive for members of an art audience both attuned to a networked production apparatus and happy to brag about their ability to track the industry and the players.

Making daily life into art has an evident efficiency: everything one does can be understood as significant or important if it is all art. Even the unwanted can be repurposed, as Warhol readily understood: "The acquisition of my tape recorder really finished whatever emotional life I might have had, but I was glad to see it go. Nothing was ever a problem again, because a problem just meant a good tape, and when a problem transforms itself into a

good tape it's not a problem anymore."⁴⁹ This also happens to be
the logic of reality television. Take daily life, turn it into a self-
conscious pastiche of itself, make a video record, and rake in the
profits. It might be understood as a form of reverse *dérive*, in which
the situationist anti-spectacular model of aimless, non-productive
activity has been reterritorialized for voyeuristic consumption, and
thereby absorbed into new commercial channels. In the art-world
context, the romantic cliché of the artist who lives for his or her
art intersects with a form of artist professional whose life seems
to have become the main attraction, even as that life turns around
social networking as much as studio time.

Alternatives?

There is no reason to suppose that mining everyday life, or setting
up an interactive situation, should constitute an inherently provoc-
ative act. In many hands, the result can be an indulgent affair. Yet
it is still possible to produce incisive gestures based on observing
the dynamics of the relationship between individuals and social or
political structures. Likewise, the global biennial circuit that has
spawned a roving band of interconnected collectors, curators, and
artists moving en mass around the world to attend the same parties
also supports an increasing diversity of voices and perspectives.
For certain artists, the nomadic lifestyle fostered by participation
in far-flung exhibitions can become the basis for art that takes
cultural intersections or negotiation as the basis for provocative
formations. And when their existing structures are exploited for
interesting ends, art institutions can provide strategic platforms for
reaching an extended international audience.

It is also frequently the case that artistic engagement with the
dynamics of fashion produces little more than a minor, largely
affirmative gloss; so it is striking when one encounters genuinely
stimulating work derived from such material. The partial abstraction
of Emily Jacir's 1991–2001 *From Paris to Riyadh (Drawings for my
mother)* speaks eloquently to a process of translation. Some of the
works in the series read quite legibly as silhouette-like bodies, with
black-delineated limbs set against the white field that encompasses
both the surrounding page and the negative shape of clothing. But

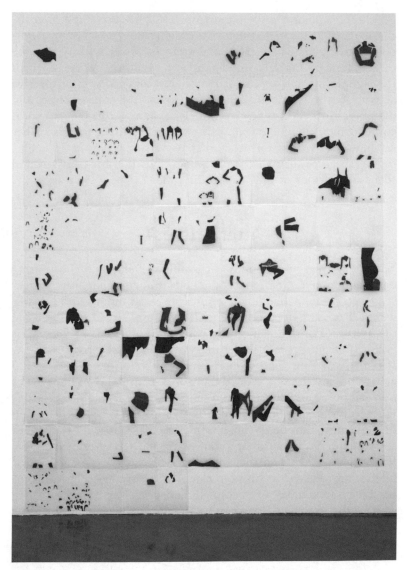

23. Emily Jacir, *From Paris to Riyadh (Drawings for my mother)—Mars 1996,* 1999–2001. Marker on 115 sheets of vellum, 12″ × 9″ each. Courtesy of Alexander and Bonin, New York. Photo: Bill Orcutt.

even the most abstract have an archival source in Jacir's personal history, since they are based on direct tracings from pages of *Vogue* reprising areas where her mother inked out the exposed portions of the models' bodies before taking the magazines to Saudi Arabia. The intersection of Western consumer culture and Islamic fundamentalism quite literally delineated in the work can be read critically in both directions, for ways that it implicates not only the objectification of the female body in Western fashion magazines but also the problem of female invisibility in the Saudi context.[50]

As a Palestinian who was bought up in Saudi Arabia, studied in the United States, and now divides her time between New York and Ramallah, Jacir is well situated to examine the political implications of daily life—with particular attention to how the apparently unexceptional can actually be quite tenuous in circumstances where everyday existence is negotiated in relation to unrest or restrictions on movement. Rather than a relational-style exploration of the audience's interaction with a retail-inspired installation, her 2004 *Ramallah/New York* keeps the viewer at somewhat of a remove while allowing observation of habits and traditions that, if not exactly universal, share close parallels. The double video presents real-time sequences captured in retail and service establishments in each locale (shops, restaurants, hairdressing salons), where similarities between the two cities convey an underlying message about the value of such daily routines precisely because they cannot be taken for granted in the larger context of the West Bank.

24. Emily Jacir, *Ramallah/New York*, 2004–5. Two-channel video installation on DVD, 38 minutes, dimensions variable. Courtesy Alexander and Bonin, New York. Photo courtesy the artist.

The other side of that fragile normalcy is the subject of her 2001–3 *Where We Come From*, documenting the results from a question posed to Palestinians who have not shared the freedom of movement granted by Jacir's US passport: "If I could do anything for you, anywhere in Palestine, what would it be?" The requests, nearly thirty in all, poignantly illustrate the unequal privileges attached to the fate and accident of citizenship, from a son unable to return to Gaza, who sends the artist to hug his mother, or another person who requests her to photograph family members there, to a resident of Ramallah who asks her simply to walk the streets of Nazareth, which he has never seen.

But once daily life becomes the basis for work, there is no clear-cut strategy governing how that should be articulated. Jacir's work, which encompasses photography and text, drawing, and video, as well as sculpture and installation, is part of a post-medium approach, where the particular form is generated by a combination of observation and research. But the primary forum for her exploration remains the exhibition, and in that sense she follows a long-established tradition of bringing various types of material into the frame of the gallery, even if that setting is used in turn as a platform to broadcast it back into the world, through associated publicity or information generated by its display as art.

Expanding definitions of art have also led to an extended institutional purview that now includes potentially nomadic practices. There are precedents in earlier earthworks like Smithson's 1970 *Spiral Jetty*, which was funded with $9,000 grants from Virginia Dwan and Ace Gallery, and ultimately transferred by the estate to the Dia Art Foundation in 1999. But in this instance the remote arrangement does still have a clear identity as art (with evidence of that status indicated by Dia's threat of a lawsuit to prevent the Epic Brewing Company from using a photograph of the work on a beer label).[51] More recently, institutional backing has included support for interventions that are increasingly difficult to categorize.

One case in point would be Jeremy Deller's 2009 *It Is What It Is: Conversations About Iraq*, which began its life at New York's New Museum. During its first six-week run on site, museum visitors were invited to converse with journalists, soldiers, refugees, and scholars, who were present and prepared to share memories related to Iraq. Also on display in the museum, as a kind of conversation piece, was the twisted residue of a car destroyed in a bombing

attack on a Baghdad book market. Subsequent to the museum version, the project went into a second stage, in the form of a nearly four-week long trip for which Deller hit the road in an RV, together with an Iraqi artist and freelance journalist who had worked for coalition forces and an American soldier who had served in Iraq. Hitched to the RV was a trailer carrying the destroyed car, for a tour that started in Washington, DC, followed by more than a dozen other cities, before ending up at the Hammer Museum in Los Angeles. At each stop, visitors and passers-by were again invited to participate in conversations based on the direct experiences of the two guides.[52]

25. Jeremy Deller, *It Is What It Is: Conversations About Iraq*, 2009. RV towing a car destroyed in a bombing on Al-Mutanabbi Street, Baghdad, March 2007. Courtesy Creative Time.

Reviewing the New Museum version of Deller's project for the *New York Times*, Ken Johnson was willing to praise its good intentions, as well as its potential utility for education or consciousness raising, but he expressed his doubts about its value as art (in fact categorizing it as an example of relational aesthetics

and suggesting that, as such, it couldn't be evaluated in critical or artistic terms).[53] For Nato Thompson, however, who worked with Laura Hoptman and Amy Mackie on the Deller project and also serves as chief curator at Creative Time, its cosponsor, such distinctions do not seem particularly relevant. Although he operates within the art world organizational structure, Thompson's curatorial agenda encompasses a range of interventions that may or may not claim an artistic mantel. Citing a lineage that he traces through the situationists as well as Michel de Certeau's *The Practice of Everyday Life*, he has championed projects that extend from photographs of CIA black sites by Trevor Paglen (who claims artist as only one of his overlapping identities) to the Center for Land Use Interpretation. This last organization, located just down the street from the Museum of Jurassic Technology in Culver City, describes itself as a "research and education organization interested in understanding the nature and extent of human interaction with the earth's surface," a project that involves using exhibits as one of the ways it presents its findings, but as information, rather than as information-based art.[54]

Thompson's inclusion of the Yes Men in his interventionist pantheon points to an extended sphere of creative disruptions that derive their power from a close analysis of corporate imagery, rhetoric, and business practices (institutional critique, in other words, but a version that operates outside the art umbrella). For the Yes Men, many of their culture jamming hijinks have involved plausible-looking websites that lure the unwary into various forms of counter narrative, and have sometimes even resulted in invitations to speak as representatives of the organizations they are impersonating. Their pranks are particularly well known, both through internet dissemination and feature-length films, but they are only one example of efforts to interrupt the smooth flows of power and commerce that are both broad-based and highly dispersed.[55]

One question concerns the advantages or disadvantages conferred by designating a particular action or manifestation as art. If the main point of an intervention is symbolic, then the context of exhibition display provides a useful platform for disseminating information about the gesture. An early contribution to the interventionist lineage traced by Thompson, Krzysztof Wodiczko's 1988–9 *Homeless Vehicle*, is an act of provocation

that swings both ways. Refined in collaboration with several homeless individuals who acted as consultants, the mobile vehicle was designed to provide both an ability to transport empties (often fulfilled by stolen shopping carts) and potential expansion to form a protected sleeping compartment. Or at least it would have done so if it had moved beyond the prototype stage. Nonetheless, its 1988 display at New York's Clocktower Gallery came at an important moment for a debate about homelessness taking place in the context of Ronald Reagan's redistribution of wealth at the national level and the pressures of gentrification on many New York neighborhoods.

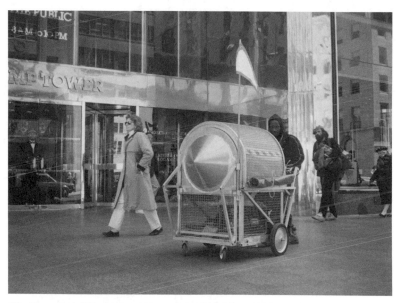

26. Krzysztof Wodiczko, *Homeless Vehicle*, 1988–9. Aluminum, Lexan, plywood, plastic, fabric, steel, rubber, 72" × 92" × 40", New York. © Krzysztof Wodiczko. Courtesy Galerie Lelong, New York.

"Instead of rendering the homeless invisible or reinforcing an image of them as passive objects," claims Rosalyn Deutsche, "the homeless vehicle illuminates their mobile existence."[56] It is not entirely clear, however, whether Deutsche is referring to its relatively brief street presence or to its symbolic function. Wodiczko himself has held that "the signifying function of the vehicle is as important

as its strictly utilitarian purpose," and has located its efficacy in its replication via images that have appeared in mass media as well as art contexts.[57] Thus its status as art is useful for keeping the idea of intervention in circulation, as part of the ongoing visibility enjoyed by works of art deemed historically important. But the gesture is present largely in galleries and publications, where the concept of street-level action continues to be disseminated, rather than on the street itself.

There is clearly a trade-off, with provocations to some degree tamed or corralled if they are labeled art, yet also granted a potential longevity they might not enjoy without this mechanism for becoming part of a historical record. And the art-historical importance of Wodiczko's work is only confirmed by the Museum of Modern Art's acquisition of a related construction by one of his former students, a 1997 example of Michael Rakowitz's *paraSITE homeless shelter*, which was one of a series of structures made from inexpensive plastic drop cloths held together with tape to create temporary shelters inflated by steam or exhaust vents from buildings. In conjunction with the work's appearance in his 2004 exhibition *The Interventionists*, Thompson emphasized Rakowitz's strategy, shared with Wodiczko, of designing these forms in consultation with their end users, and the photo on the MOMA collection website shows the tent-like object on the street, seemingly occupied.[58] But somehow the Polyethylene structure also remained property of the artist, since it is listed in the collection catalogue as a gift of Rakowitz and his gallery, Lombard-Freid Projects. Furthermore, although the modest materials make complete sense for an affordable intervention, their inherent instability becomes paradoxically decadent in the context of a permanent museum acquisition.

For Rancière, who prefers the term "dissensus" over resistance, the question of politics versus aesthetics is hardly an either / or proposition. Contending that "We no longer think of art as one independent sphere and politics as another," he emphasizes the aesthetic dimension of politics, including the potential to effect "a modification in the coordinates of the sensible."[59] In this view, aesthetics are necessarily bound up in any political process, since political change involves altering the image that a society projects. Bishop, in her oft-cited critique of relational aesthetics, invokes Ernesto Laclau and Chantal Mouffe's description of a democratic society based on a process of ongoing contestation to call for a more

aggressive dynamic. Countering Bourriaud's claims for projects by Tiravanija, Gillick, and others that she dismisses as little more than the creation of "amenities within the museum," Bishop employs the concept of antagonism, posited by Laclau and Mouffe as central for democratic debate, to support the sense of confrontation posed by the work of Santiago Sierra and Thomas Hirschhorn.[60]

Bishop focuses on Hirschhorn's 2002 *Bataille Monument*, for Documenta XI, emphasizing how its location in a largely working-class suburb of Kassel not only challenged exhibition visitors with the project of making the off-site journey, but also addressed itself seriously to local inhabitants. Yet it is a little difficult to understand the extensive critical support Hirschhorn has received from Bishop and others, given his propensity for reducing world events and philosophical arguments into so much fodder for fun-house environments—as evident in his 2002 *Cavemanman* at the Barbara Gladstone Gallery, where the ostentatiously modest environment built with cardboard and tape was filled with a pretentious mélange of great books and banal celebrity images, or his 2005 *Utopia, Utopia = One World, One War, One Army, One Dress* at the Boston ICA, where images of global conflict were subsumed into camouflage-decorated spectacle. Sierra, on the other hand, presents more of a genuine challenge, posing difficult questions by simultaneously highlighting and perpetuating systems of exploitation and inequality.

In works familiar via documentation circulated in the art world, Sierra has made a specialty of setting up disturbing situations that emphasize profound economic disparities through the evidence he provides of what people are willing to do or have done to them in exchange for payment. In 1999, in Guatemala City, eight people (out of the many who responded to Sierra's ad) were paid the equivalent of approximately $9 dollars to sit inside cardboard boxes for four hours. That same year, six unemployed men in Cuba were paid $30 to have a 250 cm line tattooed across their backs. Visitors to the Venice Biennale encountered the result of his 2001 call to immigrant street vendors, 133 of whom were paid the equivalent of $60 to have their hair died bright blond, as well as his more direct manipulation of the biennial audience itself in 2003, when, as the official representative of Spain, he walled off the front entrance of the Spanish pavilion and allowed only those with Spanish passports to enter through the back door. Asked by an interviewer about the raw nerve hit by his work, however,

Sierra disclaimed both activism and radicalism, emphasizing his collaboration with established institutions, curators, and collectors, and arguing that there is no contradiction in criticizing capitalism by reproducing its methods because "there is nothing outside the system, and the system is exploitation."[61]

Not mentioned by Bishop in her critique of relational aesthetics (though discussed by her elsewhere), Tania Bruguera has also frequently confronted audiences with direct acts of aggression. For her 2002 contribution to Documenta XI, she evoked Kassel's history as a major site for ammunition production during World War II with an installation where viewers were greeted by bursts of blinding light accompanied by the recorded sound of a gun being continuously reloaded. And at the Tate Modern, her 2008 *Tatlin Whisper #5* subjected visitors on the Turbine Hall bridge to unannounced crowd control movements orchestrated by two uniformed police officers mounted on horseback. Even more manipulative, because less readily identifiable as art, was her 2006 *The Dream of Reason II* (referring to Goya's print cycle), for the

27. Tania Bruguera, *The Dream of Reason II*, 2006. Medium: public intervention. Materials: News about terrorism, security guards, search. Dimensions: variable. © Tania Bruguera. Courtesy Studio Bruguera. Photo: Frac Lorraine.

Frac Lorraine in Metz. Visitors to *Maintenant, ici, là-bas*, Bruguera's two-person exhibition with Lida Abdul, were presented with a security guard and police dog in front of the entrance, followed by a clothing and bag check in order to enter the exhibition. Nor were the guards consciously performing a work of art, having only been told that they were being hired because of concern about potential violence in response to an exhibition by a Cuban and an Afghan artist.[62]

Bruguera had generally avoided showing in the Havana Biennial, in part because she did not want to impose her own aesthetic on Cátedra Arte de Conducta (Behavior Art Studies), the art school she ran out of her home in Cuba. But in 2009, having reached a decision to close the school, she participated in two ways—with *State of Exception*, a nine-night affair highlighting work by the students as well as the international roster of visiting artists who had taken part in the program. And she made far more news with her *Tatlin Whisper #6*, mounted in the courtyard of the Centro

28. Tania Bruguera, *Tatlin Whisper #6 (Havana version)*, 2009. Medium: Behavior art. Materials: Stage, podium, microphones, one loudspeaker inside and one loudspeaker outside of the building, two persons dressed in a military outfit, white dove, one minute free of censorship per speaker, 200 disposable cameras with flash. © Tania Bruguera. Courtesy Studio Bruguera.

Wifredo Lam. Over the course of an hour, audience members were invited onto the stage to speak freely for up to one minute each. A man and woman in military-style clothing flanked the podium and placed a trained dove on speakers' shoulders, in an echo of a 1959 speech by Fidel Castro; and they also physically removed anyone who exceeded his or her allotted minute. The first person to the microphone, Lupe Álvarez, a Cuban critic who had returned from exile in Ecuador for the occasion, simply wept, but the second, well-known blogger Yoani Sánchez, managed to provoke quick government condemnation for her criticism of Cuban censorship.

The impetus behind establishing a biennial is likely to be complex, involving a desire to address a global audience, but linked to the idea of offering a specific perspective or vantage point. For Hans Belting, the biennial phenomenon lies at the heart of a major shift in orientation, away from a conception of world art with its universalist assumptions, and toward a model that recognizes multiple histories as well as the complex intersection of national or regional traditions with an international dialogue.[63] In this context, the Havana Biennial has been positioned as the biennial of the third world, highlighting art from outside Europe and North America, while another alternative forum, Dak'Art, the Dakar Biennial, evolved from an international claim to an emphasis on contemporary Africa.[64] Yet, even as biennial culture has opened up representation, the constant movement of both curators and artists contributes to new forms of homogenization. And the specific function of the Havana Biennial remains a fraught issue.

In a response to Bishop's enthusiastic account of Bruguera's event in *Artforum*, Coco Fusco emphasized the biennial's complicated and necessarily compromised status. Because the open microphone was staged during the inaugural festivities, those in attendance were an invited audience, including a number whose prepared statements indicated that they had been alerted to the nature of the event in advance. With its strategic positioning as a third-world forum, the Havana Biennial also figures as a form of propaganda directed at an external audience—with the relative absence of censorship in this context therefore actually constituting a way of consciously shaping Cuba's image. For Fusco, these tensions were encapsulated at the 2000 Havana Biennial by the contrast she found between the live events and multiple video projections available during the opening, for the benefit of international visitors, and her discovery

that little of the equipment was operating later in the exhibition's run, when it was theoretically open to the Cuban public.[65] And even though Bruguera attempted to counter a lack of internet access in Cuba by distributing hundreds of disposable cameras to those who were present, Fusco concluded that the viewership for the intervention (during the event, and subsequently on YouTube) was still skewed toward the international audience that the biennial was designed to attract in the first place.[66]

Another perspective, however, would be that Bruguera took full advantage of the lack of government censorship control over the biennial to use the occasion as a platform to convey a message about conditions in Cuba to the same left-leaning international audience the government was courting. An extension of Bruguera's already confrontational practice, it functioned as a piece of agit-prop smuggled into an art event designed to be broadcast to a wider world. Rather than institution critique, it is more a form of institutional hijacking, with an analysis of the dynamics of the situation generating a performance that, instead of making the art institution its subject, used it as a vehicle for a work that was a direct extrapolation of that situation.

The smooth segue between art and political intervention is just one indication of how permeable the concept of art has become in the face of recent practices. Just as there is no consensus about what art is supposed to look like in the context of the heterogeneous present, there is also no agreement about what it is supposed to do. Aesthetic pleasure might or might not be at odds with theoretical complexity or political efficacy. Nor is it always clear what advantages are to be had by designating a gesture or phenomenon art, given the many points of close resemblance between proclaimed artistic acts and other strategies for political intervention, cultural critique, as well as commercial promotion. In fact Bruguera herself has indicated a lack of concern about whether her open microphone action had the status of art, and it is obviously continuous with an overall project that is focused, in her own formulation, on a desire to create rather than represent the political.[67] For certain types of intervention (some of Bruguera's among them), the category of art could be described as a flag of convenience that is significant primarily for allowing access to art-world information and distribution channels.

It is equally true that overtly political gestures are far from the only phenomena emanating from art-world institutions that erode

any prospect of arriving at a coherent definition of contemporary art. At one end of the spectrum there is the porous relationship between politicized art and other creative or playfully inventive forms of activism—along with attendant issues regarding what criteria one can use to evaluate such gestures. But plenty of other art-related activities also raise questions about the ongoing relevance of art as a functional category. In fact a great deal of what goes on in the art world is motivated by compound agendas—not because it is political in nature, but because the balance has tipped toward entrepreneurial and entertainment strategies designed to feed institutional bottom lines.

In the art business

The one thing museums aren't supposed to do is sell off the works in the collection. But in every other respect they are expected to function as businesses, appealing to popular taste with crowd-pleasing exhibitions and finding other ways to exploit their resources. Debates about corporate sponsorship of art institutions, so vigorously pursued by artists and critics during the 1980s, seem almost quaint in relation to the multifaceted ventures in operation by the turn of the twenty-first century. Who could have anticipated the extent of the Guggenheim's late twentieth-century transformation from art museum into high-end showcase, with its 1998 motorcycle exhibit or 2000 Armani retrospective, the latter funded in part by a controversial $15 million contribution from the designer? The Boston Museum of Fine Arts also shrugged off criticism of its enterprising agreement to send part of its impressionist collection to Las Vegas for a 2004 exhibition at a casino in exchange for a rumored one million dollars in rental charges. But to a certain extent it was purely a question of semantics, since that same year the Museum of Modern Art took in a reported eight million Euros in lending fees for an immensely popular exhibition of its collection at Berlin's National Gallery while the museum's Manhattan building was closed for expansion.

It was also only a matter of time before the big business of museum blockbusters was recognized as an opportunity by the for-profit sector. The young pharaoh whose 1976 appearance

in "The Treasures of Tutankhamun" helped inaugurate the age of the exhibition spectacular has clearly retained his immense popularity—and potential as a revenue center. Even though the subject's recent iteration, "Tutankhamun and the Golden Age of the Pharaohs" made its US debut at a nonprofit institution when it opened at the Los Angeles County Museum of Art in 2005, the exhibition was actually organized by AEG, a for-profit American sports and entertainment company with extensive experience promoting concert tours and sporting events. According to Tim Leiweke, head of AEG, "I'm not sure there's so much difference between Tutankhamun and Celine Dion"—and apparently he understood the market potential involved, since even after paying a $5 million fee for the exhibition, LACMA reportedly cleared $2.5 million for its own coffers.[68] By the time the exhibition opened in New York in 2010, however, even the museum veneer was gone, since the venue was not the Metropolitan Museum of Art (whose notorious Thomas Hoving was instrumental in organizing the 1976 Tut blockbuster), but the Discovery Times Square Exposition, a for-profit exhibition hall.

But who needs a boy pharaoh's regalia when you can have contemporary fashion? The Met managed to tap into a different blockbuster market with its 2011 Alexander McQueen exhibition, posting a final attendance figure of 661,509 that unseated a 2008 roof garden show by Koons for eighth most popular exhibition at the museum, thereby joining Tutankhamun and the Mona Lisa in the Met's top-ten pantheon. There were plenty of other wins for the museum as well, including the thousands of people willing to pay a premium $50 entry fee to see the show on Mondays, when the museum was normally closed, 100,000 catalogue sales, and seemingly insatiable demand for related gift-shop merchandise. Nor did there appear to be any downside in the fact that the exhibition was, as the press release indicated, "made possible by Alexander McQueen." The Guggenheim was subjected to withering criticism for accepting sponsorship from the relevant interested parties for their 1998 BMW and 2000 Armani displays, and the Met was likewise chastised for taking funding from Chanel for a 2005 exhibition devoted to that fashion house. But somehow such qualms had become passé by 2011.[69]

Lines are blurring in other directions as well, with high-end galleries mounting museum-style exhibitions. The Gagosian Gallery

in particular has played a significant role in this trend, with major survey exhibitions devoted to Piero Manzoni and late Pablo Picasso filled with works borrowed from museum collections while watched over by uniformed guards. And it was Deitch's project space that hosted the New York re-creation of Allan Kaprow's *18 Happenings in 6 Parts* in conjunction with Performa 07 (the second iteration of RoseLee Goldberg's biennial for performance art). The mounting of historical shows by the commercial sector should, however, hardly be romanticized as an altruistic gesture. In many respects such exhibitions are a logical outgrowth of a business model where top-tier art galleries derive their real money from secondary market sales taking place behind the scenes rather than from the more evident exhibitions of recent work by gallery artists. The objects borrowed from museums for museum-like gallery shows provide a context for private collection works that rarely appear with a visible sale sign, but which can be assumed to be quietly available, for the right price.

On the other side of the rather permeable divide between commercial and non-profit sectors, the museum embrace of spectacle was further confirmed by Deitch's first prominent act as newly installed director of the Los Angeles Museum of Contemporary Art, which was exactly that—a brief appearance (playing the part of Jeffrey Deitch, director of MOCA) on a 2010 General Hospital shoot taking place on a set in front of the museum. Deitch's cameo was part of a plotline involving James Franco's role on the soap opera as a crazy conceptual artist (and serial killer) named Franco, whose outdoor exhibition in front of the museum, "Francophrenia," was facilitated by the museum director character played by Deitch.

One striking feature of this enterprise is the appeal to various different audience segments. Franco's presence would be marked out for the soap opera's primary viewership, not as a result of the somewhat incredible story line (itself just one among many), but because, in Franco's own estimation, his participation in the drama "disrupted the audience's suspension of disbelief," with a recognizable presence "perceived as something that doesn't belong in the incredibly stylized world of soap operas."[70] For another audience, inclined to revel in a postmodern play of quotation and reference, Franco's appearance in front of MOCA as the soap opera character of Franco could potentially be understood as part of a larger performance art project by James Franco, artist as well as actor,

29. General Hospital set, Los Angeles Museum of Contemporary Art, 2010. Courtesy MOCA.

who happened to be presenting a simultaneous exhibition of his artwork at New York's venerable Clocktower Gallery. Moreover, the use of the museum as soap-opera set was indeed arranged by Deitch, operating in his real-life role as museum director.

Although Deitch's move from gallery to museum made a big splash, the larger context suggests that there should not really have been anything surprising about his appointment as MOCA director (other than the fact that he actually wanted the job).[71] Like Warhol before him, Deitch is clearly an interesting as well as polarizing figure, attuned to intersections of art and popular culture (in both street art and entertainment industry versions), yet suspiciously adept at playing these interests to his own advantage. Quoted in an article covering the General Hospital shoot, Maria Bell, co-chair of the MOCA board, expressed her support for the controversial hire, emphasizing Deitch's capacity to "really build our constituency and bring more people to the museum in new and exciting ways."[72] What the *New York Times* story did not elaborate, however, was Bell's day job as head writer on *The Young and the Restless*, another long-running soap that has featured a number of art-world subplots, including one involving a billionaire owner of a Damien

Hirst shark tank sculpture that he smashed when his curator love interest was killed (with permission to reproduce the notorious artwork granted by Bell's friend Hirst).

It is not clear what criteria should be used to judge such overlays—sophisticated artistic play, nice ironic spin, or, in the case of the Hirst shark tank incident, perhaps an example of already spectacular art being reduced to a clever soap-opera aside. But it is evident that the entertainment industry/art-world intersections are only increasing. Franco's interactions with Marina Abramović have included taking a turn in the seat opposite her during *The Artist Is Present* at MOMA as well as sampling a prototype of the dessert-as-art that she fashioned for the Park Avenue Winter restaurant, and his collaborations with video and performance artist Kalup Linzy have also been extensive.[73] Long before Franco and Linzy met up at Art Basel Miami Beach in 2009 (on the occasion of Linzy's performance at a party honoring curator and MOMA P.S. 1 director Klaus Biesenbach), Linzy had pursued his own riff on the soap-opera theme, his 2003 video *All My Churen*, where he played most of the characters in drag—and Franco fittingly included him in the General Hospital plotline, as performer Kalup Ishmael (to whom the character of Franco utters the line "You know the problem with most performance art—it doesn't go far enough").[74] Franco's engagement with the art world continued in 2011 with *Unfinished*, a two-person show with Gus Van Sant at Gagosian's Beverly Hills gallery, featuring Franco's *My Own Private River*, his reflection on Van Sant's 1991 *My Own Private Idaho* created by re-editing extensive outtakes featuring River Phoenix from the earlier film, accompanied by a soundtrack by REM's Michael Stipe, as the basis for a new study of the ill-fated actor.

One striking aspect of this history is Franco's ability to enter the art world at the top tier. Given the connections between art and celebrity widely in evidence, perhaps it should not be surprising that an artist who is already a famous actor gets to go to the head of the line. Yet, even if the general frenzy surrounding all aspects of Franco's work prompts a degree of cynicism about the art-world embrace, it is also interesting to think about how his plays on media-driven image construction can be related to a range of critically lauded artistic practices, from Warhol's fascination with celebrity to the exploration of overlapping virtual realities in Parreno and Huyghe's *No Ghost Just a Shell*—though with the key

difference that Franco can readily tap entertainment industry as well as art-world distribution channels for his exploration of such dynamics.

There are plenty of other examples of Hollywood-inflected art as well (not to mention a notable subset of artists turned directors). The 2011 Venice Biennale saw Lindsay Lohan's debut as a performance artist, in a short video directed by erstwhile Gagosian painter Richard Phillips that featured Lohan in a series of guises designed to evoke such classics as Godard's *Contempt* and Bergman's *Persona*. The video was supposed to be showcased with related works on a floating video screen (during the Biennale's preview festivities only) as part of a project that claimed pop-art lineage for its "Commercial Break" theme. But when Venice denied permits for the outdoor screen shortly before it was due to take to the canals, all was not lost, since the organizers were able to change gears and show the videos during the launch party for the project—which was breathlessly reported as one of the hottest events of celebrity-packed opening festivities.[75] And even before Deitch's arrival on the scene, MOCA demonstrated its willing embrace of spectacle with a gala celebration of its 30th anniversary in November 2009—which included as its centerpiece a live musical number created by the artist/filmmaker Francesco Vezzoli.

Ballets Russes Italian Style (The Shortest Musical You Will Never See Again) featured Lady Gaga performing a debut of her ballad "Speechless" while playing a Steinway grand decorated by Hirst and wearing a hat designed by Frank Gehry. Filmmaker Baz Luhrmann and his wife Catherine Martin created masks worn by both Lady Gaga and Vezzoli, while the main acts were further accompanied by Bolshoi Ballet dancers wearing costumes by Vezzoli and Miuccia Prada. Since the gala doubled as a fundraiser for the financially strapped museum, the piano went directly from performance to auction, where it was bought by none other than Larry Gagosian for $450,000—with the art dealer's generous support for the museum therefore helping sustain high prices for one of his stars in the context of a musical event created by another gallery artist.[76]

Activities in the top echelons of the art world do tend to be tightly intertwined, as the overlapping interests of Deitch and Gagosian indicate. Yet there are residual differences as well, with Deitch willing to play host to the decadent messiness of Dash

30. Francesco Vezzoli, *Ballets Russes Italian Style (The Shortest Musical You Will Never See Again)*, 2009. 30th Anniversary Gala, Museum of Contemporary Art, Los Angeles, November 14, 2009. © Francesco Vezzoli. Courtesy Gagosian Gallery and MOCA. Photo: Charley Gallay/Getty Images.

Snow and Dan Colen's notorious 2007 *Nest*, in contrast to the tame and overly produced work that Colen went on to present in a widely panned solo show at Gagosian in 2010. For the former, Deitch provided a gallery frame for an alternate-lifestyle relational situation that would likely be described as vandalism (or over-indulged privilege) in its earlier iterations, when Snow and Colen transformed a series of hotel rooms into human hamster nests by creating tangled piles of bed linen and shredded paper, then cavorting in the mess in a frenzy of drug and alcohol-fueled dissipation. (For the gallery-scale installation, however, part of the destruction was outsourced, with art students enlisted to shred the thousands of copies of the New York yellow pages used to fill the space.)[77]

Deitch has described his gallery as operating "as a private ICA," based on his emphasis on non-commercial programming. But his version of non-commercial is interesting, to say the least.

For project-based work, Deitch would provide "up to twenty-five thousand dollars in production or travel money and a living stipend; if we sold the work, the twenty-five thousand dollars would be reimbursed and we would split the remaining proceeds." To this extent the procedure is indeed related to museum-made projects, where the institution often stands to be reimbursed for fabrication expenses if the resultant work later sells. On the other hand, Deitch indicates, if what he was exhibiting couldn't be sold, "the artist didn't have to worry. I would just keep an equivalent amount of work for my own collection to cover the investment and production."[78] Thus there was always something tangible in hand, whether or not it was actually on display.

Deitch's standard front money was modest, however, compared to the resources that were clearly necessary to realize Colen's subsequent show at Gagosian, which included, in addition to vaguely abstract-expressionist paintings made from smeared chewing gum, a free-standing brick wall, a half-pipe skateboard ramp, and a sculpture made from 13 customized Harley Davidson motorcycles that had been tipped over like dominos (with obvious echoes of a well-known scene from the 1985 movie *Pee-Wee's Big Adventure*). In a striking contrast to Deitch's 2002 skate bowl installation, with its open-ended performance options, Colen's ramp was inverted for its display at Gagosian—rendering definitively nonfunctional an object that would presumably have been off-limits to skateboarders in any case once brought into that setting. The overall effect was one of lavish indulgence with any interesting messiness removed; and the exhibition's only truly outstanding quality was its demonstration of the degree of fabrication support sometimes accorded to art made from the thinnest of ideas.

What the general art-world emphasis on solo artistic authorship masks (but definitely does not hide) is the fact that much art presented by top-tier galleries could easily be accompanied by a credit roll similar to the one at the end of any Hollywood movie. For all that the piano Gagosian acquired from the MOCA benefit auction was billed as Hirst's creation, one has to assume that it was not Hirst himself who customized the Steinway with its blue butterflies on a field of pink, any more than he paints the many dot-filled canvases presented over his signature. Rather, the grand scale of his operation (like those of many of his contemporaries) is made possible because of a resurgence of workshop-type arrangements,

with name-brand artists presiding over and delegating many aspects of their work, even though the results are nonetheless presented under the authority of a single creative voice.

When contemporary artists talk about their work, they often describe their efforts in the plural "we did this," "we found a solution to that"—reflecting not so much the royal "we" (though there could be some of that, too) but the fact that they are speaking as heads of large operations, where much problem solving as well as execution is accomplished by operatives with specialized forms of expertise. No matter that a certain number of these artists might be grouped under the post-studio umbrella because their work is centered on installations realized at the point of display or interaction. It turns out that even post-studio artists often employ a surprising number of studio assistants to support the logistics of their international careers. One also finds the term "deskilling" used with some frequency in discussions of contemporary artistic production, in reference to the fact that artists can no longer be construed as artisanal holdouts against industrial divisions of labor. But artists who send work out to be fabricated or preside over studios of specialized assistants are operating on the other side of the process, not victims of such labor efficiencies, but rather controlling the assembly line and taking sole credit for work done in their name.

In some artists' hands, the logistics of large-scale art studio operations may also be tied to the international labor market, with artists pursuing global production sources for the same economic reasons that drive other forms of manufacture. Witness, for example, Zhang Huan's dramatic transition to object production, on a scale that requires the substantial support system afforded by his affiliation with mega-gallery PaceWildenstein (resulting in works that stand in sharp contrast to the relatively modest solo and then group performances discussed in Chapter 4). Notably, Zhang shifted his base of operations to Shanghai (after having earlier relocated from Beijing to the United States), where he directs what the *New York Times* has characterized as "China's largest production line of avant-garde art, overseeing a factory that creates wood carvings, ash paintings and Tibetan-inspired copper sculptures," with a staff of more than 100.[79] For an extended series of carved wood reliefs based on photographic source material, in fact, traditionally trained craftspeople provide skills that he does not himself possess.

Who pays the fabrication bill? The art world, like many national economies, has seen a tremendous concentration of resources at the top tier of the economic hierarchy. Spectacular levels of fabrication support allow certain artists to produce work that is unavoidably attention-grabbing in its material presence. The distance separating Zhang's mid-career operation from his early performance-based work was made strikingly evident by a massive nod to fragility, his *Canal Building* realized for a 2008 PaceWildenstein exhibition, which involved an old photograph of the digging of a canal that Zhang and assistants recreated using ash from temple incense. Created on top of a huge slab of ash almost 60 feet long, it could be viewed only from a scaffolding-style walkway above the bottom edge of the piece. Though the aesthetic is markedly different from that of Hirst, the approach to production is similar, with the added wrinkle of taking advantage of global disparities in labor costs. Nor was it particularly clear what was accomplished by the overwhelming magnitude, other than a spectacular demonstration of Zhang's ability to command the resources necessary to have his idea realized on this grand scale.

It is often not exactly evident why certain lavish or large-scale projects are deemed worthy of being realized—though it is safe to say that the system of validation has more to do with market success than with the impact of critical judgment. The larger picture also involves a whole series of relationships that connect galleries, museums, biennials, fairs, auctions, and academic programs, through the interwoven activities of artists, dealers, curators, critics, and collectors. In the process, a range of practices put forward on the promise of their ability to inspire thoughtful reflection are absorbed into a system that becomes an end in itself: once an idea is deemed important enough to merit large-scale backing, over-the-top production values confirm the significance of the initial gesture. Artists who achieve this pinnacle of success can be understood (akin to certain high-flying financial concerns) as too big to fail, given the number of different parties invested in their ongoing historical significance.

Art's ability to engender aesthetic pleasure, critical insight, and a whole host of other worthy goals continues to justify the many forms of direct and indirect support that make it accessible to a broad audience. It is by no means a bad thing that museums have become increasingly willing to embrace alternative narratives,

along with divergent contemporary practices. Likewise, the eclec-
ticism of contemporary art is a source of vitality, with no single
mode or group able to assert dominance. Yet the flip side of this
extreme variety is an art world where not only can anything be
claimed as art, but anything can also be marketed as such, its
potentially enduring significance impossible to disentangle from
promotional strategies. And perceived artistic importance brings
with it many ancillary effects, including art's role as status symbol,
with its cachet only amplified by notions of difficulty or resistance.
In tandem with a vast expansion in all aspects of the contemporary
art world, a remarkable range of seemingly critical or resistant
practices have become attractive to elite collectors who pride
themselves on their edgy taste.

The tension between art's enduring value—both culturally and monetarily—is
supposed to be one of the main qualities that sets it apart from
other luxury goods that are subject to more speedy cycles of
obsolescence. Yet, even as art is produced and disseminated
within this extensive yet specialized field, with its own discourse,
paradigms, and system of valuation (all of which are frequently
scoffed at by outsiders), it is deeply enmeshed in other forms of
information flow, entertainment, and consumption. Not only are
the strategies employed by many artists difficult to distinguish
from those of curators and collectors; their post-studio activities
are closely aligned with other participants in a larger creative
economy. In a version of circular logic, art is set off from other
forms of production based on cultural significance assumed to
extend well beyond monetary value. Yet the more that art comes
to resemble familiar goods and services, the more that price alone
sets it apart.

The tension between progressive claims made for art and its
all-too-easy assimilation into an elite version of spectacle culture
is part of a lengthy history of contradiction, starting with the
spoils of the wealthy presented as educational for all classes of the
museum-going public. Obviously there is no escaping the fact that
art has long played a role as a bauble of the rich, enmeshed in a
larger luxury trade, and functioning as a marker of status—even
as one can hope that it fulfills other roles as well. In the contem-
porary context, however, it has become particularly evident that
the assertion of art's special status is at once confirmed and under-
mined by activities and hype at the top end of the spectrum.

What happens around the work is hardly peripheral. Regardless of initial artistic impulse, it is impossible to separate the reading of the work from the history of its reception. As earlier chapters have shown, art is deeply embedded in a whole series of practices and conventions dedicated to its presentation as well as preservation—with production and reception part of a linked chain of activities. Institutional critique in particular (as practiced by both artists and theorists) has been instrumental in drawing attention to the significance of context for all forms of art. Yet work that is generated through a conscious manipulation of the network of forces in the art world is even more evidently dependent on the very system it ostensibly critiques. In the process, the fact that art has become increasingly embedded in institutional conventions serves to reinforce a form of contingency that can amount to expedient malleability.

It has become painfully obvious that many of the most interesting developments in art of the last half century have simultaneously opened up opportunities for cynical manipulation. On the one hand, there are the various ways that artists have played, both humorously and critically, with questions of artistic authorship; yet the idea of the artist as brand operates without irony in the context of market hype. Institutional critique has helped to transform artistic and museum conventions alike; but it has also spawned a whole series of practices that are essentially decorative in function, with artists invited to create site-specific work that is basically affirmative in nature. And who would want to come out against opening up opportunities for exchange and community building? Too often, however, promoting dialogue seems to be little more than an excuse for a party, in the context of a contemporary art business model centered on opening-night festivities and other largely social events. Critical claims are equally fungible, since there are few instances where one can't find someone willing to make a notionally plausible argument for a work's inherent resistance or at least ironic critique. Nor is it possible to envision a viable alternative sphere, as long as the yearning to be free from evident constraints is accompanied by an ambition to achieve art-world recognition or to participate in the associated dialogue about art.

The question therefore remains of how to navigate this terrain, still looking for moments of insight, even inspiration, despite the many distortions associated with artistic marketing and promotion.

The art world has to be understood as an industry, at the same time that art production retains a utopian dimension for many who contribute to the enterprise. Being an artist is increasingly articulated as a profession rather than an avocation—despite the fact that the prospect of making a living solely through art creation continues to be a largely elusive goal. It is clear enough that the resources poured into the top end of art production and consumption have little to do with general realities for the vast majority of artists (a significant number of whom maintain a remarkable degree of stubborn romanticism about their endeavors). Even though the superheated market for certain high-status art commodities constitutes only a small segment of the art world, it has transformed the audience for contemporary art through changes in patronage as well as public exposure. No one operating in this larger field of activity can claim outsider status; so the ongoing challenge is to search out productive forms of engagement in the face of art's corrosive success.

NOTES

Introduction

1 Elisabeth Franck, "The Transom: Too Close for Comfort," *The New York Observer*, March 17, 2002, http://www.observer.com/node/45756.

2 On the social dimension of the November 2010 contemporary auctions, see David Velasco, "Wild Carte," New York, November 12, 2010, in *Artforum.com*'s "Scene & Herd" section, http://artforum.com/diary/id=26817. Farah's 2010 *Baptism* was lot number 200, Phillips de Pury & Company, Part II, Contemporary Art, November 9, 2010, http://phillipsdepury.com/auctions/online-catalog.aspx?sn=N Y010610&search=&p=&order.

3 Two versions of the diagram are reproduced in Sybil Gordon Kantor, *Alfred H. Barr, Jr. and the Intellectual Origins of the Museum of Modern Art* (Cambridge: MIT Press, 2002), 367.

4 On the relationship between antiquarian and cabinet, see Susan A. Crane, "Story, History, and the Passionate Collector," in Martin Myrone and Lucy Peltz, (eds), *Producing the Past: Aspects of Antiquarian Culture and Practice 1700–1850* (Aldershot: Ashgate, 1999), 187–203.

5 One point of departure for critical accounts of the museum, particularly those offered by Tony Bennett and Douglas Crimp, has been Michel Foucault's reading of the coercive nature of such citizenship rituals. See Tony Bennett, *The Birth of the Museum: History, Theory, Politics* (London: Routledge, 1995) and Douglas Crimp, *On the Museum's Ruins* (Cambridge: MIT Press, 1993).

6 Crimp, *On the Museum's Ruins*, particularly 236–75.

7 Smithson refers to the museum as a tomb in "Some Void Thoughts on Museums" and "What Is a Museum? A Dialogue between Allan Kaprow and Robert Smithson," both published originally in 1967 and reprinted in *The Writings of Robert Smithson*, ed. Nancy Holt

(New York: New York University Press, 1979), 58–66. Kaprow refers to the museum as a mausoleum in the dialogue with Smithson.

8 On the show at the Metropolitan, see Calvin Tomkins, *The Scene: Reports on Post-modern Art* (New York: Viking Press, 1976), 4–6.

9 For a more detailed discussion of the conflict, see Chapter 4 in this book.

10 Walter Benjamin, "The Work of Art in the Age of Mechanical Reproduction," in *Illuminations*, ed. Hannah Arendt, trans. Harry Zohn (New York: Schocken Books, 1969), 217–51.

11 Alan Wallach, "*Norman Rockwell* at the Guggenheim," in Andrew McClellan, *Art and its Publics: Museum Studies at the Millennium* (Malden, MA: Blackwell, 2003), 105.

12 On this transformation in terminology, see Hans Belting, *The Invisible Masterpiece*, trans. Helen Atkins (Chicago: University of Chicago Press, 2001), 17. Catherine Soussloff makes a related argument regarding the romantic conception of the artist in *The Absolute Artist: The Historiography of a Concept* (Minneapolis: University of Minnesota Press, 1997).

13 George Kubler posits the historical object as a kind of signal, interpreted over time by receivers who in turn become part of a system of relays through which the initial signal is successively deformed. Kubler, *The Shape of Time: Remarks on the History of Things* (New Haven: Yale University Press, 1962), particularly 21. Michael Ann Holly also addresses the deferred action whereby our understanding is revised in light of the present in *Past Looking: Historical Imagination and the Rhetoric of the Image* (Ithaca: Cornell University Press, 1996).

14 Stendhal, *Histoire de la peinture en Italie*, 1817, cited in Donald Sassoon, *Becoming Mona Lisa: The Making of a Global Icon* (New York: Harcourt, 2001), 32.

15 Theodor W. Adorno, "Valéry Proust Museum," in *Prisims*, trans. Samuel and Shierry Weber (Cambridge: MIT Press, 1981), 176 & 175. See also "Bach Defended against his Devotees," *Prisims*, 133–47.

16 Adorno, "Valéry Proust Museum," 185.

17 Andreas Huyssen, *Twilight Memories: Marking Time in a Culture of Amnesia* (New York: Routledge, 1995), 22–3.

18 The framing of experience as a strategy of contemporary art is the focus of Nicolas Bourriaud, *Relational Aesthetics*, trans. Simon Pleasance and Fronza Woods (Dijon: Les Presses du réel, 2002).

19 Svetlana Alpers, "The Museum as a Way of Seeing," in Ivan Karp and Steven D. Lavine (eds), *Exhibiting Cultures: The Poetics and Politics of Museum Display* (Washington: Smithsonian Institution Press, 1991), 31.

20 "Author-function" is the locution used by Michel Foucault in his important analysis of literary authorship, "What Is an Author?" in *Language, Counter-Memory, Practice: Selected Essays and Interviews by Michel Foucault*, ed. Donald F. Bouchard (Ithaca: Cornell University Press, 1977), 113–38.

21 On tourism as the selling of experience, see Dean MacCannell, *The Tourist: A New Theory of the Leisure Class* (New York: Schocken Books, 1976).

22 James Cuno, "Against the Discursive Museum," in Peter Noever, ed., *The Discursive Museum* (Ostfildern: Hatje Cantz, 2001), 52.

Chapter 1

1 Tacita Dean, "Block Beuys: Hessisches Landesmuseum, Darmstadt, Germany," *Artforum* 46 (December 2007), 314–15.

2 See David D. Galloway, "Beuys and Warhol: Aftershocks," *Art in America* 76 (July 1988), 114. The rest of Ströher's collection was sold after his death, with a large group of pop artworks purchased for the Museum für Moderne Kunst in Frankfurt, but the Beuys Block was eventually acquired by the Darmstadt museum.

3 See Edgar P. Richardson, "Charles Willson Peale and His World," 80, and Brooke Hindle, "Charles Wilson Peale's Science and Technology," 110, in Richardson, Hindle, and Lillian B. Miller, *Charles Wilson Peale and His World* (New York: Abrams, 1982).

4 On the expedition, as well as Peale's relationship to enlightenment thought, see Sidney Hart and David Ward, "The Waning of an Enlightenment Ideal," in Lillian B. Miller and David C. Ward (eds), *New Perspectives on Charles Willson Peale* (Pittsburgh: University of Pittsburgh Press, 1991), 219–35. Rembrandt Peale is quoted in Roger B. Stein, "Charles Willson Peale's Expressive Design," in *New Perspectives*, 192.

5 See Hart and Ward, "The Waning of an Enlightenment Ideal," 229–30.

6 George Gaylord Simpson and H. Tobien, "The Rediscovery of Peale's Mastodon," in *Proceedings of the American Philosophical Society* 98 (August 16, 1954), 279–81.

7 These works are McCollum's 1991 *Lost Objects* (cast dinosaur bones from the Carnegie Museum of Natural History), 1994 *Natural Copies* (casts of the solid forms created naturally from negative impressions left by dinosaur tracks and found in the roofs of Utah coal mines), 1997–8 *The Event: Petrified Lightning from Central Florida (with Supplemental Didactics)*, and 1998–2001 *Signs of the Imperial Valley: Sand Spikes from Mount Signal*. For a discussion of the sand spike project, see Martha Buskirk, "McCollum's Curiosities, Natural and Cultural," in Rhea Anastas, ed., *Allan McCollum* (Zürich: JRP Ringier, 2012).

8 See Tony Bennett, *The Birth of the Museum* (London: Routledge, 1995), 70–2, and Michael Conforti, "The Idealist Enterprise and the Applied Arts," in *A Grand Design: The Art of the Victoria and Albert Museum* (eds) Malcolm Baker and Brenda Richardson (New York: Harry N. Abrams, 1997), particularly 25–33.

9 On the DSA and its impact in India, see Arindam Dutta, *The Bureaucracy of Beauty: Design in the Age of its Global Reproducibility* (New York & London: Routledge, 2007), especially 1–37.

10 See Andrew McClellan, "A Brief History of the Art Museum Public," in McClellan, ed., *Art and its Publics* (Malden, MA: Blackwell, 2003), 17.

11 On these different stages, see Richard Dunn and Anthony Burton, "The Victoria and Albert Museum: An Illustrated Chronology," in *A Grand Design*, 58–71.

12 Cornelia Parker, conversation with the author, March 9, 2006.

13 Lisa Tickner, "A Strange Alchemy: Cornelia Parker" (interview), *Art History* 26 (June 2003), 381.

14 "Cornelia Parker Interviewed by Andrea Jahn," in Cornelia Parker, *Perpetual Canon* (Stuttgart: Kerber Verlag, 2005), 17.

15 *A Grand Design: The Art of the Victoria and Albert Museum* (eds) Malcolm Baker and Brenda Richardson (New York: Harry N. Abrams, 1997), 130–2.

16 For a summary of these shifts, see Anthony Burton, *Vision & Accident: The Story of the Victoria and Albert Museum* (London: V&A Publications, 1999), 49–54. On collecting originals versus replicas, see Timothy Stevens and Peter Trippi, "An Encyclopedia of Treasures: The Idea of the Great Collection," in *A Grand Design*, 152.

17 On the MFA's cast collection, see Alan Wallach, "The American Cast

Museum: An Episode in the History of the Institutional Definition of Art," in Wallach, *Exhibiting Contradiction: Essays on the Art Museum in the United States* (Amherst: University of Massachusetts Press, 1998), 41.

18 Quoted in Paul DiMaggio, "Constructing an Organizational Field as a Professional Project: U.S. Art Museums, 1920–1940," in *The New Institutionalism in Organizational Analysis*, (eds) Walter Powell and Paul DiMaggio (Chicago: University of Chicago Press, 1991), 269–70. On this tension, see also McClellan, "Brief History of the Art Museum Public," 17–22.

19 Carol Vogel, "Going to Auction: Pieces of History," *New York Times*, January 13, 2006. Sotheby's auction sale results, Historic Plaster Casts from the Metropolitan Museum of Art, New York, February 28, 2006, http://www.sothebys.com/app/live/lot/LotResultsDetailList. jsp?event_id=27711&sale_number=N08176.

20 Matthew Prichard, of the Boston MFA, dismissed casts as the "stock in trade of every ready-made museum of art." Quoted in Wallach, "American Cast Museum," 52.

21 35,942 prints were sold during 1859–63, the years that the salesroom was open. See Anne McCauley, "Invading Industry: The South Kensington Museum and the Entry of Photographs into Public Museums and Libraries in the Nineteenth Century," in Mark Haworth-Booth and McCauley, *The Museum and the Photograph: Collecting Photographs at the Victoria and Albert Museum, 1853–1900* (Williamstown, MA: Sterling and Francine Clark Art Institute, 1998), p. 66. n. 16.

22 See the Victoria & Albert Museum website, http://www.vam.ac.uk/images/image/58334-popup.html.

23 John Physick, *Photography and the South Kensington Museum* (London: Victoria and Albert Museum, 1975), especially 6–7.

24 McCauley, "Invading Industry," 37 & 41. See also Mark Haworth-Booth, *Photography: An Independent Art. Photographs from the Victoria and Albert Museum, 1839–1996* (Princeton: Princeton University Press, 1997).

25 Kynaston McShine, *The Museum as Muse: Artists Reflect* (New York: Museum of Modern Art, 1999), 26.

26 Koons cited his Fragonard in a press conference marking the opening of the Versailles exhibition, which was reported in Elaine Sciolino, "At the Court of the Sun King, Some All-American Art," *New York Times*, September 10, 2008. On his collection in general, see Randy Kennedy, "The Koons Collection," *New York Times*, February 24, 2010.

27 Both Andrea Fraser and Isabelle Graw cite claims that institutional critique "analyzes," "reveals," or "exposes" "the structures and logic of museums and art galleries," in the context of a 2005 symposium at the Los Angles County Museum of Art entitled "Institutional Critique and After." See Andrea Fraser, "From the Critique of Institutions to an Institution of Critique," and Isabelle Graw, "Beyond Institutional Critique," in John C. Welchman, ed., *Institutional Critique and After* (Zurich: JRP Ringier, 2006), 127, 137.

28 Graw, "Beyond Institutional Critique," 148.

29 Haacke entry, *Give & Take: 1 Exhibition 2 Sites: Serpentine Gallery, London, Victoria and Albert Museum, London* (London: Serpentine Gallery and Victoria & Albert Museum, 2001), 43–59, and Janet A. Kaplan, "Give & Take Conversations," *Art Journal* 61 (Summer 2002), 84–90.

30 See Dutta, *Bureaucracy of Beauty*, especially 25–37. See also Partha Mitter and Craig Clunas, "The Empire of Things: The Engagement with the Orient," in *A Grand Design*, 224–5, on the pursuit of the authentic, even as the object has been altered by interaction.

31 Paine's *SCUMAK* exists in two versions, one from 1998, which was exhibited at the V&A, and a second version that was created in 2001.

32 See *Give & Take*, 28–9. The device in question, Benjamin Cheverton's 1826 "Sculpturing Machine" (borrowed from the Science Museum), also figured in a 1994 exhibition at the Centre for the Study of Sculpture, Henry Moore Institute. See Ben Dahliwal, "Catalogue of the Exhibition," in *Reproduction in Sculpture: Dilution or Increase* (Leeds: Henry Moore Institute, 1994), 6–7.

33 Dutta, *Bureaucracy of Beauty*, 162.

34 The importance of this museum validation is confirmed by the press release for a 2002 exhibition at the Bernard Toale Gallery in Boston, timed to coincide with the appearance of a Roxy Paine survey exhibition at the Rose Art Museum, which specifically noted that the *SCUMAK* sculptures on display at the gallery were created during exhibitions at the Victoria and Albert and the San Francisco Museum of Modern Art.

35 Koons' 1986 *Italian Woman* sold at Sotheby's on May 15, 2007. The final price, with buyer's premium, was $2,168,000, against an estimate of $900,000–$1,200,000.

36 Walter Benjamin, *The Arcades Project*, trans. Howard Eiland and Kevin McLaughlin (Cambridge: Belknap Press of Harvard University, 1999), 7 & 17.

37 Carol Duncan and Alan Wallach, "The Universal Survey Museum," *Art History* 3 (December 1980), 448–69.

38 See Germain Bazin, *The Museum Age*, trans. Jane van Nuis Cahill (New York: Universe Books, 1967), 158.

39 Bazin, *Museum Age*, 158. The reinstallation was begun in 1776–8 and completed by Chrétien de Mechel in 1781, with a catalog of the collection published in 1784.

40 Quoted in Bazin, *Museum Age*, 159. On the rehanging of the Austrian royal collection, see also Neils von Holst, *Creators, Collectors and Connoisseurs: The Anatomy of Artistic Taste from Antiquity to the Present Day*, trans. Brian Battershaw (New York: G. P. Putnam's Sons, 1967), 206–7.

41 On Hilton Kramer's response to the Met's rehang, see Douglas Crimp, *On the Museum's Ruins* (Cambridge: MIT Press, 1993), especially 44, 54.

42 For a spectrum of viewpoints, see "The Musée d'Orsay: A Symposium," *Art in America* 76 (January 1988), 84–107.

43 See Alan Wallach, "The Battle over 'The West as America,'" in *Exhibiting Contradiction*, 105–17, for an examination that considers both the political and media response, and the heavy-handed rhetoric employed by the curators. On other contemporaneous battles over arts funding and related issues, see Richard Bolton, ed., *Culture Wars: Documents from the Recent Controversies in the Arts* (New York: New Press, 1992).

44 On Barr's neutral walls, see Mary Anne Staniszewski, *The Power of Display: A History of Exhibition Installations at the Museum of Modern Art* (Cambridge: MIT Press, 1998), particularly 61–6; and on *Machine Art*, see 152–60.

45 See in particular Catherine Grenier, "Destruction / Destruction," in *Big Bang: destruction et création dans l'art du 20e siècle / Creation and Destruction in 20th Century Art* (Paris: Centre Pompidou, 2005), 40–58.

46 The 2006 categories were Material Gestures, Poetry and Dream, Idea and Object, and States of Flux, each of which contained further subdivisions.

47 The four non-Western or non-art influences set off in red boxes in Barr's chart were "Japanese prints," "Near-Eastern art," "Negro sculpture," and "Machine esthetic." On MoMA's *"Primitivism" in 20th Century Art* see James Clifford, "Histories of the Tribal and the Modern," in *The Predicament of Culture: Twentieth-Century*

Ethnography, Literature, and Art (Cambridge: Harvard University Press, 1988), 189–214.

48　For an incisive contemporaneous critique of *Magiciens de la terre*, see Rasheed Araeen, "Our Bauhaus Others' Mudhouse" (1989), reprinted in Peter Weibel and Andreas Buddensieg (eds), *Contemporary Art and the Museum: A Global Perspective* (Ostfildern: Hatje Cantz, 2007), 150–62.

49　On global versus world art, see Hans Belting, "Contemporary Art as Global Art," in Belting and Andreas Buddensieg (eds), *The Global Art World: Audiences, Markets, and Museums* (Ostfildern: Hatje Cantz, 2009), 38–73.

50　See the Tate's May 11, 2010, press release, "Tate Modern is 10: Tate reaches across the world with works acquired from Latin America, Asia, the Middle East and North Africa," http://www.tate.org.uk/about/pressoffice/pressreleases/2010/21930.htm, as well as related news reports, including Gareth Harris, "British Museum and Tate expand focus on Middle East: Both set up acquisition committees," *Art Newspaper* 208 (December 2009) and Mark Brown, "Tate Modern marks 10th birthday by expanding collection: Museum acquires new works from around the globe as part of 'ambitious' repositioning," *Guardian*, May 11, 2010.

51　Coverage of these developments has been extensive. See, for example, Alan Riding, "The Louvre's Art: Priceless. The Louvre's Name: Expensive," *New York Times*, March 7, 2007; Carol Vogel, "Abu Dhabi Gets a Sampler of World Art," *New York Times*, May 26, 2009; and Carol Vogel, "On a Mission to Loosen Up the Louvre, *New York Times*, October 9, 2009.

52　Interview with Thomas Krens, "Krens' Museum for Global Contemporary Art," Spiegel Online, March 27, 2008, http://www.spiegel.de/international/world/0,1518,druck-543601,00.html.

53　See Nicolai Ouroussoff, "Abu Dhabi Guggenheim Faces Protest," *New York Times*, March 16, 2011, as well as the petition posted on March 16, 2011, http://www.ipetitions.com/petition/gulflabor/.

54　Richard Brooks, "British Museum Treasures Head for Abu Dhabi," *The Sunday Times*, July 26, 2009.

Chapter 2

1 Stephan Bann recounts this story about Kenneth Clark in *The Clothing of Clio* (Cambridge: Cambridge University Press, 1984), 77, emphasizing the relationship of the individual figurine to the entire system constituted by Berenson's collection.

2 Susan Feinberg Millenson, *Sir John Soane's Museum* (Ann Arbor, MI: UMI Research Press, 1987), 88.

3 Peter Thornton and Helen Dorey, *Sir John Soane: The Architect as Collector, 1753–1837* (New York: Harry N. Abrams, 1992), 75. On casts of classical works in general, see Francis Haskell and Nicholas Penny, *Taste and the Antique: The Lure of Classical Sculpture, 1500–1900* (New Haven: Yale University Press, 1982).

4 For a list of these works, see, Millenson, *Sir John Soane's Museum*, 77–8. On the Flaxman acquisitions, see Thornton and Dorey, *Architect as Collector*, 60.

5 Thornton and Dorey, *Architect as Collector*, 58, 60.

6 John Elsner, "A Collector's Model of Desire: The House and Museum of Sir John Soane," in Elsner and Roger Cardinal (eds), *The Cultures of Collecting* (Cambridge: Harvard University Press, 1994), 155.

7 Elsner, "A Collector's Model," 170.

8 Stephen Barker, ed., *Excavations and their Objects: Freud's Collection of Antiquity* (Albany: State University of New York Press, 1996), viii.

9 On this point, see Sven Spieker, *The Big Archive* (Cambridge: MIT Press, 2008), 39–41.

10 Freud's correspondence, quoted by John Forrester, "'Mille e tre': Freud and Collecting," in Elsner and Cardinal, *Cultures of Collecting*, 227.

11 Barker, *Excavations and their Objects*, xvii & 79.

12 See, for example, James Putnam, *Art and Artifact: The Museum as Medium* (New York: Thames & Hudson, 2001), which presents an overview that ranges from museum-like constructions to insertions into extant institutions—some of which Putnam himself instigated, first at the British Museum and then at the Freud Museum in London. A more recent analysis of the fortunes of institutional critique, in the wake of this embrace, can be found in *El Medio es el Museo / O Medio é o Museo / Bitartekaria Museoa da / The*

Museum as Medium (Vigo: Fundación MARCO; Donostia-San Sebastián: KM Kulturunea, 2009).

13 Susan Hiller, *Thinking about Art: Conversations with Susan Hiller*, ed. and introduced by Barbara Einzig, with a preface by Lucy Lippard (Manchester: Manchester University Press, 1996), 227.

14 Spieker, *Big Archive*, 184. Spieker invokes Michel Foucault's distinction between a pre-classical emphasis on similarities, and classical taxonomy, in this observation about Hiller's play with the archival form.

15 On the exhibition, see Sophie Calle, *Appointment with Sigmund Freud* (New York: Thames & Hudson, 2005), as well as Putnam, *Art and Artifact*, 158–9, and Spieker, *Big Archive*, 186–91.

16 For an archive of these and other exhibitions, see the Freud Museum website, http://www.freud.org.uk/exhibitions/. Additional information about the exhibitions curated by James Putnam can also be found at http://www.jamesputnam.org.uk/inv_exhibitions.html.

17 The exhibition was curated by Jon Wood and accompanied by a catalogue, *Freud's Sculpture*, ed. Penelope Curtis and Jon Wood (Leeds: Henry Moore Institute, 2006). After its appearance at the Henry Moore Institute, the arrangement was also shown at the Freud Museum itself, in one of the exhibition rooms set off from the preserved study. Another layer was added by the replication of Freud's distinctive chair—not as an initial part of the exhibition plan, but rather as a happy coincidence, since the chair in question had been fabricated as part of a movie set, then given to the museum, where it lingered in the basement before being loaned along with the genuine artifacts that visitors could inspect while sitting in the simulated chair.

18 See the section "Museen von Künstlern," *Documenta 5* (Kassel: Verlag GmbH, 1972). A number of these works, including a reconstruction of Oldenburg's *Mouse Museum*, were also exhibited in the Museum of Modern Art's 1999 *Museum as Muse*.

19 On Broodthaers' claim that he became a creator because he lacked the means to be a collector, see Douglas Crimp, "This is Not a Museum of Art," in *Marcel Broodthaers* (Minneapolis: Walker Art Center; New York: Rizzoli, 1989), 71, and see this same publication for a general chronology of the different stages of the museum project, 180–93. On the play between the site of production and reception, see Benjamin Buchloh, "The Museum Fictions of Marcel Broodthaers," in A. A. Bronson and Peggy Gale, (eds), *Museums by Artists* (Toronto: Art Metropole, 1983), 55.

20 *The Mouse Museum / The Ray Gun Wing: Two Collections / Two Buildings, by Claes Oldenburg* (Chicago: Museum of Contemporary Art, 1977), 18.

21 Jorge Luis Borges, "The Analytical Language of John Wilkins," in *Other Inquisitions, 1937–1952*, trans. Ruth L. C. Simms (Austin: University of Texas Press, 1964). Citing Wilkins' *An Essay Toward a Real Character, and a Philosophical Language*, which does exist, though Borges claims not to have had access to it, Borges compares Wilkins' division of the universe to a Chinese encyclopedia entry that is apparently Borges' invention, despite its attribution to Franz Kuhn, an actual sinologist. The entry, in full (as translated in Foucault's preface), divides animals into "(a) belonging to the emperor, (b) embalmed, (c) tame, (d) sucking pigs, (e) sirens, (f) fabulous, (g) stray dogs, (h) included in the present classification, (i) frenzied, (j) innumerable, (k) drawn with a very fine camelhair brush, (l) *et cetera*, (m) having just broken the water pitcher, (n) that from a long way off look like flies."

22 Michel Foucault, *The Order of Things: An Archaeology of the Human Sciences* (New York: Pantheon, 1971), xvii.

23 *The Mouse Museum / The Ray Gun Wing*, 50–1.

24 Swizzle sticks and souvenir buildings are two of the collection examples in Mitch Tuchman, *Magnificent Obsessions: Twenty Remarkable Collectors in Pursuit of their Dreams* (San Francisco: Chronicle Books, 1994), 33–5 and 69–71.

25 See Marilynn Gelfman Karp, *In Flagrante Collecto: Caught in the Act of Collecting* (New York: Abrams, 2006), 35–6, 46–7, 144–5, and 314–21.

26 Warhol's process of selection is described in Daniel Robbins, "Confessions of a Museum Director," and David Bourdon, "Andy's Dish," *Raid the Icebox 1 with Andy Warhol* (Providence: Museum of Art, Rhode Island School of Design, 1969), 8–24.

27 On the unpacking of Warhol's time boxes, see John W. Smith's entry on Warhol in Ingrid Schaffner and Matthias Winzen (eds), *Deep Storage: Collecting, Storing, and Archiving in Art* (Munich & New York: Prestel, 1998), 278–81.

28 A 1947 auction of objects from the "Collyer Collection" realized $1,892.50. There was, however, some value based on association with the famous hermits, indicated by one junk dealer's regret that he hadn't saved more of the newspapers from his purchase, since he was able to sell them for 10 cents each. See Franz Lidz, *Ghosty Men: The Strange but True Story of the Collyer Brothers, New*

York's Greatest Hoarders (New York: Bloomsbury, 2003), especially 148–53.

29 A single collector, Gedalio Grinberg, bought the majority of the 175 jars for sale, paying $198,605 of the $247,830 they commanded. See Rita Reif, "At the Warhol Sale, A Hunt for Collectibles," *New York Times*, April 28, 1988. On connections between *Raid the Icebox* and Warhol's collection, see John W. Smith, ed., *Possession Obsession: Andy Warhol and Collecting* (Pittsburgh: Andy Warhol Museum, 2002), particularly Pamela Allara, "Please Touch, Warhol's Collection as Alternative Museum," 40–8, and Michael Lobel, "Warhol's Closet," 65–74.

30 Walter Benjamin, "Unpacking My Library" (1931), in *Illuminations*, trans. Hannah Arendt (New York: Schocken, 1969), 67.

31 Trevor Fairbrother, "Museum / Sleuthing Storage: The 'Connections' Series at the Museum of Fine Arts Boston," in Schaffner and Winzen, *Deep Storage*, 211.

32 At the time of the 2003 exhibitions, Historic New England was still known by its earlier identity, the Society for the Preservation of New England Antiquities, or SPNEA.

33 Nancy Carlisle, *Cherished Possessions: A New England Legacy* (Boston: Society for the Preservation of New England Antiquities, 2003). The exhibition itinerary included stops at the Colby College Museum of Art, Amon Carter Museum, Honolulu Academy of Fine Arts, Bard College Graduate Center, and the Public Museum of Grand Rapids.

34 Laura Steward Heon, *Yankee Remix: Artists Take on New England* (North Adams: MASS MoCA Publications, 2003).

35 Zoe Leonard, "For Which It Stands." Unpublished note to Laura Heon, courtesy the artist.

36 Lawrence Weschler quotes Marcia Tucker on how Wilson "never even breaks irony" in *Mr. Wilson's Cabinet of Wonder* (New York: Pantheon Books, 1995), 39. The stink ant is discussed on pp. 3–4, 63, and 66–8.

37 Michel Foucault, *The Archaeology of Knowledge & the Discourse on Language*, trans. A. M. Sheridan Smith (New York: Pantheon Books, 1972), 126–31. For an overview of theories of the archive, see Robin Kelsey, *Archive Style: Photographs & Illustrations for U.S. Surveys, 1850–1890* (Berkeley & Los Angeles: University of California Press, 2007), 8–12.

38 Atlas Group projects are archived at http://www.theatlasgroup.org/.

On the miniature museum version, see Leslie Dick, "Scratching on Things I Could Disavow: A History of Modern and Contemporary Art in the Arab World / Part I Volume 1 Chapter 1 (Beirut: 1992–2005), A Project by Walid Raad, REDCAT, Los Angeles, CA," *X-TRA* 12 (Fall 2009), 53–7.

39 Alessandro Balteo Yazbeck, lecture, "Entanglements," February 7, 2008, in conversation with José Luis Falconi and Nuit Banai, at the Harvard University Carpenter Center for the Visual Arts. For reviews of the exhibition, see Robin Adèle Greeley, "Alessandro Balteo Yazbeck," *Art Nexus* 7 (June–August 2008), 112–13, and Nuit Banai, "Alessandro Balteo Yazbeck: Carpenter Center for Visual Arts," *Modern Painters* 20 (May 2008), 91.

40 Boris Groys, "The Curator as Iconoclast," in *Cautionary Tales: Critical Curating*, ed. Steven Rand and Heather Kouris (New York: Apexart, 2007), 46.

41 Groys, "The Curator as Iconoclast," 52.

42 Alexander Ferrando, "Ultimate Images: 2010 Gwangju Biennale" (interview with Massimiliano Gioni), *Flash Art* 43 (July–September 2010), 46.

43 See Ydessa Hendeles, *Partners* (Cologne: Verlag der Buchhandlung Walther König, 2003).

44 For the background of the project, as well as a complete catalogue of the collection, see Francis Alÿs, *Fabiola: An Investigation*, ed. Karen Kelly and Lynne Cooke (New York: Dia Art Foundation, 2008).

45 Francis Alÿs, "Fabiola or the Silent Multiplication," in Cuauhtémoc Medina, *Fabiola* (Mexico City: Curare, 1994), 4.

46 Stephen Bann emphasizes the "productivity" of the reproduction, in the context of a wider visual culture. Bann, "Beyond *Fabiola*: Henner in and out of his Nineteenth-Century Context," in *Fabiola: An Investigation*, 40. See also p. 32, note 2, regarding the disappearance of the painting and its photographic reproduction.

47 Ralph Rugoff, "Jim Shaw: Recycling the Subcultural Straitjacket" (interview), *Flash Art* 163 (March–April 1992), 93.

48 Marcel Duchamp, "The Creative Act" (1957), in Michel Sanouillet and Elmer Peterson, (eds), *The Writings of Marcel Duchamp* (New York: Da Capo Press, 1989), 138–40.

Chapter 3

1 Allan Kaprow, "The Legacy of Jackson Pollock" (1958), reprinted in Kaprow, *Essays on the Blurring of Art and Life*, ed. Jeff Kelley (Berkeley and Los Angeles: University of California Press, 1993), 1–9.

2 Paul McCarthy, in "Allan Kaprow: Art & Life" (transcript of panel discussion held at the Jewish Museum, November 8, 2007), *Art in America* 96 (March 2008), 136. The retrospective, *Allan Kaprow—Art as Life*, opened in 2006 at the Haus der Kunst, Munich, and subsequently traveled to the Van Abbemuseum, Eindhoven; Kunsthalle Bern, Berne/CH; Museo Villa Groce Genova/IT; and the Museum of Contemporary Art, Los Angeles.

3 For the 2008 installation of the retrospective at the Los Angeles Museum of Contemporary Art, which was the version viewed by the author, Allen Ruppersberg reinvented *Words*, John Baldessari and Skylar Haskard took on *Apple Shrine*, and Barbara T. Smith was responsible for *Push and Pull*.

4 On the justification for re-enacting *18 Happenings in 6 Parts*, see André Lepecki, "Redoing 18 Happenings in 6 Parts," in *Allan Kaprow—18 Happenings in 6 Parts—9/10/11 November 2006* (Göttingen: Steidl Hauser & Worth, 2007), 45–50, and Stephanie Rosenthal, "Agency for Action," in *Allan Kaprow—Art as Life*, ed. Eva Meyer-Hermann, Andew Perchuk and Stephanie Rosenthal (Los Angeles: Getty Research Institute, 2008), 66. *18 Happenings in 6 Parts* was restaged in various locations in conjunction with the traveling retrospective, and also in New York as part of Performa 07.

5 Allan Kaprow, "The Education of the Un-Artist, Part II" (1972), in *Blurring of Art and Life*, 111.

6 Allan Kaprow, "The Education of the Un-Artist, Part I" (1971), in *Blurring of Art and Life*, 98.

7 Allan Kaprow, "Doctor MD" (1973), in *Blurring of Art and Life*, 127.

8 Brian O'Doherty, "The Gallery as Gesture," in Reesa Greenberg, Bruce W. Ferguson and Sandy Nairne, *Thinking about Exhibitions* (London: Routledge, 1996), 322.

9 For transcriptions from this work, see Silvia Kolbowski, "An Inadequate History of Conceptual Art," *October* 92 (spring 2000), 53–70, and *Silvia Kolbowski, Inadequate...Like...Power at the*

Secession (exhibition catalogue, Cologne: Verlag der Buchhandlung Walther König, 2004), 6–17.

10 Mignon Nixon, "On the Couch," *October* 113 (summer 2005), 72.

11 On this dynamic, see Judith F. Rodenbeck, "Foil: Allan Kaprow before Photography," in Benjamin H. D. Buchloh and Judith F. Rodenbeck, *Experiments in the Everyday: Allan Kaprow and Robert Watts—Events Objects, Documents* (exhibition catalogue, New York: Wallach Art Gallery, 1999), 47–67.

12 For descriptions of various works involving the incorporation of photography, see Jeff Kelley, *Childsplay: The Art of Allan Kaprow* (Berkeley: University of California Press, 2004), 130, 133, 144–5, and 188–9.

13 *New Forms—New Media 1* (New York: Martha Jackson Gallery, 1960), n.p.

14 See Kelley, *Childsplay*, 58, referencing Kaprow's recollections to Kelley in a conversation from May 1995.

15 Claes Oldenburg, interview by Paul Cummings, December 4, 1973–January 25, 1974, transcript, Archives of American Art, New York, quoted in Julie H. Reiss, *From Margin to Center: The Spaces of Installation Art* (Cambridge: MIT Press, 1999), 40.

16 See Reiss, *From Margin to Center*, 36–41, for an account of these responses to the 1961 Jackson Gallery exhibition. Reiss cites reviews from four sources: *Art News*, *New York Times*, *Village Voice*, and *Newsweek*.

17 Jack Kroll, review of *Environments, Situations, Spaces*, in *Art News* 60 (September 1961), 16.

18 Brian O'Doherty, "Art: 3 Displays Run Gamut of Styles," *New York Times*, June 6, 1961, 43.

19 Kelley cites a 14-page guest list that included David Tudor, Claes Oldenburg, Jim Dine, Jasper Johns, Leo Castelli, Ivan Karp, Dan Flavin, Meyer Schapiro, Richard Bellamy, and Fairfield Porter. See Kelley, *Childsplay*, 34.

20 The disagreement is addressed in interviews Susan Hapgood conducted with Kaprow and Oldenburg in 1992 and 1993 respectively. See the interview section in Hapgood, *Neo-Dada: Redefining Art, 1958–1962* (New York: American Federation of Arts, 1994), particularly 120 and 125.

21 Allan Kaprow, *Assemblage, Environments and Happenings* (New York: Harry N. Abrams, 1966), 21.

22 André Malraux, *Museum without Walls*, trans. Stuart Gilbert and
 Francis Price (Garden City, NY: Doubleday, 1967), 12.

23 Allan Kaprow, "The Legacy of Jackson Pollock" (1958), as reprinted
 in *Blurring of Art and Life*, 5.

24 Kaprow, "Legacy of Jackson Pollock," 7. For a more recent analysis
 of this dynamic, see William Kaizen, "Framed Space: Allan Kaprow
 and the Spread of Painting," *Grey Room* 13 (fall 2003), 80–107.

25 Kaprow, "The Shape of the Art Environment" (1968), in *Blurring of
 Art and Life*, 92.

26 See the correspondence files in the Kaprow papers, box 34, in the
 Special Collections of the Research Library at the Getty Research
 Institute.

27 Allan Kaprow, introductory text in *Allan Kaprow* (Pasadena:
 Pasadena Art Museum, 1967), 3. On the specific decision to use tar
 paper, see Robert E. Haywood, "Critique of Instrumental Labor:
 Meyer Schapiro's and Allan Kaprow's Theory of Avant-Garde Art,"
 in Buchloh and Rodenbeck, *Experiments in the Everyday*, 42.

28 See Barbara Haskell, *Blam! The Explosion of Pop, Minimalism,
 and Performance, 1958–1964* (New York: Whitney Museum of
 American Art, 1984). The checklist on pages 157–60 indicates that
 works by George Brecht, Walter De Maria, Red Grooms, Allan
 Kaprow, Robert Morris, Robert Watts, and Robert Whitman were
 reconstructed for the 1984 exhibition.

29 Eleanor Heartney, "Report from Sydney: The Expanded
 Readymade," *Art in America* 78 (September 1990), 91.

30 Kelley, *Childsplay*, 220. See also Allan Kaprow, *7 Environments*
 (Milan: Fondazione Mudima, 1992), for extensive photographs of
 the reconstruction of all seven environments.

31 Paul Schimmel, "Intentionality and Performance-Based Art," in
 Miguel Angel Corzo, ed., *Mortality Immortality? The Legacy of
 20th-Century Art* (Los Angeles: Getty Conservation Institute, 1999),
 138. The correspondence between Kaprow and Schimmel appears
 in the Kaprow papers, box 34, in the Special Collections of the
 Research Library at the Getty Research Institute. For the exhibition
 overview, see Paul Schimmel, *Out of Actions: Between Performance
 and the Object, 1949–1979* (Los Angeles: MOCA; New York:
 Thames & Hudson, 1998).

32 See www.ubu.com/aspen for a survey of the contents of all ten
 issues of *Aspen* that, while failing to provide the important tactile
 experience of sifting through the loose pieces that constitute this

magazine, does have the advantage of comprehensiveness not necessarily found in the sometimes fragmentary condition of library holdings, as well as access to audio and film components from 5+6.

33 Susan Sontag, "The Aesthetics of Silence," *Aspen* 5+6 (1967), section 3.

34 Kaprow, "Doctor MD," 127.

35 Roland Barthes, "The Death of the Author," quoting from the 1968 version of the essay reprinted in *Image Music Text*, trans. Stephen Heath (New York: Hill and Wang, 1977), 143.

36 Barthes, "Death of the Author," 146.

37 Kaprow tells Schimmel that he provides services rather than making objects in a September 16, 1997, note in the Kaprow papers.

38 George Kubler, *The Shape of Time: Remarks on the History of Things* (New Haven: Yale University Press, 1962), 21.

39 See "What is a Museum? A Dialogue between Allan Kaprow and Robert Smithson (1967)," reprinted in Nancy Holt, ed., *The Writings of Robert Smithson* (New York: New York University Press, 1979), 59, as well as Allan Kaprow, "Death in the Museum," and Robert Smithson, "Some Void Thoughts on Museums," *Arts Magazine* 41 (February 1967), 40–1. On the importance of Kubler for Smithson and other artists, see Pamela M. Lee's chapter "Ultramoderne: Or, How George Kubler Stole the Time in Sixties Art," in *Chronophobia: On Time in the Art of the 1960s* (Cambridge: MIT Press, 2004), 218–56.

40 George Kubler, "Style and the Representation of Historical Time," *Aspen* 5+6 (1967), section 3.

41 Malraux, *Museum without Walls*, 11.

42 Michael Ann Holly, *Past Looking: Historical Imagination and the Rhetoric of the Image* (Ithaca: Cornell University Press, 1996), 26.

43 See in particular Kaprow's February 8, 1997, letter to Schimmel in the Kaprow papers.

44 Schimmel, "Intentionality and Performance-Based Art," 138.

45 Kaprow, "Doctor MD," 129.

46 References to the junkyard alternative appear in Kelley, *Childsplay*, 59, and a June 4, 1997 letter from Kaprow to Christine Stiles in the Kaprow papers. Tony Smith made his comments about the New Jersey Turnpike in an interview with Samuel Wagstaff, Jr., "Talking with Tony Smith," published in *Artforum* 5 (December 1966), 18–19. Robert Smithson, "The Monuments of Passaic,"

Artforum 6 (December 1967), 48–51, was reprinted as "A Tour of the Monuments of Passaic, New Jersey," in *The Writings of Robert Smithson*, ed. Nancy Holt (New York: New York University Press, 1979), 52–7.

47 On Smithson's "Monuments of Passaic," see Ann Reynolds, *Robert Smithson: Learning from New Jersey and Elsewhere* (Cambridge: MIT Press, 2003). The reference to Kaprow appears on p. 265, note 86.

48 In addition to inhabiting the site of *Yard*'s original appearance, Hauser & Wirth also represents the Kaprow estate.

49 On the role of the photograph within a range of practices from the 1960s to the present, see Martha Buskirk, *The Contingent Object of Contemporary Art* (Cambridge: MIT Press, 2003), particularly 211–58.

50 Kaprow, "The Education of the Un-Artist, Part I" (1971), in *Blurring of Art and Life*, 109.

51 See, for example, Andrea Fraser, "How to Provide an Artistic Service: An Introduction" (1994), in Zoya Kocur and Simon Leung, (eds), *Theory in Contemporary Art since 1985* (Malden: Blackwell, 2005), 69–75.

Chapter 4

1 Brigitte and Gilles Delluc, "Lascaux II: A Faithful Copy," *Antiquity* 58, no. 224 (1984), 194–6.

2 According to the Dordogne's official tourist facts and figures, reported on http://www.dordogne-perigord-tourisme.fr.

3 For 2005 stories on the new replica, see Colin Randall, "Replicas Open Door to Forbidden World of Caveman's Art," *Daily Telegraph*, August 30, 2005, and "Le clone démontable de Lascaux," *Le Soir*, August 18, 2005.

4 Walter Benjamin, "The Work of Art in the Age of Mechanical Reproduction" (1936), *Illuminations*, trans. Harry Zohn (New York: Schocken Books, 1969), 220.

5 Dean MacCannell, *The Tourist: A New Theory of the Leisure Class* (New York: Schocken Books, 1976).

6 See Carlos Basualdo, ed., *Tropicália: A Revolution in Brazilian Culture (1967–1972)* (São Paulo: Cosac Naify, 2005). The author's

encounter with the exhibition took place in 2006 at the Barbican in London.

7 Yve-Alain Bois, "Introduction," in Lygia Clark, "Nostalgia of the Body," *October* 69 (Spring 1992), 86.

8 Clark, "1966: We Refuse..." in "Nostalgia of the Body," 106.

9 Chris Burden's relics were shown at the Ronald Feldman gallery in 1976. Jasper Johns bought relics from *B.C. Mexico* (1973), *Trans-Fixed* (1974), and *Dreamy Nights* (1974); Warhol purchased relics from *I Became a Secret Hippy* (1971), *Jaizu* (1972), and *Movie on the Way Down* (1973); and Larry Gagosian acquired the relic from *Five Day Locker Piece* (1971). For a list of owners as of 1988, see *Chris Burden: A Twenty Year Survey* (ex. cat. Newport Beach: Newport Harbor Art Museum, 1988), 167–8.

10 Quoted in Joan Rothfuss, entry on *Painting to Hammer a Nail*, in Alexandra Munroe with Jon Hendricks, *Yes Yoko Ono* (New York: Japan Society & H. N. Abrams, 2000), 104.

11 Yoko Ono spoke about the possibility of participating in one's mind at an October 20, 2001, event at the MIT List Center for the Visual Arts in conjunction with the appearance of *Yes Yoko Ono* at that venue.

12 Ono, "Some Notes on the Lisson Gallery Show" (1967), quoted in Munroe, *Yes Yoko Ono*, 104.

13 Rothfuss, entry on *Ceiling Painting (YES Painting)*, in Munroe, *Yes Yoko Ono*, 100.

14 For a summary of these events, see "The Limits of Licence at SAM," *Artnet*, September 2, 2009, http://www.artnet.com/magazineus/news/artnetnews/amanda-mae-yoko-ono9-2-09.asp. A letter to the fired guard from Yoko Ono curator Jon Hendricks was posted by Jen Graves on August 28, 2009, http://slog.thestranger.com/slog/archives/2009/08/28/yoko-onos-people-give-seattle-artist-the-smackdown.

15 Paul Schimmel, "Intentionality and Performance-Based Art," in Miguel Angel Corzo, *Mortality Immortality? The Legacy of 20th-Century Art* (Los Angeles: Getty Conservation Institute, 1999), 139.

16 See the entry for *Ben's Window*, in the collections section of the Walker Art Center website, http://collections.walkerart.org/item/object/964.

17 Schimmel, "Intentionality and Performance-Based Art," 138.

18 Kimberly Paice, entry on *Site*, 1964, in Rosalind Krauss, et al.,

Robert Morris: The Mind/Body Problem (New York: Solomon R. Guggenheim Museum, 1994), 168–9. The three other Morris works recreated with new performers for film were *Arizona* (1963), *21:3* (1963), and *Waterman Switch* (1965).

19 See *Aspen* no. 5+6, item 24, "Four Films by Four Artists," available in a QuickTime version on Ubuweb, http://www.ubu.com/aspen/aspen5and6/film.html.

20 See the interview with Robert Morris on the website for the Guggenheim exhibition "Seeing Double: Emulation in Theory and Practice," http://www.variablemedia.net/e/seeingdouble/.

21 See Maurice Berger, *Labyrinths: Robert Morris, Minimalism, and the 1960s* (New York: Harper and Row, 1989), 121–3.

22 On Duchamp's installation, see Lewis Kachur, *Displaying the Marvelous: Marcel Duchamp, Salvador Dali, and Surrealist Exhibition Installations* (Cambridge: MIT Press, 2001).

23 For the curators' framing of these projects, see Aaron Moulton's interview, "Extraordinary Rendition: On the Institutional Kidnapping of Cady Noland and David Hammons," *Flash Art* 39 (July–September 2006), 58–9. See also the archived information on the gallery website, http://www.triplecandie.org/Archive%20 2006%20Cady%20Noland.html. Taylor Davis and Rudy Shepherd were the two artists involved in the project who were willing to be identified.

24 See Rosalind E. Krauss, *The Originality of the Avant-Garde and other Modernist Myths* (Cambridge: MIT Press, 1985), 151–3.

25 Nancy Spector, *Felix-Gonzalez-Torres: America* (New York: Solomon R. Guggenheim Foundation, 2007), 41–3.

26 On various decisions involved in the fabrication, including Holt's scattering of birdseed, see Randy Kennedy, "It's Not Easy Making Art that Floats," *New York Times*, September 16, 2005.

27 The author's experience of the *Floating Island* (including its delayed appearance) took place on the afternoon of September 24, 2005.

28 See Caroline Jones, "Preconscious / Posthumous Smithson," *Res* 41 (Spring 2002), for a discussion of both the later editions and the attention to the way that drawings done prior to the 1964 date that Smithson gave for the moment he "began to function as a conscious artist" have been brought back into view.

29 W. K Wimsatt, Jr. and Monroe C. Beardsley, "The Intentional Fallacy," in Wimsatt, *The Verbal Icon: Studies in the Meaning of Poetry* (Kentucky: University of Kentucky Press, 1954), 5.

30 For examples of this tendency, see Stephan Götz, *American Artists in their New York Studios: Conversations about the Creation of Contemporary Art*, ed. Craigen W. Bowen and Katherine Olivier (Cambridge: Center for Conservation and Technical Studies, Harvard Art Museums; Stuttgart: Daco-Verlag Günter Bläse, 1992); IJsbrand Hummelen and Dionne Sillé (eds), *Modern Art, Who Cares? An Interdisciplinary Research Project and an International Symposium on the Conservation of Modern and Contemporary Art* (Amsterdam: Foundation for the Conservation of Modern Art & Netherlands Institute for Cultural Heritage, 1999); and the site for the Variable Media Network: http://www.variablemedia.net/

31 Jaap Guldemond, "Artificial Respiration," in Hummelen and Sillé, *Modern Art, Who Cares?* 80–1.

32 Documents from the Guggenheim exhibition *Seeing Double*, March 19–May 16, 2004, http://www.variablemedia.net/e/seeingdouble.

33 Documents from *Seeing Double*, http://www.variablemedia.net/e/seeingdouble.

34 Carol Mancusi-Ungaro, quoted in Brian D. Goldstein, "Where's Rothko?" *Harvard Crimson*, November 21, 2003. See also Marjorie B. Cohn, ed., *Rothko's Harvard Murals* (Cambridge: Center for Conservation and Technical Studies, Harvard University Art Museums, 1988).

35 See "Uncertain Mandate: A Roundtable Discussion on Conservation Issues," ed. Chad Coerver, in Elisabeth Sussman, et al. (San Francisco: San Francisco Museum of Modern Art & New Haven: Yale University Press, 2002), 297, 299.

36 "Uncertain Mandate," 300.

37 "Uncertain Mandate," 301.

38 For one exception, see the photographs of the retrospective exhibition on the Hauser & Wirth website for the estate of Eva Hesse, http://www.hauserwirth.com/artists/34/eva-hesse/images-clips/34/.

39 Maria Eichhorn, "Interview with Robert Ryman, 27 April 1998, New York," in Eichhorn, *The Artist's Contract*, ed. Gerti Fietzek (Cologne: Verlag der Buchhandlung Walther König, 2009), 219 (interview quote) and 220 (reproduction of Robert Ryman's Notice).

40 Arthur Danto describes this encounter in a number of places, including his *Beyond the Brillo Box: The Visual Arts in Post-Historical Perspective* (Berkeley and Los Angeles: University of California Press, 1998).

41 The four boxes (*Heinz Ketchup*, *Campbell's Tomato Juice Box*, *Kellogg's Cornflakes Box*, *and Brillo Soap Pads Box*, all from 1964) were offered as lot 11 in Christie's Post-War and Contemporary Evening Sale, November 10, 2010, where the set of boxes sold for $2,322,500. Tellingly, the catalogue photograph does not show the works with the plexi protection: http://www.christies.com/LotFinder/lot_details.aspx?from=salesummary&intObjectID=5371696&sid=738c7914-999a-4c43-bf13-21ee3cee933e.

42 On the idea of restoring the work if 85 percent could be found, see Jeffrey Gold, "Role for Damaged Sculptures Undecided," Associated Press, February 12, 2002. As of October 12, 2005, however, the Calder Foundation indicated (in correspondence with the author) that there were no plans at that time to restore or reconstruct the work.

43 Zhang Huan makes passing references to the authority of the museum in "A Piece of Nothing," in *Zhang Huan: Altered States*, ed. Melissa Chiu (Milan: Charta; New York: Asia Society, 2007), 69, 85.

44 Michele Robecchi, "Zhang Huan Speaks with Michele Robecchi," in *Conversaciones con fotógrafos / Conversations with Photographers* (Madrid: La Fabrica, 2006).

45 Zhang Huan describes the making of *12 Square Meters* in "A Piece of Nothing," 58–9.

46 The materials list was included as one of the displays in a counter exhibition, "Made at MASS MoCA," which opened in May 2007, and this summary of its contents is based on Roberta Smith, "Is It Art Yet? And Who Decides?" *New York Times*, September 16, 2007.

47 The October 28, 2006 email from Joe Thompson is quoted in Massachusetts Museum of Contemporary Art Foundation, Inc., v. Christoph Büchel, on appeal to the United States Court of Appeals for the First Circuit, No. 08-2199, before Lipez and Howard, Circuit Judges, and Woodcock, District Judge, January 27, 2010.

48 January 31, 2007, email from Susan Cross to Joe Thompson, released in conjunction with Massachusetts Museum of Contemporary Art Foundation, Inc., v. Christoph Büchel, US District Court, District of Massachusetts, civil action no. 3:07-30089-MP.

49 Email correspondence with the subject line "Some lines as to how far to go in putting objects in Buchel..." initiated February 14, 2007, by Joe Thompson (museum director), to Nato Thompson (curator), and copied to Dante Birch (production manager) and Richard Criddle (director of fabrication), with responses from Birch and Criddle, released in conjunction with the district court case.

50 http://www.smb.museum/smb/news/details.
 php?lang=en&objID=18525. MASS MoCA announced that a
 settlement was reached between the artist and the museum in
 December 2010. According to the museum, "If those elements are
 subsequently resold, under certain conditions MASS MoCA will
 be entitled to cash payments which would partially reimburse the
 museum for expenses associated with fabricating the unrealized
 installation." See http://www.massmoca.org/event_details.
 php?id=144.

51 See Virginia Rutledge, "Institutional Critique," *Artforum* 46 (March
 2008), 151–2, 382.

Chapter 5

1 According to Young, all were involved with art institutions or art
 fairs between 2002 and 2007. Conversation with the author, May
 16, 2010.

2 Pierre Bourdieu, *Distinction: A Social Critique of the Judgement of
 Taste*, trans. Richard Niece (Cambridge: Harvard University Press,
 1984), 32.

3 Leo Steinberg, *Other Criteria: Confrontations with Twentieth-
 Century Art* (London and New York: Oxford University Press,
 1972), 11.

4 Calvin Tomkins, *Off the Wall: Robert Rauschenberg and the Art
 World of Our Time* (New York: Penguin Books, 1980), 296.

5 Barbara Rose, "Scull Sale at Sotheby Parke Bernet, October 18,"
 New York Magazine, November 5, 1973, 80.

6 On Deitch's career, see Calvin Tomkins, "A Fool for Art: Jeffrey
 Deitch and the Exuberance of the Art Market," *New Yorker*,
 November 12, 2007, 64–75.

7 David Robbins, ed., "From Criticism to Complicity," *Flash Art* 129
 (Summer 1986), 46–9.

8 On this dynamic, see Thomas Hine, *The Total Package: The
 Evolution and Secret Meaning of Boxes, Bottles, Cans, and Tubes*
 (Boston: Little, Brown and Co., 1995) and *I Want That! How We All
 Became Shoppers* (New York: Harper Collins, 2002).

9 Andy Warhol, *The Philosophy of Andy Warhol: From A to B and
 Back Again* (New York: Harcourt Brace Jovanovich, 1975),
 100–1.

10 Ed Ruscha, *Leave Any Information at the Signal: Writings, Interviews, Bits, Pages*, ed. Alexandra Schwartz (Cambridge: MIT Press, 2002), 184.

11 Ruscha, *Leave Any Information*, 183.

12 Walter Hopps, in Ruscha, *Leave Any Information*, 315.

13 For a brief history of Spam, see Mary Cross, ed., *A Century of American Icons: 100 Products and Slogans from the 20th-Century Consumer Culture* (Westport, CT: Greenwood Press, 2002), 106–8.

14 Claes Oldenburg, *Store Days: Documents from The Store, 1961, and Ray Gun Theater, 1962, Selected by Claes Oldenburg and Emmett Williams* (New York: Something Else Press, 1967), 31–4, 150.

15 For an overview of the Berges furniture store event, see Peter Chametzky, *Objects as History in Twentieth-Century German Art: Beckmann to Beuys* (Berkeley and Los Angeles: University of California Press, 2010), 204–5.

16 Oldenburg, *Store Days*, 150.

17 Laura Hoptman, "Down to Zero: Yayoi Kusama and the European 'New Tendency,'" in Lynn Zelevansky, et al., *Love Forever: Yayoi Kusama, 1958–1968* (Los Angeles: Los Angeles County Museum of Art, 1998), 51–2.

18 David Deitcher, "Polarity Rules: Looking at Whitney Annuals and Biennials, 1968–2000," in Julie Ault, ed., *Alternative New York: 1965–1985* (New York: The Drawing Center; Minneapolis: University of Minnesota Press, 2002), 214–15. The Museum of Modern Art did the same, with the price list for the 1959 *New American Painting* exhibition, for example, instructing interested purchasers to make their check payable to the museum.

19 The Christie's 20th Century Art, May 12, 1998, New York, sale offered the Claes Oldenburg's *Yellow Girl's Dress*, with an estimate, $150,000–$200,000, for a final price of $244,500. Sotheby's Contemporary Art Evening Auction, May 14, 2008, New York, offered the work with an estimate of $1,500,000–$2,000,000, for a final price of $1,721,000.

20 For information about these works, see Conrad Bakker, *Objects and Economies: Untitled Projects, 1997–2007* (Des Moines: Des Moines Art Center, 2007). The *Untitled Product Distribution Network* also appeared (with its hand-made table) at MASS MoCA in Rebecca Uchill's 2003 exhibition *Trade Show*. See the catalogue for the

exhibition, available as a download at http://www.halfletterpress. com/FREE_STORE/tradeshow_catalog.pdf.

21 Douglas Crimp, *On the Museum's Ruins* (Cambridge: MIT Press, 1993), 78.

22 On the conceptual read of Ruscha's books, see Benjamin H. D. Buchloh, "Conceptual Art 1962–1969: From the Aesthetics of Administration to the Critique of Institutions," *October* 55 (Winter 1990), 105–43.

23 Dara Birnbaum discusses this dynamic in "Do It 2," a conversation between Birnbaum and Cory Arcangel, *Artforum* 47 (March 2009), 192.

24 See "Do It 2," 192, and also 198, for Birnbaum's discussion of the changes in access.

25 See Cory Arcangel's website, http://www.coryarcangel.com/ things-i-made/dreiklavierstucke/.

26 On YouTube, see "Cory Arcangel – Arnold Schoenberg, op. 11 – I – Cute Kittens," http://www.youtube.com/watch?v=lF6IBWTDgnI; "Cory Arcangel – Arnold Schoenberg, op. 11 – II – Cute Kittens," http://www.youtube.com/watch?v=6ay0nOIWSo4; and "Cory Arcangel – Arnold Schoenberg, op. 11 – III – Cute Kittens," http:// www.youtube.com/watch?v=aHrMlgKrons. For his own description of his process, see "Drei Klavierstücke op. 11 (2009)" under the "Things I Made" section of his website, http://www.coryarcangel. com/things-i-made/dreiklavierstucke/.

27 See the links under "Things I Made," http://www.coryarcangel.com/ things-i-made/.

28 See Daniel Soutif's discussion of this exhibition in "Feux pales. Souvenirs," in Manuel J. Borja-Villel, *Readymades Belong to Everyone* (Barcelona: Museu d'Art Contemporani de Barcelona, 2000), 109–30.

29 On this dynamic, see Buchloh, "Conceptual Art 1962–1969," and Alexander Alberro, *Conceptual Art and the Politics of Publicity* (Cambridge: MIT Press, 2003).

30 See William Wood, "Capital and Subsidiary: The N.E. Thing Co. and the Revision of Conceptual Art, in *You Are Now in the Middle of an N.E. Thing Co. Landscape: Works by Iain and Ingrid Baxter, 1965–1971*, curated by Nancy Shaw and William Wood (Vancouver: UBC Fine Arts Gallery, 1993), 11–23.

31 Robert Smithson, "The Monuments of Passaic," *Artforum* 6 (December 1967), reprinted as "A Tour of the Monuments of

Passaic, New Jersey," in *The Writings of Robert Smithson*, ed. Nancy Holt (New York: New York University Press, 1979), 54.

32 Moira Roth, "Robert Smithson on Duchamp: An Interview with Moira Roth," in *Writings of Robert Smithson*, 198.

33 See David Revill, *The Roaring Silence* (New York: Arcade, 1992).

34 See Liz Kotz's chapter on Cage and *4'33"*, "Proliferating Scores and the Autonomy of Writing," in her *Words to Be Looked At: Language in 1960s Art* (Cambridge: MIT Press, 2007), 13–57.

35 "'You can't copyright silence—There's too much of it about,'" *Telegraph*, September 28, 2002.

36 Ben Greenman, "Silence is Beholden," *New Yorker*, September 30, 2002.

37 See, for example, Emma Allen, "6 Hilarious Zingers from the Balloon-Dog Freedom Suit Filed against Jeff Koons," *Artinfo.com*, January 21, 2011, http://www.artinfo.com/news/story/36786/6-hilarious-zingers-from-the-balloon-dog-freedom-suit-filed-against-jeff-koons/ and Kate Taylor, "All Bark, No Bite: Settlement Reached in Balloon Dog Dispute," Art Beat, *New York Times*, February 3, 2011, http://artsbeat.blogs.nytimes.com/2011/02/03/all-bark-no-bite-settlement-reached-in-balloon-dog-dispute/.

38 Sotheby's sold lot archive, http://www.sothebys.com/en/catalogues/ecatalogue.html/2007/contemporary-art-evening-sale-n08317#/r=/en/ecat.fhtml.N08317.html+r.m=/en/ecat.lot.N08317.html/5/. And even in recessionary times, *It Just Is*, also offered with a $100,000–$150,000 estimate, managed to sell for $110,500 at Sotheby's May 2009 contemporary auction, http://www.sothebys.com/en/catalogues/ecatalogue.html/2009/contemporary-art-day-sale-n08551#/r=/en/ecat.fhtml.N08551.html+r.m=/en/ecat.lot.N08551.html/301/.

39 See, for example, "News," *Artnet*, March 28, 2006, http://www.artnet.com/magazineus/news/artnetnews/artnetnews3-28-06.asp.

40 Simon Doonan, "How Did I Become the Typhoid Mary of the Art World?" *New York Observer*, April 16, 2006.

41 See Laura Steward Heon, *Billboard: Art on the Road. A Retrospective Exhibition of Artists' Billboards of the Last 30 Years* (North Adams: MASS MoCa; Cambridge: MIT Press, 1999).

42 "NYC Billboards," in Marilyn Minter, *Marilyn Minter* (New York: Gregory R. Miller & Co., 2007), 36.

43 Marilyn Minter, "The Commercial," in *Marilyn Minter*, 29.

44 Marilyn Minter 100 Food Porn, on YouTube (http://www.youtube.com/watch?v=ubw-FZFa8bg.

45 Minter, http://www.greenpinkcaviar.com/.

46 Background information from http://www.greenpinkcaviar.com/.

47 http://www.instyle.com/instyle/package/general/
 promo/0,,20227278,00.html.

48 See the Art Production Fund sales page, with towels and other
 products (where the towels were selling for $50 in February 2009,
 but up to $95 by August), http://www.artproductionfund.org/.

49 Carol Vogel, "A 7,500-Square-Foot Ad for Chanel, with an Artistic
 Mission," *New York Times*, July 24, 2008, and Nicolai Ouroussoff,
 "Art and Commerce Canoodling in Central Park," *New York Times*,
 October 21, 2008.

50 Robert Murphy, "Chanel Cancels Mobile Art Tour," *WWD*,
 December 22, 2008, http://www.wwd.com/eyescoop/
 chanel-cancels-mobile-art-tour-1899292.

51 Information from the LVMH on-line magazine, September 22, 2006.
 The nine artists were Shigeru Ban, Sylvie Fleury, Zaha Hadid, Bruno
 Peinado, Andrée Putman, Ugo Rondinone, James Turrell, Tim White-
 Sobieski and Robert Wilson.

52 For background on the project, see Michael Elmgreen and Ingar
 Dragset, *Prada Marfa* (Cologne: Verlag der Buchhandlung Walther
 König, 2007).

53 See, for example, Richard Dorment, "Britain Turns up the Heat,"
 Telegraph, June 18, 2003.

54 Sarah Thornton, *Seven Days in the Art World* (New York and
 London: W. W. Norton, 2008), 212.

55 On the fake Canal Street shops at the opening, see Guy Trebay, "This
 Is Not a Sidewalk Bag," *New York Times*, April 6, 2008. On the
 counterfeit crackdown, see Anthony Ramirez, "Chinatown Journal:
 On Canal St., Ferreting out the Louis Vuitton," *New York Times*,
 January 29, 2006.

56 On the expanding range of posthumous Warhol merchandise, see
 Ruth la Ferla, "The Selling of St. Andy," *New York Times*, October
 26, 2006.

57 Scott Rothkopf, "Takashi Murakami: Company Man," in Paul
 Schimmel, © *Murakami*, (Los Angeles: Museum of Contemporary
 Art; New York: Rizzoli, 2007), 129, 130.

58 On Murakami's multi-faceted production, see Rothkopf, "Takashi
 Murakami: Company Man."

59 Joe Scanlan, "Please, Eat the Daisies" (2001), reprinted in Alex

Coles, ed., *Design and Art* (London: Whitechapel; Cambridge: MIT Press, 2007), 65. Robert Gober's *Untitled (Dog Bed)* was offered for sale at Christie's Post-War and Contemporary (Evening Sale), November 13, 2002, New York, http://www.christies.com/LotFinder/lot_details.aspx?from=salesummary&intObjectID=4010457&sid=31 83612f-a4e1-4d89-acb9-4c0a4e0bfb4b.

60 See, among other reports, Adrian Searle, "The Day I Tried to Sword-fight a Pensioner," *Guardian*, May 31, 2011, and Georgina Adam, "Dare in the Community," *Financial Times*, June 11/12, 2011.

61 See, for example, David Connet, "The Mystery of the £50m Skull: Is Hirst's Record Sale All it Seems?" *The Independent*, September 2, 2007.

62 See, for example, Caroline Grant, "Teenage Graffiti Artist Accused of Stealing '£500,000 Box of Pencils' in feud with Damien Hirst," *Daily Mail*, September 5, 2009.

63 Arifa Akbar, "Damien Hirst in Vicious Feud with Teenage Artist over a Box of Pencils," *The Independent*, September 4, 2009.

64 Henry Fielding, *The History of the Adventures of Joseph Andrews and his Friend, Mr. Abraham Abrams*, first published in 1742.

65 Jean-Hubert Martin, "The Musée Sentimental of Daniel Spoerri," in Lynne Cooke and Peter Wollen, (eds), *Visual Display: Culture Beyond Appearances* (Seattle: Bay Press, 1995), 58.

66 Example number 5/8 from the *Fountain* edition sold for $1,762,500 at a November 1999 Sotheby's auction, above its estimate of $1–$1.5 million. Another example sold at the Phillips de Pury May 2002 contemporary auction for $1.3 million. For the latter, see "Auction Highlights 2002 in Review—Prices Paid for Impressionist, Modern and Contemporary Art," *Art in America* 91 (August 2003), 48.

67 Robert Ryman, "Untitled Statement" (1971), in Kristine Stiles and Peter Selz, (eds), *Theories and Documents of Contemporary Art: A Sourcebook of Artists' Writings* (Berkeley: University of California Press, 1996), 607.

68 William Shaw, "The Iceman Cometh," *New York Times*, June 3, 2007.

69 Miuccia Prada quoted in Sarah Thornton, "The Art Market: Hands up for Hirst," *The Economist*, September 9, 2010.

70 Sotheby's press release, dated June 19, 2008.

71 Quoted in Thornton, *Seven Days in the Art World*, 6.

72 Carol Vogel, "Heat Upstages Art at the Venice Biennale," *New York Times*, June 16, 2003.

73 Ariel Levy, "Enchanted: The Transformation of Marc Jacobs," *New Yorker*, September 1, 2008.

74 John Tagliabue, "In Italy's Piracy Culture, Black Market is Thriving," *New York Times*, July 3, 1997.

75 See Richard Dorment, "What Andy Warhol Did," *New York Review of Books*, April 7, 2001, and Reva Wolf, reply by Richard Dorment, "'What Andy Warhol Did': An Exchange," *New York Review of Books*, June 9, 2011.

76 Clement Greenberg, "Avant-Garde and Kitsch" (1939), reprinted in Greenberg, *The Collected Essays and Criticism, Volume 1, Perceptions and Judgments, 1939–1944*, ed. John O'Brian (Chicago: University of Chicago Press, 1986), 11.

77 Pierre Bourdieu, *The Rules of Art: Genesis and Structure of the Literary Field*, trans. Susan Emanuel (Stanford: Stanford University Press, 1996), 148.

78 Grace Gluck, "Painting by Jasper Johns Sold for Million, a Record," *New York Times*, September 27, 1980.

79 Tomkins, "A Fool for Art," 66.

80 Isabelle Graw, *High Price: Art Between the Market and Celebrity Culture*, trans. Nicholas Grindell (Berlin: Sternberg Press, 2009), 48–51.

81 Damien Hirst, *For the Love of God: The Making of the Diamond Skull*, ed. Jason Beard (London: Other Criteria/White Cube, 2007). The Rudy Fuchs text appeared as advertising copy on the Other Criteria website listing for the Damien Hirst print, *For the Love of God, Laugh*, 2007 (1004 × 750 mm, silkscreen print with glazes and diamond dust, edition of 250, signed and numbered, £10,500.00, as of summer 2011).

82 Tomkins, "A Fool for Art," 64–5. Prior to Bravo's 2010 *Work of Art: The Next Great Artist*, Deitch helped create *Artstar*, a 2005 art-based reality TV series that achieved much more limited distribution. See Randy Kennedy, "Reality (on TV) Reaches the Art World," *New York Times*, March 2, 2005.

Chapter 6

1 Maurizio Cattelan, *Sixth Caribbean Biennial*, curated by Maurizio Cattelan and Jens Hoffmann; edited by Bettina Funcke (Dijon: Presses du réel, 2001), n.p.

2 Jenny Liu, "Trouble in Paradise," *Frieze* 51 (March–April 2000),

52–3; Ann Magnuson, "Caribbean Castaway," *Artnet*, February 24, 2000, http://www.artnet.com/magazine/features/magnuson/ magnuson2-24-00.asp.

3 *Sixth Caribbean Biennial*, section I, "Interview" (interview among Massimiliano Gioni, Jens Hoffmann, and Maurizio Cattelan), n.p.

4 Nancy Spector, *Theanyspacewhatever* (New York: Guggenheim Museum, 2008), 199.

5 Isabelle Graw, *High Price: Art Between the Market and Celebrity Culture*, trans. Nicholas Grindell (Berlin and New York: Sternberg Press, 2009), 67.

6 The works in question were *The Ballad of Trotsky* (1996), $2,080,000, Sothebys New York, May 12, 2004; *Not Afraid of Love* (2000), $2,751,500, Christie's New York, November 10, 2004; *Untitled* (1991), $2,023,500, Christie's New York, November 10, 2004; *The Ninth Hour* (1999), $3,032,000, Phillips, de Pury & Co., November 11, 2004. For overviews of these sales, see http://www.artnet.com/Magazine/news/artmarketwatch2/ artmarketwatch11-9-04.asp and http://www.artnet.com/Magazine/ news/artmarketwatch2/artmarketwatch5-13-04.asp.

7 "Animal Testing: An Interview with Maurizio Cattelan, Massimiliano Gioni and Ali Subotnick by Nancy Spector," *Of Mice and Men: 4th Berlin Biennial for Contemporary Art* (Ostfildern-Ruit: Hatje Cantz Verlag, 2006), 55–6.

8 Hans Ulrich Obrist interview in Pierre Huyghe and Philippe Parreno, *No Ghost Just a Shell* (Köln: Buchhandlung Walther König, 2003), n.p. See also the case study produced by Christiane Berndes for Inside Installations, http://www.inside-installations.org/artworks/ artwork.php?r_id=356.

9 Molly Nesbit, "Utopia Station: Some of the Parts," in Spector, *Theanyspacewhatever*, 226. See also the e-flux site devoted to the project, http://www.e-flux.com/projects/utopia/about.html.

10 Molly Nesbit, Hans Ulrich Obrist, and Rirkrit Tiravanija, "What is a Station?" http://www.e-flux.com/projects/utopia/about.html.

11 On the tenuous functionality of Atelier van Lieshout's *scatopia* (2002), even during the opening, see Linda Nochlin, "Less than More," *Artforum* 42 (September 2003), 178–9, 240, 246. On the litter left behind by the Superflex Guarana Power initiative, see Natilee Harren, "*Utopia Station*: Manufacturing the Multitude," *PART* Number 12: (In)efficacy, http://web.gc.cuny.edu/arthistory/ part/part12/articles/harren.html.

12 See Jacques Rancière, "Artistic Regimes and the Shortcomings of the Notion of Modernity," in *The Politics of Aesthetics*, trans. Gabriel Rockhill (London: Continuum, 2004), 20–30, and "Aesthetics as Politics," in *Aesthetics and Its Discontents*, trans. Steven Corcoran (Cambridge: Polity, 2009), 19–44.

13 Jacques Rancière, *The Emancipated Spectator*, trans. Gregory Elliott (London and New York: Verso, 2009), 16–17.

14 Fulvia Carnevale and John Kelsey, "Art of the Possible: Fulvia Carnevale and John Kelsey in Conversation with Jacques Rancière," *Artforum* 45 (March 2007), 264.

15 Gilles Deleuze, *Cinema 1: The Movement-Image*, trans. Hugh Tomlinson and Barbara Habberjam (Minneapolis: University of Minnesota Press, 1986), 109.

16 John Kelsey, "Theanyspacewhatever," *Artforum* 47 (March 2009), 236–7.

17 Nicolas Bourriaud, *Relational Aesthetics*, trans. Simon Pleasance and Fronza Woods with the participation of Mathieu Copeland (Dijon: Les Presses du réel, 2002), 29.

18 Bourriaud, *Relational Aesthetics*, 113.

19 Rirkrit Tiravanija, *Supermarket* (Zürich: Migros Museum für Gegenwartskunst, 1998), 224.

20 Blogger "According to G" described taking advantage of the opportunity to meet Saltz after reading his tweet in "Lunch with Jerry Saltz," posted March 13, 2011, http://according2g. com/2011/03/lunch-with-jerry-saltz/. Nicole Caruth also blogged about dining with Saltz, "Gastro-Vision | On Soup," posted March 18, 2011, http://blog.art21.org/2011/03/18/gastro-vision-on-soup/.

21 Bourriaud, *Relational Aesthetics*, 85.

22 Claire Bishop, "Antagonism and Relational Aesthetics," *October*, 110 (Fall 2004), particularly 52 and 62.

23 See Hans Ulrich Obrist, *Hans Ulrich Obrist—Interviews*, volumes 1 & 2 (Milan: Charta, 2003).

24 Bourriaud, *Relational Aesthetics*, 30.

25 Nicolas Bourriaud, ed., *Altermodern: Tate Triennial* (London: Tate Publishing, 2009), and Bourriaud, *The Radicant*, trans. James Gussen and Lili Porten (New York: Lucas & Sternberg, 2009). For a cogent critique of this turn, see Owen Hatherley, "Post-Postmodernism?" *New Left Review* 59 (September/October 2009), 153–60.

26 See Jeffrey Deitch, "The Bowl in the Gallery," in Aaron Rose and

Christian Strike, eds, *Beautiful Losers* (New York: Iconoclast, 2004), 171–6.

27 Andrea Fraser, "How to Provide an Artistic Service: An Introduction" (1994), in *Museum Highlights: The Writings of Andrea Fraser*, ed. Alexander Alberro (Cambridge: MIT Press, 2005), 156.

28 Hill discussed the responses to these three works in Regine Debatty, "Interview with Christine Hill," *We Make Money not Art*, July 4, 2007, http://we-make-money-not-art.com/archives/2007/07/interview-with-20.php.

29 Janet A. Kaplan, "Christine Hill's Volksboutique" (interview), *Art Journal* 57 (Summer 1998), 38–45.

30 Michel Foucault, "What is an Author?" in *Language, Counter-Memory, Practice*, trans. Donald F. Bouchard and Sherry Simon (Ithaca: Cornell University Press, 1977).

31 Jury statement, quoted in a June 6, 2009, press release issued by La Biennale di Venezia.

32 Interview with Tobias Rehberger by Leontine Coelewij, "The Chicken-and-Egg-No-Problem Wall-Painting," in *Tobias Rehberger 1993–2008* (Köln: DuMont Buchverlag, 2008), 19.

33 Daniel Birnbaum, "Chair, Film, Lamp: Rehberger's Bastards," in *Tobias Rehberger 1993–2008*, 67.

34 Jörg Heiser, Frieze Magazine Editors' Blog, "Postcards from Venice pt. 7—Golden Lion Best Artist," http://www.frieze.com/blog/entry/postcards_from_venice_pt_6_golden_lion_best_artist/.

35 "ARTEK Salutes Tobias Rehberger on the Golden Lion Award at The 53rd International Art Exhibition," http://www.artknowledgenews.com/artek-salutes-tobias-rehberger-on-the-golden-lion-award.html. The announcement also indicated that "Selected pieces which Tobias Rehberger created for the Biennale café will be sold as an art furniture edition. All the pieces are handcrafted. The range includes tables painted in black-and-white camouflage as well as chairs and a lounge chair, which are produced using genuine Artek furniture components."

36 The pilot ad appeared on various web-based job listings in early 2009 and the architect ad in early 2010.

37 Nimfa Bisbe, interview with Jorge Pardo, in *Jorge Pardo: un projecte per a la Col·lecció d'Art Contemporani Fundació "la Caixa"* (Barcelona: Fundació "la Caixa," 2004), 61–2.

38 Suzanne Muchnic, "Rediscovering Latin America," *Los Angeles Times*, July 26, 2008.

39 Holland Cotter, "Ancient Art, Served on a Present-Day Platter," *New York Times*, August 26, 2008.

40 Lane Relyea, "Lane Relyea in Conversation with Jorge Pardo," in Christina Végh, et al., *Jorge Pardo* (London and New York: Phaidon Press, 2008), 32.

41 Barbara Steiner, "What Does this Text Do? About Distortion, Resistance, Dislike and Subjectivity," in *Jorge Pardo*, (eds) Jörn Schafaff and Barbara Steiner (Ostfildern: Hatje Cantz, 2000), 28.

42 Although the inception of Pardo's house is linked to its role as museum exhibition, MOCA actually contributed a relatively modest amount to its production: $10,000, against a total cost of $350,000, according to Joel Sanders, "Frames of Mind," *Artforum* 38 (November 1999), 131.

43 Interview, *Andrea Zittel: Critical Space*, (eds) Paola Morsiani and Trevor Smith (Munich and New York: Prestel, 2005). Zittel refers to clothing as public art, p. 54, discusses the small spaces, p. 46, and the corporate identity, p. 51.

44 Trevor Smith, "Rules of Her Game: A-Z at Work and Play," in *Andrea Zittel: Critical Space*, 39.

45 Entry for A-Z Carpet Furniture in *Andrea Zittel: Critical Space*, 110.

46 Zittel's 1997 *Untitled (Carpet)* sold at Sotheby's Contemporary Art (Day Sale) in New York, November 10, 2004, for $10,800.

47 Christie's Contemporary Art (Evening Sale), November 19, 1999, http://www.christies.com/LotFinder/lot_details. aspx?from=searchresults&intObjectID=1613202&sid=088 bd00e-3a6b-4570-8d24-dcdae15ce9f5.

48 Walter Benjamin, *Charles Baudelaire: A Lyric Poet in the Era of High Capitalism*, trans. Harry Zone (London: Verso, 1973), 53–4.

49 Andy Warhol, *The Philosophy of Andy Warhol (From A to B and Back Again)* (New York: Harcourt Brace Jovanovich, 1975), 26.

50 See Andreas Baur and Roland Wäspe's discussion of this work in "Public—Private," *Emily Jacir* (Nürnberg: Verlag für Moderne Kunst, 2008), 10.

51 On the beer-label conflict, see Glen Warchol, "N.Y. Arts Group has Epic Problem with Utah Brewery," *Salt Lake Tribune*, March 11 & 27, 2011, http://www.sltrib.com/sltrib/home/51413972-76/jetty-spiral-epic-says.html.csp.

52 Jeremy Deller, *It Is What It Is: Conversations About Iraq*, 2009, curators Laura Hoptman, Amy Mackie, and Nato Thompson. See http://www.conversationsaboutiraq.org/index.php.

53 Ken Johnson, "From China, Iraq and Beyond, But is it Art?" *New York Times*, February 19, 2009.

54 Center for Land Use Interpretation website, http://www.clui.org/about/index.html. See also Nato Thompson, *Experimental Geography* (Brooklyn: Melville House; New York: Independent Curators International, 2008).

55 For a general discussion of culture jamming, see Naomi Klein, *No Logo* (New York: Picador, 10th anniversary edition, 2009), particularly 279–309. There are also links to a number of websites in the culture jamming section on the website for the Center for Communication & Civic Engagement, http://depts.washington.edu/ccce/polcommcampaigns/CultureJamming.htm.

56 Rosalyn Deutsche, *Evictions* (Cambridge: MIT Press, 1996), 104–5.

57 See Krzysztof Wodiczko, *Critical Vehicles: Writings, Projects, Interviews* (Cambridge: MIT Press, 1999), particularly "Homeless Vehicle Project," with David Lurie (1988–9), 83, and "An Interview by Bruce W. Ferguson" (1991), 187.

58 See Nato Thompson and Gregory Sholette (eds), *The Interventionists: Users' Manual for the Creative Disruption of Everyday Life* (North Adams: MASS MoCA Publications; Cambridge: MIT Press, 2004), 33–4, and the Museum of Modern Art's online collection archive, http://www.moma.org/collection/object.php?object_id=94026.

59 Fulvia and Kelsey, "Art of the Possible," 259.

60 Bishop, "Antagonism and Relational Aesthetics," 52–3, 65–7.

61 Santiago Sierra, "Interview" (with Hilke Wagner) in *Santiago Sierra* (Málaga: Centro de Arte Contemporáneo de Málaga, 2006), 31, 33.

62 Yuneikys Villagonga, "Tania Bruguera: Her Place and Her Moment," in *Lida Abdul, Tania Bruguera: Maintenant, ici, là-bas [Now, Here, Over There]* (Metz: Frac Lorraine, 2007), 76.

63 Hans Belting, "Introduction," in *The Global Art World: Audiences, Markets, and Museums*, (eds) Hans Belting and Andrea Buddensieg (Ostfildern: Hatje Cantz, 2009).

64 Thomas Fillitz, "Contemporary Art of Africa: Coevalness in the Global World," in *The Global Art World*, 125.

65 Coco Fusco, *The Bodies that Were not Ours, and Other Writings* (London and New York: Routledge, in collaboration with Institute of International Visual Arts, 2001), 156.

66 See Claire Bishop, "Speech Disorder," *Artforum* 47 (Summer 2009), 121–2, as well as Coco Fusco's letter in response and Bishop's reply, "Public Address," *Artforum* 48 (October 2009), 38, 40.

67 Tania Bruguera made this point in the context of the Max
 Wasserman Forum on Contemporary Art, MIT List Visual Arts
 Center, March 13, 2010.

68 Quoted in Christopher Knight, "The Boy Shill: How King Tut
 Evolved from Cold War Cultural Ambassador to Today's Corporate
 Pitchman," *Los Angeles Times*, August 28, 2005. See also Mike
 Boehm, "Tut Sequel's Audience is Second Largest," *Los Angeles
 Times*, November 22, 2005.

69 According to the attendance figures released by the Met in
 an August 8, 2011, press release, "661,509 Total Visitors to
 Alexander McQueen Puts Retrospective among Top 10 Most
 Visited Exhibitions in Metropolitan Museum's History." Stephanie
 Cash discussed the exhibition funding in a July 29, 2011, *Art in
 America* post, "No Sponsorship Controversy for McQueen?" http://
 www.artinamericamagazine.com/news-opinion/news/2011-07-29/
 metropolitan-alexander-mcqueen-sponsorship/.

70 James Franco, "A Star, a Soap and the Meaning of Art: Why an
 Appearance on 'General Hospital' Qualifies as Performance Art,"
 Wall Street Journal, December 4, 2009.

71 The most controversial aspect of Deitch's appointment was his stated
 plan to continue selling works from his own holdings after assuming
 the directorship—including art transferred to his personal collection
 from gallery inventory after he closed down the business prior to
 taking up the reins at MOCA.

72 Quoted in Randy Kennedy, "Museum Role Fits a Former Art
 Dealer," *New York Times*, June 29, 2010. See also Dana Goodyear,
 "L.A. Postcard: Francophrenia," *New Yorker*, July 12, 2010.

73 See "James Franco Interviews Artist Marina Abramovic," *Wall Street
 Journal Online*, December 3, 2009, http://online.wsj.com/video/
 james-franco--interviews-artist-marina-abramovic/43CA82D1-5CF8-
 48CF-A12A-897C5C641E12.html. The Marina Abramović dessert
 was part of a series of food-as-art collaborations with chef Kevin
 Lasko, organized by Creative Time at the Park Avenue seasonal
 restaurant, with further contributions by Paul Ramírez Jonas, Janine
 Antoni, and Michael Rakowitz.

74 See Rachel Wolff, "Made for Each Other: In Kalup Linzy, James
 Franco Met his Performance-art Match," *New York Magazine*,
 January 30, 2011, http://nymag.com/arts/art/features/70940/, as well
 as the General Hospital performance clip, http://www.youtube.com/
 watch?v=l_TPLAPsxuc&feature=player_embedded#at=12.

75 "Commercial Break," which was supposed to appear in Venice, June

1-5, 2011, was sponsored by Garage Projects and curated by Neville Wakefield—with a related iPad application for *POST* magazine. See http://www.garageccc.com/eng/projects/17524.phtml for the project. On the party, see (among other reports), "Stampede of the Glitterati: Stars Swarm Dasha Zhukova's 'Commercial Break' Party at the Bauer Hotel," *Artinfo*, June 3, 2011, http://www.artinfo.com/news/story/37815/stampede-of-the-glitterati-stars-swarm-dasha-zhukovas-commercial-break-party-at-the-bauer-hotel/ and Bettina Prentice, "A Lovely Triumvirate: Dasha Zhukova, Alexander Dellal and Neville Wakefield Host Commercial Break," *Paper Magazine*, June 6, 2011, http://www.papermag.com/party_snaps/2011/06/commercial-break-at-the-bauer-hotel-in-venice.php.

76 Dana Goodyear, "Celebromatic," *New Yorker*, November 30, 2009, and Linda Yablonsky, "Star Turn," Scene and Herd section, *Artforum.com*, November 20, 2009, http://artforum.com/diary/id=24212.

77 See David Velasco, "Trash and Vaudeville," Scene and Herd section, *Artforum.com*, July 31, 2007, http://artforum.com/diary/id=15591.

78 Jeffrey Deitch, contribution to "The Museum Revisited," *Artforum* 48 (Summer 2010), 279.

79 David Barboza, "Provocateur's Products Roll off the Assembly Line," *New York Times*, September 3, 2007.

INDEX

Page numbers in boldface indicate illustrations